Undoing Whiteness in the Classroom

"Teacher educators who are working for social justice need to read this book. In this highly readable edited volume, Lea and Sims show how the arts tap powerfully into emotions and unspoken assumptions to disrupt the intellectualism that blocks authentic dialogue about racism and whiteness in so many teacher education courses. *Undoing Whiteness in the Classroom* unpacks the philosophy and practice of educulturalism—art linked to social activism. Using personal story-telling, authors share well-conceptualized, arts-based approaches that invite teachers to grapple with, question, and begin to challenge whiteness. This book is a terrific resource!"

Christine Sleeter, Author of Facing Accountability in Education: Democracy and Equity at Risk

"Lea and Sims embody the best of educational academia because they live the research that is the focus of this book: undoing whiteness in the classroom. I first met these two women, when they with many others, were trying to stop a Eurocentric textbook from becoming the main source of history information for America's schoolchildren. They have taught and struggled around issues concerning social justice and equity inside and outside of the educational system, and their accumulated wisdom and that of the other contributors fills this book."

Kitty Kelly Epstein, Author of A Different View of Urban Schools: Civil Rights, Critical Race Theory, and Unexplored Realities

"In *Undoing Whiteness in the Classroom*, Lea and Sims magnificently combine their thirst for social justice, their visionary leadership in dismantling racism, and their passion for art and culture. Lea and Sims ingeniously connect critical multicultural and anti-racist pedagogy with educulturalism, defined as 'an activist learning process' that incorporates music, the visual and performing arts, narrative, oral history, and critical dialogue. They give voice to a group of accomplished scholar activists and the processes they use to engage their students in the creative deconstruction of racism and hegemony. They offer tomorrow's educators practical but critical activities for simultaneously fighting injustice and tapping the cultural capital of marginalized communities, including story quilts, Chicana children's literature, Black women's feminist thought, and pre-Columbian math. The book provides teachers and teacher educators with realistic and meaningful classroom activities aimed at disrupting white privilege in a classroom setting. Lea and Sims acknowledge that challenging whiteness is a difficult process, but one in which white students are more likely to participate 'if they do not feel blamed for embodying it' (Lea and Sims, introduction). By reading this book, those who are committed to educational justice will add to their repertoire of educational theories and pedagogy and engage in the process of undoing whiteness, creatively, artistically, and critically."

Theresa Montano, Associate Professor of Education, Department of Chicana/o Studies, California State University, Northridge

Undoing Whiteness in the Classroom

Studies in the
Postmodern Theory of Education

Joe L. Kincheloe and Shirley R. Steinberg
General Editors

Vol. 321

PETER LANG
New York • Washington, D.C./Baltimore • Bern
Frankfurt am Main • Berlin • Brussels • Vienna • Oxford

Undoing Whiteness in the Classroom

Critical Educultural Teaching Approaches for Social Justice Activism

Edited by
Virginia Lea and Erma Jean Sims

PETER LANG
New York • Washington, D.C./Baltimore • Bern
Frankfurt am Main • Berlin • Brussels • Vienna • Oxford

Library of Congress Cataloging-in-Publication Data

Undoing whiteness in the classroom: critical educultural teaching approaches
for social justice activism / edited by Virginia Lea, Erma Jean Sims.
p. cm. — (Counterpoints; v. 321)
Includes bibliographical references.
1. Critical pedagogy—North America. 2. Multicultural education—North America.
3. Racism in education—North America. I. Lea, Virginia. II. Sims, Erma Jean.
LC196.5.N67U53 370.11'5—dc22 2007000759
ISBN 978-0-8204-9712-9
ISSN 1058-1634

Bibliographic information published by **Die Deutsche Bibliothek**.
Die Deutsche Bibliothek lists this publication in the "Deutsche
Nationalbibliografie"; detailed bibliographic data is available
on the Internet at http://dnb.ddb.de/.

Cover image, *Josephine*, by Louise Gadban

The paper in this book meets the guidelines for permanence and durability
of the Committee on Production Guidelines for Book Longevity
of the Council of Library Resources.

Printed in the United States of America

Table OF Contents

Acknowledgments

VIRGINIA LEA

This book has been inspired by a commitment to the power of music, art, narrative and dialogue to move our minds, bodies, and souls to a place where we can see ourselves more clearly. With this greater clarity, we are more likely to understand and challenge the oppressive ways in which societies work. In turn, this knowledge can be turned into the kind of compassionately, creative activism necessary to bring greater equity, caring and social justice to the lives of our fellow human and other sentient beings.

Educulturalism began for me when my husband, Babatunde Lea, and I finally had the opportunity to come together for a second time to build one life with our family. His music has become a mirror to my soul; my critical multicultural analysis of the world has mirrored his long-term knowledge of the influences on his life path. It has not been easy but it has been a truly educational and, I would say, predestined journey.

So my first thanks goes to Babatunde—my soul's companion in the dark and the light. Thanks, of course, to Jean, my friend, colleague, and co-editor. We have grown and learned so much together. Thanks to my adult children, Lichelli, Tanya and Mayana, and to my granddaughter, Eli, such a welcome newcomer to our world—all artists in their own fields; all beautiful, creative people who have inspired and taught me more than they will ever know.

Thanks to my students, friends and colleagues, who have made such huge contributions to my own knowledge. Thanks to all of the authors in this book. What a wealth of creativity has been brought together here, and how proud I am to be part of it.

Thanks, finally, to Chris Myers, Bernadette Shade, Shirley Steinberg, and all of the other brilliant folks at Peter Lang who helped us through this editorial process.

ERMA JEAN SIMS

I want to thank my family for their endless love and support throughout this journey that we call "life". My husband, Victor Sims, is a pillar of strength and his love sustains me. He has been patient and understanding through all the re-writes, re-edits and the seemly endless hours that it takes to make a book a reality. My daughter, Ashley, is my mirror. She is the eyes through which I see myself. Her encouragement and daily, "I love you Mom," makes me know that I can accomplish many things with her love and support. My son, Steven, challenges me to live my convictions. His search for the answers to life's many riddles has made me re-examine many things.

A very special thank you to my co-editor, Virginia Lea, whose faith in me has helped me grow in ways I never thought possible. Her keen insight into the complexities of writing a book about "whiteness" and "educulturalism" has been the driving force behind our successful completion of this exciting new book. I cherish her friendship and love.

I want to thank the authors who contributed their scholarship and expertise to this very special book. Our journey together has been a very rewarding experience.

Your chapters in this book will enlighten, transform, and propel educators for social justice and equity into greater awareness and action.

Last but not least, Virginia Lea and Erma Jean Sims would both like to gratefully acknowledge the following copyright holders for permission to use their copyrighted material:

Images by Cathy Bao Bean in chapter 12. Used by permission of Cathy Bao Bean.

Art work by Sandra Brewster, Toronto, Canada, in Pauline Bullen's chapter 13. Used by permission of the artist, 2007.

"Josephine," Paris, 1936, by Louise Payne, nee Gadban. Cover image, also found in the Introduction to the book. Used by permission of the artist.

Images recreated by Shimmering Wolf in Virginia Lea's and Erma Jean Sims's chapter 11. Used by permission of Shimmering Wolf Studios, Felton, CA.

Undoing Whiteness
IN THE Classroom:
Different Origins,
Shared Commitment

VIRGINIA LEA AND
ERMA JEAN SIMS

With this book, we aim to empower our readers to develop the critical consciousness and social activism necessary to the pursuit of social justice and equity, and to facilitate these qualities in others. Specifically, we hope to show teachers and educational activists how they may use the philosophy and practice of educulturalism to identify and take action to undo—that is, reverse the effects of—the hegemony of whiteness as it is manifested in schools and classrooms.

Educulturalism is an activist learning process through which we teach critical thinking about social and cultural issues through music, the visual and performing arts, narrative and dialogue. In our educultural courses, we also aim to deepen our students' awareness of their deep-seated social and cultural assumptions and prejudices. Through educultural experiences, they are more open to challenging and interrupting the social construction of whiteness, race, socioeconomic class, gender, and other dimensions of social inequality in our schools, classrooms, and themselves. Preservice and practicing teachers are inspired to develop social justice-oriented, culturally responsive, critical, and creative curricula.

Whiteness is a complex, hegemonic, and dynamic set of mainstream socioeconomic processes, and ways of thinking, feeling, believing, and acting (cultural

scripts) that function to obscure the power, privilege, and practices of the dominant social elite. Whiteness drives oppressive individual, group, and corporate practices that adversely impact schools, the wider U.S. society and, indeed, societies worldwide. At the same time, whiteness reproduces inequities, injustices, and inequalities within the educational system and wider society. We use the term whiteness rather than hegemony alone to signal these processes because a disproportionate number of white people have benefited, to greater or lesser extent, from whiteness. However, it is not our intention to continue to center whiteness. As a set of processes, whiteness recenters itself, and as such needs to be identified and transformed.

We begin this book with personal educultural narratives that introduce the reader to how we, individually, came to embrace educulturalism as a process that can be used to undo whiteness and empower social justice activism in the classroom and beyond.

VIRGINIA LEA

Louise Mary Gadban is my mother. She is a woman of style and stories—the latter told repeatedly to people who have never heard them before and to some of us who have. Born in England of European and Arab descent, she has bowed deeply to hegemonic forces that expected her to turn her face away from identification with the Arab Middle East. To fit into English upper-middle-class society, her father was raised as an Englishman, and my mother sees herself as a truly English rose. She finds my embrace of our Syrian ancestors unfathomable. When we are alone she agrees with my active stance against the imperial intentions of the United States and Britain in the Middle East, and Israeli Zionism; in company, she finds my politics uncomfortable.

Louise is, however, like most human beings, a highly complex individual. Louise is an artist. She went to Paris before the Second World War to paint. She lived on the left bank with a hatmaker, and exchanged paintings with some of the now famous artists of her generation. Perhaps predictably she lived in the center of an unorthodox artists' community without really becoming part of it. Her parents' voices continued to speak loudly in her head. She painted nude figures, but tells the story, as if it were humorous, of her father coming to visit the studio and fainting at the sight of a nude model. She does not emphasize the tragedy implicit in a grown man perceiving the naked human body in an artistic setting as an immoral blight, and failing to recognize its beauty and sensuality.

Louise returned from France in 1937 when the start of violence in Europe seemed inevitable. She stored the "paintings" that she had received in Paris in

exchange for some of her own in her room in her parents' house in Alton in Southern England. Alas, when she went on honeymoon with my father in 1947, her mother, my grandmother, cleaned out her room and threw all of the paintings away. I often muse over the kind of self-centered and soul-alienated individual who could have carried out this act. My own mother seemed to me to be afraid of fully participating in life, in part, I believe, because of her family's puritanical morality, and in part, because she had been raised and controlled by a mother, whose desire to be fully accepted in the upper echelons of "society" knew few bounds.

The above is not a criticism of my mother. Indeed, it was Louise, who first inspired my focus on educulturalism. At the same time as being constrained by the dominant nationalistic and moral cultural scripts of her time, Louise's unconscious mind is a storehouse of beautiful and courageous narratives. These have not been thrown away. I believe her unconscious mind harbors an unrealized moral adventurer, nurtured by kindness and the capacity to imagine and create. She has told my children that she admires what she perceives as my bravery to step outside of her norm. In another time and place, I believe Louise would have found the courage and energy to look at the cultural scripts she has borrowed, unexamined, from the significant others in her life—principally, her mother, father, and husband. She would have found the courage and energy to step outside of her privileged world and interrupt what she sees as unfair and unkind in the world just beyond. Indeed, she does so unfailingly within the confines of her own family. Although her art became less profoundly complex during the patriarchal years of her marriage to my father, whom I loved deeply, it is now beginning to regain some of its dense complexity. It is no longer an event, quickly executed in preparation for the next act. It is beginning to recuperate some of the characteristics that made Josephine, the African head that she painted in 1936, so powerfully beautiful. The painting of Josephine is a reflection on human and indeed all sentient strength and frailty, love and conflict, material and immaterial life. It is inclusive of the complexities of life and spirit, not a dichotomous, liberal humanistic treatise. Educulturalism draws on what I have learned from the painting of Josephine, which hangs on the wall in my living room. The painting is copied below.

As I hope the above indicates, I am full of appreciation for the educultural lessons Louise has taught me. If I see her as less than conscious of the dominant cultural scripts that have shaped her life, I can hardly talk. I am aware of the practical nature of our unconscious minds, as they guard our unconscious drives and patrol cultural scripts that might cause cognitive dissonance, but which have huge consequences in our behavior (Festinger, 1957; Marcuse, 1966). Moreover, having sidelined my own art for so many years, I have not been the most active

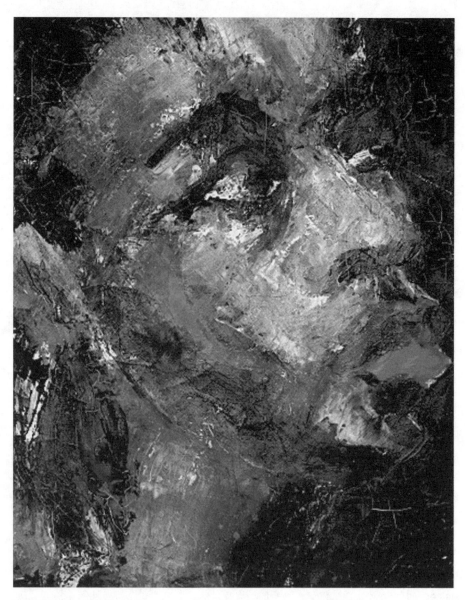

Josephine by Louise Mary Gadban

educulturalist. Although I have worked hard for years at practicing true educul-
turalism and examining my own practice as I engage in it through the lenses of
liberational and transformative critical multicultural theory (Freire, 1993/1970),
I have been, at times, typical of the many who spout rhetoric while busily immers-
ing ourselves in less-than-reflective practice.

At this point in my life, I am more than ever committed to remaining on the educultural path by which we use art in its many forms to find and sustain the courage and energy to engage in social justice activism. In fact, while my journey to lead a reflective, educultural life began with Louise, I have been helped in this endeavor by my life partner and husband, Babatunde Lea (see Chapter 9 in this book).

Babatunde Lea and I began the Educultural Foundation in 1993. The Educultural Foundation was a child born of our two major disciplines: art and education. Babatunde is a professional musician; I am a professional educator. However, Babatunde is also an educator and I have always loved, explored, and, as I have said, should now pursue more fully my drawing, painting, and sculpture. My mother's artistic and educultural voice speaks within me.

Babatunde plays jazz influenced by the African diaspora (Motema Music, 2006). His concerts are punctuated with voices that resemble his angels—Paul Robeson and Sun Ra. He tells his audience that music is like oil and water: It does the bidding of whosoever controls it. In this light, Babatunde asks his audiences to respectfully draw on his music to gain energy to fight the "isms" of this world—racism, sexism, classism, and homophobia. His tune "Outlyer," for example, evokes enslaved Africans who, when they were brought in chains to American shores, "caught hat," "got in the wind," "got out of Dodge," or in other words escaped into the Everglades to live out their lives with the Seminole people. "They sent slave catchers into the Everglades to retrieve the escaped slaves but all they caught was hell." According to Babatunde, we need more of this independent, alternative spirit today if we are to challenge the cultural scripts that promote accountability to essentially inequitable, one-size-fits-all, mainstream, socioeconomic, cultural, and educational standards (Roediger, 2006; Sleeter, 2005; Tabb, 2006).

Babatunde Lea is also a teacher. For the last five years, through the Educultural Foundation, he has been inspiring an entire elementary school in northern California to learn how to play African diasporic rhythms, to sing chants, and to perform for parents and community at an end of the semester assembly (Educultural Foundation, 2006). As research has shown us, immersion in musical narrative rubs off positively on the academic and social lives of children. Indeed, Babatunde Lea's *Rhythms of the African Diaspora* program has had very positive consequences on the lives of the children of—school in a town north of Oakland, California. As one of his 6-year-old African–American students said during the most recent end-of-semester performance, "After I have drumming with Babatunde I am able to be more calm and do my work."

Rhythms of the African Diaspora is just one of many Educultural Foundation programs, all of which use music, visual and performing arts, narrative and dialogue to raise the critical consciousness of children and adults to the ways in which they

are being designed by the social and cultural worlds within which they are trapped (Geertz, 1973), and to help them to construct alternative, authentic, individual, and community knowledge. As Mary Kalantzis and Bill Cope (2004) have written:

> If formal education is to continue to play a central role in shaping effective and satis-fied citizens, workers and learners it needs to recognise and harness the new means of creating and distributing knowledge. Education is thus a more pivotal social invest-ment than it ever was in the past. The level of creativity and innovation required will also alter the relationship between government and places of learning... Traditional classrooms and traditional bureaucratic education systems, cannot provide society what it now needs. (p. 3)

In our view, this new learning requires educultural input. It requires that we, the educators, are the first to rethink traditional categories of knowledge, our own relationships with others, our sense of who we are, and what counts as legitimate objectification (Foucault in Rabinow, 1984). In this light, we conclude our per-sonal introductions with personal educultural poems, the following being mine:

> I am an educultural traveler, inspired by my educultural muses—mother, life partner and husband, daughters, and the other educultural artists I have known and loved—to search for shadows of meaning beneath the patterns of my truncated creativity.

> I am an educultural warrior, committed to challenging political and corporate policies that crush life, liberty, and creativity in the pursuit of global control.

> I am an educultural whisperer, trying to tread softly the path of social justice in the wake of educultural giants who have generously given hope beyond the known day.

> I am an educultural dreamer, imagining kinder worlds in which humans have learned to creatively partake their resources, and no longer call upon physical and psychic violence to selfishly appropriate more than their fair share.

ERMA JEAN SIMS

My maternal grandmother, Arbirta Cloud, a Cherokee and Irish woman, was my first educultural teacher. My grandmother loved to quilt. It was a creative way for her and my mother to spend time together. Stitch by stitch and patch by patch; they quilted together the pieces of our lives. They both looked forward to this time spent reminiscing and sharing little known parts of the lives of our ances-tors. Perhaps my grandmother, Arbirta, had a plan and goal in mind when she sat down for these quilting sessions that took place after they both had their house-holds and families in tact and could devote time to this important effort. She told me that at first my mother and she worked on their individual quilts but shared the time and space together. They both realized quickly that a more beautiful and

rich product would come out of their collaborative efforts together. It was a time of laughing, sometimes singing, and at other times time spent in prayers of praise and thanksgiving that these quilts were made of sadness, sorrow, and happy times spent within each other's reach.

Carolyn Mazloomi (1998) reveals the past and growing popularity and significance of quilts as an art form. In her book, *Spirit of the Cloth: Contemporary African American Quilts*, Mazloomi tells us that "American quilters have long recognized the value of handmade quilts as a reminder of home, family, and friends. Using the quilt as a narrative medium, they combine needlework and cloth to capture life's joys and sorrows." Many of the African-American quilters in her book were inspired by our country's African-American cultural and artistic legacy. They were also inspired by the rich heritage of Africa, incorporating African textiles, such as Kente cloth and mud cloth, into their quilts. They frequently celebrated history and their ancestors by using African symbols and imagery in their designs, revealing the power of life stories and ritual in abstract patterns and form. Mazloomi points out the power of quilts as vehicles for political and social activism:

> Anti-slavery quilts and freedom quilts…record and comment topics ranging from civil rights and political injustice to urban politics, race, gender, and status. With strong bold images, they remind us of our own responsibilities and roles in shaping the world we live in and underline our shared values of freedom, equality, and justice. (Ibid)

The exquisite quilts in her book attest to the diversity, quality, and creativity of the artists "to transform lifeless materials into lively and life-sustaining statements of the human spirit" (Ibid). For example, Virginia Harris, an African-American northern California quiltmaker and master fabric artist, challenges the stereotypes of quilt making and the stereotypes of subject matter. Harris says her fabric is her palette, and stitching is her brush stroke. Harris' images are particularly relevant during these politicized times. In her *Guaranteed Safety* quilt, Harris points out "There are ten titles in both the USA PATRIOT ACT and the Bill of Rights." However, the rights guaranteed by the Bill of Rights have been put into jeopardy by the USA PATRIOT Act "supposedly to make citizens feel safer—a definite oxymoron." In her quilt, *The New Alchemy*, Harris shows a pipeline taking oil and natural gas from the Caspian Sea and dumping "gold" into Texas (Wasp, 2004).

My grandmother's quilts were equally political. They were "story quilts." I always admired her ability to quilt, crochet, and knit. She had a unique talent for turning a ball of yarn, thread, and scraps of cloth into a masterpiece. She was also blessed with a special gift of making each of us feel special and a part of a long proud history. My grandmother held dear to her heart the oral history of her Cherokee mother's family and found time to share the stories of her Cherokee ancestors' long and torturous walk on the Trail of Tears. I listened intently to every word, hoping

to understand how we became who we are—proud, strong, and sure that we would always survive through our belief in the Great Spirit and the confidence that comes from knowing who you are. I was to be the carrier of these words of wisdom. I reveled in the thought that my grandmother trusted me with this body of family knowledge that she wanted preserved and remembered. I knew that she had shared our family history with my mother who seemed always too busy to share it with me. As the eldest granddaughter, I took my responsibility as family historian seriously and was surprised later to learn from other members of my family that they had not been privileged with this information. I wondered if there were other ways that my grandmother had attempted to communicate this important and valuable information to them; this wisdom and truths that make you whole and connects you in intimate ways to your past, your present, and your future.

It was these thoughts that made me think critically about the educultural people and influences in my life. I was the proud recipient of one of my grandmother and mother's artistic masterpieces. It was to be given to me when I left for college; so that I'd always have a visual reminder of their love and the comfort that a family quilt could bring to a stranger in a strange place. The time, love, and care that went into the making of this beautiful, colorful quilt rich in the fabric that make us the Cloud family was not lost on me. I did receive my quilt on the day I went off to college. I held it close to me in the car knowing that I was taking a precious part of them with me.

> I am a educultural teacher inspiring those I touch with a love of creativity and endless freedom to those courageous enough to want to be set free.

> I am a lover of beauty in art, music, and song that penetrate my being and stimulate a deeper search for my inner self in a world that is both complex and simplistic in a universe of possibilities.

> I am a seeker of truth that opens the mind and spirit to creative solutions to seemly impossible global problems that rob the human spirit and kill the soul wanting to be made whole.

> I am a dreamer envisioning peace in a world full of turmoil, strife and destruction, committed to positive social change that heals the human heart longing for harmony, justice and peace on this lonely planet.

WHY "UNDOING WHITENESS IN THE CLASSROOM?"

> Those of us committed to resisting and promoting alternatives to (the highly standardized political and educational climate in which we are currently living) need to gain clarity about the ways in which hegemony operates in classrooms, communities and in ourselves (Bartholome, 1996; Kumashiro, 2004; Lea & Helfand, 2004). As a result of

hegemonic structures and practices, the road ahead of us is littered with obstacles, both structural and ideological. We need to be able to support each other in our work, and encourage student teachers, beginning teachers, practiced teachers, teacher educators, parents, and community members to join the movement. (Lea & Sims, 2004)

In her book, *A Different View of Urban Schools: Civil Rights, Critical Race Theory, and Unexplored Realities*, Kitty Kelly Epstein (2006) contributes to our gaining clarity about how this hegemony works. Epstein examines the myths that mask the actual purposes and processes governing urban schools in the United States. She does so by looking at Oakland, California, as a case study. Epstein challenges the myth that claims that there was a golden age of schooling (Bastian et al., 1993), and argues that race has always governed educational structures in the United States, as exemplified by the processes of standardized testing and tracking. In her view,

> race is undertheorized as an aspect of U.S. society and education...[it] is rooted in property relations...and racism is permanent in the U.S. society (Ladson-Billings & Tate, 1995; Bell, 2004)...As we ask, for example, why is there an "achievement gap" between white and black students, these three contentions can help us look more clearly. First, we will be more likely to look for racial structures, rather than individual characteristics, to explain the gap. Second, we will understand that it may be connected to issues of property, particularly "whiteness" as a possession in and of itself. And third, we will not be expecting an easy fix through some new government policy. (Epstein, 2006, p. 6)

By containing the term "achievement gap" in inverted commas, Epstein is carefully refusing to validate the schooling system that gave rise to and is currently assessing the "achievement gap." In fact, she effectively scrutinizes the system that is given daily legitimacy when we treat the notion of "achievement gap" as unproblematic. We consider Epstein's focus on racism and whiteness critical to understanding how the "achievement gap" was socially constructed. She helps us to recognize how we can dismantle these components and engage in social justice activism in the classroom.

Our definition of whiteness includes Epstein's proposition, drawn from critical race theory, that whiteness is related to property rights (Harris, 1995).

> The origins of property rights in the United States are rooted in racial domination. Even in the early years of the country, it was not the concept of race alone that operated to oppress blacks and Indians; rather it was the interactions between conceptions of race and property which played a critical role in establishing and maintaining racial and economic domination...Only white possession and occupation of land was validated and therefore privileged as a basis for property rights. (pp. 277–278)

For us whiteness is, however, more than property rights. As mentioned earlier, it is a set of the hegemonic processes by which plutocratic oligarchies—the principle owners of property and the means of production—are sustained in the United States and Western Europe. The ownership that results from whiteness constitutes socioeconomic and political power over others. Its longevity was built into and assured by the Constitution of the United States and has been protected by subsequent law. Whiteness is also the means by which the origins of and inequities associated with this power are mystified so that the majority of the population will not perceive the need to question, or offer a protest or challenge to institutionalized, systemic, socioeconomic, and political system inequities.

It is our intention to name the dynamic attributes of whiteness to interrupt, if not abolish, its operations (Ignatiev & Garvey, 1996). As Epstein acknowledges, this is unlikely to be achieved in the near future (Bell, 1992). Whiteness is in the air we breathe (Butler, 1998); it is in the mainstream waters of society in which we all, to a greater or lesser extent, swim (see Lea & Sims, Chapter 5 of this book). It morphs to continue to disproportionately privilege white, propertied people.

Whiteness also gives privilege to poor white people in relation to people of color. It enables those of us who find ourselves poor and white to feel good about ourselves despite the economic challenges we face by believing we have more merit than the people of color have (Wray & Newitz, 1997). Many whites embrace a superior racial identity, reinforced by the corporate media and public school culture. Some of us perceive that our economic interests lie in defending the largely white corporate capitalist power structure instead of becoming allies with low-income people of color in the struggle for social justice. Although the incentives for this alliance are no longer as blatantly legal, as were from the middle of the seventeenth century until the civil rights laws of the 1960s (Zinn, 1997), they continue to function in the form of insidious corporate media manipulation and subtle social policy. Among many examples of such policy is California's Proposition 209 (1996), passed by the voters after an effective media campaign. Officially termed the *Prohibition Against Discrimination or Preferential Treatment by State and Other Public Entities. Initiative Constitutional Amendment,* Proposition 209 was presented to the public as a "Civil Rights Initiative" in an age when race and gender no longer impacted state hiring and recruitment practices. In actuality, it mandated the abolition of affirmative action at a time when the race, class, gender, and the cultural dimensions of institutional policy and practice continue to have a differential impact on the opportunities and outcomes of individuals from different ethnic and socioeconomic groups.

Given the dominant myths in the United States that frame this country as the embodiment of social justice and freedom, benevolent individualism, and a

meritocracy that allows all comers access to the "American Dream" (Oakes & Lipton, 1999), most citizens find it much more comfortable to remain less than conscious of the realities of whiteness that govern the dominant institutions of the United States. We are particularly set on protecting ourselves from the knowledge that, to a greater or lesser extent, whiteness inhabits the unconscious minds of everyone immersed in the institutional waters of the United States. In our classrooms, we tell our students that for us whiteness is not about individual acts of meanness—although they are related to whiteness (McIntosh, 1989). Whiteness is not an essential attribute; nor is it usually an intentional act—although it can be intentional. Whiteness is learned; it is embodied discourse. Institutionalized and embodied whiteness continue to explain why some white people and some others who embody whiteness continue to practice racism and class oppression, and treat people of color and low-income people with contempt. This was exemplified recently by the negligent government response to the needs of the largely black and low-income population in New Orleans that was inundated as a result of hurricane Katrina (Epstein, 2006; Lee, 2006; West, 2005).

The antithesis to keeping one's whiteness safely entrapped within the cellar of one's unconscious mind (see Berlak, Chapter 2 in this book), or at least relegating one's whiteness to a less-than-conscious or "dysconscious" space (King, 1991), is becoming aware of the systemic inequities one might be benefiting from at the expense of other people. However, knowing that one's acts are leading to the oppression of others is painful. It is easier to find an effective rationale that justifies one's relative privilege. For example, it is comforting to draw on the myth of a U.S. meritocracy, and argue that one has merited privilege because one has worked hard and others have not. However, apart from often being blatantly untrue, this narrative fails to acknowledge the relative social and cultural benefits with which most people who have done well in the socioeconomic and political hierarchy began their life journeys. In other words, the behavior of individuals who practice whiteness reflects a normalized, institutionalized system that disproportionately privileges one group over others.

Whiteness, in the classroom and without, also provides an avenue to individual status and material success to some individuals of color (Ogbu, 1995b). Many immigrants of color feel the need to embrace whiteness, which is often perceived as a synonym for Americanness (Lee M. W., 1994), to survive and/or fit it to the U.S. dominant cultural system. They do not often see the ways in which they are supporting a system of race, socioeconomic class, and cultural hegemony that puts down whole groups of people to raise up others. In other words, whiteness divides many people of color from many white people and vice versa, preventing both groups from seeing their common socioeconomic oppression and working in solidarity to transform systemic whiteness.

In the classroom, whiteness can function in insidious ways to reproduce inequities and inequalities. Indeed, undoing whiteness in the classroom requires identifying the forms that it takes to privilege some students and alienate others (see Lea and Sims, Chapter 14 of this book), a difficult process because of the complexity, ubiquity, and invisibility of whiteness. In fact, we have found that our student teachers are more likely to participate in undoing the whiteness they embody if they do not feel blamed for embodying it. Our approach, and the approaches that the reader will find in this book, have been about naming, not blaming. In fact, we decided to edit this book for the very reason that we wanted to be more effective in reaching our goals of undoing whiteness in the classroom, and helping our student teachers engage in social justice activism, without dissolving under the combined weight of shame, guilt, denial, and avoidance. We have found art to be a way of moving forward this process so that student teachers do not feel as blamed—although some of them inevitably do. Some come back years later and thank us for planting seeds of social justice that they could not see or appreciate when they were in our classrooms.

In sum, whiteness, as the norm in dominant white countries, reproduces the disproportionate power and privilege of people socially constructed as white, and to some extent of people of color who choose to put into practice the cultural scripts of whiteness. We are caught up in a system of privilege and disadvantage that we did not choose, but we can choose to opt out and participate in changing this system. Therefore, a goal of this book is to offer our readers *"new"* theoretical frames/scripts/ideas for developing alternative social justice practices in the classroom and beyond. To undo whiteness, we need to be able to recognize, or "re-cognize," as Jean Ishibashi (2004) would say, the cultural shape(s) we are in (Bao Bean, 2006). However, once we have found this out we need to find out the extent to which our current shape(s) reflects whiteness, and then what cultural shape we need to morph into to be able to participate in undoing whiteness. Readers do not have to buy into the specific alternative frames/scripts/ideas suggested in the book. Indeed, we know that we cannot control outcomes—nor do we want to do so. Nevertheless, we want our readers to be "shaken up." We hope they will be inspired by the work in this book that is designed to help us name and frame our ideas about whiteness and social justice activism more clearly.

THE "UNCLE IN THE ATTIC" METAPHOR

In his book, *We Can't Teach What We Don't Know: White Teachers, Multicultural Schools,* Gary Howard (1999) offers the reader a metaphor for the omnipresence

of racism and white privilege in our lives. We see racism as a hugely significant dimension of whiteness.

> Racism for whites has been like a crazy uncle who has been locked away for generations in the hidden attic of our collective social reality. This old relative has been part of the family for a long time. Everyone knows he's living with us, because we bring him food and water occasionally, but nobody wants to take him out in public. He is an embarrassment and a pain to deal with, yet our little family secret is that he is rich and the rest of us are living, consciously or unconsciously, off the wealth and power he accumulated in his heyday. Even though many of us may disapprove of the tactics he used to gain his fortune, few of us want to be written out of his will. (p. 52)

Howard shared his "uncle metaphor" with a group of educators at the 2005 NAME Conference. He then asked the audience to break up into groups and share what came up for them as they listened to the narrative. One of the teacher educators in my group told us about a young, white, preservice teacher, Jane,[1] with whom she had been working. This young teacher's nose and brows were pierced with silver studs, and her clothes were described in the university and school as inappropriate dress for a "professional" teacher. After a series of conversations with the dean and chair of her department, Jane was counseled out of teaching.

It was clear that the preservice teacher, Jane, was considered the "Other" by her school administration. Jane did not match up to the conservative external form or representation of a teacher, required by the school of education. She was also extremely reluctant to present her students with one, standardized narrative by teaching to the official school text. In other words, Jane did not meet the administration's standard of whiteness. However, according to the teacher educator who shared the story, Jane most definitely did what she considered the most important characteristics of a good teacher: she was highly creative and loved her students. She was a critical multicultural educator who struggled to give voice to all of her students, and adapted all of her lessons so that they were culturally responsive and relevant to the social and cultural needs of her students.

Jane was very familiar to those of us at Howard's session, as she will be to many teachers and teacher educators reading this Introduction. One of us recently supervised a white, student teacher, Crystal, in a highly scripted, standardized school in a relatively wealthy northern Californian school district. The school district was in the process of losing some of its white middle-class students to private schools, as it received more and more Latino immigrant children. Crystal had been an art student at college. Unsure of how to use her art preparation as a career, she decided to try teaching. Her mother was an elementary school teacher so teaching was a familiar field. However, Crystal found herself ill-suited to the one-size-fits-all mandates that she met on arrival in the field. Confiding in me, Crystal wanted to

know how to respond to her students, who were clearly bored or, worse, alienated by the scripted lessons she was obliged to deliver. At the same time, I was confronted by the school principal and Crystal's mentor teacher who felt that Crystal was unwilling to follow the rules that governed teaching practice in the school.

Another student, Mike, a 50-something, white, preservice teacher, also doing his full-time student teaching in a relatively privileged, white, middle-class school district in northern California, found himself in a similar situation. Mike developed a positive, easy-going relationship with the students, with whom he worked especially well in small intimate groups. He was a musician, whose route to teaching had included a very difficult journey through the civil rights era, at one time struggling with drugs and alcohol. Mike had found a positive identity as a social justice educator, and he had much to offer his students for whom he cared deeply. He took very seriously the exhortations of his credential program that he found spaces within the standardized curriculum to create a rich classroom filled with texts that represented his students' out of school, lived cultural experiences. He wrote songs out of his students' "funds of knowledge" (Moll et al., 1992), and facilitated dialogue about critical issues in the students' lives. Yet, he was criticized by both the principal and his mentor teacher at his teaching site for not fully adhering to the rules of the school day. Thus, keeping faith with the rigid, reductive school curriculum script seemed to be more important than the innovative, educultural work that Mike was attempting.

In our view, Mike and Crystal were both potentially magnificent teachers, in part because they were critical and creative human beings, driven to think outside of the mainstream—the dominant cultural waters of the United States' society. We also think that their behaviors targeted by their principals and mentors as "irresponsible"—for example, Mike failed to turn up to escort his students from the playground into class, and Crystal became so alienated that she failed to communicate with her mentor teacher about her role in the classroom—were exaggerated out of all proportions to their severity because they were carried out by individuals whose more serious "crime" was that they did not fit the standardized framework in which they were placed. Our advice to both, if they planned to work in similar sites, was to take care of the mandated details of their professional lives, especially those that involved the safety and welfare of their students, and to find the spaces in their school day to engage in educulturalism and teaching for social justice. Crystal was unable to take this advice; the trade-off was not worth it to her. Mike did take our advice, and will, we believe, become a great teacher.

Going back to Howard's uncle metaphor, the legacy of whiteness for public schools in the United States has been a system that privileges those raised in and embodying dominant cultural scripts. It is a system that also punishes those who do not inhabit whiteness. The white teachers described earlier are, in the sense

traitors to whiteness. As Howard writes, "the legacy of racism, which has been fueled and legitimized by our assumption of rightness, has haunted the house of collected white identity for ages" (Howard, 1999, p. 52).

If we are ever going to interrupt whiteness and empower critical consciousness and social activism, we need to work on several fronts. These fronts include

1. Working on ourselves to recognize the influence of public cultural scripts and personal experience on our identities, ideologies, and practices;
2. Examining how we embody the public expression of whiteness—how whiteness is manifested in dominant, normative, institutional arrangements and cultural practices;
3. Deconstructing whiteness in our classroom practices, including pedagogy and curricula;
4. Challenging whiteness on socioeconomic, political, and cultural levels beyond the classroom; and
5. Recognizing that there will be consequences to challenging whiteness that require us to work in solidarity with students and other educators, teach for social justice activism and build on actions for positive social change.

WHY EDUCULTURALISM TO UNDO WHITENESS?

Educulturalism is a process that helps us to work on all of the above-mentioned fronts. It is an activist learning process. Educultural courses draw on hands-on experiences in music, the visual and performing arts, narrative, oral history, and critical dialogue—examples of which you will find in this book—to begin to open the guarded gates of our unconscious minds and expose us to the assumptions we hold and keep hidden therein, even from ourselves. Our own research has shown that educulturalism deepens preservice teachers' awareness of the deep-seated social and cultural biases that they embody, and challenges and interrupts the social construction of whiteness and social inequalities in our schools, in our classrooms, and in ourselves (see the chapters by Lea & Sims in the proposed book; Lea & Helfand, 2004).

Educulturalism is not a new concept in education, but is a new term to define this concept. Educators have long argued that music, art, and narrative are essential ingredients in a liberal arts education. This educational model, it is said, produces balanced, creative, informed, and open-minded citizens, who are able to fully participate in a democratic society.

However, today's practical manifestation of state and federal mandates has been the removal of most arts curricula from our elementary schools, particularly

in low-income school districts. This is an appalling but legitimate indictment of those who wield power over our educational system and the lives of our children. They are either ignorant of the power of art to positively impact the academic, emotional, and spiritual lives of students, or their agenda includes depriving low-income children, who are disproportionately of color, of this cognitive, emotional, and spiritual empowerment. Echoing Epstein, Shor and Pari (1999) write,

> The fate of democracy in school and society will be decided by the funding and cur-riculum wars now under way. Teachers, students and parents are stakeholders in this debate over educational and economic policies. Official agendas are maintaining tracking, imposing more standardized testing, legislating more restrictive courses, and continuing unequal funding of urban public schools while promoting vouchers, priva-tization, and tax monies for private and religious units. (p. viii)

Putting art at the core of the public schools curriculum goes against the grain of the current dominant trends in education where the emphasis is on teaching, reading, and math skills in preparation for standardized testing and one-size-fits-all state and federal mandates. Encouraging people to question assumptions and work for social justice does not fit well with a system that sees students as human resources to be molded for the benefit of a market-driven society. An art-integrated curriculum helps us to rethink what constitutes knowledge. It engages our emotions and imagination and enables us to see the endless possibilities for positive social change.

Indeed, we live in an age in which some educators are being lauded for pro-moting cultural deficit models. One well-known educator recently stated publicly that schooling for children in low-income communities should only consist of teaching them to read and develop math skills to a 9th grade level (Gorski, 2006; Payne, 2005; Payne, 2006). This is in marked contrast to the position of edu-cators, like Eisner (1998) who talks about the power of the arts "not simply as objects that afford pleasure, but as forms that develop thinking skills and enlarge understanding." Seen in these terms "the significance (of the arts) as a part of our educational programs becomes clear" (p. 64).

Maxine Greene's (1995) book, *Releasing the Imagination: Essays on Education, the Arts, and Social Change*, is

> a hymn to the liberating potential of art, music, dance, and literature as portraits of the other imagined worlds. And it is a forceful argument that these portraits are essential to students' repertoires of images of what it means to be human in a com-munity. (Vallance, 1996, p. 102, in Davis, McDonald-Currence, & Whipple, 2006)

In her book, Greene challenged us to use the arts as a vehicle to open minds and dismantling the barriers to imagining the realities of the world in different,

more creative, and more human ways. When teachers act as genuine social justice activists, they work to transform schools into communities defined by cultural, economic and political equity. Greene argues for schools to be restructured as democratic spaces in which students aspire to make their own meanings of the world and find their voices in hitherto oppressive climates. Greene's book encourages teachers to use their imaginations to seek alternative teaching approaches to the current zeitgeist in which students are stratified, divided from one another, and treated as less than valuable within the dominant cultural world. Teachers can work creatively to challenge the present educational environment that is based on reductive standardized tests, quantitative measurements, and economic productivity. They "can choose to resist the thoughtlessness, the banality, technical rationality, carelessness, and the 'savage inequalities' that now undermine public education at every turn" (Kozol, 1991, in Greene, 2005, p. 2).

We see Maxine Greene as an educulturalist. Educulturalism strives to overcome the barriers to our imagining alternative, kinder, more socially just worlds, and acting to realize them. In our view of the philosophy, the cognitive, emotional, and spiritual power of art is interwoven with neopsychoanalytical theory and critical multicultural, antiracist, and postcolonial theory. The emergent theoretical framework offers ways of interrupting institutional systems that reproduce inequities. It also suggests ways of overcoming the difficulties we experience when trying to access our unconscious minds, to interrupt the often ethnocentric, racist, classist, and sexist assumptions that lie sealed in that space. Ann Berlak (2006) argues in Chapter 2 of this book that "the central claim" in Malcolm Gladwell's (2005) bestseller *Blink*,

> is that we have two non-redundant information processing systems that are relatively independent of one another. These two systems have evolved in different ways, and serve different functions. One of these, the adaptive unconscious, operates almost entirely out of conscious view. The adaptive unconscious is far more sophisticated, efficient, and adult-like than the unconscious portrayed by psychoanalytic theory. People can think in quite sophisticated ways and yet be thinking "non-consciously". In fact, the mind relegates a good deal of high level thinking to the unconscious. Wilson calls it the adaptive unconscious because it has evolved to enable human survival. It permits us to notice danger, and initiate behavior quickly. (p. 7)

It feels dangerous to recognize our own whiteness. The adaptive unconscious performs the assuaging task of helping us to avoid recognizing our whiteness, and to give ourselves permission to rationalize our thoughts, feelings, and actions associated with whiteness.

However, educulturalism consists of processes that help us to lift the lid off our adaptive unconscious minds. Through our experiences with art, we are able to

develop greater critical awareness of the influence of social and cultural worlds on our unconscious minds and as a result on our conscious minds, since the former is often hidden from the latter through our capacity to rationalize. The idea is that art facilitates the unlocking of our unconscious minds, to interrupt the often ethnocentric, racist, classist, and sexist assumptions that lie sealed in that space. Through art, we are given insight and voice.

Human beings tend to avoid dissonant emotions. We do not readily question our own assumptions, or challenge our own identities (how we know ourselves), since this process may uncover contradictory, painful, uncharted territory (Festinger, 1957; Marcuse, 1966). This uncharted territory often includes certain assumptions that, in the field of formal education, may be experienced as oppressive teaching practice by some of our students. As a result, we believe that those of us holding or planning to hold institutional power over others must find effective and meaningful ways of accessing our assumptions and undoing the whiteness that may be embedded in some of these assumptions, as well as institutional practice, policy, and law.

There are many different art forms addressed in this book to assist educators and students in undoing whiteness and developing social justice activism in the classroom. The contributors have undertaken sound research into the academic and spiritual contributions of music, the visual and performing arts, narrative and dialogue to raise critical consciousness and promote social justice activism. The following is an introduction to their work.

UNDOING WHITENESS: CRITICAL EDUCULTURAL TEACHING APPROACHES FOR SOCIAL JUSTICE ACTIVISM

Literature, Poetry, and Narrative

Research has shown that through literature, music, and art, we can access narratives that play a significant role in helping us to develop inspired states of mind and an enhanced sense of meaning and identity in our lives. A collection and comparative analysis of narratives of

> supernormal experiences from different cultures and fields of human activity...would help us understand various synergies of transformative practice and the lasting witness in most sacred traditions to an integral embrace of body, mind, heart, and soul. Extraordinary capacities emerge in clusters, perhaps, because we are attracted, consciously or not, toward a many-sided realization of them. We want to experience different kinds of supernormal functioning because they are latent in us and—if we choose to think metaphysically—because all the divinity in us wants to find expression in this ever-evolving world. (Murphy, 2002)

Patricia Halagao (2003) spoke to the effort of unlocking the unconscious mind in her essay, "Unifying mind and soul through cultural knowledge and education." In this essay, she draws on the poetic form "'balagtasan', a traditional form of debate used in the Philippines." This art form was refined by Francisco Baltazar "in the nineteenth century…into a political tool of expression" (p. 194). Halagao realized that she had been using balagtasan "throughout my process of becoming a multicultural person and educator."

> Much introspection and internal debate between my mind and soul have finally led me to valuing my ethnic identity as a Filipina American, finding my voice and presence in curriculum content, using my ethnic and cultural identity in teaching, and realizing my contribution to the field of multicultural education. (p. 195)

Halagao's process is educultural. She draws on ancient understandings, often lost to people in the so-called Western world, that art—in her case *narrative* and dialogue—can be positively functional in facilitating the unlocking of the unconscious mind and developing greater critical awareness of the impact of social and cultural worlds on our consciousness. Halagao uses self-narrative as an alternative way of becoming a multicultural educator. She writes, "It is important to find your sense of ethnic and cultural self before you can open yourself up to others and honor their ethnicities" (p. 214). As persons of multiethnic descent—Virginia is part European and part Arab, and Erma Jean is part African, part indigenous American, and part Irish—we personally resonate with this advice. It is also a practice to which we introduce our disproportionately white, preservice teachers, through two assignments—the "cultural portfolio" and the "I am poem" (see Chapters 3 and Afterword in this book). Halagao's work intersects with our own educultural work and that of an increasing number of scholars in the field of teacher education, some of whose contributions are featured in this proposed book. The validation of alternative ways of knowing is especially important since we are living in a global community, and many of our public school students, and some teachers and teacher educators bring into the classroom cultural learning and communication styles that differ from the mainstream.

Catherine Kroll's essay begins Section One in this book (Chapter 1) since she uses multiple educultural vehicles—art, oral storytelling, and narrative—to show one cultural perspective coming into physical conflict with another. She contends that this is the essence of what our pedagogy must do for our students and for ourselves: while learning the histories of the world, we must come to see them as parallel, intersecting narratives, not as intractable binaries within a value hierarchy. Our best energies as teachers ought to be devoted to ensuring that multiple narratives are told in the classroom, and that entire, full histories are told as well. If students don't readily bring up parts of the missing dialogue on race, teachers should.

Thinking in terms of the adaptive unconscious has helped Ann Berlak refocus the racial autobiography assignment that she assigns her preservice teachers (Chapter 2). Berlak felt in the past that the assignment rarely got to the heart of the matter—having her students address racism and internalized racism, white privilege, and whiteness. However, since she has come to think about racial autobiographies as narratives that reflect the adaptive unconscious as well as conscious racial goals, feelings and beliefs, she has revised the assignment. Berlak's chapter traces her theoretical and practical journey. Despite the fact that Berlak uses video to achieve her goals, we have placed her chapter in this section because her theoretical framework and her emphasis on the narratives that teachers construct about themselves are so seminal to this book.

Next, Erma Jean Sims and Virginia Lea discuss the ways in which they have used poetry to undo whiteness and inspire social justice activism (Chapter 3). Poetry allows student teachers the space to engage in genuine self-reflection about the often-biased cultural scripts or deep-seated assumptions that they inhabit. Since poetry is so open to interpretation student teachers' assumptions are exposed in their analyses of the poems they read and write. Recognizing their assumptions and biases is a first step in the process of critiquing how they drive their classroom practice.

Lastly, in this section, Rosa Furumoto (Chapter 4) employs a critical theoretical framework to examine the work and activities of students enrolled in an upper division Chicana/o/Latina/o children's literature course. The students, including future teachers, explore and practice the use of Chicana/o/Latina/o children's literature to challenge whiteness, and promote humanization, identity formation, and cultural awareness among children and families. Chicana/o/Latina/o children's literary themes and the sociopolitical context of literature and literacy instructions are addressed. Students develop and implement, with families, curricular units based on Chicana/o/Latina/o children's literature. Furumoto's findings suggest that Chicano/a/Latinao/a students' race and social class provide them with the cultural capital to engage in challenging literary themes and work effectively with Chicano/a/Latino/a families. Findings also point to Latino parents' interest in supporting their children's education.

Music, Film, and Drama

Research has shown that on a physical level music, as an example of the arts, has an impact on the cells of our bodies, sensitizing them to the possibility of change. "Sharon Begley's article, 'Your Child's Brain...' in *Newsweek* reported that researchers at the University of Konstanz in Germany had evidence that exposure to music rewires neural circuits" (Hawaiian Music Educators, 2006/1997). In the

February 1997 issue of *Leka Nu Hou*, the *Hawaiian Music Educators Association Bulletin*, Harvey writes,

> In the January 1997 article, "The Musical Mind," Gardner was quoted as saying that music might be a special intelligence which should be viewed differently from other intelligences. He stated that musical intelligence probably carries more emotional, spiritual and cultural weight than the other intelligences. But perhaps most important, Gardner says, is that music helps some people organize the way they think and work by helping them develop in other areas, such as math, language, and spatial reasoning...Gardner states that school districts that "lop off" music in a child's education are simply "arrogant" and unmindful of how humans have evolved with music brains and intelligences. Students are entitled to all the artistic and cultural riches the human species has created... What we as musicians knew experientially and intuitively, scientific studies on the brain, intelligence and music are confirming that we hold in our hands as music educators a powerful tool, a key that may unlock the door to developing the great potential residing in the human brain.

Sufi teacher, Hazrat Inayat Khan (2006) talks about the spiritual channels opened up by music and art that allow us to develop new creative ideas and emotions.

> And what does music teach us? Music helps us to train ourselves in harmony, and it is this which is the magic or secret behind music. When you hear music that you enjoy, it tunes you and puts you in harmony with life. Therefore man needs music; he longs for music. Many say that they do not care for music, but these have not heard music. If they really heard music, it would touch their souls, and then certainly they could not help loving it. If not, it would only mean that they had not heard music sufficiently, and had not made their heart calm and quiet in order to listen to it, and to enjoy and appreciate it. Besides, music develops that faculty by which one learns to appreciate all that is good and beautiful in the form of art and science, and in the form of music and poetry one can then appreciate every aspect of beauty.

Drama is another powerful vehicle that teachers can utilize to allow their students to explore their world and their place in it. Through improvisation, group-devised dramas, process drama, and text analysis, we can offer our students useful tools to deconstruct oppressive realities and liberate their minds and hearts. The "Theater of the Oppressed" was established in the early 1970s by Brazilian director and political activist, Augusto Boal. It is a popular rehearsal theater form designed for people engaged in the struggle for liberation, who want to learn ways of fighting back against the oppression in their daily lives. The Theater of the Oppressed is practiced by "spect-actors" who have the opportunity to act, observe, and engage in the self-empowering processes of dialogue. Dialogue helps foster critical thinking and is rooted in the pedagogical

and political principles of popular education methods developed by Brazilian educator Paulo Freire (1993/1970).

> The Theater of the Oppressed is emphasized not as a spectacle but rather as a language designed to: 1) analyze and discuss problems of oppression and power; 2) explore group solutions to these problems; and 3) to act to change the situation following the precepts of social justice. It's a language that is accessible to all. (Spunk Library, 2006)

An application of Theater of the Oppressed principles to the classroom can help preserve teachers and their students access their subconscious thought processes and begin to critique the oppressive forces that may be driving their teaching and learning process. With its emphasis on physical dialogue, Image Theater can evoke subconscious thought processes and initiate insightful discussions of complex topics such as racism, sexism, homophobia, ableism, ageism, and whiteness. It can provide a powerful springboard for in-depth critical analyses across the curriculum of externalized or internalized forms of oppression, power relations, prejudice, and stereotypical notions held by both teachers and students.

In this section of the book, Babatunde Lea (Chapter 5), artistic director of the Educultural Foundation (2006), shares one of the activities he engages in with teachers, student teachers, parents, and community activists. Lea facilitates a hands-on drumming experience with his audience through which they learn to recognize where "the one"—or the beat that connects polyrhythms—is situated. While appreciating the difficulty people have in recognizing "the one," Lea also helps them to see that with effort, they could play different rhythms with their two hands and connect them. He then frames this activity as a metaphor for culture, and the cultural process we must go through to live together in social justice and harmony in the world. Lea helps his students appreciate the intricate, interconnectedness of the cultural worlds we inhabit, and exhorts us to take a musical and cultural journey to work for greater equity and social justice in our communities and the wider society.

Drawing on postcolonial and critical race theory, professor/educator Roberta Ahlquist, and high school English teacher, Marie Milner (Chapter 6), analyze the 2005 Academy Award winning film, *Crash*, as a critique that presents insight into the complexities and contradictions of racism and prejudice in everyday life. They examine the often dysconscious ways that the assimilationist and colonizing mentality of white hegemony contributes to divisive accidental culture clashes, as people literally and figuratively "crash" into each other in contemporary life in Los Angeles, CA.

In Chapter 7, Karen McGarry shows how the use of visual imagery that incorporates elements of hypervisuality and mimesis can often serve to disrupt

conventional racist assumptions about non-Western cultures. Visual imagery can also function as a useful starting point for discussions of race and a decentering of the whiteness embedded in Canadian multiculturalism. She hopes that the types of self-reflexive exercises and discussions that she presents in the chapter will have a positive impact on student teachers, given their role in shaping future generations of students' perceptions of race.

Denise Hughes-Tafen (Chapter 8) discusses how theater in the classroom can be instrumental in creating critical dialogue on whiteness and Americanness. She presents research on a program that used the theater of black women from the Global South as an instrument for examining notions of otherness among students attending an Upward Bound Summer Program in Appalachia, Ohio. Most of the students selected for this program were considered "at risk." The majority of the students were white from low-income families in rural Appalachia. Those from the urban region of Ohio were black and historically disadvantaged students, who attended an Afrocentric school. These two groups of students were often marginalized; white Appalachians because of social economic class and blacks mainly because of race. Both groups were able to address the barriers of whiteness and Americanness, and explore issues of identity and power, through their engagement in theater of black women.

Framing the educulturalist as an ethnographer in the classroom, Eileen Cherry-Chandler (Chapter 9) faces the challenge of maintaining an ethical cultural practice with her students. She offers an overview of the ethnographic movement in performance studies with a focus on the ways performance researchers have impacted pedagogical practice and contested whiteness by blending educulturalism and performance. In addition, Cherry-Chandler's chapter powerfully evokes the ways in which drama can give us a greater understanding of what it means to be the self and the Other. Exploring socioeconomic and cultural experience through drama is to give actors the opportunity to read their own experience and the experience of other characters through their authentic knowledge, held in the body as well as the mind and spirit. To act is to know bodily; to know bodily is to come closer to tapping unconsciously held awareness, including that of whiteness.

Art and Imagery

An art integrated curriculum that puts social justice and activism at the core is a powerful tool for teaching students how to unpeel socially constructed layers of meaning so that they are able to "read the word and the world" in radically new and creative ways (Freire, 1993/1970). Infusing arts-based, critical multicultural, teaching strategies into classroom teaching goes against the grain of the

current dominant trends in education, where the emphasis is on teaching, reading, and math skills in preparation for standardized testing and one-size-fits-all state and federal mandates. Encouraging people to question assumptions and work for social justice does not fit well with a system that sees students as human resources to be molded for the benefit of a market-driven society. An art-integrated curriculum helps us to rethink what constitutes knowledge (Joshee, 2003). It engages our emotions and imagination and enables us to see the endless possibilities for positive social change.

In an interview with Cecilia O'Leary (2006), Richard Bains and Amalia Mesa-Bains describe their Reciprocal University Arts Project, an experimental arts education model created at California State University, Monterey Bay. The project is an example of transformative art practice that brings together the community and art educators in an engagement that ties art to social justice and activism. Bains and Mesa-Bains developed the idea of reciprocal partnerships that would help surrounding communities to build their institutions and help deepen transformative art practices. According to Mesa-Bains,

> In the art world, there is a double standard...what is considered art is set by collectors and the investment market. Art that is popular, consumable, community-based, and public has little value in that monetary system—because anyone can enjoy it. Art that is engaged, that has content, that has a connection to community, and is accessible is set apart in the art world.

Mesa-Bains pointed out that their program, the Reciprocal University Art Project, was designed to strike a balance between these two models.

> In our belief system, art is a transformative practice that arises from people's struggle to make sense of the world. Art is a language and a form in which people express their deepest needs and beliefs, and in doing so, art lives for them. It is not something put in a building for which you pay to get a glimpse, but do not even receive an explanation. It is the set of practices concerning people's choices. In Latin America, and many other places, art is not separate form culture. There are ministries of culture and artists are influential cultural citizens. This is not true in this country. Our programs provide students with the opportunity to think about what is means to be an artist, what it means to stand between private and public enterprises, and how an artist is capable of creating work that activates, propels and gives vigor to the daily life that people lead. (Ibid)

In Section Three, Judy Helfand (Chapter 10) aims in her class on American Cultures that she teaches in a California community college to use visual art, music, and narrative to make whiteness visible, to model behaviors that challenge whiteness, and to introduce activities and readings that help her students

question ideologies, norms, and values that maintain whiteness. This attention to whiteness helps students to see themselves within the political, economic, and cultural hierarchies within the United States. Further, they can begin to understand the meaning of their own social locations within these hierarchies in terms of self-identity, relationships with others, and responsibilities within the larger community. Within the classroom, students work together to construct knowledge that can help them in building a more equitable system.

In Chapter 11, Virginia Lea and Erma Jean Sims report on how their preservice teachers have responded to an assignment to identify whiteness hegemony in the classroom. Having defined, discussed and suggested examples of hegemony, and whiteness as a form of hegemony, in class, the teachers are asked to identify the practical, everyday manifestations of whiteness, initially in the form of images and captions. The images and captions are then placed in a power point presentation and played back to the entire class, engendering critical analysis, dialogue, and ideas for social action to undo the hegemonic practices represented. A yearlong research project into the impact of this assignment on preservice teachers indicates it has helped them to better understand the ways in which they embody the cultural scripts of whiteness.

In Chapter 12, Cathy Bao Bean explores her dual identity—Chinese immigrant woman and participant in the dominant white culture of the United States. She offers the reader a paradigm that will help some immigrant people to recognize "the cultural shapes they are in" and the cultural webs that they occupy. Bao Bean quotes Edward T. Hall, who wrote in his book, *The Silent Language* that "Culture hides much more than it reveals, and strangely enough, what it hides, it hides most effectively from its own participants." People who pursue Bao Bean's suggestions are likely to more easily recognize their own whiteness hegemony.

Pauline Bullen (Chapter 13) takes a critical look at approaching social justice "educultural" teaching from a black radical feminist and activist standpoint. Bullen begins by examining what may be defined as "modern" black feminism by looking at the work of Canadian and American theorists and artists, who challenge exploitative relationships. Their work is integrated into the chapter as she discusses the equity work that she has been engaged in with public schools in Toronto, Canada. Leadership and artistry is required for effectiveness in doing such work. Becoming a skilled teacher, facilitator, social justice advocate, and advocate for the most disenfranchised in the school community involves becoming a skilled communicator.

In the final chapter, Carlos Aceves (Chapter 14) draws upon his Mesoamerican heritage as a source to re-create a process of undoing whiteness in the classroom. In doing so, he faced a dilemma. Was he pitting one cultural framework against another and thus committing the same "sin" of "exclusivity" as the culture of

colonization? This apparent contradiction was resolved through focusing on process rather than content. He realized that the initial attempt of all cultures was to create a means of survival for a group and insure the survival of coming generations by passing on this cultural knowledge. This process is still necessary for the survival of his Mesoamerican community. It is only when a cultural group attempts to take and control the natural resources of other groups that that group begins to experience the need to be oppressively exclusive.

In conclusion, as the Afterword by the editors suggests, this book offers in one volume, a unique and valuable set of educultural perspectives, that have been shown to be effective in empowering teacher educators, preservice teachers, teachers, and community activists to undo whiteness in the classroom and wider community, and engage in social justice activism.

NOTE

1. We have changed the names of all of the teacher educators and student teachers mentioned in this Introduction.

REFERENCES

Bartholome, L. I. (1996). Beyond the methods fetish: Toward humanizing pedagogy. In P. Leistyna, A. Woodrum, & A. A. Sherblom (Eds.), *Breaking free: The transformative power of critical pedagogy* (pp. 229–252). Cambridge, MA: Harvard Educational Review Reprint Series no. 27.

Bastian, A., Fruchter, N., Gittell, M., Greer, C., & Haskins, K. (1993). Three myths of school performance. In H. Svi & D. Purpel (Eds.), *Critical social issues in American education: Toward the 21st century* (pp. 67–84). New York: Longman Publishing Group.

Bell, D. (1992). *Faces at the bottom of the well: The permanence of racism.* New York: Basic Books.

Berlak, A. (2006, April). Getting to the heart of the matter: The adaptive unconscious and anti-racist teaching. Paper presented at the meeting of the American Educational Association, San Francisco, CA.

Butler, S. (1998). *The way home.* Oakland, CA: World Trust.

Davis, M., McDonald-Currence, K., & Whipple, L. (2006). Constructing gardens of knowledge: A trilogy gardening your imagination, becoming wide awake. Available online: http://www.rwesig.net/Proceedings/MDavis.doc

Educultural Foundation. (2006). Available online: http://www.educulturalfoundation.org

Eisner, E. (1998). *The kind of schools we need: Personal essays.* Portsmouth, NH: Heinemann.

Epstein, K. K. (2006). *A different view of urban schools: Civil rights, critical race theory, and unexplored realities.* New York: Peter Lang.

Festinger, L. A. (1957). *A theory of cognitive dissonance.* Evanston, II: Ron, Peterson.

Freire, P. (1993/1970). *Pedagogy of the oppressed.* New York: Continuum Publishing Co.

Geertz, C. (1973). *The interpretation of cultures.* New York: Basic Books.

Gladwell, M. (2005). *Blink: The power of thinking without thinking.* New York: Little, Brown and Co.

Gorski, P. (2006). *The classist underpinnings of Ruby Payne's framework.* Teachers College Record. Retrieved April 30 2007, from Teachers' College Record website: http://www.tcrecord.org/Content.asp?ContentId=12322

Greene. M. (1995). *Releasing the imagination: Essays on education, the arts, and social change.* San Francisco, CA: Jossey-Bass.

Halagao, P. E. (2003). Uniting mind and soul through cultural knowledge and self education. In G. Gay (Ed.), *Becoming multicultural educators: Personal journey toward professional agency* (pp. 194–220). New Jersey: Jossey-Bass.

Harris, C. I. (1995). Whiteness as property. In K. Crenshaw, N. Gotanda, G. Peller, & K. Thomas (Eds.), *Critical race theory: The key writings that formed the movement.* New York: New Press.

Hawaiian Music Educators. (2006/1997, February). An Intelligence View of Music Education: Dr. Arthur Harvey, University of Hawaii (Manoa). *Leka Nu Hou, Hawaiian Music Educators Association Bulletin.* Retrieved August 30 2007, from The National Association for Music Education website: http://www.menc.org/publication/articles/academic/hawaii.htm

Howard, G. R. (1999). *We can't teach what we don't know: White teachers, multicultural schools.* New York: Teachers College Press.

Ignatiev, N. & Garvey, J. (Eds.). (1996). *Race traitor.* New York: Routledge.

Ishibashi, J. (2004). Personal communication.

Joshee, R. (2003). Art and multicultural education: Building commitment to social justice one brick at a time. Seattle, WA: New Horizons for Learning. Retrieved August 28, 2007, from New Horizons for Learning website: http://www.newhorizons.org/strategies/multicultural/joshee.htm

Kalantzis, M. & Cope, B. (2004). Learning by design overview. Retrieved August 28, 2007, from Learning by Design website: http:/l-by-d.com/pics/LbyDOverviewDec04.pdf, (p.3).

Khan, H. I. (2006). The mysticism of sound, music, the power of the word, cosmic language. The Sufi Message of Hazrat Inayat Khan: Volume II. Retrieved April 30, 2007, from wahiduddin's website: http://wahiduddin.net/mv2/II/II_22.htm

King, J. (1991). Dysconscious racism: Ideology, identity, and the miseducation of teachers. *Journal of Negro Education,* 60 (2), 1–14.

Kozol, J. (1991). *Savage inequalities: Children in America's schools.* New York: Crown Publishers, Inc.

Kumashiro, K. (2004) Center for Anti-Oppressive Education. Retrieved August 14, 2004, from Center for Anti-Oppressive Education website: http://www.antioppressiveeducation.org/

Lea, V. & Helfand, J. (Eds.). (2004). *Interrupting race and transforming whiteness in the classroom.* New York: Peter Lang.

Lea, V. & Sims, E. J. (2004, Fall–Winter). Voices on the margins: Collaborative and individual approaches to sustaining an identity as an anti-racist critical multicultural educator. *Taboo,* 8 (2), 97–111.

Lee, M. W. (1994). *The color of fear.* Berkeley, CA: Stir-Fry Productions.

Lee, S. (2006). *When the levees broke: A requiem in four acts.* HBO Films.

Marcuse, H. (1966). *Eros and civilization.* Boston, MA: Beacon Press.

Mazloomi, C. (1998). *Spirit of the cloth: Contemporary African American quilts.* Clarkson Potter. Retrieved April 30, 2007, from Carolyn L. Mazloomi website: http://carolynlmazloomi.com/publications.html

McIntosh, P. (1989). White privilege: Unpacking the invisible knapsack. *Peace and Freedom,* July/August, 49 (4), 10–12.

Moll, L. C., Amanti, C., Neff, D., & Gonzales, N. (1992, Spring). Funds of knowledge for teachers: Using a qualitative approach to connect homes and classrooms. *Theory into Practice, XXXI* (2), 132–141.

Motema Music. (2006). Available online: http://www.motemamusic.com

Murphy, M. (2002). Towards a natural history of supernormal attributes. Retrieved April 30, 2007, from Esalen Center website: http://www.esalenctr.org/display/paper.cfm?ID=18

Oakes, J. & Lipton, M. (1999). *Teaching in a changing world.* San Francisco, CA: McGraw Hill College.

Ogbu, J. (1995b). Cultural problems in minority education: Their interpretations and consequences-Part Two: Theoretical Background. *Urban Review,* 27 (4), 271–297.

O'Leary, C. (2006, January). A reciprocal University: A model for arts, justice, and community. *Social Justice,* 29. Retrieved April 30, 2007, from Questia website: http://www.questia.com/PM.qst?a=o&se=gglsc&d=5001923690&er=deny

Payne, R. K. (2005). *A framework for understanding poverty.* Highlands, TX: aha! Process, Inc.

Payne, R. K. (2006, January). Personal communication.

Rabinow, P. (Ed.) (1984). *The Foucault reader.* New York: Pantheon books.

Roediger, D. (2006). The retreat from race and class. *Monthly Review,* 58 (3), 40–51.

Shor, I. & Pari, C. (1999). *Education is politics: Critical teaching across differences K-12.* Portsmouth, NH: Heinemann.

Sleeter, C. E. (2005). *Un-standardizing curriculum: Multicultural teaching in the standards-based classroom.* New York: Teachers College Press.

Spunk Library. (2006). What is the Theater of the Oppressed? Retrieved April 30, 2007, from Spunk Library website: http://www.spunk.org/texts/art/sp000338.html

Tabb, W. K. (2006). The power of the rich. *Monthly Review,* 58 (3), 6–17.

Wasp, J. (2004). Virginia R. Harris brings her political quilts to SSU gallery. *Sonoma State University News Release.* Retrieved April 30, 2007, from Sonoma State website: http://www.sonoma.edu/pubs/release/2004/270362089.html

West, C. (2005). Exiles from a city and from a nation. Retrieved April 30, 2007, from Observer website: http://observer.guardian.co.uk/international/story/0,6903,1567216,00.html

Wray, M. & Newitz, A. (Eds.). (1997). *White trash: Race and class in America.* New York: Routledge.

Zinn, H. (1997). *A people's history of the United States.* New York: New Press.

Imagining Ourselves
INTO Transcultural Spaces:
Decentering Whiteness
IN THE Classroom

CATHERINE KROLL

How do you make people see that everyone's story is now a part of everyone else's story?

—SALMAN RUSHDIE,
INTERVIEW IN THE PARIS REVIEW,
SUMMER 2005.

I contend that the artificial construction of whiteness almost always comes to possess white people themselves unless they develop antiracist identities, unless they disinvest and divest themselves of their investment in white supremacy.

—GEORGE LIPSITZ,
THE POSSESSIVE INVESTMENT IN WHITENESS:
HOW WHITE PEOPLE PROFIT FROM IDENTITY POLITICS.

RE-PRESENTING LOST HISTORY

I stood in the library at the University of the Witwatersrand, Johannesburg in 2004, gazing up at Cyril Coetzee's *T'kama Adamastor* (1999),[1] which depicts the San and Khoi people being assaulted by Dutch explorers in the seventeenth century. Tears of grief welled up in my eyes as I felt the imposing scale of the

painting as well as the very weight of history above me. This allegorical narrative telescopes time to represent both the Dutch landing and their later activities as merchants, land thieves, and missionaries. Playing on the familiar trope of the imperial gaze set on appropriating Africa for its human and natural resources, Coetzee repositions the putative heroes of European cultural history as predatory *objects* of the conquered peoples' story, radically contesting the normative "master narrative" of racial and cultural superiority. With its day-to-night panorama, the painting foreshadows indigenous peoples' enslavement, forcible removal from traditional lands, and eventual genocide. Coetzee evokes the Dutch presumption that they had found Eden, but he also subverts this "discovery" by depicting the violence of the colonial encounter to come. Demonic conquerors pawing young women and winged baptizers people a grotesque landscape awash in ideological delusion. Nevertheless, the Tree of Life at the center of this painting—apart from its ironic religious allusion—suggests that true longevity and life spirit belong to the African continent, rather than to its transient interlopers.

In parodying the narrative of heroic conquest, Coetzee yokes together what is often kept separate in a nation's public discourse: the official historical narrative and the silenced or discredited counterstories. Thus, he reveals a potentially productive transcultural space in which dialogue between conquerors and indigenous peoples can occur: a space in which both the rhetoric used for nation-building and the narratives of those who labored to build the country can inform each other. And indeed this is a prime function of art: to "cross conceptual wires" (Geertz, 1973: 447), to fuse aspects of our experience that supposedly "belong" in separate realms—public versus private, or "official" statement versus community memory. As distinct, but intersecting communities, the powerful and the marginalized operate from very different cultural narratives and retain unique historical memories that structure what Louis Althusser called our imaginary relation to the real (1971: 163). Wherever we are situated—as teacher or student, as privileged or economically struggling—we will influence our imaginary relation to the real that we both create and by which we are created.

Throughout the U.S. media, we hear an ideology that repeatedly invokes a very narrow national mythos—often to the exclusion of multiple, intersecting viewpoints. However, art has the power to transcend a nation's propaganda and the rhetoric of humanistic ideals that politicians, corporate officials, and ad-crafters often employ. In its appeal to cognitive, aesthetic, and affective realms, art propels us into transcultural spaces, urging us to entertain alternative explanations for the social fissures and inequities around us. Art deconstructs rhetoric with ethics: its texts, canvases, and lyrics can help us say things we long to say, by helping us recognize our commonality and our deepest drive for human connection with communities we may be separated from.

CULTURAL MEMORY AND THE MAKING
OF COMMUNITY NARRATIVE

Our public discourse in the United States rings with lofty goals and catchphrases derived from the tradition of liberal humanism: "Everyone has the same start in life, with thirteen years of free education;" "It's up to you to seize the opportunities that this country affords you." This unquestionably inspirational rhetoric has become such a pervasive, dogmatic ideology that it is often extended further to help rationalize failure. No matter that to people of color, the economic and political realities prove these slogans to be problematic, the smug rationalizations echo loudly throughout the popular press and talk shows: "I made it; why can't they?;" "We now have a level playing field: look at all of the black governors we have;" "Life isn't fair; stop complaining and move on." And indeed, recent polls of white Americans demonstrate their belief—their imaginary relation to the real— that "things are getting better" for ethnic minorities, despite economic evidence to the contrary. A 2004 Gallup poll illustrates the gap between various communities' perceptions of how well African Americans, for example, are faring: 77% of whites and 69% of Latinos polled assume that African Americans "have as good a chance as whites do to get any kind of job for which they are qualified ... [but] only 41 percent of blacks felt the same" (Lui et al., 2006: 2).

The optimistic slogans on opportunity represent only the loudest voices in our public discourse. As is usually the case when people of color are criticized for their supposed deficits, those who utter such self-satisfied rhetoric are the ones with the institutional power and leisure to mete out judgments. Communication today between the privileged and economically stressed communities could not be more absent because their worldviews often derive from radically different assumptions and experiences. The economic and political nexus of whiteness— that set of institutional mechanisms within financial services, housing, education, social work, health care, and the job market that often preserves white culture as the norm—both permit and control an individual's mobility, depending on where one is positioned in terms of race and class. What is missing are the voices of the most vulnerable, directly critiquing those who hold power within our core institutions.

Arbitrary cultural and racial hierarchies that sustain white-preferential hiring and promotional practices permeate all our major social and economic institutions, leading to educational inequities (both at the level of school funding and instructional quality), discrimination in the housing and lending markets (including redlining and other inequitable consumer lending practices), the denigration of nonwhite family structures in the social welfare system, and the known sentencing disparities within the criminal justice system. As Lui, Robles, Leondar-Wright,

Brewer, and Adamson emphasize, these systems have been literally engineered to exclude and to disadvantage people of color. They point out that

> policies that might seem to have nothing to do with building wealth, such as welfare, bankruptcy, and criminal justice, in fact have everything to do with whether or not a family survives a period of unemployment and rises to work and save again. (p. 113)

Despite the fact that race has been shown to be a significant factor in the financial, education, and employment spheres, public discussion of this reality remains taboo. Often individuals are unable to see the connections between racial, class, and gender discrimination and economic power because our ideology on social equality creates a climate of denial around documented inequities. Add to this our social etiquette in the post–civil rights era that demands that we not bare our souls on race (at least not beyond our own communities), and you have an oppressive shroud of silence around the inequities and despair that many people of color experience daily. A community's particular cultural memory bears witness to its history of struggle and success, but too often this knowledge stays within that community. By contrast, the dominant discourse, which Foucault argues emerges out of the Power/Knowledge nexus, repeatedly intones the ideals of economic success within a hegemonic, white-preferential culture, and these ideals of success (and the blame for lack of success) are internalized unconsciously in the daily lives of individuals as they rank and order the world according to these ready-made ideas (1984: 292–300).

But our contemporary art—in its literary, musical, and visual spheres—can disrupt the workings of the Power/Knowledge nexus and vividly yoke together realities that have typically been kept separate, letting us see the current mystification and hypocrisy around race. In particular, oral storytelling, art, and narrative can help us articulate these issues of identity politics. These are forms of art that we might call (alter) narratives, for they invite us to see, *and to see from*, alternative perspectives that displace whiteness from the center. I use written and oral stories, pieces of visual art, and music in the writing classroom for their instigatory power, their potential to move students away from dichotomous thought patterns—the flawed binaries of "those people" and "us." These pieces invite students into transcultural spaces in which they can interrogate the often entrenched prejudgments that inflect our relationships, public policy, and discussions about race in our highly politicized and media-defined culture. These (alter) narratives articulate multiple points of view, reaching far beyond what is told in and by the majority culture.

Second, these narratives powerfully critique the "master narrative" that suppresses stories of marginalized peoples, even as this art points to rival epistemologies and ethical systems that compel our attention. In hearing these narratives and in responding to them, we are struck that their power lies in the way they contest

existing cultural hierarchies, thus reorienting us to see "difference" as parallel, not as a deficit (Minh-ha, 1990: 372–374). Finally, narrative—whether verbal or visual—is immediately appealing, as it is arguably the form of art most accessible to us because it reflects our own life trajectories: moving from the reckless naiveté and ideological confidence of youth, to personal struggle as ideas are tested by experience, and eventually to the wisdom of an integrated and mature conscious-ness. This chapter shows how art can put us in touch with beauty and raw truths, allowing us to advance the conversation about race in ways that mainstream pub-lic discourse cannot. Observing the experiences of students in one writing class as they listened to, watched, read, and critiqued many forms of art, we see how this art brought them skin-close to the real.

FRESHMAN COMP AND THE STRUGGLE
TO SEE COMPREHENSIVELY

Given the lack of genuine cross-community understanding in our public dis-course, we need to expect that students are likely to bring with them knowledge filters or "terministic screens" (Burke, 1966: 45) that have shaped their percep-tions. What can the first-year college writing course offer students as they start to scrutinize the cultural scripts that define both their knowledge and their identi-ties? I accept the widely held assumption that the intent of the freshman writing course is twofold: (1) to prepare students to read critically and to write cogently, and (2) to develop their awareness of how power and institutions operate and how cultures embody traditions of both immanent self-expression and resistance (Thelin, 2005: 115; Fishman et al., 2005: 225; Bartholomae, 2005: 306). Neither well-honed reading and writing skills nor critical political literacy alone is suffi-cient. Students need to be able not only to express themselves with grace and pre-cision, but they must also be able to think beyond a single given perspective: they must become conversant with one another's cultural histories. Indeed, what many instructors see as the core of the college composition class—training in sound argumentation—implies that students will learn to see from multiple worldviews.

As people who still speak in terms of centers, margins, insiders, and "others," we are in such urgent need of emotional intelligence and acts of conciliation, that we delude ourselves if we think that knowledge of how to advance an argument is enough. Conventional rhetorical strategies based on proposition, support, and "winning" an argument *crowd out* other kinds of knowing—for example, the active empathy that Carl Rogers advocates to foster communication, or the possibilities for personal growth that we find in the expressive arts. Rogers's communicative approach relies on each party in the discussion stating the other's position *to her or*

his satisfaction before being able to articulate her or his own (1992: 30). We need to show our students ways of representing not only their own positions, but also replicating accurately and respectfully positions that may run counter to their own.

Here is one instance of how divergent perspectives would best be seen as intersecting so that the entire history is told. White narratives frequently assume credit for the origins of "civilization," and the building of a national infrastructure (Fanon, 1963: 51). For many in the majority culture, what constitutes civilization is defined according to Eurocentric norms. As Toni Morrison has argued, from its very ideological origins, American identity was predicated on a self-definition that was exclusionary: for example, the framers of the constitution used whiteness against the semiotic of blackness to construct the country's nascent identity (1993: 8). But in the modern era, not only have oppressed peoples risen up in self-determination in numbers greater than at any other time in history, but they have also often dissociated themselves from this white-inflected rhetorical tradition, creating resistance literatures, music, and other arts that embody their histories and commitments to social justice (Gilroy, 1993: 36–40). Hip-hop culture is just one contemporary manifestation of a long creative tradition in the American arts built on resistance.

One could say, as my students sometimes do, "[W]ell, there are economic disparities, but that's the way it is; there is nothing wrong with individualism and the pursuit of material success." This belief in meritocracy may seem initially acceptable, but to what extent is it used to legitimize systemic inequities? Such an ideology of individual success is often used to rationalize poverty; further, we do damage in foisting a set of judgments on those who may define themselves differently, perhaps in terms of cultural affiliations designated by family, kinship, race, and ethnicity. However, even this line of reasoning participates in the vexing nature of white/nonwhite binary politics: this is not to say that whites do not have affiliations. The problem with whiteness is that it is allied with power and normativity, and thus reproduces categories of otherness when it defines itself as the center. This is why an unreflective multicultural curriculum is so problematic. Teachers want to make their reading lists "diverse," but texts from the Western canon still form the curricular core of many schools and universities. "Multiculturalism" still frequently presumes that white, mainstream culture is central and that all other cultures must occupy the periphery, as if whiteness were the sun and minority cultures its orbiting planets. Instead, we need to select works of art and literature that invite us into shared transcultural spaces that mediate between communities' distinctive histories and perspectives.

In my semirural, mostly white college classroom, no matter how assiduously I may work to decenter whiteness by using narratives that expose daily, lived racial prejudice, there will still be many white students who say, literally, "It's not my

problem; it doesn't affect me, so I'm not interested in that." Even if some students see the value of these narratives, there is still such a level of ambient racism toward people of color in our culture that students' openness to hearing narratives about struggle can seem rare. Often, in an attempt to counter the charge of racism in American culture, they invoke the rhetoric that it is solely individual responsibility that shapes one's fate.

When I gave students the lyrics of the Geto Boys' (1996) rap "The World is a Ghetto," I asked them to put aside their preconceptions of hip-hop, especially "gangsta rap," and to read the lyrics attentively. This proved very difficult for most of my students—probably because much rap music is already "coded" by the media as a celebration of violence and gang behavior. Its status as a form of resistance art is frequently ignored by the mainstream press. Nearly all my students wrote rather reductive, one-dimensional responses to the lyrics that amounted to the inference that "the ghetto is a terrifying place where poor people suffer." Many seemed to resort to "safe" judgments they had heard before. Virtually all students in the class ignored these lyrics' repeated, overt indictment of a system that encourages the neglect and vilification of those who live in poverty:

> Five hundred niggas died in guerilla warfare/In a village in Africa, but didn't nobody care ... You know they got crooked cops/Workin' for the system ... They call my neighborhood a jungle/And me an animal, like they do the people of Rwanda. (1996)

However, as students often bring into the classroom untested assumptions and value hierarchies about race from the surrounding culture, perhaps we should not be surprised that their judgments are not more critically nuanced.

There is a second issue at work here. Students from the more privileged majority culture are loath to admit that they come from a racist country and, because they often have not experienced racism firsthand, often maintain that being "color-blind" is the best policy for all to be able to get along. Because many students are often ignorant about systemic racism, they would not know to look for the enmeshed financial connections between privileged and impoverished communities: specifically, business interests' use of poor communities as both a vulnerable market and a source of cheap labor. Instead, students focus on the immediate tragedy and despair, remaining at the level of unexamined binaries—that is, the ghetto is a nightmare—which is a position that does not move the discussion in the direction of problem solving or responsibility. Nor does it foster connection, or a subtle examination of how a term such as "ghetto" is used, or what the group's calling themselves "Geto Boys" signifies.

The writing and discussion on the Geto Boys' lyrics constituted my least successful attempt to use art as a catalyst to deconstruct race as a set of politically

defined categories. Were I to use hip-hop again to initiate the conversation, I would spend more time setting up the discussion to teach my students to ask how messages are framed, how ideologies are always already constructed and for what purposes, and what a black musical genre in the hands of a largely white music industry says about the reproduction of racial stereotypes and the distribution of power. As a counterpoint, I would have students discuss Gwendolyn Pough's argument about how female rappers turn women's objectification and victimization in hip-hop into powerful political commentaries (2004: 163–192).

Coming to a topic from multiple angles is part of good teaching, and this process includes what Henry Giroux calls "memory work." Like him, I believe that there is a "need for people to speak affirmatively and critically out of their own histories, traditions, and personal experiences" (1998: 125; 1999: 197). To reach students at the affective level, I sometimes interweave stories of my extended travel through Ghana and South Africa. One story of entering a decidedly transcultural zone centers on the time my friend Rita—a black woman and ethnic studies scholar—and I were walking in Bloemfontein, a city in the interior of South Africa. It was mid-morning, and we were out with our fresh coffees in hand, backpacks slung over our shoulders, getting ready for the day's outing. I noticed a car driving by us somewhat slowly—red, and decorated with Rasta bumper stickers. The African driver himself wore a green, red, black, and yellow striped tam. He pulled the car into a dead end just ahead and waited until we reached it; then he started walking toward us, grinning broadly. Rita and I looked at each other nervously, thinking, "oh-oh, something's up here—does he want something from us?" But no—he reached out to shake hands with each of us, saying,

> I'm driving along here, and I see you two walking. I say to myself, "These women must have my very warmest welcome to our town on this morning." And so I stop, and now I want to tell you how very welcome you are.

That was all he wanted to do: this ambassador of goodwill simply wanted to extend a gesture of welcome, but my Western, racialized, and gendered reading prevented me initially from seeing this. Although this was just one incremental movement in my consciousness, I could feel the power of a forgotten, but still familiar ethical system transcend the boundaries of my own contracted norms. Here was also perhaps a kinship of a new kind between the three of us.

As I studied African spiritual traditions and communitarian value systems further, what I had assumed about selfhood—that it was the same as individualism—came to be redefined as subjectivity operating within a deep sense of collective responsibility. The power of a principle like *umuntu ngumuntu ngabantu*—often translated as "a person is a person through other persons"—made me aware of how relationships and networks are central to African value systems. In class, we

discuss the ethical and epistemological assumptions that define many African peoples' traditions and compare them to those of American cultures. Reading about and hearing stories of the Igbo in Nigeria, the Asante in Ghana, or the Xhosa in South Africa, my students see these cultures' sustaining rituals, deep generational connections, self-confident artistic traditions, and resilience—a picture quite distinct from the negative images reported in the Western media.

But I struggle with how to tell these stories, being wary of reproducing discourses of difference, not wanting to elevate African cultures to the realm of something so exquisitely Other—"more spiritual than us," "more rooted than us." For to insist on the superiority of a given culture is just as distancing and alienating as is judging it to be inferior. Entering imaginatively into transcultural spaces means coming from a position of equivalency, with no one culture being assumed to possess superiority or authority over the other.

ART THAT SHIFTS EPISTEMOLOGIES ON RACE

Just as my task is often to complicate students' views of African cultures with facts, personal experiences, and new narratives, I recognized that I faced much the same obligation teaching John Edgar Wideman's *Brothers and Keepers*, a narrative that unsettles our assumptions about poverty, despair, and crime in America. I had used this text often before, and knew the pitfalls. Wideman's book calls into question the predictably salacious narratives about criminals that appear in our media. However, his work is more than a reportorial exposé of the ways in which black men are profiled and demonized, whether they are criminals or not. The subject of Wideman's book is his own brother Robby, who struggled with drug addiction and finally was arrested for his role in a robbery and homicide. As the older brother, Wideman had been long out of the house when Robby began to get into trouble, and thus Wideman himself wrestles with a constellation of issues: guilt, his abnegation of responsibility to the family, the meaning of being a writer, and the fear of appropriating his brother's story in writing about it.

I knew the kinds of responses some of my students would have to the text: "[E]very criminal deserves the punishment he gets"; "it's the environment that causes people to turn out bad"; "he had his chance, but he blew it." We aired these common views on crime, and then we discussed how Wideman's text acknowledges those preexisting judgments and works to dismantle their "logic" through an opposing epistemology, and the power of narrative to move us.

What is so remarkable about Wideman's writing in this piece is that, as he searches for explanations for Robby's isolation and desperate choices, he offers multiple beginnings and a plurality of voices to help make sense of Robby's

struggles, and, more importantly, to counter the dominant narrative of "another black man caught up in the drug culture." For Wideman knows that the answer to the riddle of Robby's life cannot be so simplistically stated. He gives us the voices of their father, mother, and family friends, shifting the majority culture's self-satisfied assumptions of how African American realities are known. The mother's central memorable teaching imparted to her children—"always give people the benefit of the doubt"—in turn encouraged our class to suspend judgment of Robby and to hold competing explanations for his actions in our minds.

By the end of our discussion of the piece, we had seen intimately into the character of Robby: the man who reads poetry to his fellow prison inmates and who writes letters to his mother asking her forgiveness for having caused her so much grief. It was as if we had expanded our very limited epistemology, to the point where we could say: "I want to know what you know in the way you know it" (Spradley, 1979: 34). Wideman teases out the complexities of Robby's story, including his depression over his best friend Garth's death due to the neglect of a public clinic doctor, and thus we see Robby in all his flawed, aching humanity. Wideman presents a familiar narrative of "good boy gone bad" but, far from issuing judgment, he offers us a way to experience dialogically the relationship between the two brothers, their family members, and between the family and ourselves. In dialogue there is by definition room for movement and growth. What this narrative ultimately says is that behind any one fact—in this case, a crime committed by an individual—lies an entire history that must be heard as well, a history to which we are connected.

I thought carefully about how to prepare my students for Wideman's text. I knew the power of Lee Mun Wah's film *The Color of Fear* (1994), and I suspected that it would shake students out of their sometimes categorical thinking about race. To create this film, Lee invited eight northern California men representing a variety of ethnicities to join him for a weekend discussing race. The film is challenging and provocative: some students weep as they listen to the men express their internal struggles with power and notions of masculinity, and as they confront one another's ignorance and failure to value their identities. In working with this film, teachers should anticipate a wide variety of student reactions and allow a generous amount of time for reflection and discussion afterward.

I showed the first two minutes of the film that depict Victor, an African American participant in the group, walking past a few windows on the porch of the house where Lee held his weekend retreat to make this film. His slow motion gait on the porch and the foreboding music combine to make the viewer "read" this as a scene straight out of a crime drama. And indeed that is what my students saw, although they admitted they were appalled that they had so quickly judged Victor as a criminal. As students discussed the effect of this opening scene, they traced

their responses back to their conditioning from a young lifetime's worth of crime stories that often cast black men in the role of violent criminals. Revealing our susceptibility to racialized readings, Lee in this scene reads *us* as the judging "Other."

After the film was over, one student waited until the rest of the class had left to say "About that rough draft I just turned in: I'm afraid you'll think I'm a racist." Brad[2] told me his paper had argued that illegal immigrants had no right to employment, social services, or education in the United States. I asked him what he thought about the film. With tears springing from his eyes, he said,

> I don't like the way that film made me feel. I mean, it's not as if all white people are racists. You saw that other people in the film had prejudiced ideas, too. I'm tired of always being blamed for everything.

We talked for perhaps 20 minutes or so, and at the end, I complimented him for having the courage to start scrutinizing his ideas about race. Brad shook his head and said, "You know what's messed up? That I should need *courage* to talk about race." It seems to me his words and his tears said different things simultaneously. He was struggling with the conflicting feelings of what it means to be "read" as white, and also hoping for a world in which discussions on race could finally be based on trust. Buried beneath this is a fundamental paradox: the current public discourse on race that insists all of us are living in a just society defined by freedom and opportunity is belied by narratives of people of color. What we ought to hear as a counterpoint is their impatience with white America's prevailing fiction that racial equality is a finished project. If we can begin to feel this dissonance, maybe there is hope that we can begin to shift what we think we "know."

Brad's paper went through three drafts, with each submission representing a further development in his perspective. By the time he turned in the final version, he had included the perspective of Mexican immigrants coming to the state to improve their lives; he acknowledged their key role in the functioning of the California economy and affirmed their legitimate claim to the social benefits of living in the state. He did not change his original thesis, but he demonstrated he had learned the rhetorical skill of conciliation in an argument. More importantly, the paper also demonstrated his ability to think empathically beyond his own privilege. Part of this was due to our group discussions that pushed students to examine the intersections of power, race, and class, and part of this was due to my patient nudging of his thinking in my notes on his papers. Brad was one of a group of students who asked for three draft cycles on this paper, and this suggests that when students find their work to be "real," they push for the chance to articulate their thoughts in a way that can do justice to them.

By far the most successful work we did together—successful because students demonstrated their ability to break down reified categories of race—was centered

on Hank Willis Thomas's artwork "Priceless #1" (2005).[3] In this photograph, Thomas depicts a black community at a funeral, with the immediate family in the foreground. Two men stand behind women who are seated with their heads bowed, weeping. White text rings the image: "3-piece suit: $250 new socks: $2 gold chain: $400 9mm Pistol: $79 Bullet: ¢60 Picking the perfect casket for your son: priceless." In its brutally ironic twist on the MasterCard advertising campaign, the image provokes somber reflection. Students met for 15 minutes in small groups to pool their ideas about the piece and then came back together as a class. They interpreted the color, placement, and content of the text and image, and then eagerly moved to speculations about Thomas's larger political statement. Almost every student commented on Thomas's multidirectional irony in the piece, noting that he fused ideas that are often kept in separate discursive realms in our culture: euphoric consumerism and everyday tragedy, material display and fragile family connections.

Lindsay's thoughts are representative of the kinds of responses students wrote:

> I can clearly see that Thomas is telling two stories that come together to form a bigger story. The bigger story is what the photograph depicts as priceless: a family having to bury their dead son. The story told on the right side of the picture is of how the boy was killed: with a nine millimeter pistol and a bullet. The story on the left side of the picture is the amount of money someone spent on an outfit to wear to the boy's funeral. Both the story on the left and the story on the right lead to the story at the bottom (choosing the casket).... The text on the left of the photograph is aimed at our materialistic society. I believe it's rather poignant that, although a boy close to the hearts of the people in the picture has died, there was still time to shop for ridiculously priced commodities to wear at his funeral. I believe Thomas is telling the media that emotion is not some tool to be used to advertise. In addition, I think there is a strong statement that society is beginning to see the murder of African Americans as something to take lightly, something to satirize. Thomas makes this clear by turning a devastating loss into a "cute" pitch for a credit card.

Lindsay is able to see how Thomas's piece works in multiple directions, exposing materialistic values in contemporary culture at large at the same time that it critiques those values in our communities. Most importantly, her reading resists falling into binaries; instead, she suggests that the power of Thomas's critique is its telescoping of horrific tragedy into mere cliché. It is worth pointing out that, even though her knowledge of the African American struggle may lack historical specificity, her assessment of current attitudes does show the way this art stimulated her ethical and empathic sensibility.

Thomas indicts the white-dominant financial services industry that would willingly profit from any kind of sale, even those made in the midst of sorrow.

The mercantile mechanism is exposed as frighteningly anonymous and amoral: whether it is clothing or bullets, the card will fulfill your every whim. However, the soft textures of this clothing, with their faint suggestion of warmth and nurturing, is no match for the hard, metallic realities of pistol and bullet: even their capitalization and stark prominence seem to reveal an incisive and threatening power. Finally, another ideological "frame" seems to float around this piece. Insofar as Thomas depicts the widespread impulse to project a showy or "hip" image through fashionable clothing—a drive found across all cultures, certainly—he also critiques the culture of image at large. In an increasingly unreflective, accelerated world, personal image becomes a kind of flip, transitory shorthand that people use to categorize others and to express themselves.

Students emphasized Thomas's ability to contest assumptions about race and the meaning of wealth. Jessica interpreted the image in this way:

> His portrait could be political. He could be trying to get the attention of people (white people) by using something they adore (the sentimental MasterCard commercials) to convey a negative, yet meaningful message. The fact that the 9mm pistol and bullet are used in the picture leads us to assume that the boy was shot. Due to the fact that the people are black, and there was mention of a shooting, people would generally make a snap judgment that the boy was in a gang or something to that effect.
>
> Wideman's recommendation for reading ["give people the benefit of the doubt"] comes into play with the words 'picking out the perfect casket for your son: priceless.' Obviously, this person had a family who loved him and he must have been a good person because there are a lot of people at his funeral shedding tears because he's gone. Just because the guy was black and got shot doesn't mean that he was up to no good. And, even if he was involved in a gang, he still had a lot of people who cared for him, and that says something about his character. Thomas is telling white people to give black youth the benefit of the doubt. Just because a black kid was murdered with a 9mm, doesn't mean he had it coming.

Jessica insists that viewers of Thomas's piece make room in their consciousness beyond what they have been conditioned to believe. In particular, she emphasizes that, though our culture at large may demonize those in gangs, their very humanity ought not to be called into question, even if they are engaged in crime.

Taking another direction, Jaime shrewdly addresses the way the image asks us to consider what wealth means in this country: "Being wealthy isn't a fact; it's an observation of an assumption of who is higher or lower on the socioeconomic ladder." In this sentence she seems to pry open the semiotic spaces of wealth: this term is not an essentialist, fixed designation, but rather something like: "wealth-seen-by-the observer." She seems to reach toward the Heideggerian notion of the contingency of all of our judgments about the world as being based on

the "what-for" and the "wherefore" (1996: 77). In this, she demonstrates how judgment is always conditioned by its use and the motives of the judger. This was a bold movement in a college freshman's mind, and one that gave me some assurance that students were indeed pushing their thinking forward, beginning to expand their own processes of forming judgments. When students see into the narratives of "Priceless #1," they are writing themselves into that artwork's transcultural space. Taking all of our work into consideration, I knew we had achieved visible success over the semester, but it is important to stress that this level of dialogue was built up over time through the interconnection of text, art, and film, as well as through a deepening trust among all the members of the class.

CREATING A LEARNING METHODOLOGY FOR SOCIAL JUSTICE

Teachers can help students analyze how forms of political rhetoric—slogans, manifestoes, and everyday ideologies—construct a nation's mythos. While all political leaders use rhetorical themes and strategies to try to shape a national identity, such practices often obscure economic, social, and political relationships that historically have disadvantaged many groups. But when teachers show oppositional art forms that reveal the disconnect between ideology and lived realities, it can open up discussions about alternative forms of knowledge and expression, the function of the arts in the public sphere, and marginalized communities' continuing struggle to be recognized. To bring about these goals, I offer the following specific suggestions for teachers' pedagogical practice:

- Gain multicultural competence: cultural awareness, knowledge, skills, ownership of your own history, and a commitment to the education of all.
- Learn to "read double" to see from the perspective of individuals in communities beyond your own. Look for evidence of white-centered curriculum or perspectives in your course materials. Where can you find opportunities to introduce parallel narratives into the course to invite your students to see beyond mainstream narratives and dominant cultural scripts? For example, American history texts commonly begin the story of the post–Civil War Reconstruction Era from the point of view of those whose businesses were destroyed during the war, and the politicians who fought contentious battles in Congress over extending blacks the vote. Incredibly, stories of black families who tried to lift themselves up out of poverty by traveling north and seeking jobs and education—arguably the "real" stories of the Reconstruction Era—are moved to the periphery. One would have to ask: from whose lens is this history being told?

- Emphasize Americans' shared, interconnected history: make sure the history of collaboration among racial and ethnic groups does not get lost (e.g., Freedom Rides and Voter Registration Drive in the South in the early 1960s). Accentuate unities and commonalities as an antidote to our contemporary culture's implicit emphasis on hierarchical difference.
- Create an assignment in which your students research these "buried" stories and write "You Are There" narratives told from the perspectives of politically marginalized peoples, perhaps having them write from the point of view of a young person around their own age.
- Build into the rubric for your assignments the following criteria: the ability to articulate multiple perspectives and to demonstrate the rhetorical skills of conciliation in persuasive writing.
- Help students see the consequences of their thoughts, words, and actions. If a student makes a racist or otherwise offensive comment in class, stop and focus on it. Dr. Elisa Velasquez-Andrade (2006), a psychologist specializing in early child development and cross-cultural psychology, suggests the following sequence:

(1) When an offensive comment comes out in class, ask the student in a neutral tone, "Could you repeat that? I know you, and know that you probably didn't mean to say that." This gives the student the chance to re-think and re-phrase the comment.

(2) If the student still doesn't understand why the comment is offensive, ask, "How would you feel if you were a member of that group and heard that remark?"

(3) Use this juncture to expose whiteness as a social force: focus the class on the intersection of power, normative viewpoints, and their contingency.

PARALLEL NARRATIVES AND SEEING DOUBLE:
TOWARD A PEDAGOGY OF MOVEMENT

I began this chapter recounting the vibrantly surreal effect of transcultural conflict painted into an enormous landscape. We need a pedagogy similarly capable of unseating the cultural, political, and economic hegemony of whiteness. Indeed, we have an ethical imperative to help our students envision transcultural spaces for dialogue, personal evolution, and social change. Our best energies as teachers ought to be devoted to ensuring that multiple narratives are told in the classroom, and that entire, full histories are told as well. If students do not readily bring up

parts of the missing dialogue on race, I do. This is not a form of indoctrination or "politicizing" education. Giroux's distinction between "political education" and "politicizing education" is crucial here:

> A *political education* constructs pedagogical conditions to enable students to under-stand how power works on them, through them, and for them in the service of constructing and expanding their roles as critical citizens. In contrast, a *politicizing education* refuses to address its own political agenda and often silences through an appeal to a specious methodology, objectivity, or notion of balance. Politicizing educa-tion polices the boundaries of the disciplines, is silent about its own cultural authority, and ignores the broader political, economic, and social forces that legitimate peda-gogical practices consistent with existing forms of institutional power. (1999: 199)

Although our political system has lately been seen as a "democratic imagi-nary" in flux rather than a fully realized achievement, a robust democracy depends on authentic communication in which all parties are heard and common ground is built (Laclau and Mouffe 2001: 164). We need to commit to Rogers's basic guideline that, before we even begin to advance our argument, we must accurately state our discussion partner's position in the terms that she or he would use—even if this is painful to articulate. The very fact that oppositional speech from diverse communities may be seen as transgressive (or dismissed for any number of rea-sons) proves the degree to which hegemonic political power continues to name the terms of the discourse.

I long for the conditions in which everyone will hear each other's story with-out defensiveness, in which subjects in stories will hear themselves read as objects and vice versa, in which cultural pride will exist without a hierarchy, and in which our politically inflected categories of race will be dismantled in favor of mutual regard. As we move in this direction, it is crucial to remember that, in reading the (alter) narratives of our fellow human beings, we must acknowledge the para-dox that even though we read for connection, our lived realities are nowhere near the same. It is as if to say, "Go there—in consciousness, in solidarity—but realize you're *not there*." Much more work is needed so that we can finally bridge this distance and live within one another's lives.

NOTES

1. Available at: http://www.cyrilcoetzee.co.za/narrative.html. I would like to acknowledge support from the Fulbright-Hays Commission and from the School of Arts and Humanities at Sonoma State University. My thanks also to Kathy Charmaz, Kim Hester-Williams, Gerald Jones, and Rita Cameron Wedding, who read and commented on an earlier version of this essay.

2. Students' names have been changed. For practical suggestions for initiating conversations on the politics of race and for intervening in institutional racism, see Paul Kivel, *Uprooting Racism: How White People Can Work for Racial Justice*. Gabriola Island, BC: New Society Publishers, 2002.
3. Available at http://www.sfgate.com/cgi-bin/object/article?f=/c/a/2005/07/3/DDGQGDVBOS1. DTL&o=0). Thomas's piece was exhibited as part of Bay Area Now 4, Yerba Buena Center for the Arts, San Francisco, 2005.

REFERENCES

Althusser, Louis. (1971). *Lenin and Philosophy, and Other Essays*. Translated by Ben Brewster. New York and London: Monthly Review Press.

Bartholomae, David. (2005). Freshman English, Composition, and CCC. In *Writing on the Margins: Essays on Composition and Teaching* (pp. 299–311). Boston: Bedford/St. Martin's.

Burke, Kenneth. (1966). *Language as Symbolic Action: Essays on Life, Literature, and Method*. Berkeley, CA: University of California Press.

Coetzee, Cyril. (1999). T'kama Adamastor. Oil on canvas. 8.64 m x 3.26 m. William Cullen Library, University of the Witwatersrand, Johannesburg, South Africa. Available at: http://www.cyrilcoetzee.co.za/narrative.html

Fanon, Frantz. (1963 [orig. published 1961 as *Les Damnés de la Terre*]). *The Wretched of the Earth*. New York: Grove Press.

Fishman, Jean, Lunsford, Andrea, McGregor, Beth, and Otuteye, Mark. (2005). Performing Writing, Performing Literacy. *College Composition and Communication*, 57 (2), 224–251.

Foucault, Michel. (1984). We "Other" Victorians. In Paul Rabinow (Ed.), *The Foucault Reader* (pp. 292–300). New York: Pantheon Books.

Geertz, Clifford. (1973). Deep Play: Notes on the Balinese Cockfight. In *The Interpretation of Cultures*. (pp. 412–453). New York: Basic Books

Geto Boys. (1996). "The World is a Ghetto." *The Resurrection*. Rap-a-Lot.

Gilroy, Paul. (1993). *The Black Atlantic: Modernity and Double Consciousness*. Cambridge, MA: Harvard University Press.

Giroux, Henry A. (1998). Youth, Memory Work, and the Racial Politics of Whiteness. In Joe. L. Kincheloe, et al. (Eds.), *White Reign: Deploying Whiteness in America* (pp. 123–136). New York: St. Martin's Griffin.

———. (1999). Performing Cultural Studies as a Pedagogical Practice. In David Slayden and Rita Kirk Whillock (Eds.), *Soundbite Culture: The Death of Discourse in a Wired World* (pp. 191–202). Thousand Oaks, CA: Sage Publications.

Heidegger, Martin. (1996). *Being and Time: A Translation of Sein und Zeit*. Albany: State University of New York Press.

Kivel, Paul. (2002). *Uprooting Racism: How White People Can Work for Racial Justice*. Gabriola Island, BC: New Society Publishers.

Laclau, Ernesto and Chantal Mouffe. (2001). *Hegemony and Socialist Strategy: Towards a Radical Democratic Politics*. Second Edition. London and New York: Verso.

Lee, Mun Wah. (Director). (1994). *The Color of Fear* (Videotape). Oakland, CA: Stir-Fry Productions.

Lui, Meizhu, Robles, Bárbara, Leondar-Wright, Betsy, Brewer, Rose, and Adamson, Rebecca. (2006). *The Color of Wealth: The Story Behind the U.S. Racial Wealth Divide*. New York: New Press.

Minh-ha, Trinh T. (1990). Not You/Like You: Post-Colonial Women and the Interlocking Questions of Identity and Difference. In Gloria Anzaldúa (Ed.), *Making Face, Making Soul/Haciendo Caras: Creative and Critical Perspectives by Women of Color.* San Francisco, CA: Aunt Lute Foundation Books.

Morrison, Toni. (1992). *Playing in the Dark: Whiteness and the Literary Imagination.* New York: Vintage.

Pough, Gwendolyn D. (2004). *Check It While I Wreck It: Black Womanhood, Hip-Hop Culture, and the Public Sphere.* Boston, MA: Northeastern University Press.

Rogers, Carl. (1992). Communication: Its Blocking and Its Facilitation. In Nathaniel Teich (Ed.), *Rogerian Perspectives: Collaborative Rhetoric for Oral and Written Communication.* Norwood, NJ: Ablex Publishing Corporation.

Spradley, James P. (1979). *The Ethnographic Interview.* New York: Holt, Rinehart and Winston.

Thelin, William H. (2005). Understanding Problems in Critical Classrooms. *College Composition and Communication.*

Thomas, Hank Willis. (2005). Priceless #1. Bay Area Now 4, Yerba Buena Center for the Arts. Available: http://www.sfgate.com/cgi-bin/object/article?f=/c/a/2005/07/30/DDGQGDVBOS1. DTL&o=0).

Velasquez-Andrade, Elisa. Presentation at the School of Social Sciences Cultural Competence Retreat, Sonoma State University. March 10, 2006.

Wideman, John Edgar. (1984). *Brothers and Keepers.* New York: Holt, Rhinehart, and Winston.

Challenging THE Hegemony OF Whiteness BY Addressing THE Adaptive Unconscious

ANN BERLAK

A central goal of critical multicultural teacher educators is to challenge the reproduction of white power and privilege that is ubiquitous in US schools. At the end of each semester, those of us who share this commitment often receive testimonials similar to one I received written by Sue, a white woman:

> The most profound changes that have taken place throughout the semester have been my attitudes about race … I was one of those people who believed racism no longer existed. Now I know how wrong I was.

In the past I took such claims as evidence that I had made significant progress toward interrupting the hegemony of whiteness. But to do so I had to read right by comments such as the following, *written the same week by the same student:*

> When I asked my master teacher about her thoughts about the achievement gap and the African American culture (single mothers, children from multiple fathers) she quickly corrected me that it wasn't about any particular culture or race since all races do care about their children. In no uncertain terms she (the master teacher) let me know it was all about socio-economic status [not race]. I now realize this is true.

Failure to pay attention to such comments made it possible for me to remain unaware that students like Sue continued to hold stereotypical views of "African

American culture" and to discount the significance of racism in the lives of children, despite my best intentions and thoughtfully crafted curriculum and their heartfelt belief that their racial awareness had changed profoundly.

I recall the moment when I first noticed the contradiction between a student's claim to repudiate teachers' perpetuation of white privilege and power and her classroom behavior. It was Katie, another white student who some years ago made an A in the Foundations of Education course I teach, who made that moment possible. The A signified, among other things, that I thought Katie had explored the issue of racism and white supremacy thoughtfully, had unlearned most aspects of her blindness to white racism, and was well on her way to becoming an antiracist teacher and an ally to people of color. The semester after Katie's participation in my course, I supervised her student teaching. Within the first half hour of my first observation of her teaching, I watched this intelligent and committed young woman put the names of three misbehaving black boys on the board while ignoring the fact that several white boys were engaging in identical behavior. It was at this moment that the gap between students' espoused beliefs and values on the one hand and behaviors on the other came clearly into focus and I began to think systematically about how I could address this gap through my teaching. Such observations also prompted me to think about the gap between *my* own espoused commitments and *my* teaching practice.

THE CHALLENGE: ALIGNING MY COMMITMENTS
WITH MY PRACTICE

When I first saw Katie teach, I became aware that I had failed her, but I had no framework for thinking about what I could do about it.

My First Attempt to Understand: Resistance Theory

In 2001, I coauthored with Sekani Moyenda a book called *Taking It Personally: Racism in Classrooms from Kindergarten to College.* In *Taking It Personally,* I looked at my own antiracist pedagogy and students' responses to it by focusing on a traumatic racially charged incident that occurred one day in class after Sekani, a black first-grade teacher and former student in my Foundations course, had made a guest presentation to my class. I analyzed the event, its antecedents, and its consequences using the psychoanalytic concepts of trauma, guilt, anxiety, fear, mourning, denial, repression, and resistance. The incident was ignited when Jim, a white middle-class student who had had no teaching experience, repeatedly challenged the expertise and knowledge regarding the teaching of poor black children that

Sekani had accrued by virtue of her membership in a poor black community and years of teaching there.

Even after this analysis and my attempts to adjust my teaching in response to my new understandings, I knew that many (primarily, but not only, white) students still left the course without deeply grasping the degree to which whiteness as an interlocking system of advantages affected the ways they and others moved in and saw the world. I was also aware that only a few students had come to understand deeply that the vast majority of people in the United States naturalized white supremacy, white entitlement, and white superiority; that is, they did not see that these phenomena were not part of the natural order. Sue's blindness at the end of the course to how racism affects the schooling of underrepresented so-called minorities—despite her protestations to the contrary—seemed an unwelcome repetition of the same tenacious blindness I had hoped my explorations in *Taking It Personally* would prepare me to reverse.

My pedagogy, particularly after writing *Taking It Personally*, had been informed by two assumptions I shared with others who look at teaching through a psychoanalytic lens (Kumashiro, 2000; 2002). First, what and how students learn is influenced by an unconscious *resistance* to learning things that reveal the problematic nature of our beliefs. It is not our lack of knowledge but our resistance to knowledge and our desire for ignorance that often prevent us from changing the oppressive status quo. In *Taking It Personally*, I explained my own and my students' unconscious resistance to acknowledging the racism that was palpable in students' responses to Sekani's presentation as follows:

> Perhaps I didn't want to know how powerfully implanted were Jim's fear of and disrespect for Black people, in part because such an awareness would remind me how deeply I had been implanted with the same ... Perhaps the (white and Asian) students' fear of Sekani was an instance of unconscious but deeply engrained fear of encirclement by dark-skinned others. Perhaps they were associating Sekani with the terror they felt at the prospect of teaching a class populated by what they ... had come to see as violence-prone Black children ... Perhaps ... some of the students were deeply invested in keeping at bay Sekani's view that she and other people of color had been unjustly disempowered because it challenged their understanding of how the rewards and punishments are meted out in a society they had learned to think of as just ... Maybe Jim and the others resisted acknowledging Sekani's expertise because they were trying to maintain the floodgates that protected them against a dawning awareness that their positions in the racial hierarchy, which provided important sources of self esteem, were unearned and undeserved. (122–123)

Before the session in which Sekani made her presentation was over, several students had broken down in tears, angry tones of voice had reverberated

down the hall, and one student had abruptly left the room. A white student later reported,

> I'm still thinking of the [Sekani's] visit … I feel like my insides have been ripped out … So far this has been my range of emotions: intimidation, rage, defensive attitude, hopelessness, guilt, confusion, hope, respect … And I would say that's just the tip of the iceberg.

A second conclusion I drew from my analysis was that any serious confrontation with one's racist conditioning was necessarily traumatic, as it had been for many students in that class. Therefore, when in subsequent classes that level of trauma did not happen I felt the course was falling short. That, coupled with evidence such as Sue's failure to sustain her new awareness of the contribution racism makes to the "achievement gap," provoked my curiosity about how to "get through" to more students at a deeper level.

Looking at Teaching through the Lens of the Adaptive Unconscious

It was at this point that I came upon Malcolm Gladwell's bestseller *Blink* and then read Tim Wilson's *Strangers to Ourselves: Discovering the Adaptive Unconscious,* to which Gladwell refers. The theory of the adaptive unconscious they set out suggested a new way to think about making the power and privilege of whiteness visible.

The central idea of the theory is that we have two non-redundant information-processing systems that are relatively independent of one another. These two systems have evolved in different ways and serve different functions. One of these, the adaptive unconscious, operates almost entirely out of conscious view. The adaptive unconscious is far more sophisticated, efficient, and adult-like than the unconscious portrayed by psychoanalytic theory. It can set goals, interpret and evaluate evidence, and influence judgments, conscious feelings, and behavior. People can think in quite sophisticated ways and yet be thinking "non-consciously." In fact, the mind relegates a good deal of high-level thinking to the adaptive unconscious. Wilson calls it the *adaptive* unconscious because it has evolved to enable human survival. It permits us to notice danger and respond to it quickly.

Gladwell compares the adaptive unconscious to a giant computer that crunches all the data from all the experiences we have had. These efficient, sophisticated, unconscious information-processing systems that select, interpret, and evaluate incoming information, direct our attention, and filter our experience influence almost all our second-by-second responses. Thus, the adaptive unconscious

is more influential in our day-by-day living than most of us think, and we exert less control over our actions than we imagine.

Attitudes toward concepts such as race or gender, for example, operate at two levels—at a conscious level our stated values direct our behavior deliberately, and at an unconscious level we respond in terms of immediate but quite complex automatic associations that tumble out before we have even had time to think. The adaptive unconscious is unintentional, effortless, and responsive to the here and now. It is also rigid; that is, it is slow to respond to new and contradictory information. Conscious thought takes a longer view; it is controlled, slow, and effortful.

The idea is that we have two personality systems: the adaptive unconscious and the conscious self. As exemplified by Katie, each has characteristic and sometimes diametrically opposed ways of interpreting the environment and its own feelings and motives that guide behavior. Many studies have documented that the disconnect between the conscious intentions of people like Katie and the unconscious views that motivate their behavior is ubiquitous (e.g. Ferguson, 2000; Lewis, 2004).

So independent are the two systems that Gladwell characterizes the snap judgments or rapid cognitions characteristic of the adaptive unconscious as taking place behind a locked door. Thus, individuals can honestly claim they are aware of the diverse set of racist practices that hold in place the hegemony of whiteness and yet be completely unaware of them at an implicit automatic level. People may act on their conscious views when they are behaving deliberately but act on the more unconscious dispositions of their adaptive unconscious when they are not monitoring their actions.

The Interpretive Function of the Adaptive Unconscious

Our conscious mind is often too slow to figure out what is going on and how to respond to it in a timely manner. Though our "gut feelings" are not always what we (consciously) want to guide our action, with so much information out there to analyze, there can be important advantages to these rapid unconscious mental processes.

Gladwell calls the process by which the adaptive unconscious culls through experience and finds patterns "thin-slicing" (2004, 34). Thin-slicing is the instantaneous ability of the adaptive unconscious to find patterns in situations and behaviors based on very narrow slices of experience. He gives an example of a police officer who made a split-second decision not to shoot a young African-American boy who appeared to be reaching for a gun. On the basis of many features of the situation and considerable past experience in similar situations that were in that moment inaccessible to his consciousness, the officer "knew" the boy was not dangerous. I was thin-slicing when I recognized the racialized pattern in Katie's behavior.

One of the most important judgments we make is about the motives, intentions, and dispositions of other people, and it is often, as in the case of the officer, essential to make them quickly without the help of conscious analysis. Sometimes thin-slicing delivers a better on-the-spot response than more deliberate thinking. In fact, conscious thinking may at times negatively influence the insights of the adaptive unconscious. In Gladwell's words, "insight," the processing of information by the adaptive unconscious, is a flickering candle that can easily be snuffed out (2004, 122).

Origins of the Hegemony of the White Supremacist Views of the Adaptive Unconscious

The adaptive unconscious is in part genetically determined: we are all pre-wired to fit experiences into categories. This enables us to scan (select what to pay attention to), interpret, evaluate, and respond to our environments. However, the particular categories we use are certainly not innate. Whereas conscious learning requires effort, the categories of the adaptive unconscious are acquired without effort or awareness, fashioned and built up through repetition and frequent use.

Each of us develops regular or habitual ways of construing the world that are rooted in early childhood, generated from the thousands of micro-messages our families and communities send us nonverbally as well as verbally, the books we have read, the media we have encountered, and what we have learned at school, particularly through the hidden curriculum. In the United States these cultural forces reinforce and naturalize white supremacy and blindness to the hegemony of whiteness.

Since white-on-black racism is the archetype of racial oppression in the United States and has played a central role in the creation and evolution of systematic racism for centuries, people of color who are not black as well as whites and even many blacks have been conditioned to take for granted that groups and individuals whose skin and other features are closest to whites' are superior. (The internalization of this view by people of color themselves is frequently labeled "internalized racism.") A study of white middle-class Americans' views about race concluded that color is recognized in the first contact between blacks and whites, before a handshake or a spoken word. It is the indelible symbol that triggers assumptions about an individual's intelligence, morality, reliability, and skills (Shipler, 1997, 280).

However, the adaptive unconscious of racial groups and individuals varies, in part in response to experiences that flow from their positions in the racial order. Many people of color, as a result of the family, community, and historical context they grew up in, have come to view light-skinned people as racists. (I often tell my

white students that people of color are likely to consider them guilty—of racism and of blindness to the hegemony of whiteness— unless they demonstrate their innocence.

Paradoxically, like myself, the vast majority of prospective teachers in my classes, very few of whom are African American, whether brought up in the United States or not, have grown up in societies in which the concepts of equality of opportunity and meritocracy are ubiquitous and racism and white skin privilege are rarely acknowledged or discussed. Taken together, the silences about racism and white privilege and the conceptions of meritocracy deeply etched in all of us almost from birth ensure that most people (particularly white people) will not have the lenses through which to see the racism and white privilege that is right before our eyes.

These fast and automatic racial judgments made by all of us occur primarily in the adaptive unconscious. Thus, qualities of appearance or phenotype (and other ethnic/racial attributes) trigger powerful and deeply engrained associations that have been laid down long before we enter school (Van Ausdale & Joe, 2001). Wilson uses the metaphor of the "spin doctor" to convey the power of our unconscious category schemes to influence our interpretations. If the facts we encounter do not fit our frames, the facts bounce off or are transformed or distorted to fit the frames. The power of the frames or categories of the adaptive unconscious is so automatic and deeply engrained that in one experiment even subjects who were reminded or "primed" to avoid using racial stereotypes were unable to avoid using them. People responded in ways that contradicted their conscious explicit intentions (Payne, 2002).

The Dangers of the Adaptive Unconscious

Acting in response to the adaptive unconscious can of course be dangerous and damaging both to oneself and to others; the adaptive unconscious can betray us as it did Katie. It can countermand conscious rational processes of thinking, jump to conclusions, and fail to change in the face of contrary evidence. It is responsible for some of society's most troubling problems. Much research in cognitive psychology has been concerned with the implications of non-conscious processing for racial prejudice and white racism. Some of these studies show that, particularly when under time pressure or facing anxiety-provoking situations, people do not rely on the evidence of their senses and fall back on the rigid, unyielding categorical stereotypes that inhabit their adaptive unconscious. That four police officers, "thinking" he was about to shoot them, decimated the dark-skinned Amadou Diallo with a total of 41 bullets as he reached into his pocket to locate identification papers one winter night in the South Bronx is evidence of the potential destructiveness of the racial lenses of the adaptive unconscious.

Which Lenses Will We Use?

Each of us has a variety of automatic category systems we might use to screen the data we encounter. Which system will be operative at any particular moment—which one will be, in Wilson's terms, *chronically accessible*—depends on several factors. One factor is whether and how often the category system has been used in the past. As the examples of Katie and Sue suggest, a semester of concerted use of a lens that brings racism and white supremacy into focus may be no match for the multitude of times they have looked at racial hierarchy through meritocratic frames.

A second factor is how recently a particular frame has been called into play. Data from priming studies show that presenting subjects with verbal or visual cues can evoke entire frames of reference that influence how subjects will perceive an experience that occurs immediately after the cues, without the subjects having any awareness that they have been primed (Gladwell, 2004, 53). One relevant study was carried out by Claude Steele and Joshua Aronson (1995). Using black college students and 20 questions drawn from the Graduate Record Examination (GRE), they asked half the students to identify their race on a pretest questionnaire immediately before taking the test. The simple act of self-identification was sufficient to prime the students with the negative stereotypes associated with African Americans and academic achievement; this group got half as many correct as those who were not explicitly asked to think about their race (Gladwell, 2004, 56). None of the participants had any idea about what had affected their performance.

A third factor that affects which frames we use to screen information is self-relevance: we call into play frames that exclude information that will challenge our sense of well-being. The "psychological immune system" that protects us from threats to our psychological well-being is a central function of the adaptive unconscious (Wilson, 2002, 39). It is here that the theory of the adaptive unconscious incorporates the psychoanalytic concepts of denial and repression (ibid. 12–14).

The Difficulty of Accessing the Adaptive Unconscious

If the adaptive unconscious is like a hidden engine humming below the surface of the mind where there is no engine hatch that we can open to take a direct look at its operation or, to use another metaphor, if it resides behind a locked door, identifying aspects of the adaptive unconscious may be no easier than (to use still another metaphor) viewing and understanding the assembly language controlling our word-processing computer program (Wilson, 2002, 16).

That doesn't mean we shouldn't try. However, there is compelling research evidence that, though people may be ignorant of why they acted as they did, they rarely *feel* ignorant (Gladwell, 2004, 71). Instead, asking people to explain their

actions or responses to particular stimuli is likely to lead to fabrications that may be contrary or irrelevant to the beliefs and motivations of the adaptive unconscious (Wilson, 2002, 99–106). Thus, introspection as ordinarily understood is more often an imaginative *construction* than a retrieval process.

We are likely to construct explanations for our racialized interactions that are consistent with the conscious cultural and personal theories that come most easily to mind (Wilson, 2002, 169), that is, are most accessible. The frameworks of the dominant "race" tend to become the reference points on which most of us ground our explanations for our behaviors and thoughts (Bonilla-Silva, 2003, 9). One of the most common and powerful of these "smokescreens" is the idea of meritocracy—if we are wary of dark-skinned people, it is because (as the meritocratic framework dictates) they lack the drive, rationality, or intelligence of white people. Katie's initial explanation for why she disciplined the black boys was that they were the (only) ones talking out of turn. Such explanations fail to recognize how long-established feelings and beliefs of the adaptive unconscious motivate one's beliefs, perceptions, fears, and actions.

Making Inferences about Our Adaptive Unconscious

Despite the difficulties of finding out what is going on behind the locked door, it is not impossible to do so. One way is to learn to make better guesses or inferences about our unconscious dispositions (Wilson, 2002, 90). We can deduce the nature of our hidden minds by looking outward at our behavior (ibid. 16) and at our mental responses to particular situations, rather than engaging in what Wilson calls fruitless introspection (ibid. 211). Though Wilson does not disparage all kinds of introspection, he argues that to identify the feelings and beliefs that propel us, we need to hone our abilities to look closely at the thoughts and actions we do have access to and try to deduce from them how our non-conscious underpinnings are patterned.

Another way to access information about the unconscious is to pay close attention to what others think of us and to consider using that information to revise our beliefs about ourselves, even if this means adopting a more negative view of our behavior and its unconscious determinants (ibid. 199). If others experience us as blind to the hegemony of whiteness, for example, but we are sure that race is not an issue, at the very least we might ponder this discrepancy.

Of course, using others' views of us as clues to our adaptive unconscious presents difficulties. To utilize this source of information about ourselves we would first need to know what others *really* think of us, and others often hide their true views and impressions of us, particularly if these are critical; students in some of my classes hear remarks they view as racist spoken in class but will only report

this to me in their journals. Another reason it is difficult to use the views of others as clues to our adaptive unconscious is that when others tell us what they really think, we often do not hear it (ibid. 196); our unconscious filters may protect us from negative feedback in order to enhance our sense of well-being.

Constructing Coherent Narratives

Better or more accurate self-stories are ones that are coherent; that is, they capture the nature and origins of our non-conscious goals, feelings, and beliefs as well as our conscious ones. Such journeys to self-understanding can be more satisfying because they include a wider range of experiences than those that take into account only thoughts and behavior we are conscious of. Nevertheless, as we have seen, such accounts depend on inferences we make about our adaptive unconscious that, even when based on close observation of our own behaviors and the reactions of others to us, may still be deeply flawed.

In sum, according to the theory of the adaptive unconscious we all have two non-redundant information-processing systems, the conscious mind and the adaptive unconscious. The adaptive unconscious operates almost entirely out of view, behind a locked door, but is nevertheless a greater source of teachers' minute-to-minute, second-to-second classroom behavior than is our consciousness. Therefore, we ignore it at our peril.

WHAT DOES THIS MEAN FOR TEACHING TEACHERS?

In teacher education we rarely look closely at first impressions and habits of rapid cognition, where they come from, and their effects on individual children and on the future of the society in which we live. This includes our automatic responses to race. Acknowledgment of the racial adaptive unconscious and studies of how to change it are more likely to take place in "pre-service" and "in-service" training programs for the police. As the 50-bullet killing by members of the New York Police Department of the unarmed and black Sean Bell on his wedding day reminds us, the racial adaptive unconscious of the police can be a matter of life and death. Teachers, like the police, are servants of the state, and though catastrophic racial interactions that spring from the adaptive unconscious of teachers may not be as visible, newsworthy, and immediate, our racialized patterns of behavior are also, ultimately, matters of life and death.

Fortunately, our unconscious thinking is in one critical respect no different from our conscious thinking: in both, we are able to change our responses with training and experience (Gladwell, 2004, 237). Taking our adaptive unconscious

seriously means we have to take serious and systematic steps to learn about it and how it shapes our acts in classrooms and how we can alter or reeducate it. Failure to address the racial adaptive unconscious of teachers and degrading and harmful actions that may flow from it are one form of institutional racism.

Teaching Students about the Adaptive Unconscious

Since I have begun to think about Katie's and other teachers' disciplinary patterns in terms of a disconnect between one's conscious beliefs in the importance of racial equality and an adaptive unconscious that motivates racialized pattern of teaching, I have begun to teach students to explore their adaptive unconscious, how it affects their teaching behavior, and how they can change it. I begin this on the first day of class by asking each student to describe the racial/ethnic composition and tracking patterns in their elementary and high schools. I then lay out some rudiments of the theory of the adaptive unconscious and ask the students to hypothesize how these early school experiences might have affected the lenses through which they were learning to make sense of race, class, and opportunity: which students were they learning through the hidden curriculum to categorize as smart and hardworking, and which as dumb and/or lacking in ambition?

This initiates a process of teaching that I now conceptualize as an effort to affect the deep structures of students' adaptive unconscious—structures that are in my view the most significant aspects of what educators often conceptualize rather superficially as "prior knowledge." I have begun to teach students to consider how their racial adaptive unconscious may have a more profound effect on their teaching than the beliefs about privilege, intelligence, race, and merit they learn through formal education and that they are conscious of.

Teaching As Strengthening Selected Lenses: The Value of Repetition

Developing the lenses and associations of the adaptive unconscious requires much time (in fact, a lifetime) beginning from infancy, and very frequent repetition. In the last class session of our three-session focus on racism, I show the film *The Color of Fear*, an hour-and-a-half documentary in which a racially diverse group of men candidly and emotionally grapple with racism. Though students had already done a lot of reading selected to show the reality of racism in schools and in society at large (Lewis, 2004; Robinson, 2000; Baldwin, 1963/1988 and many others), and they had discussed, read, and seen videos about racism and white privilege during the two previous three-hour classes, it was after viewing this film that June for the first time began to contribute eagerly to class discussion and engage thoughtfully with the issue of race in her journal.

The centerpiece of the film is an articulate and angry speech by Victor, an African American man, which conveys how he experiences racism daily. June asked why I had not shown the film earlier in the course. It would have saved us a lot of time and work, she said. I told her that when I first began to teach the course I *had* shown the film during the first class session, but many students had responded to it with anger—and anger not at the racism the men of color had experienced, but at the men of color for picking on David, one of the two white men. In her final journal entry June wrote,

> Most of what I learned [in the entire class] had to do with racism ... One thing I learned about was white privilege. I had heard the term but I had no idea how deep and pervasive it was. When we watched *The Color of Fear* I saw how David didn't see how the non-whites experienced racism, and heard what the non-whites had to say about their experiences with racism. Combined with the white privilege exercise it made a powerful impression on me. These things made me re-think everything else we'd talked about on the subject of racism and finally shed a light that I had been lacking.

I could interpret June's reaction to the film in terms of resistance: that Victor's speech and the film more generally created a trauma that loosened her resistance to acknowledging the reality of racism. Alternatively, I can read her response as that of someone who, though she may have been somewhat resistant to recognizing racism in herself, is primarily a person whose lens for perceiving racism simply needed to be strengthened and reinforced before she could bring it to bear on what had always been right before her eyes. June's response illuminates the necessity of repetition in the laying down of frames for perceiving racism and white privilege.

I now think about the challenge of teaching credential candidates to recognize the hegemony of whiteness in terms of making particular frames chronically accessible. This requires frequent repetition, particularly when the new lenses conflict with already well-established and therefore more easily accessible ones. An example of a lens that conflicts with one that brings into focus the hegemony of whiteness is the well-entrenched meritocratic framework discussed earlier. An alternative to this framework must become chronically accessible for students to recognize the role white privilege and racism play in success at school.

In his final journal entry John described the tenacity of the meritocratic frame:

> My refusal to dismiss the myth that "One will make it as long as she/he works hard" was certainly a high hurdle to conquer. This might explain the persistence of my initial judgment against affirmative action [during the last week of class]. I still assumed

everyone was granted the same resources and placed at the same starting points even though as I now realize we had been thinking critically about this view all along.

Another example: the journal entry written by Lisa, a Chinese immigrant, describing the persistence of a lens that blinds her to the hegemony of whiteness:

> The biggest accomplishment [that] emerged from this experience [the course] for me ... is my realization that I've internalized so many concepts that were essentially unhealthy to my overall being. The reason I did not see myself as a victim under racism was ... I somehow welcomed the notion that white equates [with] superiority without registering [this] consciously. It was the most difficult step in this self-discovery journey for me ... I understand it must be a great challenge to overwrite [sic] much internalization that had been rooted in our minds and bring the subconscious to the surface.

Another way to think of this is in terms of figure/ground. For most students who come into class, a meritocratic framework is ascendant; it is the "figure," and white supremacy is the pale and mostly invisible "ground," or background. My hope is to accomplish a reversal.

Looking at challenging the hegemony of whiteness in terms of the adaptive unconscious sheds light on the disproportionate time I spend addressing racism—in contrast to classism and sexism and Euro-centrism, for example, although I think each of these issues is of equal and crucial importance. However, particularly because so few of my students have examined any of these issues before entering the class, I think I have understood intuitively that affecting even one deep and fundamental structure of the mind, such as the hegemony of whiteness, within a 45-hour course is hard—often impossible—to do. Spending equal time on each issue is likely to have a significant impact on none.

During the past few semesters, as I have begun to look at classroom processes through the lens of the adaptive unconscious, I have become less judgmental of my students. I conceptualize variations in students' adaptive unconscious as normal and inevitable rather than as evidence of pathological resistance. In the past I have been particularly judgmental of "been there, done that" (primarily, but not always, white) students who enter the course thinking they know all there is to know about the racial order and therefore have nothing to learn from this segment of the course. Since I have begun to think about antiracist teaching in terms of the adaptive unconscious I have come to see students' blindness to their own blindness as a consequence of lenses that have been insufficiently built up or reinforced, and not primarily a result of resistance they can with determined effort eject. One result seems to me to be that the resistance that does exist decreases, or, in Wilson's terms, I less frequently call students' psychological immune systems into play.

Framing anti-racist teaching in terms of the adaptive unconscious also brings more clearly into focus the importance of teaching an anti-bias curriculum to very young children at the very time when their lenses are still in the process of being formed. Thus, it clarifies the dialogue assignment I give that requires each student to talk with a child on an issue related to race, class, ethnicity, sexual orientation, or gender, to identify what the child seems both to know and not to know, and on the basis of this analysis to consider what to teach that child. I now see that what I really want my students to do is to make some inferences about a particular realm of children's adaptive unconscious, to discover, for instance, to what extent a child already has a framework for perceiving certain groups of people as "less than" either because of the color of their skin or because of another aspect of their identity, to consider what kind of framework they want to reinforce or begin to build, and to plan curriculum for doing so.

Presenting Alternative Images

An anecdote Gladwell tells in *Blink* suggests the importance of presenting alternative images when attempting to construct lenses that position people of color as capable and powerful. The story revolves around the race IAT (Implicit Association Test). The race IAT is a computer-generated test that measures our implicit racial valences (http://www.implicit.harvard.edu). More than 80% of all those who take this test end up having pro-white associations (Gladwell, 2004, 84). This includes about half of the 50,000 African Americans who have taken the test. Gladwell reports that after months of taking the test daily and scoring with the majority every time, one day an IAT researcher was stunned to discover that he got a positive association with images of black people. He was deeply puzzled by this turn of events. Finally, he realized that he'd spent the morning watching the Olympics on TV. From this, he and other researchers surmised that repetitive and recent exposure to positive images of black people had affected the racist features of his adaptive unconscious and thus his response to the IAT. They extrapolated that altering our exposure to the images we come into contact with regularly is one way to alter the adaptive unconscious.

The implication is that just because something is out of awareness doesn't mean that it is out of control; once we identify aspects of our adaptive unconscious that we hope to change, we can take active steps to manage and control the images and experiences with which we interact (ibid. 2004, 97–98). What this suggests for curriculum is that both teacher educators and classroom teachers must carefully consider what images we are offering our students.

At first, the emphasis on race and racism seems tedious to many students, some of whom complain that they are thinking about race all the time. However

many eventually become more expert at interpreting what lies behind their snap judgments and first impressions, and, eventually, build up a kind of alternative unconscious database that fundamentally alters the nature of their first impressions (Gladwell, 2004, 184). It is at this point that they can begin to trust those on-the-spot responses that make up the vast proportion of teachers' classroom actions.

Making Better Inferences about Our Adaptive Unconscious

How can we learn more about our implicit thoughts and attitudes, particularly the negative stereotypical automatic and unintentional aspects of our adaptive unconscious that seem unresponsive to new and contradictory information? The first step is to begin to habitually, consciously, and deliberately analyze our behaviors for clues to our unconscious racial lenses, paying special attention to the pitfalls into which we know from social research we are likely to fall. White- and light-skinned people could, for example, vow to keep closer track of how we act in interracial settings.

One classroom activity that provides an opportunity for students to make inferences about racialized elements of their adaptive unconscious occurs at the beginning of our focus on race and racism. Because the activity concerns students' responses to a video clip, I describe the clip in some detail. It is a three-minute excerpt from *School Colors*, a documentary about Berkeley High School, made more than a decade ago.

The clip shows a single scene, a conference between Jeff—a black student at Berkeley High—and two white men, a teacher and a guidance counselor. Jeff is wearing a hooded sweatshirt and sunglasses. He has already been suspended. He tells the two white men that he had come upon two female friends of his who were fighting in the hall. He decided it was his responsibility to break up the fight so his friends wouldn't get in trouble. One of the two men at the conference, the white teacher—whom Jeff had never seen before—had grabbed Jeff (rather than intervening in the fight), assuming Jeff was going to join the fight. When grabbed by the white stranger, Jeff said to him, "If you touch me again I'm going to phuck you up." He had been suspended for threatening a teacher.

Later in the scene Jeff tells the two men that he was issuing a warning and not a threat: "If you look in your dictionary, you'll see the difference. 'If you touch me again' is a warning;' 'I'm going to phuck you up'—that's P-H-U-C-K, in my language—is a threat." He also tells them that in his culture "if a man grabs you who you do not know you defend yourself," and that if he had not been on school grounds he would have hit any stranger who put his hands on him. After Jeff has left the room, the white men commiserate that they don't think Jeff really heard anything they said.

After showing this video clip I ask the students to do a "quick write," reporting what they saw happening in the scene, and how well they think the adults handled the conference. I then collect and redistribute the writing so that each student reads aloud to the class what another has written, and no one knows whose view is being spoken. In the "read-around" a variety of views are expressed. Far more than half endorse the suspension and the adults' handling of the situation. Since we have just finished a focus on Euro-centrism, another common view is that there was a conflict of cultures between Jeff and the two men. At most one or two mention the racial power differences. No one mentions the hegemony of whiteness or the institutional racism implicit in the fact (clearly established in the clip) that it was white people who made, applied, and enforced the school rules.

Last semester, when I raised the question of possible ways to explain why only one or two in each section initially mentioned the fact of racial power differences, and fewer still saw the scene in terms of racism, many of the students in one section of the course (a section that prided itself on being more progressive than the others) supported one another in wanting me to understand that it was because the racism was so obvious it did not need mentioning. I interpreted this response as evidence of their blindness to the hegemony of whiteness and as a form of self-protection against their shame at being blind to it. After the course was over, on the day I was to give a presentation of this paper, I met one of the students from this class at a subway stop and asked him what he thought about me portraying the class's explanation for their blindness as a rationalization rather than the real reason. "You're damn right it was," he said.

Several students of color initially were silent on the racial dimensions of the *School Colors* clip. One, a Korean American, reflected upon his response later. He wrote,

> During our last meeting I along with the few other students who missed the previous session viewed a clip from School Colors. We were asked to write down some observations as well as our thoughts on how well the situation was dealt with by the adults. I thought it was interesting how Sally [a Chinese American] and I noticed the issue of race in correlation to the power structure and how stereotypes reinforce them but it was John [who is white] who was the only one to mention it. If one believes in such a thing as model minorities I wonder how much Asian Americans such as Sally and myself have been conditioned not to offend white Americans with our concerns on the issue of race.

I see this response as an example of a thoughtful inference about the (until that moment) unconscious motive that influenced his initial response.

There are always several students who, when describing what happened in the video, say that Jeff hit the teacher, though there is absolutely no suggestion of this in the clip. After all the students' responses to the clip are read aloud, these

students become aware of how they had misread the situation and infer that their misreading is evidence of the terrain of their racial adaptive unconscious. I suggest the parallel between their responses and the well-known research that demonstrates that people's perceptions of an object as a tool or a weapon are related to whether it is preceded by an image of a black or a white man (Payne, Alan, & Larry, 2002).

Now that I am looking at my teaching through the lenses of the adaptive unconscious I formulate the discussion after the initial video-clip activity explicitly in terms of what inferences each student can make about his or her own adaptive unconscious from the differences between his or her responses to the disciplinary hearing and those of the other students. I try to remember to call attention to the need to scrutinize this inferential process carefully, remembering that inferring our internal states from our behavior may result not in identifying those states accurately but in fabricating stories (such as "racism was too obvious to mention") to explain why they feel and see as they do.

The tenacity of well-established lenses is indicated by my attempts to affect students' initial responses to the disciplinary hearing clip by immediately preceding it with the part of the *School Colors* documentary that shows black students discussing clear and compelling instances of racism they have experienced at Berkeley High. I had anticipated that showing this discussion immediately before the clip of the disciplinary hearing would act as a sort of "hint," that it would activate students' frameworks for apprehending racism. However, priming the disciplinary scene in this way seems to have little effect on increasing students' tendencies to see the scene in terms of personal or institutional racism. This, I think, underscores how tenacious the deeply embedded lenses of the adaptive unconscious are.

Though seeing ourselves through the eyes of others has long been a goal for my course, until recently I did not see it as a route to exploring the unconscious. I wrote in *Taking It Personally*,

> I wanted Kathy and others, white students and students of color, to see through Sekani's eyes, and more generally through the eyes of racially conscious people of color … My assumption was that as the students developed their abilities to see from the perspectives of others, they would be in a better position to identify racism in themselves and others, and to grasp it deeply enough to be moved to interrupt it. (156)

I quoted Jennifer in *Taking It Personally*

> This experience (of Sekani's presentation) is probably the closest I have come to feeling like I know what I look like or could look like through the lenses of an African-American woman. This information is so valuable to me. (67)

Before I looked at anti-racist teaching in terms of the adaptive unconscious, I did not understand that seeing ourselves through the eyes of particular others could help students identify *unconscious* racism or internalized racism in themselves. Particularly, in part because my classes are so racially unbalanced, students of color are hesitant to say publicly how they see the racial views of their classmates (though they often reveal it in their journals). So, to provide a perspective of a racially conscious person of color I have over the years continued to require that students read Gloria Yamato's (1998) "Something about the Subject Makes It Hard to Name." Yamato's essay categorizes all white people into one of four categories of racists. I ask students to write about how they *feel* about Yamato's essay. Now I more fully understand the part this assignment plays in my curriculum. I now see that Yamato's essay provides both white students and students of color with the opportunity to see themselves through the eyes of another and to make inferences about what their feelings about how they are seen might suggest about their racial adaptive unconscious. What does it tell you about your adaptive unconscious, I often ask students, that you are angry about what Yamato thinks of you but not about the racism she writes about?

Thinking in terms of the adaptive unconscious has helped me refocus the racial autobiography assignment, which I felt rarely got to the heart of the matter and have been dissatisfied with for years. Since I have come to think about racial autobiographies as narratives that trace the development of the racial unconscious as well as conscious racial attitudes, feelings, and beliefs, I have revised the assignment. I now ask students to begin their autobiographies by engaging in three activities designed to evoke responses from which they can make inferences about the shape of their adaptive unconscious. First, I ask the students to compare their initial responses to the disciplinary hearing video clip to the responses of others. Second, I ask them to write about the similarities and differences between themselves and one of the characters in the movie *Crash*. I particularly hope white students will see themselves in the younger white policeman and identify with the discrepancy between his conscious view of himself as non-racist or even anti-racist and the part of his adaptive unconscious that propels him to kill the black hitchhiker. (Many white students do so and so do many students of color.) A third opportunity to make inferences about racial elements of their adaptive unconscious is to consider what their responses to the Yamato essay suggest about it.

Only after students identify elements of their adaptive unconscious can they write meaningful and coherent self-narratives, that is, narratives that explore the genesis of the conscious racial views and the racial aspects of their adaptive unconscious.

CHANGING BEHAVIOR

Another approach to changing racist aspects of the adaptive unconscious is suggested by Wilson's claim that if we want to change some aspect of the adaptive unconscious a good place to start is to begin deliberately acting like the person we want to be (2002, 203). One of the most enduring lessons of social psychology is that behavior change often precedes changes in attitudes and feelings (ibid. 212). Though people do not transform their automatic responses by a few forays into discussions of racism at Thanksgiving dinner tables—a not infrequent activity of students who take the course in the fall—we can more easily change feelings and patterns of thought by changing behavior than we might think. Acting in non-or anti-racist ways, interrupting racist behavior, and challenging institutional racism can lead to change at the automatic level because the more frequently people perform a behavior the more habitual and automatic it becomes, requiring less and less effort or conscious attention (ibid. 212).

This aspect of Wilson's theory suggests two changes in my curriculum: first, that I give more attention than I have done previously to role-playing situations in which white students have the opportunity to act as allies to people of color (and other groups positioned as "less than") and to stand up for themselves and others in the face of bias; second, that I require students to enact and report on instances of their anti-racist behavior.

There appears to be some consensus that people can sometimes restrain the automatic responses that are propelled by their adaptive unconscious given ample knowledge about the psychodynamics that inform their behavior, opportunity, (conscious) motivation (Payne, Alan, & Larry, 2002, 184), and sufficient time to notice and reflect on their thoughts, feelings, and actions. We can learn to be especially vigilant of our "gut feelings" in situations where we are required to act quickly or are under stress. We can learn to wait a beat before responding to first impressions or challenging situations, particularly when we have a hunch that elements of our adaptive unconscious are not in sync with our conscious beliefs and intentions. We can learn to sit with uncomfortable feelings and take time to think about where they might be coming from. This bolsters arguments for reducing the time pressure on teachers that results from overcrowded classrooms and scripted curricula.

Learning more about ourselves and the ways we habitually and unconsciously envision ourselves and Others is essential if teachers are going to challenge the hegemony of whiteness. I believe thinking about teaching in terms of the power of the racial adaptive unconscious has already enabled me to more successfully challenge the deeply entrenched master narrative of whiteness of people who

will soon become classroom teachers and will then themselves be in a position to interrupt the transmission of this narrative to the next generation.

I still find myself thinking that students can become attuned to racism and to the hegemony of whiteness if they just read the books I assign more closely or if I could just find some better readings and videos. However, as I continue to internalize the theory of the adaptive unconscious, I understand more deeply there is a lot more to it than that.

REFERENCES

James Baldwin. (1963/1988). A Talk to Teachers. In Rick Simonson & Scott Walker (Eds.), *Multicultural Literacy: Graywolf Annual Five* (pp.1–12). St.Paul, MN: Graywolf Press.

Berlak, Ann & Sekani Moyenda. (2001). *Taking it personally: Racism in the classroom from kindergarten to college.* Philadelphia, PA: Temple University Press.

Bonilla-Silva, Eduardo. (2003). *Racism without racists: Colorblind racism and the persistence of racial inequality in the United States.* New York: Rowman & Littlefield.

Ferguson, Ann. (2000). *Bad boys: Public schools in the making of Black masculinity.* Michigan: University of Michigan Press.

Gladwell, Malcolm. (2004). *Blink: The power of thinking without thinking.* New York: Little, Brown.

Kumashiro, Kevin. (2000). Toward a theory of anti-oppressive education. *Review of Educational Research, 70* (1), 25–53.

Kumashiro, Kevin. (2002). Against repetition: Addressing resistance to anti-oppressive change in the practices of learning, teaching, supervising, and researching. *Harvard Educational Review, 72* (1), 67–92. Reprinted in A. Howell and F. Tuitt (Eds.), *Race and higher education: Rethinking pedagogy in diverse college classrooms.* Cambridge, MA: Harvard Publication Group.

Lewis, Amanda. (2004). *Race in the schoolyard. Negotiating the color line in classrooms and communities.* New Brunswick, NJ: Rutgers University Press.

Payne, B. Keith, Alan J. Lambert, & Larry L. Jacoby. (2002). Best laid plans: Effects of goals in accessibility bias and cognitive control in race-based misperceptions. *Journal of Experimental Social Psychology, 38* (4), 384–396.

Robinson, Randall. (2000). *The debt: What America owes to blacks.* New York: Penguin.

Shipler, David. (1997). *A country of strangers: Blacks and whites in America.* New York: Knopf.

Steele, Claude & Joshua Aronson. (1995). Stereotype threat and intellectual test performance of African Americans. *Journal of Personality and Social Psychology, 69* (5), 797–811.

Van Ausdale, Debra & Joe Feagin. (2001). *The first R: How children learn race and racism.* New York: Rowman & Littlefield.

Wilson, Timothy. (2002). *Stranger to ourselves: Discovering the adaptive unconscious.* Cambridge, MA: Harvard University Press.

Yamato, Gloria. (1998). Something about the subject makes it hard to name. In Margaret L. Anderson & Patricia Hill Collins (Eds.), *Race, class and gender.* New York: Wadsworth.

Transforming Whiteness Through Poetry: Engaging THE Emotions AND Invoking THE Spirit

ERMA JEAN SIMS AND

VIRGINIA LEA

...the voice is powerful. Words mean more than what is set down on paper. It takes the human voice to infuse them with shades of deeper meaning.

—MAYA ANGELOU.

IN OUR WORK AS ANTIRACIST, CRITICAL MULTICULTURAL TEACHER EDUCATORS, WE TRY TO HELP OUR MOSTLY WHITE STUDENT TEACHERS BECOME ANTIRACIST, CRITICAL MULTICULTURAL PRACTITIONERS. WE HAVE FOUND THAT ONE OF THE MOST SIGNIFICANT BARRIERS TO THIS ENDEAVOR IS THE HEGEMONY OF WHITENESS. IN OUR VIEW, WHITENESS IS A CULTURAL AND SYMBOLIC PROCESS THAT LEADS TO WHITE SOCIOECONOMIC, POLITICAL, AND CULTURAL SUPREMACY. IN THE FIELD OF EDUCATION, WHITENESS HAS THE EFFECT OF REPRODUCING THE STATUS QUO IN WHICH LATINOS, AFRICAN AMERICANS, AND INDIGENOUS STUDENTS FIND THEMSELVES AT THE BOTTOM OF THE EXISTING MAINSTREAM INSTITUTIONAL HIERARCHIES.

USING POETRY TO IDENTIFY WHITENESS

According to Richardson (2004),

It is widely known that poetry is a powerful art form that evokes emotion, inspiration and even awe. The power that poetry has displayed over time and across cultures

speaks to a common need of the human heart and soul: the need to be inspired and the need for meaning...Poetry allows us to experience strong spiritual connections to things around us and to the past. The nature of poetry is that it can exalt, uplift and inspire whatever and whomever it touches. As such, it has much to teach us. (p. 1)

We have also found that poetry may be used as a powerful, educultural, counterhegemonic tool to interrupt whiteness. Poetry is a quintessential educultural device to open up our hearts, minds, and souls through language. Language is the most salient form of culture so although many poetic narratives aspire to universality, poetic forms are culturally embedded. In addition, not all poetic forms inspire us equally to feelings and action. Therefore, since our first goal in using poetry was to help our largely white student teachers recognize how whiteness impacts the lives of people of color and low-income people, we decided to use poetry developed by people from historically oppressed racial-ethnic backgrounds. The poems describe not only the pain these individuals have experienced around issues of race and whiteness, but also the meaning and uplift they have been able to find in these oppressive contexts.

Realizing our students' lack of background knowledge about whiteness hegemony, in preparation for this poetry activity we shared our definition of whiteness, used in the introduction to this book.

Whiteness is a complex, hegemonic, and dynamic set of mainstream socioeconomic processes, and ways of thinking, feeling, believing, and acting (cultural scripts) that function to obscure the power, privilege, and practices of the dominant social elite... Whiteness is in the air we breathe; it is in the mainstream waters of society in which we all, to a greater or lesser extent, swim [see Lea and Sims, Chapter 11 of this book]. It morphs to continue to disproportionately privilege white, propertied people. Whiteness also gives privilege to poor white people in relation to people of color. It enables those of us who find ourselves poor and white to feel good about ourselves in spite of the economic challenges we face by believing we have more merit than people of color. Many whites embrace a superior racial identity, reinforced by the corporate media and public school culture.

We structure this activity by placing students in random groups of four to examine one of six poems by people of color and poor people (see Appendix for the other five poems). In these small groups, our student teachers are asked to identify the ways in which race and whiteness have impacted the lives of the poets. They are also asked to engage the dualism that is so characteristic of their thinking processes—the black/white, good/bad dichotomies associated with the hegemony of whiteness. Our student teachers share their critique of the race and whiteness messages embedded in the poetry with their team members in an effort to deepen their analysis by "peeling back the layers of meaning" and reading the

world as well as the word (Freire, 1993/1970). Each small group then shares their poem and their analysis of the race and whiteness messages with the entire class and invites their classmates from other groups to provide their team with insights, questions, and comments about the poem in an effort to tease out more profound pronouncements about the poet's message. We have found that the depth of analysis hinges on the disproportionately white student teachers level of understanding about the hegemony of whiteness, and their willingness to accept racism as a real and ongoing personal and societal issue in the lives of people of color.

One of the poems that student teachers have found especially helpful in examining the hegemony of whiteness is a poem by Victoria Lena Manyarrows (1995), a Native/mestiza (Eastern Cherokee) woman. The poem is titled, *See No Indian, Hear No Indian*. The following is an extract from this poem:

> *it wasn't so long ago*, i tell you in a stream
> of broken words & suppressed anger,
> *when these lands were not occupied*
> *they were free*
> *and people lived in harmony*
>
> you tell me you don't
> want to hear it, you don't
> want to hear what i have to say
>
> *i tell you, what you are doing to me now is*
> *killing me*
> *negating our existence*
> *denying me our voice, our life*

This use of poetry as counterhegemonic practice is discussed in Linda Christensen's (2000) article, "Poetry, Reinventing the Past, Rehearsing the Future":

> History is the tale of the winners. Poetry helps students hear the rest of the story. What's untold? Students reinvent history by writing through a real or imagined character from the past, they live at least momentarily, the lives of the people they create, and by doing so they come to a greater understanding of the struggles those people engaged in. (Christensen, 2000, p. 129)

An analysis of the responses of our student teachers to the *See No Indian, Hear No Indian* poem has shown us that only a small percentage of them has really began to recognize the *power, process, and normalcy* of whiteness to kill and negate the existence of Native Americans in the United States. A brief synopsis of the "whiteness" messages that our students identified in this poem amounts to a generalization of

the cruelty that Native Americans experience at the hands of the white man, and how it is still going on today. However, this analysis lacks substance and complexity. When the students are asked to begin to look deeper at the whiteness messages in the poems, they begin to see the power of whiteness to deny and redefine the reality of Native Americans/Indigenous People. They hear the pain that Native American people feel when they are denied a "voice," and when their voices are not heard. They begin to see how whiteness makes Native Americans invisible and their claims to their lands nonexistent. Through our use of probing questions and definitions of whiteness, our student teachers recognize that whiteness hegemony has traditionally and currently viewed the Native American culture, language, and traditions as deficit and in need of elimination, annihilation, or assimilation into the white, dominant, cultural paradigm. The refusal of the white dominant culture to hear, to listen, to understand the plight of Native Americans is symbolic of the "entitlement" felt by whites in power over Native Americans/Indigenous People. We explain that whiteness hegemony, white privilege, and notions of white supremacy provide justifications for a sense of entitlement to define the situation, to open and close metaphorical doors, and to arrogant perceptions of reality.

As a result of our empathetic insistence, our students begin to gain sensitivity to the plight of Native American/Indigenous People. They begin to question their own assumptions, biases, stereotypical notions, and taken-for-granted realities. Our student teachers are asked to critique their own practice and begin developing a culturally sensitive and culturally relevant pedagogy that gives Native American/Indigenous people a "voice" in the curriculum. They begin challenging the misperceptions, omissions, outright lies, and inaccuracies that they find in their history textbooks and other forms of media. They claim and increasingly commit to giving their students the critical thinking skills that will allow them to challenge injustice and work for positive social change.

USING POETRY TO EXAMINE HOW WHITENESS IMPACTS OUR PUBLIC AND PRIVATE IDENTITIES

A second goal of using poetry is for student teachers to identify the ways in which they embody the narratives of cultural whiteness. This includes developing a consciousness as to how their teaching practices are driven by these narratives, and how these narratives are embedded in the practices mandated by the school, the school district, and/or the state. To engage in the above analysis, our student teachers need to have a clear understanding of who they are in the world. The "I AM POEM" is used to get our students to examine their personal, private selves and, in a postmodern sense, their multiple and invisible identities. Our

identities are situated in our practical lives, and our cultural scripts in the form of biases, assumptions, and taken-for-granted realities, are often hidden even from ourselves. We engage these cultural scripts in our poetic expressions—our attempts to catch our thoughts and feelings in words. Therefore, an examination of their poetry helps our student teachers begin to identify and connect with their biases, assumptions, and taken-for-granted realities, which is especially important as these same cultural scripts are driving their teaching practice.

Once they are in touch with the many "selves" that they potentially bring to their classrooms, student teachers are able to identify and critique the implications that the unexamined self might have on their teaching practices, assumptions, and expectations about their students, and their relationships with their students, parents, and the communities in which they live. The student teachers become increasingly aware of the need to do self-reflection, self-monitoring, and change, where appropriate, the racist, sexist, classist, homophobic, and ablest notions that they have that are likely to negatively impact their teaching and their students' learning process.

We share our own "I AM POEMS" with our student teachers to illustrate the "I AM POEM" educultural approach.

"I AM POEM"

By Erma Jean Sims

I am a truth seeker who chooses to shed light in dark places.
I am a Native American woman in black skin whose soul cries out to the ancestors for the wisdom of our people.
I am a mother who loves the unloved and cares for those long ago forgotten by a cruel and unforgiving world.
I am a child whose heart is full of gladness and sorrow.
I am the one who will feel the pain of hatred and oppression.

"I AM POEM"

By Virginia Lea

I am consciousness given creation by the people I have known and loved, and by the people who have loved me.
I am consciousness shamed by the people I have harmed and strengthened by the people who have harmed me.
I am Semite spirit, liberated by soul Africa, and uplifted by Gaelic inspiration.
I am the cruel and oppressive worlds I am a part of and the kind, egalitarian worlds for which I strive.
I am a long journey past and an even longer one ahead.
I am souls past and present, including Sylvia Payne's, our grandmother, a woman of substance!

Having shared our poems with our students, we invite our student teachers to write their own "I AM POEMS" and share them with each other in class. This sharing is followed by analysis of the messages that they hear in the poems. The poems are very revealing and illuminate the public, private, and hidden selves that we all embody. We have selected several "I AM POEMS" written by our student teachers to illustrate the insights that they have gained about themselves and the whiteness hegemony that they embody.

<div align="center">

"I AM POEM"

(Spring 2007: White female in her early 20s.)

</div>

I am privileged because my skin is white
I am powerful because I was born above the poverty line
I am fortunate because I speak the dominant language
I am normal because I am attracted to people of the opposite sex
I am marginalized because I am female
but
I am working to change that
and
I am going to make a difference

This poem was written by a student teacher who, at the beginning of the semester, responded to the project of identifying the hegemony of whiteness in the classroom with considerable resistance. She felt that the exercise was a condemnation of white people. After several weeks in which whiteness was addressed in a variety of layered approaches (videos, readings, dialogue, power point, classroom activities, culture shock experience), this student began to recognize that the course goal was not to make white people feel bad about themselves, but to interrogate the invisible systemic privileges that whiteness accords, disproportionately, to people categorized as white and, to some extent, people who embrace the cultural scripts of whiteness. Her poem reflects awareness of the categories to which she has been ascribed. She defines her race and class location as "privileged," her linguistic status as "fortunate," and her heterosexuality as "normal." She also names her positionality on the margins as a female—by its juxtaposition with her statement about her marginalization as a female, this is the reality that we understand she is clearly working to change. Her final declaration that she "is going to make a difference," leaves us with a question. Is she declaring a commitment to changing the systemic mechanisms that disadvantage so many of her students of color from low-income backgrounds, or is this commitment to transforming sexism? In terms of identifying and connecting with her biases, this student took a good look at the ambiguity of her final statement and asked herself what she was really saying about to whom she is making future commitments.

I AM ME POEM

(Spring 2007: Chinese-American male in his early 20s)

I am not yellow nor am I a chink.
You may not call me oriental.
You may not call me slanted eyes.
I am not a bad driver.
I do not know karate.
I am not related to Jackie Chan or Yao Ming.
I am not good at Math.
I am just me.
I am me.
I am your brother, your friend, and your classmate.
Refusing to be labeled and to be put in a category.
Working to break the stereotypes surrounding me.
I may be Chinese
But unique in my own way.
One who despises Math
Never been in a car accident.
Will have a fattening burgers and fries over some healthy rice.
Accept me for me
You will find that you are just like me.

This poem was written by a student teacher who, at the beginning of the semester, was caught in the matrix of whiteness hegemony, and was loathe to resist its imposition on his identity and behavior. Part of this imposition was a slew of insults, as well as the myth of the model minority.

By the end of the semester, this student's poem expresses a newly found resistance to whiteness at the same time as he is clearly still immersed in its waters ("Accept me for me, You will find that you are just like me."). The poem reflects the multiple individual identities that this student's journey has led to ("I am your brother, your friend, and your classmate. Refusing to be labeled and to be put in a category."). His is a complex declaration of the many positions within whiteness that he insists on occupying: one that is strongly individualist ("I am just me…I am unique in my own way"); one that unabashedly locates him in the mainstream, consumer-oriented corporate culture ("Will have a fattening burgers …") This poem leaves the reader with a question around this student's positionality with respect to his ethnic background ("Will have a fattening burgers and fries *over some healthy rice.*"). He may be showing a level of appreciation for his traditional Chinese culture but he also says: "I may be Chinese / But unique in my own way." This line of questioning will help the student to identify where he stands with respect to whiteness hegemony.

As a result of the poems, our student teachers have gained valuable insights into their own identities. Equipped with a better understanding of themselves,

our student teachers are then motivated to tap the "funds of knowledge" (Moll et al., 1992) that reside in their students' homes to gain greater insights into the culture, language, and worldviews of the children's families. In our 470 Multicultural Pedagogy class, our preservice teachers are also asked to participate in a mini Funds of Knowledge Project. The Funds of Knowledge Project is designed to help candidates across cultural borders, recognize the rich cultural resources that exist in cultural communities that they hitherto saw in more deficit terms, and to list cultural resources that could become the basis for learning plans and developing culturally relevant teaching practices. Our preservice teachers identify a family from a community to which they feel they do not belong, and about which they have little or only stereotypical knowledge.

This project is designed to give our preservice teachers insights into their own cultural scripts as well as the knowledge embedded in the communities to which their students belong. This knowledge can and should be the basis for learning experiences if we are to make school culturally relevant for all of our students. In fact, our student teachers use the funds of knowledge gleaned from their projects to develop and implement strong culturally relevant and responsive, social justice learning plans that are creative and engaging and value the knowledge, skills, and expertise that the children and their families bring to the classroom (Ladson-Billings, 1994). In addition, many of our student teachers have used "I AM POEMS" with their own students in public schools to allow the students to better understand themselves.

CONCLUSION

We have discovered from our use of poetry with our student teachers, the majority of whom are white, that poetry can be a powerful tool for teaching social justice and activism. As Ava McCall (2004) put it in her article, "Using Poetry in Social Studies Classes to Teach about Cultural Diversity and Social Justice":

> Poetry is a powerful resource in social studies methods classes. Poetry can often capture the attention of pre-service teacher and address controversial issues in a meaningful, less threatening manner. Poets frequently share their personal experiences with cultural diversity, racism, sexism, or classism in short potent phrases. Poems often affirm women and cultural groups that are less valued in our society, praise individuals who resist oppression, or portray the harm resulting from prejudicial comments or discriminatory actions. (p. 172)

Poetry is an effective tool for self-examination and critique and analysis of our public and private identities. The student-generated poetry reveals a great deal about the assumptions, biases, and taken-for-granted realities of our students and the

potential impact on their teaching practice and student outcomes. This new knowledge of self has aided our student teachers in developing a "pedagogy of empowerment" (Kincheloe & Steinberg, 2000) and a curriculum that is culturally relevant and responsive (Ladson-Billings, 1994) in their classrooms on the basis of the rich funds of knowledge that resides in the child's home and culture (Moll et al., 1992).

In conclusion, we found poetry to be a powerful teaching tool because it is open to interpretation by the reader or listener. Poetry that has been carefully selected for its messages about oppression, empowerment, and hope enables students to hear the authentic voices of oppressed people and their struggles to name and understand the motives and justifications given for colonization, oppression, apartheid, imperialism, and the harmful effect of these tactics on people of color and poor people worldwide. Poetry has the power to inspire people to social justice activism and positive social change. Poetry also has the power to open the mind, the heart, and the spirit to new creative endless possibilities for developing identities that are truly consonant with the ways in which we see ourselves in our struggles to develop a better world.

For all of these reasons and many more, we decided to use poetry as an educultural approach to enlighten our students and ourselves and give us insights into our own experiences and the experiences of others. We have utilized the power of poetry and language to provide meaning to our experiences, to transform our realities, and to teach for social justice and activism in our schools and classrooms. As educators, we can use the power of poetry to give hope and meaning to our students enabling them to take positive action for social justice and change. We were even more convinced of the transformative power of poetry to engage the emotions and invoke the spirit, and remain excited when our students share with us their enthusiasm for inspiring their own students to work for social justice in their own schools, classrooms, and communities. We are convinced that poetry is an effective educultural approach and teaching strategy that has the potential to undo whiteness in the classroom and learning communities.

APPENDIX

We have selected six poems that our students read and analyzed in pairs; comparing their interpretations and insights into the internal and external struggles experienced by people of color who are trying to understand and find meaning as they navigate through mainstream waters of whiteness and oppression. The students are asked to analyze each poem for its messages about race/racism, class, culture, gender, sexual orientation, and whiteness. We have included below a brief summary of five of the six poems that we asked our student teachers to analyze.

"When I was Growing Up" by Nellie Wong 1934

In this poem, the author explains, in poignant, elucidating, and picturesque language, that she now knows she once longed to be white. She clearly defines whiteness and whiteness cultural scripts as the norm and the harmful effects that efforts to assimilate and gain acceptance by the dominant culture can have on people of color. This poem provides our student teachers with a unique opportunity to understand the painful reality of internalized racism and oppression that is experienced by people of color as they try to navigate through the mainstream white culture and find meaning and a positive self-identity.

"Why Am I So Brown" by Trinidad Sanchez, Jr. for Raquel Guerrero

In this poem the author responds to a young Chicano girl's question, Why am I so brown? This is a question that children of color ask in the face of overwhelming images of whiteness as the standard of beauty and goodness and purity. Our students are able to discern that whiteness makes people of color question their own self-worth and feel inadequate in a society that does not value them. The beauty and strength of this poem is the very positive messages about being Chicano. The poem explains the beauty and historical significance of being Aztlan. The poem is designed to instill pride in Chicana girls and a love for themselves and their ancestors. The poem ends by saying, " Finally, mi'ja God made you brown because it is one of HER favorite colors.

"Two Women" by Anonymous

This poem was written by a working-class Chilean woman in 1973, shortly after Chile's socialist president, Salvador Allende, was overthrown. A U.S. missionary translated this work and brought it with her when she was forced to leave Chile. This is to be read by two people, one reading the bold-faced type, and one reading the regular type. The poem looks at the class and gender dimensions of whiteness. It exposes the ways in which the relationships of the two women are defined by whiteness cultural scripts, patriarchy, property rights, Marxian ideology of materialism, and the oppressive nature of a socioeconomic class system that insulates the ruling class from the harsh realities of the "Other."

"And When You Leave Take Your Pictures With You" by Jo Carrillo

The author points out that "Our white sisters—radical friends—love to own pictures of us" but they don't want to see the pain and suffering that women of

color worldwide experience from white domination and oppression. This kind of "Orientalism" is a form of Occidentalism (Said, 1979). Whiteness and whiteness cultural scripts allow whites to define the reality of the other people while not asking them to define themselves. Whiteness hegemony makes it possible to display women of color as "happy" with their situation and feel good about their false generosity.

"Trying to be Dyke and Chicana" by Natasha Lopez

In this poem, the author explains the conflict and tension that whiteness causes people of color when they feel pressured to choose between their own political and cultural identity and whiteness cultural scripts. Whiteness as an ideological script says that white women have the "lesbian lens" not women of color. The poem asks the question, "What do I call myself—Dyk-ana or Dyki-cana? Whiteness makes lesbian women of color feel their own "darkness" because they are seen as polluting an already bad recipe by combining Dyke (a race destroyer) with an inferior group (Chicanos.) The poem includes a heartfelt plea wishing that whiteness would understand the pain that this kind of oppression caused by cultural whiteness, racism, and homophobia.

REFERENCES

Christensen, L. (2000). Poetry, Reinventing the Past, Rehearsing the Future. In L. Christensen (Ed.), *Reading, Writing and Rising Up*. Milwaukee, WI: Rethinking Schools.

Freire, P. (1993/1970). *Pedagogy of the Oppressed*. New York: Continuum Publishing Co.

Kincheloe, J. & Steinberg, S. (2000). The Importance of Class in Multiculturalism. In J. Noel (Ed.), *Notable Selections in Multicultural Education*. Guildford, CN: Dushkin/McGraw Hill.

Ladson-Billings, G. (1994). *The Dreamkeepers: Successful Teachers of African American Children*. San Francisco, CA: Jossey-Bass.

Manyarrows, V. L. (1995). *Songs from Native Lands: Poetry*. San Francisco, CA: Nopal Press.

McCall, A. (2004, July). Using poetry in social studies classes to teach about cultural diversity and social justice. *Look Smart*. Available online: http://www.findarticles.com/p/articles.mi_hb3547/is_200407/ai_n13362544/print.

Moll, L. C., Amanti, C., Neff, D., & Gonzales, N. (1992, spring). Funds of Knowledge for Teachers: Using a Qualitative Approach to Connect Homes and Classrooms. *Theory into Practice* XXXI (2), 132–141.

Richardson, L. M. (2004). The transformational power of poetry: School leaders, like poets, are required to rise above the fray of everyday to inspire and encourage the human heart. *Look Smart*. Available online: http://www.findarticles.com/p/articles.mi_OHUL/is_4_33/ai_n6007481/print.

Said, Edward W. (1979). *Orientalism*. New York: Vintage Books.

Future Teachers AND Families Explore Humanization Through Chicana/o/Latina/o Children's Literature

ROSA FURUMOTO

Using Chicano/Latino children's literature to promote cultural awareness and humanization among children and families is very important to me personally, because I have lived through experiences where I felt isolated and left out of the curriculum because I couldn't understand the literature as a child. I have come to the understanding that in order for a Chicano/Latino child to succeed in the classroom, he or she must be able to connect to the literature presented in one way or another.

—JUDY HOLGUIN, UNIVERSITY STUDENT (2006)

INTRODUCTION

Chicano/Latino children's literature as an art form is at its most powerful when it stirs our emotions and creates recognition of our collective humanity and of our potential to create history. Born of social struggle, the themes, values, and storylines reflected in Chicano/Latino children's literature connect to the lives of poor and working-class children and families and create opportunities for dialogue

and social justice activism. The above epigraph by Judy Holguin (pseudonym), a California State University student enrolled in my upper-division Chicano/Latino children's literature course, Chicana/o Studies (CHS) 480, shares aspects of her childhood schooling experience and her new understanding about Chicano/Latino children's literature. Like nestled boxes, this chapter uncovers university students' stories and experiences that address oppression and marginalization, as well as resistance and hope. The chapter examines how CHS 480 students interrogated assumptions about what it means to work with families and children, and about how Chicano/Latino children's literature can serve as a tool for challenging whiteness. This chapter (1) defines key terms; (2) describes the project background and university students' demographics; (3) problematizes relevant theory; (4) describes the students' work with families; and (5) discusses conclusions and implications.

A DEFINITION OF CHICANO/LATINO CHILDREN'S LITERATURE

Chicano/Latino children's literature is defined here as pre-K through young adult literature written in English or in Spanish by U.S.-based authors raised within local and immigrant Chicano/Latino cultures. Contemporary Chicano/Latino children's literature was born during the period of the Chicana/o movement for social justice, peace, and educational equity (1960–1970) and fully blossomed during the 1990s through to this day. The modern giant of Latino children's literature is Alma Flor Ada, the prolific children's book author, scholar, professor, and promoter of Latino children's literature. Perhaps the most significant aspect of Ada's work has been her efforts to honor the stories and lives, language, and culture of all parents, especially marginalized, poor, and immigrant parents. Her efforts to incorporate the ideals of *Transformative Education* into classrooms and communities (Ada, 2003; Ada & Campoy, 2004) have inspired and informed the family literacy projects featured in this chapter.

PROJECT BACKGROUND

The literacy project that the CHS 480 students participated in was designed, developed, and implemented by Mexican American parent leaders (all women) from 2000 to 2006 as part of a comprehensive set of parent education projects that they developed with the support, coaching, and encouragement of project directors and resource teachers from two elementary schools (Furumoto, 2003). I served as a project director at one of the schools (1994–2001) and had established a close working relationship with parents as a bilingual (Spanish/English) teacher

(1983–1994) and a longtime community activist. The family literacy project grew from the parent leaders' success in leading numerous Family Math (Stenmark, Thompson, & Cossey, 1986) classes with Latina/o families since 1994 (Furumoto, 2003). The coaching process involved having parent leaders, teachers, and the project director identify students' academic needs and possible activities or lessons from the Family Math (Stenmark, Thompson, & Cossey, 1986) book that could address the students' needs. Parent leaders practiced these lessons with me and other parent leaders before actually presenting them to families. I would provide constructive feedback to the parent leaders in a supportive way. In this manner, over a period of two years, the parent leaders became very comfortable presenting Family Math classes and eventually took over the Family Math classes entirely and began training other parent leaders. The skills the parents learned from presenting Family Math were then applied to develop a variety of family literacy projects including the Parent Coaching Program (PCP) that is featured in this chapter.

The PCP employed a similar process of training, coaching, and providing feedback to prepare Latina/o parents to serve as parent coaches to implement literacy activities with families. The PCP employed culturally relevant, multicultural, and Chicano/Latino children's literature to promote a love of reading and to help families connect the themes and ideas in the literature with the families' lived experiences. The lessons and activities used in the PCP were developed together by the parent leaders, resource teachers, and project director. Many of the stories we used had mathematics or science themes or content that was also incorporated into the lessons. The PCP participants were all low-income Chicano/Latino families reflecting the demographics of their children's K-5 elementary schools that were 99% Latino and approximately 70% English language learners. The parent coaches visited the families of K-2nd grade students three to four times over several weeks to conduct literacy activities in their homes or community settings. Families engaged in discussions of the literary themes, creative art, writing, word games, and role-playing as a follow-up to the stories. Over the years, I wrote grants that provided funding for the project activities. Project funds from the funded grants were used to provide the families with high-quality literature books used in the project activities. The project was well received by participating families and resulted in an increased level of participation in their children's school activities and sharing books at home. Later, as a professor teaching Chicano/Latino children's literature, I wanted to engage my students, described in the following text, in interactions with Latina/o families and Chicano/Latino children's literature. Aided by discussions with the parent leaders who were coordinating these projects, we began to experiment with ways to include my students in the literacy projects that were ongoing in the Chicano/Latino community.

UNIVERSITY STUDENT DEMOGRAPHICS

The majority of students enrolled in CHS 480 during the last two years (2005–2006) were teacher candidates or in two cases practicing teachers (Year 1=75% and Year 2 =55%). The rest of the students were CHS majors with one CHS Masters (MA) candidate and one psychology major (see Table 4.1). Over the two years of the course, 95% of the students were of Chicana/o/Latina/o ethnic background with one white student who grew up in the local Latina/o community, was Spanish speaking and was quite comfortable interacting with Latina/os.

Almost all of the university students came from working-class families and many of the students and/or their parents were also immigrants. Of the 21 students, six or 28% had parents with degrees beyond high school. The students also worked from 20 to 40 hours per week and several were parents themselves. The university students had similar cultural, linguistic, and/or social class background as the children and families and this reality could help them to connect with families. However, despite their similarities with Chicano/Latino families, there were important differences. For example, the university students enjoyed the privilege of being college educated, English speaking, and were either born or naturalized U.S. citizens. These privileges along with their desire to successfully complete course requirements provided a potential for promoting whiteness, oppressive relations, and exploitation of the families. Whiteness, as used in this chapter, is conceptualized as oppressive attitudes, practices, and views of superiority that are manifested by persons of any race or ethnicity in positions of institutionalized authority over others. These attitudes, practices, and views of superiority are not neutral, however. They result in reproducing the disproportionate power and privilege of white, upper-, and upper-middle class people. Teachers, administrators, and other school personnel practice and manifest whiteness through their social interactions with students, parents, and others in the school community. Essed (2002)

Table 4.1. Majors and Career Goals of Students Enrolled in Chicano/Latino Children's Literature (2005–2006)

Year	Total # of Students	Future Teacher Candidates	Practicing Teachers	CHS Major Undergraduates	CHS Graduate (MA)	Psychology Major Undergraduates
1 (2005)	12	8	1	3	0	0
2 (2006)	9	4	1	2	1	1
Total (2005–06)	21	12	2	5	1	1

conceptualizes "everyday racism" as "the process of the system working through multiple relations and situations" (p. 189). One of the fundamental challenges in teacher education is how to interrogate and deconstruct whiteness and white privilege (Solomon et al., 2005) while simultaneously reimagining and practicing attitudes, skills, and behaviors that foster social justice and humanization in school communities. These concerns are problematized in the following discussion.

THEORETICAL FRAMEWORK

The family literacy project described here and university students' use of Chicano/ Latino children's literature to engage with families offer a terrain for an analysis and a deeper understanding of how to conceptualize whiteness to subvert it. Cross (2005) argues that teacher education students may actually learn racism through programs that do not interrogate "racism, power, and whiteness" (p. 265). For example, Cross (2005) notes how

> rhetoric about diversity and multiculturalism is often couched in how we are alike or how white teacher educators and students can explore others as cultural exotics, the racial other, or the object of study for their academic and professional benefit. (p. 265)

Sleeter and Montecinos (1999) argue that preservice teachers need opportunities to engage in "community-based learning projects that are structured around egalitarian partnerships" (partnership model versus dominator model of social interactions) (p. 114). One of the "assumptive frameworks" driving dominator models is that "deficiencies in students and families" are the cause of problems in schools and communities (Keith, 1996) as cited in (Sleeter & Montecinos, 1999, p. 121). A sample composite literacy program exemplifying dominator relationships may feature leadership and staff from white, wealthier areas; structure, programs, and materials that do not address African-American and Latino cultural empowerment; and a program that operates more for the convenience of staff than clients (Sleeter & Montecinos, 1999, pp. 126–127). In the present literacy project, the students' field experiences with Latina/o families held the potential to reproduce racism, oppression, and whiteness in the following ways.

Objectification

Latina/o families observed by students may tend to be objectified without full information about the social, cultural, and historical background and strengths of a family. This objectification may also include exoticizing families, which are not

part of the invisible white cultural norm, by focusing superficially on their food, music, or dances without interrogating the broader sociopolitical context of the families' lives. Another aspect of objectification is the direction of the observer's gaze. Teacher education field experiences that reproduce racism and white privilege do not problematize who is doing the gazing, the direction of the gaze, and how such activities may promote whiteness (Cross, 2005, p. 270). In the film *Rouch in Reverse,* (Diawara, 1995) we observe Rouch's complete inability to imagine himself, the privileged white anthropologist, as a subject that can be studied (observed) by the African subjects that he spent a lifetime observing. See Kaplan (1997) for more details on this. Similarly whites often do not "see" or problematize their privileges and practices as whites (Applebaum, 2005; Lipsitz, 2005; Marx, 2004).

Deficit View

There is a potential to view Latina/o families from the perspective of the white norm as the deficit "other" because some parents may lack formal education and the ability to speak English, and because they may be poor and/or working class. The whiteness paradigm tends to "pathologize" minority families (Solomon et al., 2005) and reify a deficit view of Latina/o families in particular (R. R. Valencia & Black, 2002; R. R. Valencia, 1997). Unfortunately, due to internalized oppression and learned self-hatred (Fanon, 1967; Memmi, 1965), the fact that a teacher candidate is of color does not automatically ensure that s/he will have the social consciousness and courage to resist internalizing such deficit views about poor and working people and/or people of color.

Promoting "Missionary" Zeal

University students may develop or deepen their sense of the "missionary" saving children and families of color through their activities with the families. The missionary view exemplifies whiteness, as the university student becomes the embodied agent of the colonial, white, racist society and schooling system attempting to teach the uncivilized persons of color how to become better by becoming like middle-class white people. Inherent in the "missionary" view is the idea that those you want to "save" are inferior and unequal to you and that you have the right to teach "them to be part of a system that oppresses them" (Giroux, 1997b, p. 302).

In contrast, the critical examination of the world pays attention to relations of power as well as to how values, norms, and ideas are produced and culturally mediated (Giroux, 1997a). Undoing whiteness engages people in critically examining

the world and acting to transform and liberate it (Freire, 1981, 2005). One of the consistent themes in the literature addresses how white teacher candidates' analysis and critique of whiteness tends to remain at an individual and superficial level instead of going deeper into the systemic manifestations of racism, whiteness, and power (Applebaum, 2005; Cross, 2005; Marx, 2004). The most fundamental issue is that education is never neutral (Freire, 1981, 2005) and that all the decisions a teacher makes reflect the beliefs and values of the teacher (Ada, 2003). Cadiero-Kaplan (2002) argues that teachers and teacher educators must interrogate their "beliefs about literacy and the curriculum materials and processes used and promoted in schools" (p. 372). Barrera (1992) argues for a critical and comprehensive examination that questions not only the materials used, but also the sociopolitical and cultural context of literature-based literacy instruction.

One of Freire's most important ideas is that common people, such as students, workers, and teachers, have the capacity to transform the world and make history. Praxis, one of the central tenets of critical pedagogy, refers to social action informed by reflection and critical ideas or theory (Darder, 1991). Lea (2004) employed a reflective cultural portfolio to support her students' increasing commitment to becoming critical multicultural educators. In my previous work with parent leaders in the community the three concurrent processes of reflection, social action, and engagement with critical ideas were found to be essential for supporting the parent leaders' evolving critical consciousness (Furumoto, 2003). Therefore, the Chicano/Latino children's literature course was conceptualized and designed to engage university students in praxis (critical ideas, social action, and reflection) to challenge whiteness and to promote authentic engagement with families. The following principles, informed by critical pedagogy, guided our work with children and families:

- Conceptualizing students, parents, and community members as equals with something valuable (Delgado-Gaitan, 2001; González, Moll, & Amanti, 2005; Rueda, Monzó, & Arzubiaga, 2003) to contribute to the education of their children and university students.
- Honoring the culture, traditions, and languages of diverse students and families through the selection and use of culturally relevant books (Ada & Campoy, 2004; Ada, 2003).
- Using popular education (Freire, 1981) strategies that engage families in constructing, understanding, and engaging in dialogue about literary themes versus banking education.
- Learning to critically analyze books and to use them for humanizing and liberatory purposes (Bishop, 1991; Escamilla & Nathenson-Mejía, 2003; Herrera-Sobek, 2002; Nathenson-Mejia & Escamilla, 2003)

In the following section, I describe the students' work with the parent leaders and the families.

PRAXIS: STUDENTS WORK WITH PARENT LEADERS AND FAMILIES

The CHS 480 course was designed to engage university students (with varying levels of privilege vis-à-vis their race, class, gender, immigration status, etc.) directly with Chicano/Latino families in homes and community settings to deepen students' understanding of the families' experiences and lives and to benefit the families by providing them with books and activities to support their children's literacy development. By situating interactions in homes and other community settings, families were more at ease and less inclined to feel threatened by the school and university as institutions. Going into homes and other spaces in which children and families feel more at ease is to position ourselves as the "other" and is part of the process of breaking down unequal social interactions that promote whiteness and privilege college students and professionals. The literacy project, as described earlier, was conceptualized, implemented, and run by working-class immigrant Latina parents from the local community for the benefit and convenience of families. This project was an example of a partnership model of service learning (Sleeter & Montecinos, 1999) because the parent leaders, professor, families, and students worked together for the mutual benefit of all.

I was concerned about students internalizing the idea that their activities were going to "save" the children and families. Middle-class white student as "savior" is inherent in the "missionary" view described earlier. This view, of course, is paired with the assumption of Latina/o families as deficient and in need of saving or conversion to white middle-class norms of behavior. To counter these ideas, before the home visits, I arranged for the students to meet and interact in the community with the Latina parent leaders who directed and implemented the literacy project. During these class meetings, the parent leaders modeled popular education strategies and activities that families might find engaging. Dinner and refreshments were provided for all, adding to the comfort and pleasure of these meetings. Once students had developed their literature-based lessons, they met with the parent leaders who provided feedback and suggestions to the students. The idea here was to break down some of the stereotypes of Latina/o parents as disempowered and uninterested in the education of children. In my work with the parent leaders, they reported that they felt very nervous about meeting the university students for the first time. They worried about their English and about how the students would react to them as they did not have a college education. The

students also expressed anxiety at this new experience. One student commented, "It was a helpful experience that they did not judge me at all for having broken Spanish."

Consistent with the notion of praxis, then, was to engage students in reflecting on their experiences with families and using their reflection to inform their activities and interactions with families. I based the students' reflective questions on a "Creative Dialogue" model developed for reading by Ada, (2003) and Ada and Campoy (2004). The "Creative Dialogue" model had four phases as follows:

Descriptive Phase: The students respond to the customary questions regarding a text such as "Who?, What?, When? Where?, How?, and Why?" (Ada, 2003, p. 85).

Personal Interpretive Phase: The students react to the text by expressing their feelings and emotions. Questions are designed to position the students as potential protagonists in similar situations to those of the characters in the literary text. At this stage the students should "compare and contrast the new information with what they already have" and juxtapose their experiences and reality with those of the characters' (Ada, 2003, p. 85).

Critical/Multicultural/Antibias Phase: Students engage in a critical analysis of the information they have collected to date and are encouraged to consider different potential outcomes. Possible questions such as these may be used: "What other possibilities exist? What would their consequences be? Who could benefit or suffer from each one?"

These reflections should have a goal of encouraging the students to learn about others and to develop understanding of and appreciation toward them as well as to build solidarity with members of other groups. (Ada, 2003, pp. 85–86)

Creative Transformative Phase: Ada (2003), describes this phase as one in which "students see a connection between their own lives and the thoughts and feelings to which the text has given rise and then consider taking actions and adopting attitudes that will enrich and improve their lives" (p. 86).

The following questions based on Ada's, (2003) and Ada's and Campoy's (2004) "Creative Dialogue" model were posed to students to engage them in reflecting on their experiences with the parent leaders:

- *Personal Interpretive Phase:* What was it like to interact with the parent leaders? How did you feel about interacting with them? Think about your

own parent(s)' or guardian(s)' interactions with your teachers and school. What was it like for them?

- *Critical/Multicultural/Antibias Phase:* Often Chicano/Latino parents are marginalized in schools and made to feel unwelcome. What are your thoughts about this practice?
- *Creative Transformative Phase:* How can teachers and schools be more welcoming to parents? What support might parents need to be more involved in their children's education?

The students' responses revealed the marginalization of their parents in the schools. One student commented, "I know that when my mother would go to my elementary or junior high school, she would not be treated like she was welcome, or like they were interested in helping her." Another student noted, "My parents' interaction with my teachers and schools was limited and poor ... Most of my teachers did not bother to have a translator in class, which made it harder for my mother to understand anything." Students also made many positive suggestions that schools could employ to help Latina/o parents feel more welcome and to meet their needs such as translators, childcare, and a more respectful attitude.

Students' interactions with parent leaders presented opportunities for them to facilitate greater parent involvement, and to experience the parents' potentially strong ability to support their children's education. The following is a student response to the *Personal Interpretive Phase* questions:

> Interacting with the parent leaders at the bookstore was a great experience for me. I was amazed to see how involved and dedicated these women were to the program despite having a busy schedule at home as parents. I enjoyed listening to their stories and interacting with them by sharing with them our *libro de dichos* (book of proverbs) and having dinner. (Silvia Gomez, 2006)

Silvia Gomez (pseudonym) noted the parent leaders' dedication and involvement and expressed her positive reaction to the experience. The *libro de dichos* (book of proverbs) was an activity modeled by the parent leaders in which students wrote down proverbs they recalled from their upbringing and then shared these with each other. The following comment by Alfredo Romero (pseudonym) suggests a strong sense of connection to the parent leaders as mothers:

> One of the mothers said something to us that I will never forget. She told us to always remember where we come from, and to never look down at anyone, regardless of what or who they appear to be. She felt that as a Latina mother, with low English skills, some teachers would treat her as if she wasn't even there ... but I will never forget because she reminded me of my mother... These women, like my mother, work as an affirmation that loving humans can change the world. (Alfredo Romero, 2005)

The students' comments both addressed the cultural knowledge shared by the parent leaders, that is, stories, proverbs, *consejos* (advice) offered about how to treat people, and the gracious sharing of food. Alfredo saw this particular mother as someone like his mother who could give him advice. This data suggests that as professors we should consider the compatibility of our teaching/learning practices with our students' schooling experiences, culture, values, and worldview.

One of the goals of the Chicano/Latino children's literature course was that students create a human connection to the children and families (Ada & Campoy, 2004) and to each other to establish a sense of community and mutual interdependence. To accomplish these goals, each student created a children's book that told about some aspect of their lives that they wanted to share with families and with each other. Many of the students' books were bilingual (Spanish and English). Some students created a story about their name, others told about the day they were born, or about their parents or ancestors. They first shared their stories in the university classroom and used these stories in their initial contacts with the families. Denisse Castellanos (real name) wrote a bilingual (English/Spanish) story titled, "The Day You Were Born"/*El Día Que Naciste Tu*. Her children's story addressed the universal theme of birth and of children's interest in knowing about the events surrounding their birth. Illustrated in beautiful black and white line drawings by Antonio Julio (real name), the story and pictures depict a Latina/o family coming together to rejoice in the birth of a child. This process of sharing their stories with families redirected the "gaze" from the students to families to go in the direction from families to students. By sharing some aspect of their personal lives and histories with a family, the student was made vulnerable to the family's perceptions, thereby fostering a human connection.

The students' visits with families in their homes helped them to understand more about the parents' deep concerns for their children's education, thereby countering the deficit view that Latina/o parents don't care about their children's education. The CHS 480 students developed a literature unit to be implemented with Chicano/Latino families. The guidelines for the children's literature unit were to use high-quality culturally relevant, age-appropriate Chicano/Latino children's literature books that were free of bias and stereotyping. The unit was to include three to four lessons based on two books that could be completed in the visits to the homes or community sites. Students were to develop their lessons to include interactive activities and "questions to initiate dialogue" from the course texts (Ada, 2003; Ada & Campoy, 2004, pp. 82–83).

Although most students chose to implement their lessons with an individual family, Martita Cruz (pseudonym), a student in my course, decided to implement her lessons with children at a nonprofit organization, Adelante (pseudonym), located in the dense downtown area of a large urban city. This organization served

as a learning site for children from a local public elementary school when the children were on vacation, and provided literacy instruction from 7:30 am to 12:00 noon. Martita had grown up in the area, attended that same elementary school, and volunteered twice a week at the organization. All of the children in Adelante were Latina/o, low income, and ranged in age from 7 to 11 years. Many of the children spoke Spanish as their first language and were English language learners.

Martita developed lessons based on the contemporary realistic bilingual picture book, *The Bakery Lady/La señora de la panadería* (Mora, 2001: see Appendix). She chose to use this book because the children were familiar with the *panadería* (bakery) in the neighborhood. This delightful story features Monica, a little girl who lives with her grandparents above their *panadería*. Monica wants to be a baker like her grandmother and also wants to find the small doll hidden in the Three Kings Bread so that she can host a party. This engaging story demonstrates the warmth, affection, and support of the family for each other and Monica's growing independence.

Martita developed several activities that could be implemented at the Adelante program's reading, writing, and art stations. She wore an apron to introduce the book and asked the children whether they had visited the local *panadería* and what they had observed there. She asked about bread and how many of them liked bread. The children didn't immediately classify tortillas as bread. However, Martita had brought a basket with a variety of different breads. They discussed where bread came from, the oldest type of bread, and how many of them had *pan con leche* (bread with milk) for breakfast. After reading the story, Martita engaged the children in a discussion about the story's characters, reactions to the story, and the author and illustrator. They discussed traditions such as Quinceñeras/15th Birthday Coming of Age Celebration, Three Kings Day/*El Día de los Reyes Magos*, Christmas, and stories such as "The Crying Woman"/*La Llorona*. Students created books shaped like *pan dulce* (sweet bread) in which students could respond to several writing prompts related to the story. Students could create their own recipes or write about their favorite family food. Other activities included baking and journaling. Martita also shared the story with parents during a parent visitation day to Adelante. She noted the students' and parents' reactions to the story:

> Reading to them literature from Pat Mora's book, *The Bakery Lady/La señora de la panadería*, showed how they loved knowing that they share common cultural ground with their classmates. Our class discussions became so much more enriched than when I read them, *The Seashore* by Charlotte Zorotow, because the story dealt with one of their most common daily experiences—going to the Central American bakery in the mornings with their moms. This learning experience was only one of the many

others that taught me how valuable a multicultural curriculum is to these students because it also helps them better communicate with their parents about their experiences in the classroom … They [the mothers] were all engaged with me in wanting to learn more about multicultural literature. The mothers in particular were eager to learn that there were books in the library that welcomed their culture because they were not aware of this.

Martita noted the children's enthusiasm for a story that they could connect with the cultural experiences that they shared with their classmates. One of the most powerful and important parts of using high-quality multicultural literature with children is allowing them to see themselves as part of the schooling and literacy process. Immigrant, poor, working-class, and diverse children are already receiving powerful messages in the school, community, media, and in books that who they are and the languages they speak are not accepted or valued (Henderson, 1991). High-quality Chicano/Latino children's literature, when used appropriately, challenges whiteness by helping children see themselves, their culture, and experiences as something worthwhile to examine, study, and celebrate.

While space does not permit descriptions of all the students' projects, their comments reveal how they viewed the parents that they visited. One student commented,

Just because a parent does not speak English does not mean they are not making an effort to learn or be involved in their child's education. The family I visited, the father worked full time and the mother went to school Monday through Thursday… Both the parent coach and parent of the child are very involved in their children's lives.

Most of the students commented on how the parents would ask them questions about how to help their children with reading or other subjects. The parents really wanted to know more about how to help their children. One of the students shared, "Some come up to me personally after my presentation, asking about what they can do to help their child read and write better." Judy Holguin (a CHS 480 student) observed this from her work with parents:

Through my observations I have learned that every parent wants the best for their children and they will do anything for them in order to succeed. The second thing I have learned is that the parent leaders know *a lot* about teaching children.

These direct experiences with families and children helped break down the stereotypes promoted in dominant society that Chicano/Latino parents don't care about their children's education. Instead, what students discovered in their work with Chicano/Latino families was a high degree of interest and desire to learn more about how to support their children's education.

CONCLUSION AND IMPLICATIONS

Praxis, the process of concurrently reflecting and engaging in activities and dialogue, pushes our social consciousness and the moral boundaries of our lives and work. This circular process emerged in the students' work with the families and with each other. The students began by creating their own children's stories and then accelerated rapidly to developing and implementing literature-based lesson with families. The process of the students writing a children's book provided them with insight into the creative process and validated their experiences. By implementing their lessons with families, they experienced their power to address social injustices and to initiate change. The students' use of culturally compatible bilingual (Spanish/English) Chicano/Latino children's literature challenged the narrative of English-only and white normativity by engaging families in literary themes connected to their lived experiences. The use of bilingual books honored the linguistic strengths of the families and invited them to participate with their children in the reading of the texts. Throughout this process, students were reflecting and applying their knowledge and understanding in deeper and more complex situations. Toward the end of the course, students were discussing and engaging with the sociopolitical contexts of literature and literacy instruction. This deepening of the students' critical consciousness was possible because the students had many carefully structured experiences, critical ideas, and reflective opportunities to inform their understanding. Even though the students worked very hard, the environment in class was very relaxed and the dialogue about our work and ideas facilitated our deepening social consciousness.

However, it is clear that the students walked into the classroom with the cultural capital necessary to work with the course materials and concepts, and with the families in the community. Their backgrounds as working-class Chicanos/Latinos have provided them with significant insights into the community and Chicano/Latino children's literary themes. The ability of all of the students to speak Spanish facilitated their interactions with the Spanish-speaking families. They experienced the potential of Chicano/Latino literature to help families recognize and celebrate their worth and strength as a people.

However, you don't have to be Chicano/Latino to develop this cultural capital. The one white student in my class already had a well-developed antiracist white identity before entering my classroom. I argue that all students need more opportunities to develop antiracist identities and to move from individualistic or superficial interpretations of information to the larger social, historical, and political context. Promoting the development of students' antiracist identities should include ample and repeated opportunities for students to interrogate the discourse of whiteness and white privilege and their systemic manifestations.

The students observed and experienced the Chicano/Latino parents' hunger for knowledge about schooling and how to help their children succeed. The parents were also eager to be involved in their child's schooling. These patterns suggest that schools can do a lot more to investigate parents' interests and tailor school support systems to address these. Understanding a family's strengths or "funds of knowledge" (Moll et al., 1992; Moll, González, & Amanti, 2005), allows the school to build on their capacity to support children's education. One of the important suggestions made by the students was to get to know the children and families earlier in the course so that students could select literature of specific interest to the families. The students' observations generated many questions that merit further investigation. For example, we need to pay more attention to the family's ways with language and literacy so that we may respond more appropriately to their needs and interests. What are the patterns of speech and interactions between family members and how are stories defined and told by them? How do families "do" literacy?

Parent leaders also demonstrated a form of cultural capital. Their extensive knowledge of multicultural literature, popular education strategies, and working with families provided the students with the support they needed for their lessons. These interactions turned the tables on the usual paradigm of the disempowered Latina/o parent. However, the parent leaders also had much to learn from the students as the students brought fresh and creative ideas for lessons and activities with families. Families' involvement in this project provided them with connections to the university, books, and ideas for supporting their child's education (cultural capital) that could be transformed into educational benefits for their children.

The findings from this course suggest that future teachers would benefit from more opportunities to interact directly with diverse families and children while employing multicultural literature. They need more firsthand experiences with Latina/o parents to refute dominant discourse and undo notions of whiteness about Latina/o parents' lack of interest in their child's education. However, the limitation is that these experiences must be carefully structured to create egalitarian two-way interactions, and not re-create inferior/superior social dynamics.

REFERENCES

Ada, A. F. (2003). *A magical encounter* (Second edition). Boston, MA: Pearson Allyn & Bacon.

Ada, A. F. & Campoy, F. I. (2004). *Authors in the classroom: A transformative education process*. Boston, MA: Pearson Allyn & Bacon.

Applebaum, B. (2005). In the name of morality: Moral responsibility, whiteness and social justice education. *Journal of Moral Education, 34* (3), 277–220.

Barrera, R. B. (1992). The cultural gap in literature-based literacy instruction. *Education and Urban Society, 24* (2), 227–243.

Bishop, R. S. (1991). Evaluating books by and about African-Americans. In M. V. Lindgren (Ed.), *The multicultural mirror* (pp. 31–44). Fort Atkinson, WI: Highsmith Press.

Cadiero-Kaplan, K. (2002). Literacy ideologies: Critically engaging the language arts curriculum. *Language Arts, 79* (5), 372–381.

Cross, B. E. (2005). New racism, reformed teacher education, and the same ole' oppression. *Educational Studies, 38* (3), 263–274.

Darder, A. (1991). *Culture and power in the classroom.* Westport, CT: Bergin & Garvey.

Delgado-Gaitan, C. (2001). *The power of community.* Lanham, MD: Rowman & Littlefield Publishers, Inc.

Diawara, M. (Writer). (1995). Rouch in reverse. In P. Vir (Producer). United States: California Newsreel 149, Ninth Street/420 San Francisco, CA 94103 newsreel@ix.netcom.com.

Escamilla, K., & Nathenson-Mejía, S. (2003). Preparing culturally responsive teachers: Using Latino children's literature in teacher education. *Equity and Excellence in Education, 36* (3), 238–248.

Essed, P. (2002). Everyday racism. In P. Essed & D. T. Goldberg (Eds.), *Race critical theories* (pp. 176–194). Malden, MA: Blackwell Publishers.

Fanon, F. (1967). *Black skin white masks.* New York: Grove Press.

Freire, P. (1981). *Education for critical consciousness* (M. B. Ramos, Trans.). New York: Continuum.

Freire, P. (2005). *Pedagogy of the oppressed.* New York: Continuum.

Furumoto, R. (2003). The roots of resistance: Cultivating critical parental involvement. *Amerasia Journal, 29* (2), 120–138.

Giroux, H. A. (1997a). *Pedagogy and the politics of hope.* Boulder, CO: Westview Press.

Giroux, H. A. (1997b). Racial politics and the pedagogy of whiteness. In M. Hill (Ed.), *Whiteness* (pp. 294–315). New York and London: New York University Press.

González, N., Moll, L. C., & Amanti, C. (Eds.). (2005). *Funds of knowledge.* Mahwah, NJ: Lawrence Erlbaum Associates.

Henderson, V. M. (1991). The development of self-esteem in children of color. In M. V. Lindgren (Ed.), *The multicultural mirror* (pp. 15–30). Fort Atkinson, WI: Highsmith Press.

Herrera-Sobek, M. (2002). Danger children at play: Patriarchal ideology and the construction of gender in Spanish-language Hispanic/Chicano children's songs and games. In N. E. Cantú & O. Nájera-Ramírez (Eds.), *Chicana traditions: Continuity and change* (pp. 81–99). Chicago: University of Illinois Press.

Kaplan, E. A. (1997). The "look" returned: Knowledge production and constructions of "whiteness" in Humanities scholarship and independent film. In M. Hill (Ed.), *Whiteness* (pp. 316–328). New York and London: New York University Press.

Lea, V. (2004). The reflective cultural portfolio: Identifying public cultural scripts in the private voices of white student teachers. *Journal of Teacher Education, 55* (2), 116–127.

Lipsitz, G. (2005). The possessive investment in whiteness. In P. S. Rothenberg (Ed.), *White privilege* (Second edition) (pp. 67–90). New York: Worth Publishers.

Marx, S. (2004). Exploring and challenging whiteness and white racism with white preservice teachers. In V. Lea & J. Helfand (Eds.), *Identifying race and transforming whiteness in the classroom* (pp. 132–152). New York: Peter Lang.

Memmi, A. (1965). *The colonizer and the colonized.* Boston, MA: Beacon Press.

Moll, L. C., Amanti, C., Neff, D., & Gonzalez, N. (1992). Funds of knowledge for teaching: Using a qualitative approach to connect homes and classrooms. *Theory into Practice, 31* (2), 132–141.

Moll, L. C., González, N., & Amanti, C. (Eds.). (2005). *Funds of knowledge*. Mahwah, NJ: Lawrence Erlbaum Associates.

Mora, P. (2001). *The bakery lady/La señora de la panadería*. Houston, TX: Piñata Books-Arte Público Press.

Nathenson-Mejia, S., & Escamilla, K. (2003). Connecting with Latino children: Bridging cultural gaps with children's literature. *Bilingual Research Journal, 27* (1), 101–116.

Rueda, R., Monzó, L. D., & Arzubiaga, A. (2003). Academic instrumental knowledge: Deconstructing cultural capital theory for strategic intervention approaches (Electronic Version). *Current Issues in Education*, 6, 1–12. Retrieved January 25, 2005, from http://cie.ed.asu.edu/volume6/number14.

Schon, I. (2003). Selecting high-quality books for Spanish-speaking children and adolescents. Retrieved January 15, 2005, from http://www.csusm.edu/campuscenters/csb/

Sleeter, C., & Montecinos, C. (1999). Forging partnerships for multicultural teacher education. In S. May (Ed.), *Critical multiculturalism* (pp. 113–137). London and Philadelphia: Falmer.

Solomon, R. P., Portelli, J. P., Daniel, B.-J., & Campbell, A. (2005). The discourse of denial: How white teacher candidates construct race, racism and "white privilege". *Race Ethnicity and Education, 8* (2), 147–169.

Stenmark, J. K., Thompson, V., & Cossey, R. (1986). *Family math*. Berkeley: University of California.

Valencia, R. R. (1997). Conceptualizing the notion of deficit thinking. In R. R. Valencia (Ed.), *The evolution of deficit thinking: Educational thought and practice* (pp. 1–12). Bristol, PA: Falmer.

Valencia, R. R., & Black, M. S. (2002). "Mexican Americans don't value education!"-On the basis of the myth, mythmaking, and debunking. *Journal of Latinos and Education, 1* (2), 81–103.

Polyrhythms
AS A Metaphor FOR Culture

BABATUNDE LEA
(WITH VIRGINIA LEA)

I am a Jazz musician and an educator. I play Jazz heavily influenced by the African Diaspora. I was born in Danville, Virginia, and raised, from three months old, in New York and New Jersey. One of my nine aunts was one of the first women to play drums in a marching band. That was in the 1940s. Since then I have pursued a career in the performing arts and the educational arena (Ixtlan, 2007).

As artistic and program director of the Educultural Foundation (2007), I have developed several educultural activities that harness the power of music to facilitate critical thinking about social and cultural issues in K-12 students, their teachers, student teachers, parents, and community activists. One of these activities is a hands-on rhythmic experience through which my students learn to recognize polyrhythms. I teach my students to play two rhythms that make up a polyrhythm. I demonstrate one rhythm to them and then ask them to try to play the rhythm along with me with their right hands (sounding out the rhythm on a desk or table top), while listening to each other. I repeat the exercise with the second rhythm of the polyrhythm, starting with the left hand. I then divide the room in half and ask one side to clap one of the rhythms and the other side to clap the second, at the same time. They fail. They try again, following my insistent lead. They get better. This part of the exercise is relatively easy for all participants.

I then ask them to play the first rhythm with their right hand while simulta-neously playing rhythm number two with the left hand, independently. I ask them to try starting with the right hand, then starting with the left hand. They all try, struggle, and fail. I then slow the process way down and just take several beats at a time (notes in the bar). I show them where their hands fall together and hit

separately. After several attempts, some of them get better. I ask them: "Was that difficult?" They reply, overwhelmingly, "Yes." I pursue this line of inquiry: "But was it getting easier?" "Yes." "And with practice do you think you could master it?" A little less certainty, but most of the students, volunteer a third, "Yes."

After a short break and a little deep breathing, I turn from music to words and metaphor. I describe the complex rhythms the students have tried to play: they are polyrhythms. I tell the students that to many people, those who have not studied the drums, the rhythms sound impossible to understand. This is an illusion because with lessons and study one can begin to understand. From the first experience in the womb, all human beings are exposed to polyrhythms. However, we are born into many varied cultural worlds with different cultural rhythms. Polyrhythms are intricately woven patterns, meeting at a central point called the "One." The "One" is the place at which the rhythms begin and intersect. The students appear to understand. I validate that finding the "One," as we have tried to do, is hard but if you want to find it enough, it can be found. It takes a concerted effort and motivation. It takes will and commitment.

That, of course, is the point of the activity. "Polyrhythms" can be seen as a metaphor for culture. In a pluralistic society like the United States, many cultures are arranged hierarchically, interrelating, jostling for recognition and space. The influence that one culture has on another can be documented. Finding out where these disparate cultures connect (like a polyrhythm) is an art. However, if we want to move toward a better understanding of social equity, we must find the "One"—the place at which different cultural expressions intersect.

While searching for the "one," we must develop a critique along the way so that we can understand when and why our efforts fail. Some of the rhythms, because of their innate differences are deemed more complicated and more powerful than others. This is an illusion that we must begin to see through. If there is any aspect of a polyrhythm that is wrong, then the whole rhythm is set askew. All must learn to understand and respect the other rhythmic components and their importance to the polyrhythm as a whole. It is finally driven home to my students that there exist road blocks that are physical, emotional, intellectual, cultural, economic, and political that will stop us from understanding the polyrhythms of culture. However, with the aforementioned, concerted will, we can come to a greater understanding and appreciation of any given cultural form. We must resist the forces that would have us find an easier way—hence, allowing us to reproduce inequities. We must develop agency.

In Afro-Cuban drumming, the key to the rhythm is called "Clave." The clave is an essential concept! Clave is the rhythm that sets all the other rhythms into their respective places, or I should say lets you know where each rhythm resides. In other words, different claves govern the interplay of rhythms. The clave starts

on the "One." In terms of culture, this clave would be akin to an economic system since the latter influences the nature of the cultural systems associated with it. Just as the clave of polyrhythms is essential to being able to make compelling and beautiful music, if we are going to create any kind of lasting equitable change in the world, we will have to develop an economic systemic clave that gives rise to equitable cultural expressions. Such a clave rhythm is essential to human beings being able to live in an equitable society. It helps people develop a deep and meaningful understanding of their own polyrhythms and how they connect with the polyrhythms of the world.

The hegemony of whiteness can prevent us from identifying an equitable clave and finding the "One." For me this hegemony involves the ideologies of individualism and entitlement. When these two ideologies are interwoven, egocentrism results and may extend to what I understand to be a peculiar American definition of freedom: "the right to be and do what I want." We live in a dominant culture in which public discourse tells us we are entitled to experience ongoing pleasure—not discomfort.

However, this thinking can be transformed. Human beings also have agency. They are culturally dynamic and always have the potential for change. Schools can support the development of discursive *communities* in which children learn to develop identities, relationships, and critical consciousness that enables them to see that they can work in solidarity with others to contribute to creating a more socially just and equitable society than we know at present. They can recognize that there are multiple ways of looking at social issues, and therefore multiple possible responses that serve different interests.

The *educultural* classroom requires that we, as teachers, see ourselves not as adults with a monopoly on the truth, "the way," or "the good life," but as educators positioned to assist young minds to become the critical democratic activists of the future. To be such a citizen, the individual must have a sense of solidarity with others across the cultural borders of the socially constructed categories of race, class, gender, sexual orientation, and ability. The teacher must model this sense of solidarity and help students make social and cultural connections by drawing on their intercultural experiences, wherever possible; the teacher helps her students to "read the world" (Freire, 1970/1993).

Educulturalism suggests that music can be a tool in the development of such citizens. Music is a creative process that can lead us into cultural spaces outside of our normal experience. In these spaces, the normal is disrupted: the frontiers between thought, feeling, and spirit can dissolve. Music can engage the passions and motivate us to become more creative. In this creative state, we are more likely to think critically about the social and cultural forces that influence us. With an enhanced sense of what is creatively possible, we are more likely to be able to

access cultural knowledge that has become "dysconscious" (King, 1991), relegated to a place below our consciousness because it makes us feel uncomfortable.

Music, then, can be a vehicle to greater knowledge of the social, cultural, political, and economic influences on our consciousness, feelings, and spirits. Through art, we may gain a sense of greater agency over our lives and our communities. We can develop awareness of ways to collaborate with others in the quest for greater equity in the world. In fact, the artistic mediums that we choose and the ways in which we express ourselves through these mediums indicate what is culturally relevant to us, and where our passions and identities lie. In our artistic expressions reside the "resources" that may be harnessed to construct meaningful academic ideas and socioeconomic community projects.

REFERENCES

Educultural Foundation. (2007). Available online: http://www/educulturalfoundation.org.

Freire, P. (1970/1993). *Pedagogy of the oppressed.* New York: Continuum Publishing Co.

Ixtlan. (2007). Available online: http://www.ixtlanartists.com & http://www.babatundelea.com.

King, Joyce. (1991). Dysconscious racism: Ideology, identity, and the miseducation of teachers. *Journal of Negro Education*, 60 (2), 1–14.

The Lessons We Learn FROM *Crash:* Using Hollywood Film IN THE Classroom

ROBERTA AHLQUIST AND
MARIE MILNER

It's the sense of touch Any real city you walk, you know. You brush past people, people bump into you. In LA nobody touches you, we're always behind metal and glass. I think we miss that sense of touch so much that sometimes we crash into each other just to feel something.

—Don Cheadle in Crash

Time is money. People are expendable. Speed-up is the accepted pace of life in urban centers. Alienation, fear, and isolation are on the rise. Fear and self-imposed numbing, amnesia, as a form of protection, keeps us from getting too close; keeps us from knowing each other "under the skin." The film *Crash* is driven by these daily realities. It explores the complexities and contradictions of racism, oppression, internalized oppression, and white privilege from multiple perspectives. The film addresses the fateful ways in which ordinary people from racially and economically diverse backgrounds accidentally crash into each other over a 36-hour period of time. *Crash* portrays peoples' attempts to live their lives evading racism and prejudice, yet trapped within the quagmire of both individual and institutional racism, against the white supremacist backdrop of Los Angeles, one of the most ethnically, culturally, and linguistically urban centers in the United States.

There are few heroes or heroines in this film. We are not provided with a historical context for how things got to the point the film addresses, nor are there any "quick fixes." Nonetheless, *Crash* makes us realize that we are in this world together, and if we want to thrive, and to understand and struggle against our racist contradictions, we need to solve these conflicts together. Some might argue that the storyline might justify or absolve whites of guilt, and that these ethnically diverse folks "do it to each other," and further, that the "divide and conquer" strategies of a brutal, competitive society leave the dominant power structure intact. The film does not address institutional racism; in fact, it mystifies it. Yet in this film everyone is culpable. Everyone is complicit. *Crash* is insightful in the ways in which it depicts our humanity in all of its depravity. Finally, with subtlety, *Crash* portrays our inherent dignity, while exposing our foibles, and our racist, sexist, and classist stereotypes and conditioning. It unveils our weaknesses, our capacity to be inhumane, while offering small glimpses of potential redemption.

THE ROLE OF THE DOMINANT MEDIA IN THE UNITED STATES

Dominant culture media is a powerful and, most often, negative force in today's society (Parenti, 2006). We are bombarded with destructive messages throughout childhood, and these images have shaped our views of "difference," of the Other, as part of our racist conditioning. We learn from the dominant media to accept racial, class, and language hierarchies in our socialization. The darker one's skin color, the lower the social class, the farther down on the ladder one is situated. This often means that the less one is legitimized or valued by the dominant white power structure, the less power one has and the more invisible one becomes. We must help students understand that these notions are not only ridiculous but they are also dangerous. Concomitantly, the homogenization of global media, especially television, video, and film, is effectively countering local as well as global attempts to teach children in the United States, and countries around the world, about their own unique cultures, languages, identities, and histories. Like other forms of dominant culture curriculum and resources, mainstream, "whitestream" media shapes and defines who and what is considered important (Berger, 1972; Chomsky, 1991; McChesney, 1999). Language also comes into play in these hierarchies. People with "standard English" are perceived as "more than" others who use non-standard English. Thus, cultural deficit theory continues to rear its ugly head.

Mainstream Eurocentric media contributes significantly to feeding our fears about "difference" by showing thousands of mainly negative, damaging, stereotypical, and racist views of people on the downside of power: poor people of color, new immigrants, poor whites, women, homosexuals, people with particular accents,

and with disabilities. These visual images, clichéd, simplistic, and superficial media bytes about those who are different from the white, male "norm," are stored both in our unconscious and conscious minds. These unconscious stereotypical and racialized associations are firmly etched into our brains, and these associations affect our impulses. The associations are often a quick "take" on a situation, especially when whites are faced with unexpected, uncomfortable, or stressful encounters with nonwhites. Yes, this also occurs between people of color. These impulses often reflect racist biases that are stored in our adaptive unconscious: one of two processing systems in our brain. Learning how to catch ourselves when these negative associations arise and to question them, to develop the ability to critique our unconscious responses, is a way of interrupting actions based on our racist stereotypes and reeducating ourselves against racism and other isms. This requires ongoing, self-critical analyses and reflection to counter our racist adaptive unconscious and retrain ourselves with self-aware, constructive interventions. Helping students understand these reactions, and to rethink the racist unconscious responses, may be a way to undo this conditioning (Gladwell, 2005). At the same time we must learn about the powerful role that dominant culture media plays in perpetuating negative, inaccurate, and racist unconscious associations, especially as the media is consolidated in fewer and fewer hands. We might heed veteran broadcast journalist Bill Moyers' caution, as keynote speaker at the January 2007 National Conference on Media Reform in Memphis, Tennessee. Besides announcing his return to the airwaves, he outlined his vision of media reform:

> As ownership gets more and more concentrated, fewer and fewer independent sources of information have survived in the market place, and those few significant alternatives that do survive, such as PBS and NPR, are undergoing financial and political pressure to reduce critical news content and to shift their focus in a mainstream direction, which means being more attentive to establishment views than to the bleak realities of powerlessness that shape the lives of ordinary people. (Moyers, 2007)

One long-term goal for students and teachers working against racism is to join the media reform movement to counter the proliferation of destructive stereotypes, especially of people of color, across the increasingly narrow band of dominant culture media. Another is to promote progressive alternative media.

CRASH SITUATED WITHIN WHITENESS AND POWER RELATIONS

We are all culpable of negative stereotypes, racism, and prejudice. Our lives have been bombarded with these in schooling and the media. To move forward requires that we unlock the silences, expose our unconscious racist conditioning, and begin

to talk about it. The framing of peoples' actions and inactions, humanity and inhumanity, set against the backdrop of white supremacy and globalization, is an unstated given. Those with power and privilege often have little idea about how their power shapes the lives of those on the downside of power. At the same time, those on the downside of power are frequently mystified about how power and privilege function to keep them in their presumed place. *Crash* is situated within this invisible norm of whiteness, where people of color and white people interact, interrupt, and sometimes confront the inequities and racism that are part of the social fabric of life under a competitive; "me, my and I" economic system, at this stage in our history.

Films such as *Outfoxed* (2004), *Independent Intervention, Breaking Silence* (2006), and *The Corporation* (2004) are useful to teach students about media power and the narrow range of points of view that most television channels portray. Most Hollywood films also stay within this narrow framework of white, male-dominant culture, depicting "small sins and happy endings," at best. *Crash*, in many ways, is not a traditional Hollywood film. We believe that this is why it is a useful and effective tool to engage prospective teachers, and college and high school students, in asking questions about how our racist conditioning has been shaped and what we can do to disrupt these preconceptions.

WHO WE ARE:

Roberta Ahlquist, Professor of Secondary Teacher Education, San Jose State University, San Jose, California

My family lived on the lower south and poor side of Great Falls, Montana, among working-class whites, a few black families who came to Great Falls via the military, a few Asians, mostly Filipino and Japanese. There was a small community of Native Americans, some of whom lived for a time on Hill 57. As a young child, I saw teepees with smoke floating out of the tops, on the hillsides overlooking the city. Yet I never heard any of my teachers talk about the genocide of these people. In school, Native Americans were invisible.

DeEtte, my best friend in elementary school, was a Native American. I first learned about racism when several "friends" pointed out that I must be an "Injun lover." In high school, I had another lesson in racism. My father told me "not to get too serious" with my Filipino-Japanese confidant Toby, who often picked me up for orchestra practice. Tobin (as he now prefers) was a year older, and on long nightly phone conversations, during our painful teenage years, we shared our deepest questions about the meaning of life. It was fine, my father said, if he was

a friend, "but he better not be your boyfriend." Tobin sensed that my father was a racist. As much as I semiconsciously tried to buffer him from my father's attitudes, I realized that he knew my father viewed him as "less than" equal to us. I later reflected that like many middle-American white parents, my father had had little contact with people of color, and had been fed typical stereotypes about "difference" that shaped his racist attitudes and beliefs.

Growing up east of the Continental Divide in "Big Sky" country Montana, in a provincial town of 55,000 people was an isolating experience because we were so protected from urban life and culture. Montana, over the past 60 years, has continued to be in a state of static depression or recession, as its economy has gone from mining to agribusiness and computer technology. For the most part, the industrial revolution passed Montana by. Great Falls has an air force base that brings a small number of people of color to a city with a homogenous white population and provides, aside from farming, the major business and service-based jobs. Within the state, there are two National Parks that support tourism. The Anaconda Copper Mines, once in Butte and Great Falls, are long gone; they were "out-sourced" to Chile in search of cheaper labor and less unionism in the 1960s. There are 12 different Native American tribes in Montana, and one of these, the Little Shell Peoples, is now landless.

I was baptized Catholic, even though my father was areligious. One condition of my parents' marriage was that my sister and I would be Catholic. Even though one of my high school debating friends, Naomi, was Jewish, neither she nor my teachers ever mentioned anything about the Holocaust or what it meant to be Jewish in a mainly Catholic and Protestant town. When I learned about the Holocaust in college, I was horrified and speechless. It was a taboo subject during my childhood and adolescence.

My parents were second-generation U.S. citizens; my mother's parents came from the Czech Republic, and my father's parents were from Turku, Finland. My parents spoke Czech and Finnish, respectively. Neither of my parents had more than a 6th grade education. Both were forced to work rather than attend school. I recall arguments about money, rationing cards, eating Spam, and being told often we were lucky that we had what we had. My mother became a sales clerk and a union member. My father became an apprentice to his coppersmith father, and later a sheet metal worker.

These experiences in childhood and adolescence shaped many of my views about race and racism. It has taken me years to peel back the layers of this socialization and engage in the lifelong process of unlearning my racism. Fortunately, I have some committed antiracist colleagues with whom I struggle in this process. If *Crash* had been available during my parents' lifetime, it might have helped them understand the myriad ways in which intolerance and racism is reproduced.

It might have ignited a conversation about skin color differences and what that meant for people who are not white in a white dominant society.

As a teacher educator at San Jose State University, I work to facilitate my prospective high school teachers' unlearning of our racist and other forms of oppressive behavior. Most prospective white teachers are unaware of their white privilege and racist conditioning. Nearly all of my students believe that they are not racist, and that being "colorblind" is a positive attribute. "We should treat all of our students *the same,*" is their routine politically correct mantra. Although San Jose is a multiethnic urban center in one of the most ethnically diverse states in the United States, until recently the majority of my students have been white. Over the past five years, the pool of prospective high school teachers has become more ethnically diverse, partly because teaching is increasingly more appealing to students of color. This is a wonderful change for the diverse students that they will serve. Now, students of color will have more role models who look and often speak as they do. So *Crash*, which fundamentally is about daily encounters with racism in the United States, where white supremacy, although still dominant, is now on the table for critique, is an important film to introduce to prospective teachers.

Marie Milner, English teacher at Andrew Hill High School, San Jose, California

Growing up in London, Ontario in Canada, I had never seen a person of color until I was about ten-years old. As a huge fan of Paul Haggis' film *Crash*, I was thrilled to discover that filmmaker Haggis was reared in London, Ontario as well.

I remember my father taking me to an A&W Root Beer fast food restaurant across the street from our tiny house in Canada when I was about eight-years old. We were not there to eat, but to pick up loose change in the parking lot, dropped from customer pockets. My father counseled me that parking lots in such places were a good place to look for money when one was desperate. We were picking up change to purchase groceries to see our family through the week until my father earned his paycheck from his working-class job in a horticultural nursery nearby.

I remember my parents being unable to make payments on the house in Canada, and so we moved to Sacramento, California, where they felt my father would be better able to make an actual living in his horticultural profession in a warmer climate. Ironically, when we arrived in California after a difficult three-day train trip, we discovered that the employer, who had sponsored my father as an immigrant to the United States, by supposedly providing him with work, was actually in the throes of bankruptcy. Consequently, my family had no income for several weeks after arriving in the United States with no savings at all.

Two years after our arrival in California, I was my father's primary caregiver, as he died a prolonged and painful death from lung cancer. My mother at that time and after my father's death supported us on a minimum wage salesclerk job. She had to declare bankruptcy after my father's death because of the insurmountable medical debt we had incurred. This was endlessly ironic to her because we had left the Canadian system of nationalized medicine behind, supposedly for more opportunities in the States.

Most of the students with whom I attended Mills High School were children of upper-middle-class backgrounds, and my sisters and I were in that small percentage of students who were ostracized for our lack of economic status. We had no cars in our family, but I watched privileged teens drive flashy sports cars to school each day. My mother taught my sisters and me how to shop for clothing at the local St. Vincent de Paul's thrift store, while my classmates continuously flaunted their new clothing around the school grounds.

The economic realities of my own life, when contrasted with the disparity of my classmates', have driven my own pedagogical philosophy and strategies. Countering class disparities and injustices along with racist ones has always been a large part of my classroom curriculum. As a white child being reared by a white Scots-Canadian mother and white British father, I do not recall ever seeing a person of color until I visited Toronto, a fairly cosmopolitan city even in the 1950s and 1960s. I recall feeling intrigued when I saw a black couple walking down the busy street in Canada's largest city. Even when I had immigrated to Northern California, and attended high school, I remember being teased because my closest friend was a Chinese-American girl named Wendy Wong, and she and her brother were the only nonwhites in my school with a student population of more than 1,700. This was in the late 1960s and early 1970s.

I now teach in the East Side Union High School District of San Jose, California, where the majority of my students are students of color. Similarly, Paul Haggis is living in ethnically and culturally diverse Los Angeles, California. I know my own life has been infinitely enriched by living and teaching in such a diverse environment, and clearly the wealth of experience drawn from contemporary Los Angeles informs Haggis' film *Crash*.

I teach in a school where only about 4% of the student population is white. I also work in a school that, at least on the surface, is relatively free of the kind of bias some might expect in such a culturally and linguistically diverse student body. Even so, I regularly observe students of color reacting negatively toward each other based on their ethnicity, religion, gender, sexual orientation, or race. Often, I read student pieces that reflect ignorance of their classmates' realities. *Crash* goes a long way toward addressing these myriad forms of ignorance and therefore, once again, makes the film an invaluable artistic tool for educators. Even with the

obstacles presented in showing an R-rated film in a public high school classroom, if a teacher can find a way to do so, students will surely benefit. *Crash* seems the quintessential film to provoke student discussion and instill awareness. The film is not going to solve all the ills of the world, but in the educational realm, it is a good way to raise consciousness.

Having immigrated to the United States and finding my family in more dire economic straits than we had been living while in Canada, I identify with some of the themes *Crash* explores regarding those on the downside of power. Although I was not a person of color or non-English speaker, because of my social class, and the linguistic differences between my classmates, and myself I was aware very early about what it means to be considered the Other.

USING HOLLYWOOD FILM IN THE CLASSROOM

Crash won the Academy Award for Best Picture in 2005. Some argue that it is too preachy, didactic, melodramatic, and stereotypical. Others claim that it is a caricature of race relations. Nevertheless, whatever the criticism, this is a film that gets to the heart. It elicits emotional responses, poses provocative questions, and requires contemplation about the future of race relations in the United States. Although the film is framed within the context of white privilege, the viewer cannot escape acknowledging that racist stereotypes are easily reproduced and acted upon across the entire spectrum of society in stressful, high-anxiety encounters. The film is comprised of a series of short vignettes, which are interwoven into the storyline. Coincidently, a more recent Hollywood film, *Babel* (2006), speaks to issues of racism and classism on a global level, and is a useful contrast to *Crash*.

Crash is useful in university preservice multicultural education courses, ethnic studies courses, sociology, history, counseling, high school English, and social science courses, among others, to better understand the insidious ways in which racism and prejudice are reproduced. We discuss specific vignettes from the film and offer structured ways in which the film can be deconstructed and critiqued, with the goal of challenging taken-for-granted assumptions about power, racism, and difference of all kinds within existing racial and social class hierarchies in society. Our hope is that we provide ways in which educators can disrupt preconceptions about race, privilege, ethnicity, and class in their own curriculum, address student responses, and critique the results of ongoing pedagogical interventions. We draw upon examples from the film to show how, within the framework of white supremacy, our racist-based fears have conscious and unconscious power over our lives, and that these perpetuate racism. Peeling back the layers of mystification about the Other is the first step.

The questions below relate to scenes we deemed to be particularly rich in encouraging discussion at both the high school and college level. They are not in any particular order because the film scenes are crosscut to emphasize the thematic connections in each of the stories.

The twin themes of abuse of power and powerlessness are portrayed in a scene between a black professional couple and two white police officers. One white police officer is overtly racist in his interaction with the couple, while the other, who perceives himself not to be a racist, acts appalled by the racist officer's actions. We posit some questions for students to consider for this particular scene.

In this scene, a black couple has been pulled over for presumably unsafe driving, and one of two white police officers frisks the woman in a sexual manner while the husband powerlessly observes.

- Why does the confrontation between the white officer and the black couple escalate so quickly?
- What does the woman mean when she says the officer pulled them over because he perceived her to be white?
- When the officer sexually molests the woman on the pretext of conducting a weapons search, what principle of power relations and authority is being exposed in the scene?
- Why does the screenwriter characterize this particular couple as well educated and upper class?
- The police officer presumably gets away with his exploitation of the woman. Why is this most likely the case?

Although the film does not address whiteness or privilege directly, the story is firmly grounded in the reality of white supremacy, from which all racial relations emanate in the United States; the people in power are white males. With a couple of significant exceptions (two white male police officers, portrayed as "bad cop, good cop," and the district attorney and his wife), the white characters in the film at some level disguise the invisible hierarchy of white power in the United States. This is the invisible "reign of whiteness." For example, the white police officer who complains to his black supervisor that he doesn't want to work with his white racist partner is told to forget his concerns, because even this black supervisor is complicit in maintaining the existing power structure. If he were to now acknowledge that this white officer under his supervision is racist, he would jeopardize his own job. He has little power over changing the white power structure under which we all function. The film begs the question of who is in control, who has

the power? But we aren't privy to the "powers that Be." The white male corporate elites behind the scenes remain unexposed.

The characters in this film are complex; at times they are victims while at other times they are heroes. *Crash*'s well-drawn characters provide a powerful reality to the viewer that makes the film especially resonant. In the manner in which power plays out, we are exposed to the contradictions in situations of perceived power, real power, and powerlessness. Ordinary life events place people of color and whites in daily collisions with one another as they live out their lives within the context of a highly charged, racist society. The following scene from the film addresses some of these themes.

> *Confrontation between a white male police officer and a black female insurance benefit administrator—In this scene, a white police officer challenges a black benefits administrator when she denies him coverage for a test for his ailing father. In response, he releases a racist tirade.*

Here are some questions we asked our students after discussing this vignette.

- Why is the white police officer so hostile to this black woman?
- Why does he respond so strongly and sarcastically to her first name?
- What negative impulses do his perceived powerlessness unleash?
- Why does the officer, in attempting to assert his power, merely demonstrate his own powerlessness?
- Who commands the power in this scene, and what are the several ways in which this is ironic?
- Why does the film include a scene in which this white police officer is seen dealing compassionately, but rather helplessly, with his ill and aging father?

OPPRESSION/INTERNALIZED OPPRESSION

Crash has many scenes that deal effectively with the notion of how oppression engenders internalized oppression (the mistaken belief that the stereotype is accurate or identifying with the oppressor). One such scene is the opening one in which a car accident has just occurred and an Asian woman hostilely confronts a Latina woman (whom we later learn is a police officer). The Asian woman accuses the Latina woman of being a poor driver and the Latina officer retaliates by mocking the Asian woman's accent.

> *Opening scene of the aftermath of a late night multiple car crash—The scene shows a conflict between two women, one Asian and one Latina, whose identities are as yet unknown.*

Here are some questions with which to engage students in this particular scene, and to reinforce the twin concepts of oppression and internalized oppression.

- Why does the Asian woman resort to ethnic slurs when confronting the Latina woman she perceives as being responsible for the crash?
- Why does this same character place blame on the Latina woman?
- Why is there ironic humor in an Asian woman accusing a Latina woman of being a poor driver, and, thus, what stereotype is addressed?
- Why does the female Latina police officer who, presumably has been trained to some extent in cultural and linguistic sensitivity, respond under stress by mocking the Asian woman's accent? How is this an example of the adaptive unconscious at work?
- What possible theme is illuminated when it is later revealed that this Latina police officer is having a sexual relationship with another police officer, a black man?

As this is a film about all of us, whether we are of color, or part of the invisible norm of "whiteness," it deftly chronicles what happens when we are extended past our limits. This is the appeal of the film to learn about how our conditioning shapes all of our interactions and reactions to "difference," and how this impacts people on the downside of power. Prospective teachers as well as students need to know their identities more deeply, in terms of ethnicity, culture, language, heritage, and ancestry, to better address the diverse and often multiple identities of their students. *Crash* often gets beyond the binaries of racism. It portrays myriad acts of racism and social injustice that may be conscious or unconscious. Finally, it provides examples of the content of one's "character" irrespective of the color of one's skin. Identity is a major focus of the vignettes in this film.

After a general discussion of the film, students are asked to write answers to the following questions:

Choose a character in the film with whom you most identify emotionally. Discuss their identities (race, class, gender) and the ways in which you are both like and different from this character.

- Why are you most drawn to this character?
- Are you identifying with someone like you or different from you?
- If different from you, describe your thoughts. How does it feel to make these comparisons?
- Did you feel comfortable addressing these similarities and differences? Why or why not?

- What have you learned about your public identity (how others see you), in contrast to your private identity (your interior view of yourself), and how might these identities contradict each other?

Many of our students identify with the white policeman who doesn't see himself as a racist. This is a good sign; they realize that all of us feel like we are the only person in the room who isn't racist, and then, at first unknowingly, but after reflection, we realize that we find ourselves acting in racist ways. Some white men identify with the white district attorney, who exposes, and as quickly "catches" his racist comments and attempts to retract them, made in a ploy for political expediency and survival. Other students choose the Latino locksmith, quietly doing his work, letting the racism roll off his back, the Sandra Bullock character, isolated and lonely and insensitive to her Latina nanny and house cleaner. Some students identify with the Persian man and his daughter. There is much to reflect on as students compare their behaviors with characters in the film. This set of questions has much potential for addressing our fears, our unconscious assumptions about who we are, and our identities in relation to others. These discussions better prepare prospective teachers to more deeply examine their racial and social class autobiographies.

EMOTIONS ARE DIFFICULT TO EVOKE

The film covers the gamut of emotional responses from fear, hatred, and alienation, to outrage, empathy, and love. Many students have a difficult time talking about feelings, especially fear, anger, guilt, and love. The question we ask students, with whom they most identify within the film, and why, is revealing. If they identify with the white cop who thinks he isn't racist, but under pressure, acts in a deadly racist way, we feel that they may have learned something about their own racism and their complicity in perpetuating it, as well as trying to challenge it. One would hope to do the right thing. This may be an indication that students realize how deeply our racism is embedded in our psyches and is manifest when in fearful, dangerous, or stressful situations. How do we overcome our programming? The film provides students with insights into their own racialized identities.

Here are some specific questions that students and teachers are asked regarding the vignette between the white policeman who picks up the black hitchhiker. This is a scene worthy of much discussion.

- What is going on in the vignette when the white policeman shoots the black hitchhiker?
- What is each of the characters feeling?

- What are some of the reasons for these feelings?
- Do you think that the white policeman might be acting on his unconscious racism?
- When thinking about this vignette, in what ways does it make us think about power and authority, and our relationship to authority figures?
- In what ways and why does the dominant culture power of whiteness shape the white policeman's behavior?
- Can you think of possible interventions, strategies, and ways to educate others and ourselves about these complex conflicts?

ILLUMINATING SOME IRONIES OF RACISM AND WHITE PRIVILEGE

As teachers, we are committed to teaching against white supremacy and for diversity: to affirm ethnicities, cultures, languages, and heritages, as assets, not deficits. We challenge assimilationist views that some people are "less than others" (i.e., Ruby Payne, a deficit theorist), and we hope to promote culturally responsive teaching. Until all people, and particularly teachers, are able to tap into their conscious and unconscious racism and privilege and struggle against it, they will continue to reproduce negative stereotypes and prejudices, and to act in racist ways. For example, in the film, when the white wife of the district attorney, after having been carjacked at gunpoint by two young black men, decides to replace the locks in her home, she exemplifies the reproduction of racist stereotypes. She assumes the young Latino male locksmith, who is replacing her locks, is a gang member who will return to further violate her safety. Students are asked to consider the following questions:

- Why would the white woman assume the Latino locksmith is a gang member and a threat to her personal safety?
- Why would the screenwriter assign this white woman a Latina housekeeper? What ironic role does this housekeeper play?
- Why is the white woman's home life later contrasted with that of the Latino locksmith who is depicted in a loving scene with his young daughter?
- Which of the three characters holds the power in this scene and why?

The challenge is to interrupt racist acts and replace stereotypes with accurate reflections of people of color in the media and in our curriculum. If we cannot do this, we cannot eradicate the racism and white privilege that exists deep within

our psyche; in our conscious and unconscious racist practices in schools and the larger society. Tackling institutional racism is the next step.

Working from a postcolonial and antiracist, unlearning privilege theoretical perspective, we seek to unravel, with our students, the racist preconceptions and contradictions of our unconscious conditioning: the ways in which they shape our views of difference, privilege, power, and identity that we have unconsciously or consciously learned from the major dominant culture institutions, including schooling and the media, and U.S. made film. We find this film helpful as one way to reflect more deeply on how to expose racism and eradicate these negative, inaccurate racial assumptions and practices living in the "belly of the beast," U.S. multiracial society.

> A single overmastering identity at the core of the academic enterprise, whether that identity be Western, African, or Asian, is a confinement, a deprivation. The world is made up of numerous identities interacting, sometimes harmoniously, sometimes antithetically. (Said, 1978)

One long-term assignment is to undertake both in and out-of-class activities that facilitate ways to understand and critique our own complex racial, class, and gender identities. Most white students claim that they do not really have a racial identity. Several related assignments, including interviews with students and parents of color create spaces for deeper reflection on how our views about difference have been shaped.

THE OBJECTIFICATION OF THE OTHER

We are living in times when the gap between rich and poor is growing immensely, and when the level of civility and humanity is on the decline. The film powerfully captures this alienation and isolation, and the resulting dehumanizing behavior. What are causes for this lack of concern for others? Why is there so much disrespect among people? Who are the authorities that young people acknowledge and respect? How can we teach and learn to be more humane? These questions for many students are turning points in deepening their understanding of their/our complex identities, and how difficult it is to get past our racist conditioning.

In one brief scene, an Asian man is seen exchanging money for an unspecified transaction, which is later revealed as the trafficking of Asian workers. In a final scene, we observe the young black carjacker, whose motives up to this point have been depicted as less than noble, releasing these Asian black market "slaves" onto the Los Angeles city streets.

Asian man selling Asians on black market/black man releasing Asians—In these two brief, but powerfully related scenes, the trafficking of humans is dramatized.

- Why does the screenwriter depict the man who is trafficking Asians as also being Asian?
- Why might the screenwriter have chosen to assign the role of their liberator to this particular character?

One student aptly summarized the power of racism; "these isms really inhibit our ability to have authentic relationships."

THE OVERWHELMING POWER OF WHITENESS

The next vignette shows the powerlessness of a professional black director when challenged by a white film producer regarding the producer's own racist stereotypes about a character in a television show.

Black Television Director/white Producer—In this scene, a white producer confronts a black director and demands he tell the black character to speak so-called black English.

- Why does the white producer insist that a black character will not be perceived as "black?"
- Why does the black television producer agree against his own better instincts to make the changes suggested by the white producer?

Once these questions are introduced and discussed, the teacher can assign to either individual students, pairs of students, or groups, scenes that the teacher wishes to employ as focal points in the film. The students could develop their own discussion questions for these scenes. These would then be used in a discussion format, preferably such as a Socratic Seminar, in which students are encouraged to participate thoughtfully, rather than resorting to facile or unsubstantiated statements. These types of questions would also lend themselves to written assignments including, but not limited to, formal essays, personal essays, short stories, short film or play scenes, and poetry. Several such questions might be

- Why does a perceived sense of powerlessness often drive people to engage in negative impulses, be they verbal or physical?
- Why would historically oppressed people resort to oppressing others?

- When people use racist, ethnic, or gender slurs, what are they hoping to accomplish?
- Why do human beings fear those they perceive as "other?"
- Why do many people feel they gain actual power by belittling others?
- What does one person hope to gain by taking another person's power away?
- How can we respect peoples' differences while still embracing our common humanity?

The above constitute some of the many questions that can be used to probe our deeper understandings of how the media, family socialization, and schooling contribute to our racialized identities and beliefs, and the contradictions between our attitudes about equity and social justice and the realities in terms of conflicting behaviors, especially when we are placed in high-anxiety life encounters.

REAL LIFE IMITATES ART

In 2006, two Hollywood celebrities, actor/director Mel Gibson and comic Michael Richards, unleashed bigoted tirades when placed in stressful situations. Gibson was being arrested for driving under the influence, and he shouted anti-Semitic slurs as the officers detained him. Michael Richards, of television *Seinfeld* fame, launched into a vile racist attack on a pair of black male hecklers in a Los Angeles comedy club, the Laugh Factory. In her essay response to Richards' outburst, Raina Kelley, a black writer with *Newsweek,* states the following,

> [...] Pop culture moments often provide us with opportunities to talk about things that don't otherwise get talked about outside think tanks or university seminars [...] Of course, it's scary to confront race. Beyond polite conversational conventions, we don't even have much of a shared vocabulary. It's a lot easier to learn the P.C. rules than confront any biases you might find within. (Kelley, *Newsweek,* 2006)

These incidents heighten the need to use works of art such as *Crash* to address the often unspoken prejudices and biases, which are embedded in our collective unconscious. Until we confront and examine these harmful and even dangerous issues, we "will *NOT* overcome" as the spiritual of old implores.

We believe the film's subversive nature lies in the fact that it does not reduce the nature of humanity's worst impulses to a simplistic equation. There are no single important characters in the film that are not portrayed as fully human in the sense that they are not rendered entirely good or bad. Perhaps this is the one element of the film that lifts it above the genre of parable. Thus, we see

ourselves. Any person who claims to have never harbored a prejudiced thought is simply lying to herself or himself. Any person who thinks s/he has been victimized by racism, sexism, or other prejudices, but has not participated in those same destructive impulses, is being either self-righteous or drinking heartily from the cup of denial.

APPENDIX

Additional Scenes with Related Questions for Teachers to Use

Once the major scenes have been examined, a culminating activity could be used in which the film's overall greater themes are addressed and related in a universal sense to the students' own experiences in the world.

One activity to begin the process of assessing how we "see" this film is the following:

> Students first write briefly, articulating their feelings as well as their ideas about the film, and listing any questions, feelings, and emotions that they have. This activity will help them determine if they can identify with any of the characters in the film and why.

These next two vignettes deal with the ironies inherent in two groups on the downside of power who embrace and act on the dominant culture stereotypes of each other.

Iranian/Daughter/buying a gun—In this scene, an elderly Iranian man, with his daughter, is seen buying a gun from a white middle-aged gun shop owner. The white man implies that the Persian man is an Arab terrorist and addresses him insultingly as "Osama." After suffering the indignation of such insult, this same Persian man assumes that a Latino locksmith, who is merely concerned about the Persian man's safety, is trying to take advantage of him financially.

- Why is the Iranian shop owner purchasing a gun?
- Why does the script depict the daughter as a fluent English speaker and highly educated? (We later learn she is a medical professional.)
- Why does the white gun shop owner become accusatory and offensive when the Iranian man speaks in Farsi to his daughter?
- What makes people uncomfortable when others speak in their presence in a language they don't understand?
- Does the daughter know she is buying blanks rather than live ammunition when she does so, and if so, why does she buy these?

- Why does the white shop owner assume the Iranian man is Arab rather than Persian?
- How is this misunderstanding later reflected in the vandalizing of the Iranian's shop?
- If the Iranian man had, in fact, been an Arab rather than Persian, why would the white shop owner hastily assume that he is a terrorist and address him insultingly as "Osama?"
- Who wields the power in this scene? Does the daughter have any particular power of her own?

Questions for the confrontation between Latino locksmith and the Persian shop owner:

- Why does the Iranian assume the locksmith is trying to take advantage of him when he is only trying to tell him that his door is defective and therefore insecure?
- Why does the screenwriter emphasize the Iranian shop owner's lack of English proficiency in this scene? What metaphoric and thematic statement is made vis-à-vis the misunderstanding that ensues as a result?
- What is ironic about the locksmith's concern for the Iranian's security as is evidenced in later scenes?
- Who commands the power in this scene? Is it possible that both men are exhibiting powerlessness in the scene?

REFERENCES

Babel. (2006). Dir. Alejandro Gonzalez Inarratu. Paramount. Classics.

Berger, J. (1972). *Ways of Seeing*. London, England: Penguin Books.

Chomsky, N. (1991) *Media Control.* Speech at MIT, March 17, Cambridge, MA.

The Corporation. (2004). Dir. Mark Ackbar & Jennifer Abbot. Zeitgeist Films.

Crash. (2005). Dir. Paul Haggis. Lion's Gate.

Gladwell, M. (2005). *Blink.* Little, Brown and Company, New York.

Kelley, R. (2006). Let's Talk About Race. *Newsweek,* December 4, pp. 42–43.

McChesney, Robert. (1999). *Rich Media, Poor Democracy: Communication Politics in Dubious Times.* Illinois: University of Illinois Press, Champaign-Urbana Press.

Moyers, B. (2007). Keynote address at the National Conference on Media Reform, January 12, Memphis, TN.

Outfoxed.(2004). Dir. Robert Greenwald. Cinema Libre Studio.

Parenti, M. (2006). *The Culture Struggle.* New York: Seven Stories Press.

Said, Edward. (1978). *Orientalism,* London: Routledge and Kegan Paul.

Schei, T. H., & Bee, D. (2006). *Independent Intervention, Breaking Silence.* DVD. Ground Productions. Portland, OR.

Destabilizing Whiteness AND Challenging THE Myth OF Canadian Multiculturalism: *THE Couple IN THE Cage* AND Educulturalism

KAREN MCGARRY

INTRODUCTION AND BACKGROUND

Every year, at the beginning of my first-year undergraduate "Introduction to Social Anthropology" class, I ask my students what images come to mind when I mention the word "anthropology." Most students have some problematic stereotypes about the discipline, and my question usually elicits romanticized responses informed by television, mainstream films, and popular magazines. Many initially equate anthropology with archaeology, and responses typically include "Indiana Jones," the study of "exotic" cultures, or the analysis of geographically distant, "primitive" peoples untouched by Western technology, and, by extension, time. Such images are the fuel for Western touristic discourses and mass media representations of the discipline. Indeed, unconsciously racist images are frequently popularized in publications such as *National Geographic* (Lutz & Collins, 1993), which often feature archaeological fieldwork, and on networks such as the Discovery Channel, which appeals to a white, Western nostalgia for authenticity and the exotic.

Such mediated, pop culture representations of anthropology are largely informed by perceptions of anthropology's past, rather than its present. In many

ways, my students are not entirely incorrect in presuming that anthropology has historically promoted images of the "exotic." Cultural anthropology (the cross-cultural study of human cultures throughout the world) has its roots in colonial curiosities about the nature of the "Other." With rare exceptions, most early cultural anthropologists were white, formally educated, upper-class males who studied small, geographically bounded communities in distant locales. In its formative years in the late 1800s, anthropology was closely intertwined with colonial projects, and many anthropologists studied indigenous peoples as guests of colonial administrators. Although several anthropologists fought for indigenous rights, many were simultaneously influenced by early, racist ideas of social evolution that positioned Western civilization as the pinnacle of human development (see, for example, Stocking, 1987). As such, their writings often did little to destabilize the widespread assumption at the time that non-Western peoples were technologically, socially, and culturally inferior.

Within the past century, however, anthropology has changed considerably. Anthropologists have developed a self-reflexive approach and have critically interrogated the colonial underpinnings of their discipline. Most no longer adhere to social evolutionary frameworks. They are just as likely to study themselves or groups "at home," and there is an increasing influx of scholars from diverse ethnic and social backgrounds. Issues of social identity—including critical explorations of race and "whiteness"—have also become central concerns of the discipline. Increasingly, anthropologists are concerned, among other things, with understanding how the predominantly white, Western cultural hegemony has historically represented other cultures. However, because of my students' early misconceptions about the nature and goals of anthropology, what they usually don't realize at first is that it is precisely the sorts of ethnocentric images embedded in this hegemony, and their problematic colonial legacy, that we will critically interrogate in our course.

Since mainstream discourses of race infiltrate and inform pedagogical practice (about half of the students in my course are typical preservice teachers), one goal in my class is to deconstruct such racialized images in various popular culture genres, including magazines and films. Ultimately, as I discuss in the following text, my course incorporates visual media to espouse a move beyond "tolerance," and toward the active affirmation, respect, and promotion of cultural difference (Nieto, 1992). In this way, my goals and the goals of many anthropologists converge with those of critical multicultural educators. Critical multicultural education seeks (among other things) to explore and critique how social, political, and cultural factors affect the learning and performance of students (Nieto, 1999). Moreover, like anthropology, it addresses the effects of the hegemony of whiteness within various educational systems, with an emphasis on how whiteness has (oftentimes unconsciously) affected the ways students learn and teachers teach.

I suggest here that anthropology can play an important role in disrupting students' stereotypes about various cultures, and in creating both culturally aware educators and students. In fact, educational anthropology has been an important subdiscipline of anthropology for at least the past 50 years. Many anthropologists, for example, have conducted ethnographic fieldwork to explore the influence of various pedagogical practices on the production of racialized identities within a wide variety of cross-cultural contexts (Abbas, 2005; Coe, 2003; Collard & Reynolds, 2005; Sinagatullin, 2005). Others are interested in how students construct identities within specific educational frameworks (e.g., Ogbu, 1974, 2003; Yon, 2001).

Despite its long history in anthropology, educational anthropology had never been a primary area of interest for me. Having grown up as a white, middle-class female within the multicultural context of metropolitan Toronto, I was always aware of the privileges my whiteness afforded me. Although I was never on the receiving end of racism, I witnessed many of my nonwhite friends endure both explicit and implicit racist behaviors, mostly in the form of racist remarks, despite the supposedly "tolerant," multicultural environment of Canada. When I went to graduate school, much of my research focused on issues of race and racism in Canadian society. In 2003, I completed my doctoral dissertation on nationalism, Olympic figure skaters, and issues of race, gender, sexuality, and ethnicity in Canadian sport. More broadly, I am interested in how mainstream ideas of whiteness, race, and nationalism inform various genres of performance arts. I stumbled upon educational anthropology through discussions about race with students, and through thinking about their responses to my questions about race.

My introductory course of 50 students at York University in Toronto often attracts large numbers of preservice student teachers as it counts as a supplementary "teachable" for them. Having only recently been introduced as a teachable subject in many programs, anthropology is currently taught in relatively few schools. In addition, because it is an elective course at the high school level, it is not consistently offered at schools that are short staffed, or where there is a shortage of teachers for mandatory core courses. Nevertheless, anthropology is a growing field at the high school level, and many of my student teachers go on to teach not only anthropology, but also related disciplines such as English, history, or geography.

Although most of my student teachers grew up in Toronto in multicultural environments, the majority are white. For many, this course will constitute their only academic experience of anthropology at university, and, possibly, their only critical interrogation of issues of race and identity. One goal of my course has been to disrupt many of their preconceived notions about race, whiteness hegemony, and multiculturalism within Canada by incorporating educultural learning

strategies through the use of film and visual imagery. It is my hope that many of my student teachers will be able to translate some of the ideas they learn to their own classrooms.

As nations like Canada become more ethnically diverse, there is a need for a better understanding of the roles that identities of race, class, gender, and whiteness play in education and their implications for teaching and learning. Educulturalism, as both a teaching practice and philosophy, aims to destabilize the official status of whiteness within educational systems, and, given education's role in enculturation, ultimately within the larger society. This often involves the use of music, performance arts, or other techniques. Later in this chapter, I discuss my own experiences surrounding the educational value of one particular film, *The Couple in the Cage* (1993), in talking about racial stereotypes in the classroom, and more broadly, in disrupting and demystifying conventional racist representations within Canadian multicultural discourses.

Most students in my course seem to think of overt racism as a "thing of the past." Part of this thinking is derived from their seemingly benevolent enculturation in school, through the Canadian media, and in official government discourses, which inform us that we are a nation of "multicultural heritage." The Canadian government, under the influence of Prime Minister Pierre Trudeau, implemented an official policy of multiculturalism in 1971. It was the first multicultural policy adopted by any nation-state, and it stressed that all cultures were equal under Canadian law, and that the nation must strive toward achieving cross-cultural understanding. Multiculturalism, Trudeau thought, would unite all Canadians across a geographically expansive landscape.

However, many scholars have argued that multiculturalism is a policy of tolerance rather than acceptance (Bannerji, 2001; Mackey, 2002), and that white hegemonic values and aesthetics pervade all aspects of Canadian society, including public school curricula. As such, as I argue, the discourse of multiculturalism has systematically erased racism from the collective historical memories of many Canadians, which allows for racism to persist.

THE MYTH OF CANADIAN MULTICULTURALISM

On the surface, Toronto, Canada's largest city, certainly looks like a cosmopolitan place. It possesses approximately 80 different ethnic groups speaking more than 100 languages. Furthermore, more than 40% of the city's inhabitants were born outside of Canada and, in 2004, Toronto attracted 236,000 immigrants (City of Toronto, 2005). The United Nations (2004) has even designated it as the most "ethnically diverse city" in the world.

However, this was not always the case. Despite the presence of indigenous cultures, Anglophone and Francophone cultures and languages dominated the cultural landscape until the middle of the twentieth century. This was owing to racist immigration laws that favored immigration from Europeans. For those minorities present within Canada, including Canada's various indigenous groups, the cultural hegemony of French and particularly English cultural values was assisted by ethnocentric practices of assimilation, drawing minority groups into an imagined dominant culture.

This process went largely unquestioned until 1971 when, spurred on by the civil rights movement and increasing opposition from minority groups, Canada instituted its first official policy of multiculturalism. In Canada, multiculturalism is frequently conceptualized as a "cultural mosaic"—the idea that the nation exists as a bricolage of discrete cultures, all with their own equally valued religious traditions, worldviews, and beliefs. Canada, in fact, has been internationally acclaimed for its multicultural policies that, many argue, promote tolerance and harmony among various groups. In comparison with the United States, with its "melting pot" philosophy, Canada is frequently hailed for its significantly lower levels of interracial violence and for promoting intercultural relations.

What I argue here is that one of Canada's national identity-markers—the discourse of multiculturalism—is problematic because, from my experiences of teaching (discussed later in the following section), it blinds student teachers to the lived realities of racism in Canadian society. When I begin to talk to my students about some of the problems with Canadian multiculturalism, I often elicit some hostile responses. After being socialized into the merits of multiculturalism within Canadian society through school and in the media, many simply urge me to look around the classroom and they point out the varied faces and backgrounds of students as an index of multiculturalism's success. As one white male student pointedly remarked to me, "See, we all get along. What's the problem? Maybe it's you." Another black female student proudly proclaimed that she was the first in her family to attend university, and that she never experienced racial or ethnic prejudice at York because, as she stated, "it's an environment where we're all so different anyway. It's not like there's a clear majority of any one colour of people. I think everyone understands that and appreciates it."

For many of these students, then, multiculturalism exists as a phenomenon in which the mere physical presence of ethnic and racial diversity in the classroom is tangible "proof" of the successes of the inclusive goals of Canadian multiculturalism. It is only when we progress in the course and explore such issues as the "erasure" of the voices of indigenous peoples in Canadian "history," that students begin to reevaluate multiculturalism. They begin to understand that a truly "multicultural" society is one that *actively* incorporates the cultural traditions and

values of various groups, rather than simply tolerating them. It is at this point where we begin to destabilize the myth of multiculturalism, and to explore the ways in which Canada's dominant culture of whiteness has impacted student perceptions of race.

Multiculturalism oftentimes privileges and valorizes whiteness in Canadian society (Henry & Tator, 2005; Mackey, 2002). Mackey (2002) argues that multiculturalism "implicitly constructs the idea of a core English-Canadian culture and that other cultures become 'multi-cultural' in relation to that unmarked, yet dominant, Anglo-Canadian core culture" (p. 2). In many ways, Canadian multicultural policies celebrate diversity and difference, but only through "controlling and managing it; difference is allowed, in defined and carefully limited ways" (Mackey, 2002, p. 148). Indeed, most theories of Canadian nationalism, as Huggins (1994, p. 56) suggests, are exclusionary, as they do not take into consideration the heterogeneous nature of Canadian society. They focus instead on the official form of nationalism promoted by the state and its legacy of primarily Anglophone and Francophone values. Canada's relatively high per capita immigration rates (in comparison with the United States) from non-European countries since the late 1960s have challenged the once-homogeneous structure of the Canadian population. This has resulted in a situation in which Canadians, "have extended the boundaries of their imagined community to *tolerate* difference" (Huggins, 1994, p. 56).

Indeed, race and ethnicity are defining features of a dominant Canadian identity. Bannerji (2001, p. 42) suggests that Canada's concept of hegemonic identity "does not reside in language, religion, or other aspects of culture, but rather in the European/North American physical origin—in the body colour of skin." Those outside this ideal of whiteness "are targets for assimilation or toleration" (Bannerji, 2001, p. 42). Mackey (2002, p. 19) notes that everyday Canadian discourse normalizes white Canadians as unmarked "Canadian-Canadians," which has led to the production of an official and dominant white Canadian culture over time. Multiculturalism is thus viewed by many as a process that accepts diversity only as far as it does not disrupt the overall political and cultural hegemony of white individuals of European descent. In the next section, I explore how such attitudes have infiltrated the discourses of my (predominantly white) student teachers.

THE EFFECTS OF MULTICULTURALISM ON STUDENT PERCEPTIONS OF RACE

As mentioned previously, many of my students perceive racism as a "thing of the past." As one student remarked in class, "racism seems like something you'd expect more from your grandfather. It's like from another generation, and not

so much a big part of ours." Although students openly decry overt displays of racism, they simultaneously and unconsciously reinforce the hegemony of whiteness within Canadian society. For example, one white, male student failed to see how the power dynamics in images in a 1950s edition of a *National Geographic* magazine were racist. The photographs depicted unclothed African men carrying a colonial administrator across a river on a chair in the 1920s. As my student claimed, "that's just how people thought then. It's the time period, you know. It's just a more primitive sort of culture and belief system." To my surprise, many other students nodded their heads in agreement. Most students perceived themselves as "tolerant" Canadians and as embracing multicultural values. However, even though students spoke openly and positively of the level of "freedom and equality" that should be afforded to different cultural and racial groups, they also frequently "Othered" nonwhite peoples and cultural traditions through the persistent and uncritical use of words such as "primitive," "exotic," and "unchanging." In other instances, as in my earlier example, I found that relatively few students thought that racism was a significant aspect of contemporary Canadian society.

Students' enculturation of multicultural values, it seems, has resulted in a form of "color blindness" (Henry & Tator, 2005). Henry and Tator (2005), for example, in their analysis of the convergences between discourses of race, multiculturalism, and Canadian nationalism, suggest that one of the most pervasive effects of multiculturalism in Canadian society is the prevalence of "color evasion" or color blindness. In various recent nationally reported incidents of race-based violence in the media, what tends to happen is that mainstream white Canadian society, "repeatedly refer to the fact that it is racial minorities who are obsessed with their racial identity and thereby implicitly asserting their own lack of racial identity" (Henry & Tator, 2005, p. 45). In fact, it is not uncommon for white individuals to presume that their bodies are unmarked by race. The privileged position afforded whiteness within multiculturalism has resulted in a situation in which some students view their own whiteness as an unmarked, normative category, and they are deeply unaware of the privileges that their whiteness affords them. For example, during a seminar discussion on the anthropology of race and ethnicity, I asked my students to (voluntarily) share some information about their own backgrounds. The first three students who raised their hands were born outside of Canada, but all immigrated to Canada with their families as children. They were quite happy to tell me about their family backgrounds, their perceptions of growing up within Canada, and how they felt that, for the most part, they were accepted into Canadian society. As the discussion progressed, I noticed that none of my white students (who represented the majority of students in my class) had shared anything about themselves. I asked Cynthia (all names here are changed), a white female student, if she would be willing to discuss her background. She said to me

that, "well, I guess I don't have as interesting a background. I was born here and grew up here. I'm just Canadian." At this point, Samantha, a black student born in Nigeria who had commented earlier about her experiences moving to Canada, piped in and said that, "yeah, she's a real Canadian." Although Samantha was herself a Canadian citizen, there was a strong perception that she was somehow "less Canadian" than Cynthia. In many ways, white students of Euro-Canadian ancestry were reticent to talk because of the assumption that their white bodies, as Mackey (2002) discussed earlier, belonged to the taken-for-granted, unmarked, and normative category of "Canadian-Canadian." White bodies, it seems, are rarely racialized in ways that those of color are, and they are often marked as "authentically Canadian." Particularly problematic with this assumption is that it implicitly marks nonwhite bodies as "Other," and as somehow outside mainstream Canadian discourses of nationhood, which results in hierarchies of a supposedly authentic "Canadianness." Such attitudes, which were prevalent among students, both white and nonwhite, at the beginning of my course, are unconsciously enculturated into students through various mainstream pedagogical practices.

Indeed, ideologies of whiteness are reinforced in Canadian students' high school curriculum, which has blinded many to the social injustices and lived realities of those who face racism on a daily basis. In Ontario high schools, for example, students learn a sanitized version of Canadian history that is often not conducive to critical thinking. In his review of Ontario's social sciences curriculum, Rezai-Rashti (2003) argues that 12th grade social science textbooks in use in the public school system—books contracted by the Ontario government—erase the nation's racial history to promote (albeit perhaps unconsciously) the "harmonious" mythology of multiculturalism. The textbooks' overviews of history, psychology, anthropology, and sociology promote racism, according to Rezai-Rashti (2003), as being a thing of the past, and they engage in little discussion of the complexities of race.

Mackey (2002) has noticed a similar phenomenon in the way in which Canadian history books discuss Anglophone and Francophone interactions with aboriginal communities. She discusses at length, for example, the problematic "Mountie Myth." In Canadian history and popular mythology, westward expansion is frequently discussed as a result of benevolent practices of the Royal Canadian Mounted Police (RCMP, or "Mounties"), who cultivated friendships with native peoples, and established relations on the basis of mutual understanding and cooperation. In contrast, American Western expansion is usually presented as a genocidal conquest of land and other resources. The content of Canadian history, so popular in the collective memories of Canadians, erases the assimilationist and racist historical practices of residential schooling in Canada as well as land rights abuses for indigenous peoples.

The result is that many Canadian students leave high school thinking of Canada as a tolerant place, and they possess an inadequate understanding of the complexities of race relations in Canadian society. This is exemplified in other studies of Ontario preservice teachers. For instance, Tara Goldstein (2001), a professor at University of Toronto, when teaching student teachers about issues of race in the classroom, discussed how confused her students were to have to name themselves as white. As she remarked: "No one had ever asked them to place themselves in a group on the basis of whiteness. No one had ever asked them to name themselves as white" (Goldstein, 2001, p. 4). Similarly, Brathwaite and Porfilio (2004) argued that the vast majority of their Ontario preservice teachers were unaware of various forms of inequalities, including racial inequality, in schools, and unaware of strategies to deal effectively with issues of race and racism.

How, then, as a teacher, is it possible to develop a sense of critical awareness about race and whiteness? In the following section, I offer my perspectives on one particular strategy that I incorporate into my anthropology class in an effort to "shock" students into the realization that race and racism are very much a part of contemporary Canadian society.

THE COUPLE IN THE CAGE, MIMETIC EXCESS, AND DISCOURSES OF OTHERING

A recent trend within teacher education has been to encourage critical thinking about race by introducing students to postcolonial theory (e.g., Tarc, 2005), a body of literature that explores the legacy of nineteenth-century European colonialism on former colonies and other subordinated populations. The *Journal of Postcolonial Education* was launched in 2002, for example, in an effort to share strategies for integrating critical theories of race and racism into the classroom. However, many educators have found that there is a strong disconnection between students' understandings of postcolonial theory and actual practice within the classroom (Brathwaite & Porfilio, 2004). This section of my chapter synthesizes anthropological theory with my experiences of teaching student teachers about racism to advocate the necessity of restoring what anthropologist Michael Taussig (1993) would refer to as a form of "contact sensuousness" to pedagogy. That is, by attempting to engage the senses when exploring issues of race and racism, students may develop a more tangible and palpable interpretation of race that "shocks" or awakens them to the daily realities of racism for minority groups. Central to such an approach is student engagement with visual imagery in the performance arts, and, as I discuss later, film can often play a central role in this endeavor.

According to anthropologist Allen Feldman (1994), it is difficult to communicate issues of racism and violence to an experientially distanced white audience that does not possess a visceral, bodily experience of it. Many white Westerners live in a state of what he calls "cultural anesthesia," which he defines as "the banishment of disconcerting, discordant, and anarchic sensory presences and agents that undermine the normalizing and often silent promises of everyday life" (1994, p. 405). Detached, Western "scientific" discourses, so prevalent within both the media as well as academia, are inappropriate, Feldman argues, for understanding the embodied nature of such things as pain or violence. In many instances, the West has deflected this embodied character of violence through the systematic erasure of senses. Feldman discusses, for instance, the early 1990s American media depictions of "Operation Desert Storm" during the Gulf War. He argues that the visual erasure of dead Arab bodies by mainstream media outlets, as well as the voices of opposition, and especially of suffering victims, contrasted with the hypervisual, realist imagery of American heroism such that "visual mastery of the campaign pushed all other sensory dimensions outside the perceptual terms of reference" (Feldman, 1994, p. 408). Ultimately, the hypervisuality of images of American "strength," partly invested in the overdetermined visual presence of American technological imagery, was heightened through the systematic erasure of suffering Arab bodies. This cultivated a sensorially deprived and detached spectator, and served to justify and/or condone the violence of the American state. To combat such complicity, it is necessary to restore a palpable self-reflexivity to our pedagogy to bridge the gap between various experiential chasms. A relatively new area of anthropology, sensorial anthropology (Geurts, 2002; Howes, 2003; Seremetakis, 1996; Stoller, 1989; Taussig, 1993), advocates the restoration of a sensorial approach to the study of culture, and in many ways, the performing arts can bridge this gap between theory and experience. Before elaborating upon this phenomenon, I discuss here one example of how I utilize the film, *The Couple in the Cage* (1993) to destabilize the "cultural anesthesia" of my students.

During the third week of my class, when we discuss racism in Euro-Canadian society, I ask students to engage in a discussion of the colonial roots of racism and the privileging of whiteness within Western society. Time constraints prevent us from integrating field trips into our class experience, and I therefore have to find other ways of "reaching students." As I discussed in my earlier *National Geographic* example, I begin by asking students to bring in images of nonwhite peoples that they find in different magazines, such as *National Geographic*. We begin with a discussion of how different groups of people are both visually and discursively represented in the magazines. For the vast majority of students, they feel that the simple inclusion of non-Western, nonwhite peoples within such Western magazines is itself an index of how our society has, in the words of one student,

"moved beyond racism." Students seemed quite unaware that many images of non-Western people in contemporary popular magazines tend to present nonwhite peoples as "primitive," "exotic," timeless, and static—all highly romanticized and nostalgic images that appeal to white, Western consumers, the primary readers of such magazines. Some students thought that I was being racist to even point out racial differences. I then asked them to write down key words to illustrate why they perceive themselves as nonracist. Some of their responses included "city-dwellers," "urban," "cosmopolitan," "used to being around all sorts of people," "not Canadian attitude." It became obvious to me, even after further debate, that discussions surrounding the visual imagery of the magazines did very little to foster any critical thinking. To interrogate such images, I had students watch a short, powerful film called *The Couple in the Cage*. Afterward, I had them to discuss it in groups, as well as submit written comments.

The Couple in the Cage: A Guatinaui Odyssey (1993) is a 30-minute film that addresses the colonial legacy of Orientalism, ethnocentrism, and racism within the West. Performance artists Coco Fusco and Paula Heredia are the film's creators and stars. The film was released to coincide with, and critique, the 500th anniversary celebration of Christopher Columbus' "discovery" of the Americas. It documents the worldwide tour of two representatives from an imaginary, "newly-discovered" aboriginal tribe from the nonexistent island of Guatinaui off the Yucatan peninsula in Mexico. Fusco and Heredia dress in stereotypical "indigenous" attire, and put themselves on display in a locked cage while performing a variety of outrageous, stereotypical acts that conform to Western assumptions about what "natives" do: eating bananas hand-fed to them by guards, walking from the cage on leashes, wearing hula skirts, and sewing together voodoo dolls. Interpreters at various locations, including major museums in New York, Chicago, Madrid, and Sydney tell onlookers that the couple is part of a newly discovered indigenous group. The goal of the performance piece is to critically examine the reactions of onlookers. What many people do not realize was that Columbus' age of exploration initiated a long period of exhibition of native peoples for public display. Colonialism, and its resulting cross-cultural contacts, was also the period during which museums, "freak shows," circuses, and sideshows proliferated. These practices were a part of an exhibitionary complex within the West, where the main attraction consisted of displaying the bodies and material culture of non-Western colonial "Others." Although the film was intended to be a satirical examination of this (ongoing) period of Western history, the filmmakers were surprised to learn that approximately 50% of onlookers believed that the indigenous peoples were real. Furthermore, the onlookers did not voice any objections to watching caged human beings. Ultimately, the film demonstrates that many of colonialism's most nefarious legacies—racism, ethnocentrism, and evolutionism—are still very much a part of white, Western culture.

I usually precede the film with an hour-long lecture that contextualizes it within the history of Western exhibitionary complexes, like circuses, museums, and world fairs, which exhibited indigenous peoples as evolutionary holdovers of a "primitive past." Although most students seem interested in this history, my description of indigenous abuses within such contexts usually generates little critical response from students. The film, however, converges with lecture material to generate an emotional response from students. Throughout the film, the images of Fusco and Heredia in a cage are juxtaposed with historical images of aboriginal peoples in cages from the 1800s and early 1900s. In our discussion after the film, some students are justifiably angry at the practice of putting people in cages and with the fact that many of the onlookers in the film were unphased by such a spectacle. Others were in disbelief that such a practice occurred, and one student this past year said that "I didn't get what you were talking about until now," and she started crying. The most interesting aspect of this experiment, however, is that many of the students were most upset with themselves for not "getting" the point of the film until it was finished (a point discussed in the following paragraph). After our discussion, I hand out a survey that asks students anonymously at what point they realized that the film was a hoax/satire, or a comment upon Western representations of "Others." In the film, this is not revealed to the audience until the very end. In 2004, 46% of students did not realize this until the end, and in 2005, it was 52% of students.

At our next class, I reveal the results of my survey to the students, and it is at this point that we discuss in greater depth the prevalence of evolutionary frameworks in contemporary society, including the persistence of racialized forms of thinking in the present, and the obvious "problems" with multiculturalism. If, as in the film, approximately 50% of students did not question the practice of putting people in cages, then what does this say about race relations/perceptions in Canadian society?

One thing that interests me, however, is why this film "works" in terms of raising awareness about racism. One reason, in my opinion, is that it is a film that elicits a highly visceral response, and many students become embarrassed by their emotions. This past year, two female students left the room temporarily, because they were crying. This raises an important point about the nature of Western forms of pedagogical practice. As O'Brien (2004, pp. 68–69) argues, "Disrupting whiteness involves making space for nondominant modes of interaction and behaviour." Indeed, in Western contexts, as Foucault (1979) discusses, students learn to discipline their bodies to create a docile body. In educational frameworks, a docile body is one that is attentive, obedient, and, for the most part, emotionally distant and, by extension, "objective." We need to recognize, however, as O'Brien (2004) points out, that such pedagogical ideals are peculiarly white,

Western, middle-class ways of knowing and learning. Ultimately, in my example of the film, it is the disruption of standard conventions of emotion, which opens a space for critical dialogue. As such, standard discursive strategies incorporated into classroom contexts, like lecturing, can only go so far in changing students' perceptions about race.

Students were also moved by the unsettling, emotional responses of many of the spectators viewing the caged couple. There is one instance where an American indigenous man begins to cry as he watches predominantly white Americans pay money to have their picture taken with the "authentic Guatinaui," and he remarks, "I can see my ancestors in that cage." In response to this, one student, in her written evaluation of the film, remarked that "it made me very emotional, and it made me recognize that our culture has not changed that much since the nineteenth century. It embarrasses me to think that, if I had seen the exhibit, I might have believed it was real."

The key for this film in decentering whiteness and heightening emotion lies in its power of mimesis. Mimesis, as described by Walter Benjamin, and elaborated upon by anthropologist Michael Taussig (1993), refers to the concept of mimicry, copying, or imitation. Taussig (1993) argues that one of the essential characteristics of mimesis is that the copy draws heavily upon, and often seeks to reproduce, the supposed authenticity, mystique, and power of the original. Of particular relevance is that mimetic reproduction involves not only imitation, but also a type of contact-sensuousness (Taussig, 1993, p. 220). To illustrate his point, he uses (among other examples) the example of police fingerprinting, which incorporates an element of close physical contact that is necessary to produce the copy. In many ways, as I address in the following text, the sensorial, mimetic displays in *The Couple in the Cage* function to destabilize the "cultural anaesthesia" of my students by encouraging emotional responses to the film's imagery.

To break through my students' "anaesthesia," the sense that is most targeted by the filmmakers to alter students' perceptions about race, and particularly to "undo" whiteness, is visuality. In fact, the film displays a satirical hypervisuality that is akin to what Taussig (1993) might describe as mimetic excess. This occurs when a piling up of visual or discursive signifiers occurs such that an "excess of signification" takes place. In many ways, Taussig's notion of hypervisuality and mimesis is akin to philosopher Judith Butler's (1993) notion of performativity, a concept she applies to understand how gender is a cultural construction. In the work of both theorists, an excessive visuality bordering on parody is at work. For example, Butler (1993) argues that gender is a performance and, like many other forms of identity, it is a learned behavior that is constantly "performed," or enacted, through attention to such things as dress, appearance, and demeanor. There are moments, however, when our

performances are excessive, or over-the-top. Think of the times when we mimic ideal gender stereotypes to an extreme—females in beauty contests, or males in professional wrestling, for instance. It is these hypervisual moments where gender categories are destabilized and revealed as cultural constructions. The excessive layering of visual signifiers of gendered identity, such as the overdone hair, makeup, and the frozen smiles of beauty pageant contestants reveal their artifice. We all know, after all, that most women do not naturally look like that! In the same way, *The Couple in the Cage* is replete with visual signifiers of excess, including ridiculous costumes, mannerisms, and speech that destabilize colonial ideas about "authenticity" and the exotic.

In their efforts to "mime" the widespread colonial practice of displaying indigenous peoples, the filmmakers, as discussed previously, make use of the visual technique of juxtaposition by contrasting their exhibition of supposedly "authentic" Guatinauis with photographs and early film clips of actual caged peoples. Of relevance here is that the mimetic replication of this colonial practice, while oftentimes "excessive," incorporates an effective strategy of hypervisuality to restore a sense of palpable, "contact sensuousness" that triggers a heightened emotional response from students, a point illustrated by earlier examples.

On another level, the film's imagery satirizes how the white majority presume supposedly authentic indigenous Guatinauis should act and "perform" their indigenous heritage. Usually for at least half of my students, the exaggerated visual displays of "indigenousness" ultimately reveal to them the ways in which racialized imagery of primitiveness and the "exotic" are the byproduct of a colonial, white heritage. One student, for example, after watching the film, remarked that "it's interesting because it's all so silly [the imagery] that it makes me realize that it's fake; this is all about how the West wants to see exotic peoples and places, and we just create them." Many other students saw some relevant present-day connections to the material. One very perceptive student, for instance, discussed how he had watched a Canadian documentary about Vancouver's successful bid for the 2010 Olympics. He mentioned how very stereotypical images of Canadian indigenous peoples were incorporated into Vancouver's promotional imagery, and how, in many instances, powerful religious Inuit iconography is decontextualized and made into images of pop culture, or as mascots for the games. At other times, exaggerated displays of "indigenousness," much like in the film, functioned to uphold and promote an inclusive sense of Canadian "tolerance" and multiculturalism as tangible proof of the success of Canada's cultural mosaic. Other students made connections between commercial interests at spectacles like the Olympics, and the promotion and representation of indigenous peoples. After much discussion, most students recognized that notions of ethnic and racial difference, so frequently promoted by the Canadian government as "national" images, are culturally constructed images

shaped in part by dominant (and usually white) stereotypes about what constitutes difference. This is an important realization for students to make, as awareness of the limitations of multicultural policies is a first step toward change.

Ironically, then, by tapping into the ocularcentrism that permeates Western forms of knowledge, truth production, and cultural expression (Howes, 2003); a critical space opens up for other sensorial ways of knowing. The hypervisuality of the film, and its "excessiveness" of detail and visual imagery, had a profound impact on many students, challenging them to reconsider many of their preliminary ideas about race. The imagery of the film served to "shock" many out of their "cultural anaesthesia" and to critique the privileged position afforded to whiteness in the production of representations of other cultures. Ultimately, the film demonstrated how mimesis in the performance arts could be integrated into the classroom to promote critical thinking about race.

SUMMARY

Despite the widespread exposure of students to differing cultural values, many students have syncretized dominant, white cultural ideals into their own identities (Brathwaite & Porfilio, 2003). This is fostered by a pervasive enculturation into the tenets of multiculturalism that privilege an aesthetics of whiteness. Government mandated school curriculum is one of the key agents of enculturation into the myth of multiculturalism. As Rezai-Rashti (2003) argues in his analysis of Ontario high school social sciences texts, multiculturalism achieves its salience and dominance through narratives of exclusion. Racism is often presented as something of the past, something to be forgotten, or, as in the Canadian "Mountie Myth" (Mackey, 2002), it is systematically erased from history. However, as Henry and Tator (2005) suggest, racism is still very much a lived reality for many Canadians of color.

In teaching my course, I felt a responsibility as an anthropologist to encourage my students to critically engage with latent racist assumptions within Canadian society. My classroom experiences illustrate that talking in theoretical terms about postcolonial theory is of limited value. Through an analysis of student reactions and discourses surrounding a class viewing of the film, *The Couple in the Cage* (1993), I have outlined how the use of imagery that incorporates elements of hypervisuality and mimesis can serve to disrupt conventional racist assumptions about non-Western cultures, and it functions as a starting point for a critique of racism and a decentering of the whiteness embedded in multiculturalism. Ultimately, it is hoped that these types of self-reflexive exercises will have a positive impact on student teachers, given their role in shaping future generations of high school students' perceptions of race within the context of the social sciences.

REFERENCES

Abbas, T. (2005). *Education of British South Asians: Ethnicity, Capital, and Class Structure.* New York: MacMillan.

Argueta, L., Fusco, C., and Heredia, P. (1993). *The Couple in the Cage: A Guatinaui Odyssey.* United States: Third World Newsreel.

Bannerji, H. (2001). *The Dark Side of the Nation: Essays on Multiculturalism, Nationalism, and Gender.* Toronto: Canadian Scholar's Press.

Brathwaite, F., & Porfilio, B. (2004). A School-Based Project: Increasing Ontario Pre-service Teacher Candidates' Experiences with Cultural Diversity. *Networks: On-line Journal for Teacher Research,* 7 (2). Retrieved January 5, 2006 from http://education.ucsc.edu/faculty/gwells/networks/journal/Vol.7(2).2004may/Porfilio.

Butler, J. (1993). *Bodies that Matter: On the Discursive Limits of Sex.* New York: Routledge.

City of Toronto. (2005). Annual Report on City Demographics and Statistics. Toronto life, 34 (5), 27.

Coe, C. (2003). *Dilemmas of Culture in African Schools: Youth, Nationalism, and the Transformation of Knowledge.* Chicago: University of Chicago Press.

Collard, J., & Reynolds, C. (2005). *Leadership, Gender, and Culture in Education: Male and Female Perspectives.* Maidenhead, England: Open University Press.

Feldman, A. (1994). On Cultural Anaesthesia: From Desert Storm to Rodney King. *American Ethnologist,* 21 (2), 404–418.

Foucault, M. (1979). *Discipline and Punish: The Birth of the Prison.* New York: Vintage.

Geurts, K. (2002). *Culture and the Senses: Bodily Ways of Knowing in an African Community.* Berkeley, CA: University of California Press.

Goldstein, T. (2001). I'm Not White: Anti-racist Teacher Education for Early Childhood Educators. *Contemporary Issues in Early Childhood,* 2 (1), 3–13.

Henry, F., & Tator, C. (2005). *The Color of Democracy: Racism in Canadian Society* (Third edition) Toronto: Thomson Nelson.

Howes, D. (2003). *Sensual Relations: Engaging the Senses in Culture and Social Theory.* Ann Arbor, MI: University of Michigan Press

Huggins, N. (1994). *Canadian Nationhood and the Identity Discourse: Incorporating Minority Ethnic Groups.* M.A. Thesis. Department of Political Science. Concordia University, Montreal, Quebec.

Lutz, C., & Collins, C. (1993). *Reading National Geographic.* Chicago: University of Chicago Press.

Mackey, E. (2002). *The House of Difference: Cultural Politics and National Identity in Canada.* Toronto: University of Toronto Press.

Nieto, S. (1992). *Affirming Diversity: The Sociopolitical Context of Multicultural Education.* White Plains, NY: Longman.

———. (1999). Critical multicultural education and students' perspectives. In S. May (Ed.), *Critical multiculturalism: Rethinking multicultural and antiracist education* (pp. 191–215). London: Falmer Press.

O'Brien, E. (2004). "I Could Hear You If You Would Just Calm Down": Challenging Eurocentric Classroom Norms Through Passionate Discussions of Racial Oppression. In V. Lea & J. Helfand (Eds.), *Identifying Race and Transforming Whiteness in the Classroom* (pp. 68–86). New York: Peter Lang.

Ogbu, J. (1974). *The Next Generation: An Ethnography of Education in an Urban Neighborhood.* New York: Academic Press.

————. (2003). *Black American Students in an Affluent Suburb: A Study of Academic Disengagement*. Mahwah, NJ: Erlbaum Associates.

Rezai-Rashti, G. M. (2003). *Race, Culture, Equity and the Ontario Curriculum: A Critical Investigation of the Social Sciences Curriculum*. Toronto: Ontario Ministry of Education.

Seremetakis, N. (1996). *The Senses Still: Perception and Memory as Material Culture in Modernity*. Chicago: University of Chicago Press.

Sinagatullin, I. (2005). *Constructing Multicultural Education in a Diverse Society*. Lanham, MD: Scarecrow Press.

Stocking, G. (1987). *Victorian Anthropology*. New York: Free Press.

Stoller, P. (1989). *The Taste of Ethnographic Things: The Senses in Anthropology*. Philadelphia: University of Pennsylvania Press.

Tarc, A. M. (2005). Education as Humanism of the Other. *Educational Philosophy and Theory*, 37 (6), 833–850.

Taussig, M. (1993). *Mimesis and Alterity: A Particular History of the Senses*. New York: Routledge.

Yon, D. (2001). *Elusive Culture: Schooling, Race, and Identity in Global Times*. Albany: State University of New York Press.

Black Women's Theater
FROM THE Global South AND THE Interplay OF Whiteness AND Americanness IN AN Appalachian Classroom

DENISE HUGHES-TAFEN

My purpose in this chapter is to discuss how theater in the classroom can be instrumental in creating critical dialogue on Otherness, whiteness, and Americanness. I present research that utilized the theater of black women from the Global South as an instrument for examining these notions among students attending an Upward Bound Summer Program in Appalachian Ohio. I use the term Global South to refer to countries located outside the industrially and technologically developed countries of Europe and the United States of America even if they are geographically located in the Northern Hemisphere. There are limitations in using the terms Global North and South since as Aubrey (2003) points out the terms Global North and South do not accurately depict the conditions that exist both between countries and within countries since "there exists a significant North within the Global South and a significant South within the Global North" (p. 2).

The students who participated in this research are examples of this "significant South within the Global North." They were considered at "risk" because they were from low-income families, would be first generation college students, and some had been historically disadvantaged owing to race. Most of the students were from areas of rural Appalachian Ohio and were white; the other students

were from an urban region of Ohio, black and attended an Afrocentric school. These two groups of students are often marginalized. The reasons for their marginalization are complex since causes of oppression are often interlocked and it is difficult to identify one single cause. Most literature on the subject, however, points to social and economic class as being the prominent cause of white Appalachians' oppression, and race as the prominent cause of the oppression of African Americans (Bell, 1992; Coats, 1996; Delgado, 1995; Ladson-Billings, 1998; Lewis, 1991; Malcolm X, 1964; Newitz & Wray, 1997).

Socially these groups of students constitute the "Other" in America. Whiteness and Americanness or lack thereof, account in part, for their Otherness. In addressing the invented category of the white race, Garvey and Ignatiev (1997) state,

> the [W]hite race is a club that enrolls certain people at birth, without their consent and brings them up according to its rules. For the most part its members go through life accepting the privileges of membership but without reflecting on the cost. (pp. 346–347)

McIntosh (1998) refers to these privileges as white privileges. She describes it as an "invisible weightless knapsack" that whites carry around, but are taught not to recognize (McIntosh, 1998). Due to white privilege, whites participate in racism, a system of advantage based on race by using their skin color for their own benefit (Tatum, 1997). In so doing people who are not white are at a disadvantage.

Although all whites participate in white privilege, the category white is not homogenous any more than the category of color (Omi & Winant, 1998). Within the category of whiteness, there are divisions of ethnicity, gender, and economics. Within the U.S. society white Appalachians as a group are viewed as ignorant, backward, and dirty by the dominant sectors of American society, and labeled with derogatory terms such as "hillbilly," "cracker," "redneck," and "white trash." These are all terms used in labeling the white "Other" (Newitz & Wray, 1997). White Appalachians as a group enjoy some privileges but at the same time, their economic status prevents them from enjoying full benefits. Their degree of privilege is not static and changes depending on the presence of other marginalized groups, particularly blacks. This is explained more fully by Toni Morrison in an interview with the *Times* magazine:

> Black people have always been used as a buffer in this country between powers to prevent class war, to prevent other kinds of real conflagrations. If there were no black people here in this country, it would have been Balkanized. The immigrants would have torn each other's throats out, as they have done everywhere else. But in becoming an American, from Europe, what one has in common with that other immigrant

is contempt for me—it's nothing else but color. Wherever they were from, they would stand together. They could all say, "'I am not that. '"So in that sense, becoming an American is based on an attitude: an exclusion of me. (Angelo, 1989, p. 120)

As Morrison explains, blackness is used as a measuring stick in assessing privileged and delineating who is American and who is not. Whiteness then becomes a marker for degree of Americanness. Ralph Ellison adds to this when he tells us that African Americans have never been considered American enough. He says that they have been used as a marker, "a metaphor for the 'outsider'. . . . Perhaps this is why one of the first epithets that many European immigrants learned when they got off the boat was the term 'nigger'—it made them feel instantly American" (Ellison, 1970, p. 161). Both Morrison and Ellison pinpoint the interrelationship between whiteness and Americanness.

My research is linked to John Gaventa's question regarding the relations of groups on the margins. With reference to Appalachia he questions, "As we acknowledge the importance of multiple diverse identities within the region, how do we link to those who also self identify as being 'voices from the margins and living on the fringe' in other regions elsewhere?" (2002, p. 87). Gaventa points to the aftermath of the September 11, 2001 bombing of the World Trade Center and Pentagon and the U.S. declaration of war on Afghanistan and further interrogates:

Does our Appalachian identity get overruled by a nationalistic identity that waves the flag and supports American power unquestionably against people in other parts of the world, many of whom perceive themselves to be on the fringe of power as well? Or do we try to understand the reasons for those perceptions of marginalization and to search for a common ground based on common problems? (2002, p. 87)

Gaventa probes whether one's Americanness prevents one from connecting with others worldwide. His questions are to Appalachians but these questions are applicable to other groups who are also on the margins. In this research, I examine whiteness, Americanness, the interrelation between both and how these factors interact in determining how students relate to other marginalized groups.

THE PROCESS

My interest in this area of research arose because of my experiences; I am from the Caribbean island of Antigua, but I had the opportunity to spend some time in Ghana (West Africa) and Appalachian Ohio (United States of America). After recognizing the economic development, historical and social similarities

between these areas, a journey of inquiry into the educational ramifications of my observations resulted. I began to question the way students learned about people from other places, particularly black women from the Global South, the category to which I belong. I also began questioning whether the boxes (North, South, West, First World, etc.) used in academia, though they may serve to simplify things, might, in some cases, actually prevent students from seeing the overall picture and the interconnectivity of their world.

It became especially clear that these questions were worth further investigation after the events of September 11, 2001. It became obvious to me that people need to be aware of their larger world, connections, their responsibilities, and contributions to the global sphere. This was reflected in a special report issue of *Rethinking Schools* titled "War, Terrorism and our Classrooms." The articles of this edition shared ways in which classrooms can help students grasp the significance of September 11 by being creative, critical, and reflective. September 11 demonstrated even more the need for meaningful global education and the need to access connectivity or what Sidorkin (1999) describes as Buber's "interhuman." The interhuman refers to what goes on between humans, the relations between people, which is in essence what life is all about. However, by centering European culture and history in classroom spaces, schools have reinforced whiteness, white privilege, Americanness that has led to Othering.

The above led me to become focused on examining how education can be more effective in establishing interconnectivity and critical dialogue in classroom spaces and on how the use of theater in education can be one way of achieving this. I was also interested in exploring the related factors that prevent interconnectivity and critical dialogue from happening. Theater is an appropriate choice to help in answering these questions because black women from the Global South have used this art as a medium for voicing and resistance. I explored it as a tool to be used in an Appalachian classroom because of its educational value in active learning and empowerment, and because of its usefulness in establishing connections, dialogue, and relations (Eisner, 2002; Grady, 2002).

My research is best described as Performative Inquiry.[1] Through performance, Performative Inquiry investigates the creative actions and interactions that take place in performance spaces. In the case of my research, the performance space was created in my classroom hence linking Performative Inquiry and classroom action research.[2] Performance Inquiry can take many forms. For my research, the focus was on the process. This is known as a process drama approach. Emphasis was on the stages the students went through as they prepared their play. Process drama allowed the learners to interact and create the world through their bodies and mind (Heathcote & Bolton, 1995; Kao & O'Neill, 1998; Moody, 2002; O'Neill, 1995).

In my research, students prepared and performed plays authored by black women from the Global South. I was the theater instructor for the Summer Phase of the Upward Bound program and assisting me was Betty, an African-American woman. She assisted me by leading some of the class activities and by contributing observations. My research followed the methodology used in "Rewriting gendered scripts" (Thomson & Wood, 1998) in which students were involved in the process of reading and performing the original script and then recreating, performing, and finally debriefing the process. Similarly, in the present research students went through the process of reading, performing, rescripting, and creating their own plays and then presenting a final performance.

Students were divided into four groups and each group was given one of the four plays to study and reenact before the class. The plays used were

1. *Living Positively* (Bulbulia, 2001)
2. *A Coloured Place* (Conning, 1998)
3. *A Black Woman's Tale* (Small, 1997)
4. *Voices from the Ghetto* (Des Vignes, 2002)

These plays were chosen because of their testimonial nature, their woman focus, the themes addressed deal with issues of gender, race, and class that can be applied internationally, and because these plays were by black women from the Global South.

Living Positively was developed first as a video documentary and then as a theatrical production that looked primarily at women living with HIV/AIDS in different parts of Africa. *A Colored Place* was written by South African Lueen Conning, and it examines the problems of being "Colored"[3] in South African society. In this play Conning (1998) examines the misplacement of the colored person owing to South Africa's system of Apartheid and the identity crises suffered by colored people living in that country. Jean Small's *A Black Woman's Tale*, tells the story of black women from a Caribbean perspective. Using language, Small examines the identity of Caribbean women from different islands. *Voices from the Ghetto* is a Calypso and through the form of music, image, and storytelling, Singing Sandra paints a vivid picture of life in ghetto areas of the Caribbean.

As part of this approach students read and prepared for their enactments. They recorded their process and their feelings and thoughts in their journals. As a way of helping students make connections between themselves and the plays they were studying, prompts were sometimes provided as an aid to their journaling. In addition, students created monologues that involved dialoguing either with the character they portrayed for their reenactment or one of the characters from the other plays. This was done while preparing the reenactment of the plays. I also

interviewed students midway through the process and again at the end of the process to gain insights into students' experiences and also to ensure that students' voices were included in the research. Once students had studied and reenacted the plays by women from the Global South, they then created their own play based on the other plays they studied in class and class discussions. In the following sections, I describe how the theater of black women from the Global South provided an avenue to examine whiteness and Americanness and the interrelatedness of these factors and their impact in affecting students' ability to form dialogic relations with others.

THE JOURNEY

As stated earlier, the process drama approach places an emphasis on the critical dialogical preparation stages that actors go through to arrive at a production. As an introduction to the lives of black women from the Caribbean and Africa, a class period in the Upward Bound Program Theater class was devoted to understanding some of the history and social makeup of the Caribbean and Africa. The class was limited to generalities rather than specifics. The low-income, marginalized, black and white students had been recording in their journals their perceptions of African and Caribbean peoples. For one of their journal entries I asked the students to record the images that came to mind when they thought of Africa and the Caribbean. Here I present some examples of students' responses:

- When I hear of the word Caribbean I think of beaches, tropical fruits, islands, and palm trees.
- Tourism.
- Drugs.
- Reggae.
- How Stella got her Grove back.
- Happy people.

With reference to Africa, students wrote,

- Savannah and all types of animals.
- I would love to go to Africa to take a Safari.
- Hot, humid place with many desserts. Everything there is strong.

One white student in her journal entry mentioned that the people of Africa were less assimilated to Western cultures. In another journal entry, I asked students to plot a scene that involved African and Caribbean women. Another

white student wrote, "My theme would be why they get lip plates and all I really know is that it attracts the men if they have big lip plates." A white male student wrote, "Excellent education since Alexander the Great was educated here." Yet another stated: "Disease, many people and cultures."

Most of the responses in students' journals support existing literature about the limited knowledge that North American students have about other cultures. Many of the images seen in students' journals are in line with portrayals of people from the Global South. There were the stereotypical images of the African safari and animals; little was mentioned of the people. With the exception of one person, when students referred to people living in Africa and the Caribbean they resembled the images presented by the media. For example, students perceived Caribbean people as happy, and lip plates worn by some Surma women from Ethiopia was generalized as an image used to depict all African women. The images presented are typical of images shown on channels such as National Geographic; this channel usually focuses on the exotic and unusual.

Mainstream American media tend to promote negative stereotypes of Africa and other areas of the Global South. Usually there is emphasis on the "sensational, preference for catastrophes such as droughts, wars, and famines, the use of simplistic explanations, notably 'tribalism,' for the causes of conflicts, and a focus on non Africans as victims or helpers" (Palmberg, 2001, p. 9). The information Americans receive about Africans comes mostly from the mass media, television in particular. In *Tarzan in the Classroom: How Educational Films Mythologize Africa and Miseducate Americans* (1993) the author states that in a report from the Carnegie Corporation in 1967 Africa was cited as being the most neglected area of the world. More than 20 years later, the Rockefeller foundation came to the same conclusion (Cudjoe, 2001). These negative images contribute to the othering of people. The "Other" is usually viewed as inferior, exotic, and ignorant (Banks, 2001; Mohanty, Russo, & Torres, 1991; Said, 1978). Countries that form the Global South are often viewed as "Other" although within the U.S. society; women, racial minorities, the poor, and homosexuals are viewed as "Other" (Sardar & Van Loon, 1997).

In *African Images: Racism and the End of Anthropology*, Rigby (1996) reported on the use of the concept of the "Other" in international context. This "Other" is seldom the white European or North American male. "The other is those people whose peculiar differences from this normative creature [the White male] need to be explained and come to terms with" (p. 1). Othering is therefore linked to whiteness and Americanness; generally, those who are not considered white or American enough are considered the Other.

In addition to media, classrooms also serve as sites that reinforce images of the Other, whiteness and Americanness. Giroux and McLaren (1999) state that

schooling takes place within a cultural and political arena where forms of student experience and subjectivity are actively produced and mediated. "In other words schools do not merely teach academic subjects, but also in part produce student subjectivities or particular sets of experiences that are in themselves part of an ideological process" (p. 317). School is therefore part of the everyday experience and is influential in determining how one relates to self and others.

School curricula in the United States have focused on Europeans and emphasized their history and culture. Other cultures were represented as inferior, or not represented at all (Asante, 1998, 1999; Takaki, 1993). Spring (2004) notes that educational policies of the English and later the U.S. government reflected the colonizer's thought of Native Americans as inferior. "Consequently schools were created to destroy Native American cultural and linguistic traditions and replace them with the English language and Anglo-American culture" (Spring, 2004, p. 1). This system of deculturalization, "the process of destroying a people's culture and replacing it with a new culture" (Spring, 2004, p. 3) was extended to African Americans and other groups as they migrated or were forced to the United States.

Hase (2002) adds to this discussion by offering a critique of the ways international women are studied in the American classroom. She concludes from her experience of teaching "global feminism" in U.S. classrooms that students were more willing to learn about the "exotic" issues such as genital mutilation that affected the women of the third world but were less willing to learn about how the United States shapes the process of globalization. She continues that

> after learning about the "plight" of third world women and the "horrific" oppression they are subjected to, my American students would come to the reassuring realization of "how lucky" they were and to the question of how they could help those poor third world sisters. (p. 95)

She asserts that these attitudes have to be challenged and advises that "in order to avoid this sort of 'globalizing as othering' a curriculum transformation should be conducted in a way to challenge students' perceptions and assumptions of western superiority, their voyeurism and their missionary attitudes" (p. 102). Further goals should include educating students to become aware of and examine U.S. responsibility as well as their own positionality and accountability in the U.S.-dominated global economy and politics.

Based on these critiques of the American classroom it would seem as though "Negroes" are not the only ones "miseducated" as proposed by Woodson (1990). This of course does not negate the unique oppression of African Americans. The vast majority of students in the United States have been miseducated but it is those students who are living in low-income brackets of society and students

of color who are most negatively affected by this miseducation. As part of this miseducation students are taught to embrace myths; they are taught how to be "American" and in the process, they are taught how to value whiteness.

DEVELOPING CHARACTERS

Once a basic introduction of the course content was given, students began reading and preparing their plays. Students developed characters based on their plays and also based on their knowledge of the theme addressed in the play. In addition, I brought in outside information to supplement students reading. For example, I gave them brochures that addressed HIV/AIDS internationally and within Southeastern Ohio. Betty, my assistant, and I went around the room interviewing students about their role.

I interviewed a white male student portraying a South African character.

Student: I am Patrick from South Africa I have AIDS.

Denise: How did you find out?

Student: I was sick and was coughing up blood.

Denise: What is your profession?

Student: Ah, I don't know.

He began searching through the script.

Denise: I don't think it is in there, what profession do you think Patrick would have?

Student (shrugging shoulders): I don't know what they do in South Africa. Maybe I am a hunter; I hunt wild animals.

A discussion about South Africa and the diversity of careers found there emerged. Although it was possible to be a hunter in South Africa, it was important to demystify notions of Africa as a jungle and help students understand that, as is the case of the United States, in developing countries such as South Africa, there are areas that are poor and lack infrastructure, and there are other areas that possess more infrastructure and modern amenities.

In role-playing one has to put oneself in someone else's shoes. One has to understand every aspect of the character. This often involves analyzing oneself, examining how similar and different one is to the character one is trying to portray. Stereotypes and otherness are often revealed through this process. Not all students depicted the Caribbean and Africa negatively, as mentioned earlier one white student from Southeastern Ohio spoke of Alexander the Great receiving

his education in Africa. In addition, the black students from the Afrocentric school described Africa as the "motherland." For them Africa represented a place of wealth and knowledge. My assumption is that school curricular choices have a large impact on what students know, value, and feel. The curriculum of the Afrocentric school taught students to value Africa, particularly African history. These students from the beginning already had a connection with the plays being studied albeit from a historical standpoint.

THE FINAL PLAY

After reading and reenacting the plays of women from the Global South we began working on the final play. This play was to be performed during the Upward Bound award ceremony. In the interest of time, I asked students to get into three groups and together we created the story for the play. Each group was responsible for creating a scene for the play. I wanted to leave the storyline of the play as open as possible, therefore I asked them to think about what we had done in class for the past weeks, the plays and our discussions, and select a theme related to the class.

To create the story line I first asked students to come up with a theme for the play and to begin thinking of scenarios that would fit in their theme. As a group, we came up with the overall theme for the play. The theme included the concepts that were laid out by each group and based on this we sketched the storyline. For the theme students chose—Understanding different cultures. Examining stereotypes and miscommunications and their objective was to establish common ground. The students explained that for them common ground meant coming to an understanding that in the midst of the differences there were many similarities.

We agreed to use an object as a narrator because of its flexibility; it was not limited by time or space and was easy to create. This object would travel to different lands at different times to tell a story about diversity. There were several suggestions about where the play should begin. I encouraged the students to incorporate either a Caribbean island and/or African country since this was the focus of the class. Nigeria was suggested as a starting point and then Kemet (Egypt) was suggested. Most of the white students in the class never heard of Kemet, and although this was not a concept or place we discussed in class, most of the students agreed that they wanted the story to begin there. This way they could learn about Kemet.

Several suggestions were made regarding what object to use as a narrator: jewelry, a trophy, jeans, book, suitcase, glove/ mitten, shoes, quilt. Finally, someone suggested an Ankh. I was informed by the black students from the Afrocentric school that it is the ancient Egyptian symbol of life, and is known as "the original

cross" and all of the students agreed to the use of this symbol. From there we discussed the roles the students would perform—actors, directors, sound, light, and props and with that in mind, we began developing the storyline.

Donnie, an African-American student suggested:

> Well what about this. We are in Kemet. There is an invasion. The missionaries see the Ankh, bring it to the Americas, take the head off and make it into a cross.

This idea raised objections from the other students in the class, particularly Lela and Ariel, two white students. They felt that when the Ankh comes to the United States it should be made stronger, not have its head taken off. A heated debate ensued:

> Student: But that is what happened—the head was removed.
>
> Student: For me I would be more inspired if the culture was not altered. If instead of the pressure to change it grew stronger and stronger.
>
> Student: I feel insulted. I feel as though you are saying that European cultures destroy cultures.
>
> Student: We have to present it the way it was and that's what happened.
>
> Student: Can I not be the director?
>
> Student: Is this supposed to be a historical play?

By the time class ended, the air was thick with tension and nothing had been resolved. It was the weekend and I suggested that we think about this some more and continue the following Monday.

When the class met again there was more opposition to taking off the Ankh's head, and more discussion about the history of the Ankh itself. The students from the Afrocentric school insisted on using the Ankh. Some of the white students agreed, but the majority wanted to use another symbol because their parents were coming to see the play and might not feel comfortable about it. They expressed that while they had experience with diversity, they did not want diversity thrown in their parents' faces. Some felt that we should work with the Ankh but should incorporate a nice ending; for example, restore the Ankh to its original form. I advised them that this was their play and it was up to them to create it. I said that if they wanted to change the symbol that would be fine with me, but I was concerned about having the time necessary to prepare the play. The white students finally agreed to keep the Ankh, although some did so hesitantly.

Sidorkin (1999) refers to these moments experienced while discussing the Ankh as dialogic moments. He says that dialogue is not necessarily the process that takes place when students have discussions in an orderly manner. It

can also occur when they become excited and talk out of turn. Sidorkin (1999) states that dialogue happens when a holistic text of curriculum is broken down, challenged, retold in one's own words, made one's own and then "stored away" (p. 73). Somehow, this dialogue touched the feelings of race relations. The story that was being created was fictional but it was laced with issues that were very real. The white students were struggling with the concept that as a group whites, their families included, destroyed many cultures and benefited as a result. In their journals students argued that they themselves were not responsible for the oppression of other groups but from their reactions in class, it would seem that they were struggling with accepting how white privilege benefited them and their families. Associated with this discomfort was conflict. Hytten and Warren (2003) state that when dealing with whiteness, students as well as teachers often avoid issues that would cause discomfort and conflict, this is because to deal with these issues would mean that they have to confront and address white privilege. The present study however indicates that discomfort and conflict could lead to dialogic moments when students and teachers are willing to work through the process. Theater in the classroom provided a forum for this to be addressed because it provides a safe space while fostering critical dialogue.

Their journals served as a space to reflect on issues of whiteness and white privilege. One student admitted, "I am subject to white privilege." The student was white and the character he portrayed was a black South African male. This student recognized how race served as a marker for oppression and privilege in both South Africa and the United States. Yet another white student in his monologue wrote:

> I am a middleclass man and I am discriminated against. Do I deserve this? Did I hold a whip and act as overseer on a plantation? Have I ever made anyone sit at the back of the bus? Then why am I stereotyped with the people who did?

Similarly, another student also white complained: "I also feel that I am not looked at the same as everyone else because I am white. Please people when equality is being preached mean it for all people."

Related to whiteness, Americanness was another theme that emerged. The white students in the class were more vocal about this aspect of their identity than the black students. The reason for this is linked to work by scholars such as Ellison (1970), Morrison (1992), Du Bois (1997), and Malcolm X (1963, 1964) who explain that African Americans as a group have never been treated as U.S. citizens. One white student wrote in his journal,

> I am also looked at differently because I actually love this country and trust the country that I am living in. That makes me a follower and one who can't make his own

decisions. I love this country because of the economic benefits it has given to my family for the span of my entire life. I don't bash it for what it has done in the past. I look at what it has done for me and what it continues to do for people everyday. You can't show me a person who actually has never benefited from living here. If you can I will shut my mouth. I just don't believe in a country that I can't trust. If I want to live in an apartment building but I don't trust the landlord, I go somewhere else.

This student complained because he perceived claiming his Americanness was seen as negative. However, in claiming his Americanness he neglected the many groups who suffered so that others could retain the privilege he enjoys. The experiences of those who do not participate in the privileges he enjoys are seen as trivial and these people are viewed in essence as being un-American and unappreciative. Interestingly, this student wrote of economic benefits, but at the same time, he fell within a low-income category, since part of the criteria for Upward Bound participants was low-income status.

During my interaction and interviews with students, I realized the student mentioned in the previous paragraph was not an exception; most of the students had a limited understanding of their past and its relationship to their present situation and their connection with others. For example on two occasions white students from Appalachia stated that they did not consider themselves Appalachian, they labeled West Virginia as Appalachia but not Southeastern Ohio. The reason for this inability to link the present and the past and connect with others can be explained by looking at the process of becoming American. Spring (2004) and Roediger (1994) tell us that assimilation, the process of becoming an American, results in subordinate groups not knowing their own history and culture but buying into mainstream culture and claiming it as their own; in my research, this was observed particularly among the white students. The more assimilated the group the more American they were.

The African-American students were more aware of their status as a subordinate group, they felt very closely tied to what they knew of historical Africa but did not seem too interested in present-day Africa. There was a degree of disconnect. This lack of connection was evident in all students since the stories and images they created about Africa were all based on the past. Buber (1955) points out that one of the examples of "I-It" relationship is when the other is presented historically and the connection between the then and now is not made. He states, "true beings are lived in the present, the life of objects is in the past" (p. 13). Using Buber's definition of relations the African-American students in the class, albeit not to the same extent, also participated in othering Africa by treating them as objects and not as subjects.

Additional evidence of Americanness and othering among black students was observed during the recreation of the play *Living Positively*. An African-American

student, Joe, performed the role of Dr. Lamptey, and monopolized the play. The play was recreated as a talk show; he was the host and did most of the talking. He completely moved the play from Africa and made it American; he replaced the words Africa with America. When he called on the rest of the world for help, his sense of the world was limited to only America. Some students objected to his monopoly but no one disagreed to the replacement of Africa with America; it seemed as though that was the normal thing to do. Although not from the dominant group, and although having a curriculum that centered on African history, these students also learned how to be Americans and embody "whiteness" and whiteness cultural scripts valued by the dominant culture in the United States. This whiteness/Americanization process is inscribed in school curriculum and other social institutions through events such as the Pledge of Allegiance, saluting the flag, and world champion sporting events in which most of the participants are from the United States, and students quickly learn that "they are the world" and anyone who does not conform to their interpretation of their world is viewed as the "Other."

CONCLUSION

My research suggests that more attention needs to be paid to national identity in the form of Americanness in the discourse on whiteness. Americanness surfaced as a barrier to critical dialogue in both groups because of the presence of the theatrical works from a marginalized group outside the United States and provided a clearer understanding of how Americanness and whiteness are interrelated and are implicated in Othering. In the process of learning how to be an American, students are taught how to value whiteness and how to objectify others who are not as "American" as they are.

The theater of black women from the Global South allowed for explorations of identity and power by creating openings for dialogic moments through which dialogue and dialogic relations could be formed. By participating in this process and taking the additional step of agreeing to perform the play in the presence of their family and friends these students demonstrated how the theater and the drama process, and Performative Inquiry can lead to social justice activism and un-doing whiteness.

NOTES

1. Performative Inquiry is a form of classroom action research that is a "research methodology that invites students to explore imaginary worlds within which space, moments of understanding and

intercultural recognitions are possible" (Fels & McGivern, 2002, p. 23). Performance infers creative action exhibited through dance, theater, writing, music, visual, and media arts.

2. Classroom action research is an example of participatory research where teachers become researchers in their classrooms.

3. Racial classification used to define a person who is neither black nor white.

REFERENCES

Angelo, B. (1989). The pain of being black. *Time*, May 22, 120–123.

Asante, M. K. (1998). *The Afrocentric idea*. Philadelphia, PA: Temple University Press.

—— (1999). The Afrocentric idea in education. In Fred Lee Hord (Mzee Lasana Okpara) and Jonathan Scott Lee (Eds.), *I am because we are—Readings in black philosophy* (pp. 339–350). Amherst: University of Massachusetts Press.

Aubrey, L. (2003). *Moving beyond collective learning from the Global North and bringing humanity back to itself: Pan Africanism, women, and co-development.* (online) Retrieved April 3, 2003 from http://www.swaraj.org/shikshantar/ls3_aubrey.html

Banks, J. A. (2001). Approaches to multicultural curriculum reform. In J. A. Banks & C. A. McGee-Banks (Eds.), *Multicultural education: Issues as perspectives* (pp. 225–246). New York: Wiley and Sons.

Bell, D. (1992). *Faces at the bottom of the well: The permanence of Racism.* New York: Basic Books.

Buber, M. (1955). *I and thou*. New York: Scribner.

Bulbulia, F. (2001). *Living positively*. Unpublished play.

Coats, L. (1996). *Crafting Appalachian identity: Regional handicrafts and the politics of culture.* Retrieved March 16, 2004 from http://www.history.upenn.edu/phr/archives/97/coats.html

Conning, L. (1998). A coloured place. In Kathy Perkins (Ed.), *Black South African women: an anthology of plays*. New York: Routledge.

Cudjoe, K. (2001). *A portrayal of Africans in textbooks: A content analysis study*. Unpublished dissertation, Ohio: University of Cincinnati.

Delgado, R. (Ed.). (1995). *Critical race theory: The cutting edge.* Philadelphia: Temple University Press.

Des Vignes, S. (Singing Sandra) (2002). Voices from the Ghetto. *On Praises for my Blessings* [CD]. Trinidad.

Du Bois, W. (1997). *The souls of black folks*. Boston, MA: Bedford Books.

Eisner, E. (2002). The state of the arts and the improvement of education. *Art Education Journal*, 1 (1), 2–6.

Ellison, R. (1970). What America would be without blacks. In D. Roediger (Ed.), *Black on white: Black writers on what it means to be white* (pp. 160–168). New York: Schocken Books, 1998.

Fels, L., & McGivern, L. (2002). Transcultural performance in classroom learning. In Gerd Brauer (Ed.), *Body and language: Intercultural learning through drama* (pp. 19–37). Westport, CT: Ablex.

Garvey, J., & Ignatiev, N. (1997). Toward a new abolitionism: A race traitor manifesto. In Mike Hill (Ed.), *Whiteness a critical reader* (pp. 346–351). New York: New York University Press.

Gaventa, G. (Spring 2002). Appalachian studies in global context: Reflections on the beginnings-challenges for the future. *Journal of Appalachian Studies*, 8 (1), 79–91.

Giroux, H., & McLaren, P. (1999). Teacher education and the politics of engagement: The case for democratic schooling. In Pepi Leistyna, Arlie Woodrum & Stephen Sherblom (Eds.), *Breaking*

free the transformative power of critical pedagogy (pp. 301–333). Cambridge, MA: Harvard Educational Review.

Grady, S. (2002). *Drama and diversity: A pluralistic perspective for educational drama.* Portsmouth, NH: Heinemann.

Hase, M. (2002). Student resistance and nationalism in the classroom: Some reflection on globalizing of the curriculum. *Feminist Teacher,* 13 (2), 91–107.

Heathcote, D., & Bolton, G. (1995). *Drama for learning: Dorothy Heathcote's mantle of the expert approach to education.* Portmouth, NH: Heinemann.

Hytten, K., & Warren, J. (2003). Engaging Whiteness: How racial power gets ratified in education. *Qualitative Studies in Education,* 16 (1), 65–89.

Kao, S., & O'Neill, C. (1998). *Words into worlds: Learning a second language through process drama.* Stamford, CT: Ablex.

Ladson-Billings, G. (1998). Just what is critical race theory and what's it doing in a nice field like education? *International Journal of Qualitative Studies in Education,* 11 (1), 7–24.

Lewis, H. (1991). Fatalism or the coal industry. In Bruce Ergood & Bruce Kuhre (Eds.), *Appalachia: social context past and present* (pp. 221–230). Ohio: Ohio University.

McIntosh, P. (1998). White privilege: Unpacking the invisible knapsack. In Paula S. Rothenberg (Ed.), *Race, class and gender in the United States: An integrated study* (pp. 165–170). New York: St. Martin's Press.

Mohanty, C., Russo, A., & Torres, L. (1991). *Third world women and the politics of feminism.* Bloomington: Indiana University Press.

Moody, D. (2002). Undergoing a process and achieving a product: A contradiction in educational drama. In Gerd Brauer (Ed.), *Body and language: Intercultural learning through drama* (pp. 135–161). Westport, CT: Ablex.

Morrison, T. (1992). *Playing in the dark: Whiteness and the literary imagination.* Cambridge, MA: Harvard University Press.

Newitz, A., & Wray. (1997). What is "white trash"? Stereotype and economic conditions of poor whites in the United States. In Mike Hill (Ed.), *Whiteness: A critical reader* (pp. 168–187). New York: New York University Press.

Omi, M., & Winant, H. (1998). Racial formations. In Paula S Rothenberg (Ed.), *Race, class and gender in the United States an integrated study* (pp. 13–23). New York: St. Martin's Press.

O'Neill, C. (1995). *Drama worlds a framework for process drama.* Portsmouth, NH: Heinemann.

Palmberg, E. (Ed.) (2001). *Encountering images in the meetings between Africa and Europe.* Sweden: The Nordic Africa Institute.

Ribgy, P. (1996). *African images: racism and the end of Anthropology.* Oxford: Berg.

Roediger, D. (1994). *The wages of whiteness: Race and the making of the American working class.* New York: Verso.

Said, E. W. (1978). *Orientalism.* New York: Pantheon Books.

Sardar, Z., & Van Loon, B. (1997). *Introducing cultural studies.* New York: Totem Books.

Sidorkin, A. (1999). *Beyond discourse education, the self and dialogue.* Albany: State University of New York Press.

Small, J. (1997). A black woman's tale. *The Caribbean Writer 11,* 133–153. Virgin Islands: University of the Virgin Islands.

Spring, J. (2004). *Deculturalization and the struggle for equity: A brief history of the education of dominated cultures in the United States.* New York: McGraw-Hill Companies.

Takaki, R. (1993). *A different mirror: A history of multicultural America.* Boston, MA: Little, Brown & Co.

Tatum, B. (1997). *Why are all the black kids sitting together in the cafeteria and other conversations about race.* New York: Basic Books.

Thomson, D., & Wood, J. T. (1998). Rewriting gendered scripts: Using forum theater to teach feminist agency. *Feminist Teacher,* 13 (3), 202–212.

War, terrorism and our classrooms. (2001). *Rethinking Schools: An Urban Educational Journal,* 16, 1–28.

Woodson, C. G. (1990). *The mis-education of the Negro.* Trenton, NJ: Africa World Press.

X, Malcolm. (1963). *Malcolm X: Message to the Grassroots.* Detroit, Michigan. Retrieved March 10 2004 from http://www.americanrhetoric.com/speeches/malcolmxgrassroots.htm.

—— (1964). *Malcolm X: The ballot or the bullet.* Detroit, MI. Retrieved March 14, 2004 from http://www.americanrhetoric.com/speeches/malcolmxballot.htm.

Educultural Performance: Embodiment, Self-Reflection, AND Ethical Engagement

EILEEN C. CHERRY-CHANDLER

Educulturalism is pedagogy that focuses on preparing students to understand themselves, the cultural world, and their relationship to others. It enables active learning of culture's complex ecology of social elements and issues that influence human lives; its intent is to engender intercultural respect and social justice. Performance is an interpretive activity that also provides interaction with others and dialogical insight on the nature of cultural relationships. As a means of social insight, it supports the aims of educulturalists who want to teach and explore the elements and issues of cultural diversity. Performance studies and cultural studies have a solid methodological partnership questioning the possibilities and problems of multicultural America. In the performance studies classroom, we are examining how America's ethnicities, races, genders, and classes influence our way of life and, particularly, how we perceive and construct identity.

As an introduction to the educultural orientation shaping pedagogical methods within performance studies classrooms, I discuss three performance scholars who understand the intervention work of educulturalists as the practice of critical pedagogy, concerned with the political agendas that "anchor, motivate and emerge through the cultural practice of education" (Pineau, as cited in Alexander, 1999, p. 307). In their ethnographic research, the classroom is always a site of intercultural education and what we are teaching is a practice where one seeks to "negotiate self within culture…and resist delimiting essentialism" (Alexander, 1999, p. 327). School is the place where we educate for critical consciousness and provide a place of safety where neglected and silenced subjectivities can be heard.

One major development has been the growing "family resemblance between pedagogy and ethnography—the pedagogical and the performative" (Stucky & Wimmer, 2002, p. 5). "Many performance studies scholars are teachers whose classrooms, both inside and outside academic institutions, serve as sites for work beyond the familiar norms of traditional instruction" (Stucky & Wimmer, 2002, p. 1). They challenge a new generation of educators to use dramatic technique, techniques of embodiment, to increase students' awareness of others' ideological and sociological subjectivities (Stucky & Wimmer, 2002, p. 4). They conclude that the "root of understanding lies in a 'felt-knowledge' of human experience" (Stucky & Wimmer, 2002, p. 3).

Elyse Lamm Pineau interprets this concept of teaching "felt-knowledge" as enfleshment, (Stucky & Wimmer, 2002, p. 4) or "schooling the body" (Pineau, 2002, p. 42). Bryant K. Alexander (1999, p. 308) refers to it as "articulated knowledge" that reflects our "lived experience," and Dwight Conquergood (1985) sees it as a respectful sensing of the other—a felt-knowledge resulting in a dialogical performance where the self and the Other genuinely converse because they are ethically engaged.

Educational theorist, Ernest Boyer (1994) appropriates the language of performance when he calls the classroom a "staging ground for self and social renewal" recognizing that the "poetics, play, process and power" of performance (Conquergood, 1989, p. 82) is an enabling metaphor for educational activism. Studies in performance examine a vast array of phenomenon touching on issues that cross disciplines, genres, and approaches from solo to social spectacles of aesthetic and cultural practice. Performance scholars ask how a particular performance is constituted: who is the performer, what is the text, and who is the audience and the world or context in which the performance occurs? Performance scholarship examines the creative process experientially; it develops empirical studies of cultural processes of representation so it must be informed by critical studies on race, ethnicity, gender, and political economy. Its epistemological roots are in the study of anthropology, literature, and theater.

Performance studies are also associated with the oral interpretation of literature, which is the explication of literary texts through performance. They retain a commitment to the close reading of literature and presentational aesthetics and the more traditionally recognized forms of theatricality. However, since the 1970s, the interpretation of literary texts has extended to the reading of all types of social texts—an awareness that through their dramatic reenactment we can increase our knowledge and understanding of them as forms of cultural production. Oral interpretation has become more multifaceted, embracing, interacting, or coperforming with anthropology, psychology, sociology, and performance art. Ethnographic research on performance in Africa, along with numerous other works, began to

provide a context for the exploration of Otherness, marginality, power, and privilege in a manner that invites cross-disciplinary dialogue and the exploration of cultural diversity. Within communication and performance studies scholarship, there later emerged a growing concern for the cultural politics of the research project itself, the ethics involved in authorship and performative representation. Performance ethnographers are currently focused on the articulation of social issues, particularly through the voices of the less privileged, as a method of intervention. The goal of their research encompasses four areas of vital interest to the educulturalist: cultural responsiveness, social justice, critical thinking, and creative process.

ELYSE LAMM PINEAU

Educational critique and school reform have been the performative research interests of Pineau, who sees "sociopolitical relations reflected in and constituted through educational practice at the macro level of public policy as well as the micro level of classroom interaction" (Pineau, 2002, p. 41). On the nature and implications of those sociopolitical relations, she asks, "What physical constraints are specific to educational culture, and what additional burdens does the body bear when it steps inside the classroom?" (Pineau, 2002, p. 45). One of those constraints is the way performance activity is traditionally used in curriculum design. Pineau advocates a pedagogy that

> embraces performance as a critical methodology that can be fully integrated throughout the learning process ... performance methodology emphasizes process over product by requiring students to use their bodies systematically over a period of time, rather than simply at the end of a unit. (Pineau, 2002, p. 50)

In addition, "performance ... enables an imaginative leap into other kinds of bodies, other ways of being in the world, and in doing so, it opens up concrete and embodied possibilities for resistance, reform, and renewal" (Pineau, 2002, p. 53). Performance recognizes that the bodies of teachers and students are ideological constructs that must be reckoned with:

> Habitually ignoring my own and my students' bodies is not a benign or prudish oversight, some innocuous standard of classroom decorum. I have found, increasingly, that it undermines my ability to engage myself and my students in meaningful ways, to provide immediate examples of the performative principles that I teach, and to genuinely confront issues of prejudice and exclusion that have become such an important dimension of my course content. (Pineau, 2002, p. 46)

In my own undergraduate humanities and performance studies courses that explore cultural diversity through performance, I invite students who think they

have little or no performance experience to consider how critical writers, scholars, and performing artists examine the issues of cultural difference in the United States by challenging them to practice the basics of performance ethnography through preparing solo and group performances for a live audience, from the studio laboratory of the classroom. However, we have taken our performative discoveries to community centers, theaters, libraries, and galleries. My purpose is to raise awareness of the dynamics of intercultural experience as an important component of educational and personal development, as well as the social/cultural assumptions and attitudes that foster fear and prejudice toward others.

We begin with some form of a self-portraiture by performing personal narratives. Each participant presents the unique ecology of his/her identity as influenced by the prevailing social forces. What emerges are tales of the body, memories of ancestry, geographical locations, and significant events. Moreover, since students are already familiar with the "script," we can focus on the fundamentals of what to do with the body on stage and building presentational confidence. From here, we explore depictions of the "Other"—someone we perceive as significantly different from ourselves based on race, ethnicity, gender, age, class, or ability—again, through performed narrative. We then struggle with the aesthetic and ethical issues of representing the chosen informant's physicality, voice, and message. As a follow-up, we discuss the aesthetic results of our performance choices as well as the assumptions about the Other we carried into our performance preparation and how those assumptions may be reshaped through this process of actual physical embodiment. The following are two examples of my classroom experiences.

I made it a practice to record some of my students' performances. I showed these exemplary performances on video to my students as course evaluations that anecdotally indicated that novice performers were encouraged by seeing someone like themselves perform well. Viewing these videos helped them gain a clear sense of my expectations and helped them get through the intimidation of performing with and before others.

When my jittery finger adjusts the volume control on the video monitor, I hear the sudden blare of my recorded voice from the tight wooden walls of the audiovisual cabinet.

"And now, a narrative fiction reading from 'The lesson' by the author, Tony Cade Bambara!"

It resounds off the ceiling over the heads of my new students in the darkened classroom. I feel a slight flush of embarrassment. I know my body and the kind of anticipation anxiety I feel before performing on stage or in the classroom. I overprepare, so my actions are automatic until my mind and body calm and synchronize.

I situate myself in the room so I can study the class' reactions to the young white male entering the frame of the bright screen. My hope is that his performance will arouse interest in how the complex ecology of their own lives relate to those of others who are different. He will illustrate what is an actor, a text, and an audience, as well, as what is an identity, an "Other" and a contact zone (Pratt, 2003). My students' faces are all youthful and white like his. Most of them hail from small-town or suburban America. I am a middle-aged female, black and urban. I am a performer/poet/scholar and self-identified educulturalist. For most in the class, I was, until the moment I entered the classroom, a small box on their checklist from the School of Education.

From his impressive screen image, Scott, the student performer, resembles the professional actor, Patrick Swayze, with his sculpted face and athletic frame. He positions himself behind a lectern and shakes his head. I hear some muffled snickers from the audience on the videotape as well as from those watching in the room, because Scott's long hair is pulled up and parted into a pair of bouncy pigtails with ribbons. He waits five long beats then begins his earnest portrayal of the story's first-person narrator, Sylvia, a low-income, preadolescent, African-American urban girl with a sassy mouth, who expresses her acute awareness of her status as "Other" in America with biting eloquence. During a field trip to a famous high-end toy store, FAO Schwartz, she is compelled to face the painful facts about her location on the economic scale and its political ramifications. After marveling at the expensive array of merchandise and well-dressed shoppers, she asks,

> Who are these people that spend … $1000 for toy sailboats? What kinda work they
> do and how they live and how come we ain't in on it? Where we are is who we are,
> Miss Moore always pointing out. But it don't necessarily have to be that way, she
> always adds then wait for somebody to say that poor people have to wake up and
> demand their share of the pie and don't none of us know what kind of pie she talkin
> about in the first damn place. (Bambara, 1972)

The field trip organizer and Sylvia's chosen nemesis is a community woman named Miss Moore who volunteers to organize cultural enrichment activities for the children in this black working-class neighborhood. Sylvia resists her throughout the story and describes her as having "nappy hair … proper speech … no makeup … and a g—d—college degree." Nevertheless, Miss Moore, who both fascinates and infuriates Sylvia, is ever the educulturalist, providing Sylvia with a new sense of possibility by experientially "raising" often-troubling questions in her young mind about her situation in society.

Evidently, Scott has invested considerable time rehearsing his five-minute interpretive reading. His careful dramatic analysis of Bambara's first-person text helps him respectfully create a credible voice for Sylvia without straying too far

from the quality of his own vocal instrument. The writer has given him plenty to work with, and it is apparent that he understands that his performance is a collaboration between himself and the writer, much as a skillful musician's interpretive rendering of a melody that honors the composer's work. He recreates her physical and gestural language articulating his understanding of her culture and background. By establishing a consistent pattern of focal points and visual cues, Scott successfully distinguishes the cast of supporting characters in Sylvia's monologue for his audience. He has embodied Sylvia's words even though he performs with an open textbook on the lectern. This allows his eyes to fully engage us and creates the illusion that Bambara's words are authentically his own—that he is, indeed, in the mind of the audience, the character named Sylvia.

Scott's performance evokes expressions of polite amusement, sullen condescension, and inscrutable blankness on the faces of the students watching the video. I receive visual checks from them that read "Is this what you expect for us to do? Is this all right? You're black and you don't look angry about what he's doing? Is this a minstrel show? How come I'm not laughing? Maybe it is cool?" I have wondered about the nature of those glances or whether there would have been any if the body I represented in this classroom were of another race or gender. Just what would our "dialogue" of physical cues be like? How would it affect our performance analysis and learning of literature? Scott's interpretive reading not only demonstrates his skill with a communication technique, but he is also representing the performativity of race, class, and gender politics, the dramatic engagement of identity and difference; the empathy, self-reflection, and moral responsibility required of genuine intercultural relationship. The students later learn that his performance required more than memorizing lines and gestures, but that performing the "Other," real or fictional calls for an added commitment to embodiment, self-reflection, and ethical engagement.

As the applause following his performance from his video audience begins to fade, Scott relieves himself of the hair ribbons and seats himself before the class. A well-dressed African-American lady discreetly tiptoes into the room having watched his performance through the glass window in the slightly ajar classroom door. Scott fields questions about how he prepared for his performance and introduces the lady as a director of a community youth project where he was devoting some time. I am delighted and intrigued when my students bring community people to class to share their performances. Was she a "Miss Moore"? I didn't ask, but I posed this question: "Did you perform this for the youth in the program?" Scott answered no. However, it was something he would consider. He just wanted the lady to see it. Then I asked, "As a white male what did you learn from being the African-American girl in the story?" I wanted to know if this performance tested his assumptions about young black girls like Sylvia. After a long pause Scott said,

"Compared to where I was before, if I saw this kid now in a department store like FAO Schwartz, I'm more aware of how we perceive each other."

In this next example, confronting assumptions about the culture of a perceived Other is not just relegated to post-performance critique. In-class rehearsal is the time when important performance choices about characterization, setting, and message are made. Not only do my questions hold students accountable for their decisions, but the comments of their classmates are considered as well.

Writer/performer Joy Harjo's poem "Remember" is a favorite first selection for some of my new performers. They must analyze the language of the poem and determine the persona—that is, determine whom the poet created as the speaker. Sometimes this can be tricky.

from "Remember" (1983)

> *Remember the sky that you were born under,*
> *Know each of the stars stories…*
> *Remember the wind. Remember her voice. She knows the*
> *origin of the universe. I heard her singing Kiowa war*
> *dance songs at the corner of Fourth and Central once.*
> *Remember that you are all people and that all people are you…*
> *Remember the dance that language is, that life is.*
> *Remember.*

New performers are quick to associate the poet's autobiography with the persona and not explore the many creative options offered by the language for a performing voice. To test their understanding of this concept, I have them do an exercise where they must identify and justify their choice of a persona and create a scene or situation where their persona is engaged in some activity—behavior that could evoke the words of the poem. Students run to Harjo because they think the language is uncomplicated and the persona is "easy" to identify. According to the biographical information provided in the textbook, the poet is a Native American. Her free verse is rhythmic and uses figurative word patterns to explain the relation of the individual to the totality of life. When challenged to invent a credible persona, many students readily appropriate an available media image. Therefore, when they arrive for the in-class rehearsal exercise, some are primed for a "cultural intervention," not just from myself alone, but from knowledgeable classmates. An example of an in-class rehearsal exercise:

A white female student enters the performance space and arranges the furniture to create her setting. She has parted her hair in the middle and created two shoulder-length braids. From a shopping bag, she pulls a decorative blanket and wraps it around her body.

Me (*to the white girl wrapped in a blanket*): So who are you and what are you doing?

White girl wrapped in a blanket: I've decided that I am a Native American woman sitting outside at her campfire having a family meeting.

Me: Have you thought about when this takes place?

White girl wrapped in a blanket: Not really.

Me: Is it modern times?

White girl wrapped in a blanket: Uh. Yes.

Me: To what nation does your persona belong?

White girl wrapped in a blanket: Kiowa, I guess.

Girl in the back of the classroom: Well, I am Native American and when we have family meetings, we just sit around the kitchen table with cups of coffee.

Returning to Pineau, "schooling the body" entails acknowledging that our bodies are differently marked by cultural norms and that we enter the classroom as embodied persons, walking metaphors of race, class, gender, and ethnicity for which our bodies will be critiqued. Not only is it important to recognize that our bodies are a "tangible expression of political forces," but also that we are each performing an ethnocultural role. We are telling our story and narrating our lives through the conventions and practices from which student/teacher roles are constructed. Performance-sensitive observations of such role interaction could illuminate the "nonverbal and paralinguistic dimensions ... that are often occluded in more traditional instructional research" (Pineau, 2002, p. 47). Pineau's belief in a performance-centered ethnography of schooling that also reconfigures the relationship between educational researchers and their subjects, teachers and students, into one of reciprocal vulnerability and dialogue as a reform and teaching model is considered in the research of the next scholar I have chosen to comment on the issue of felt-knowledge in the classroom.

BRYANT K. ALEXANDER

As an educulturalist, Alexander writes about the value of reflection and self-discovery and he records his experiences performing the dual roles of teacher and educational ethnographer. In his article "Performing culture in the classroom: An instructional (auto) ethnography" he concludes that

> The classroom ... is a border crossing where the culturally and racially lived experiences of teachers and students become tender for negotiation. They meet as a confluence of rivers that wash and flow over each other. Surely the two can meet in ways that enrich the other. (1999, p. 328)

Much like the pedagogy of the stage actor that prepares him to make the vital connection between himself and the character that he wants to embody and make believable to his audience, Alexander is "seeking to read between the lines" in search of himself and an authentic, sincere connection with others that both "reflects and refracts" his image (Alexander, 1999, p. 328).

Alexander's educultural performance emphasizes playing multiple roles and identities in classrooms, focus groups, and interviews with students and teachers. His investigations incorporate his own autobiographical reflections on his education as an African-American male, but his findings can apply in any educultural context. He is intent on developing a border pedagogy that allows him to engage in meaningful dialogue with his student subjects "to better understand their articulated experiences and desires" (Alexander, 1999, p. 322).

Alexander becomes what cultural theorist bell hooks (1994) characterizes as an "indigenous ethnographer," one who studies a culture where s/he resembles the people being studied or written about. In this instance it is the community of African-American male teachers and students who are his "company of cultural familiars" (Alexander, 1999, p. 328).

> Within the context of this instructional auto (ethnography) I critically describe and analyze my own lived experiences in the classroom, and that of others, in order to come to an understanding of where our experiences intersect while being acutely aware of my shifting and dual cultural membership and shifting borders of my intention: self reflection and research. (Alexander, 1999, p. 311)

In one segment of his essay he calls "Framing experience: Entering reflection," Alexander recounts the experience of being appraised by both students and the larger institution as an object of projection and potential in his body and person (Alexander, 1999, p. 310). Teacher and student serve as a "reflecting mirror for the other in the dominant White system" with shared affinities that inform the educational relationship. Among the consequences he observes is being impacted by "issues of representation ... intertwined with a struggle for authority and respect (Alexander, 1999, p. 314). One particular incident with a disgruntled black male student reminds him of his own personal history and cultural positionality:

> How many times were my Black male teachers expected to be a "brother" in the classroom, in which brotherhood was constructed as an unyielding and unearned support constituted in opposition to their role as teacher? (Alexander, 1999, p. 315)

This question leads him to seek the "infused knowledge and experience" (Alexander, 1999, p. 318) in the voices of other black male teachers who reflect on

their experiences relating to black male students "in shifting metaphors" as mentors, Big Brothers, uncles, and fathers. He notes:

> James said it best: "I think that when you are dealing with Black male students you have to be prepared to wear many hats." These multiple hats correspond to the shifting roles and relational orientations that must be negotiated. These all have accompanying responsibilities to nurture, to foster, to care, to harbor, to understand, to empathize, to know and to admonish. All of these are the traditional mandates of teachers and are part of the socializing process of young Black men, but they are magnified within the context of a shared minority status. (Alexander, 1999, p. 319)

This recognition of a shared status is something we must bring to the heart of our self-reflective educultural performances—an awareness that from our students' perspective, our presence in the classroom is a source of recognition and affinity seeking (Alexander, 1999, p. 322). These men, according to Alexander, articulated an "ethic of care" recognizing what was felt to be genuinely at stake in the education of these particular students. Alexander characterizes it as a pedagogy of desire in which "cultural affinity is used as a strategy for understanding and connecting" with students (Alexander, 1999, p. 319). Alexander's informants embraced the desire to be fair and to be perceived as such by all students of whatever race or cultural background. For example, their aim is not to "dis-empower White students in their classrooms 'or to play turnabout'…. They clearly acknowledge that White students…enter the system with unearned empowerment that comes from being in the majority" (Alexander, 1999, p. 320). But in relation to these students, the educultural performer's role is to clear a site where

> White students are challenged to reflect upon their racial and cultural biases … challenged to make the empathic leap, to understand what it may be like for … minority students not to see themselves consistently reflected within the faces, persons, rhetoric, language and ideology of their teachers. It becomes their challenge to understand how … minority students negotiate the chasm that sometimes exists between racial and cultural knowing and the sometimes sanitizing space of academia. (Alexander, 1999, p. 319)

In the cultural diversity through performance course, I try to train students in the educultural practice of creating performance experiences that situate our learning community across borders (Alexander, 1999, p. 328). Seeking that point of intersection where meaningful dialogue can occur and cultivate an empathic response requires that I also negotiate my roles as teacher and student, illustrated in the following example. Such a bridged approach can be risky and requires "that focus be on the student experience and not my shifting border identity … at the same time, border pedagogy demands that student knowledge and cultural power also be critiqued" (Alexander, 1999, p. 322). In the following group performance

from a class project, my students decided to revisit a familiar children's game that provided us a high moment of awareness.

To play Red Rover, the students arranged class members into two parallel lines by gender and had them link hands. The object was for members of one line to dash across the border between the two groups, try to break through the opposite line and, if successful, join that line. If unsuccessful, you were pushed back to your line of origin. The point was to get every-body to one side. Well, it didn't work neatly or fairly. It got messy—chaotic. I wanted to play, but had to leave the line because I was sweating so much. I felt very self-conscious about being black and menopausal among these perky white kids. I could really feel their tension toward me. It became much like the psychic and physical activism we feel are operating in the real world. There was pushing and pulling. Moments you had to catch your breath. It was hard getting people motivated. The males did not want to play until a certain classmate appeared—an athletic black Resident Assistant who was an informal class leader; then the guys refused to hold hands, the prettiest and smallest girls were repeatedly invited to run and try to "break the line," every time the guys broke the female line they were immediately called back because they looked so uncomfortable being in that line. They would squirm and make faces. No female was ever able to break through and join the male line. At least none of the females who were asked to "come over." It was obvious whose bodies were valued and whose were not. After we had had enough, I wrote the word "bodies" on the board and we spent the rest of the period sitting on the floor, sprawled on the sofas, sipping cool bottles of spring water, and just talking about what happened to us during our game.

Alexander's pedagogy of desire and self-reflective ethnography seeks cultural communion—the recognition of shared values and practices between students and teachers. I have often commented on the intrinsic value of how we as students and teachers, a community of learners, have chosen to spend time together—that we are linked by common interests.

[C]ulture is not a mark of difference, but a mark of practice … that effect and estab-lish … communities … while cultural performance can be used to mark the specific behaviors of particular communities, it also signals those practices and promises of a common humanity and a joint desire. (Alexander, 2002, pp. 24–25)

DWIGHT CONQUERGOOD

In the theater, characters are created for the stage. In the highest traditions of art, it is a process that develops the human character. I think it is because the per-former is constantly reminded of his/her transpersonal capacity—to be an agent of social change. This is the challenge and opportunity offered by the pedagogy of performance and it parallels with educulturalism. As performers and audiences,

we come to recognize that what we are watching is within us—that we embody a vast community of beings and therefore we have the capacity for understanding others and the responsibility for engaging each other in an ethical manner.

One of performance studies' great ethnographic innovators and theorist who strongly identifies with the mission of educulturalism is Dwight Conquergood, whose highly referenced essay, "Performance as a moral act: Ethical dimensions of the ethnography of performance" provides guidance for ethical engagement of the other within the context of performance ethnography. I believe its wisdom is applicable to an engaged educultural practice with an aim to achieve genuine understanding of others in the classroom and throughout the educational system.

Scott's performance of Sylvia from Bambara's *The Lesson*, is a variation on a more demanding ethnographic field exercise used in performance studies courses. In this exercise, the interview performance substitutes a verbatim transcript from a real, living informant instead of a fictional character in a literary text. Students are instructed to seek a person in their community who is different from themselves based on race, ethnicity, class, gender, or ability, to conduct an interview and transcribe the collected narrative into an ethnopoetic text—one that is a phonetic rendering of the informant's speech. The transcript may also include a detailed description of the informant's physical/gestural world. Students must also seek the cooperation of the informant in the development of their class performance and commit themselves to accurately re-presenting the physicality, context, verbal patterns, and message that the informant wants to communicate to the audience. In preparation for this highly challenging experience of gaining permission and admission to another person's life—particularly the world of the Other, students must consider the ethical issues involved with the politics of representations. This method of performative ethnography and intervention, if done with courage and care, can foster meaningful dialogue across cultures. Aesthetically, students learn the distinction between impersonating someone and using performance as a means of advocacy or speaking for the Other. The distinction between performing impersonation and performing advocacy is related to the amount of cultural distance that the performer perceives between herself and the informant as well as the degree of accountability one feels toward the person being represented. I encourage the presence of the informant, if possible, at the actual performance so the student ethnographer and the informant become coperformers, sharing authorship of the ethnographic experience. One aim is to provide a stage for the informant's voice—especially those who are unheard, have little voice in the public space, or have been systematically silenced. We are presenting subjective realities and perceptual experiences that may be new to our audiences. The student performance ethnographer gets firsthand experience of what it means to have her body become a site for social intervention as well as the moral

implications of one's performative act. This moral work in the classroom becomes the foundational staging ground mentioned earlier by Boyer that inspires "self and social renewal."

Facilitating this practice of empathic embodiment, self-reflection, and moral responsibility, I have seen its transformative effect on the student performance ethnographer and community informant in the deepening of their communication process and mutual respect. Conquergood describes the relational stance achieved between these two parties as the state of dialogical performance.

> This performative stance struggles to bring together different voices, world views, value systems, and beliefs so that they can have a conversation with one another. The aim of dialogical performance is to bring self and other together so that they can question, debate, and challenge one another. It is the kind of performance that resists conclusions; it is intensely committed to keeping the dialogue between performer and text open and ongoing. Dialogical understanding does not end with empathy. There is always enough appreciation for difference so that the text can interrogate, rather than dissolve into, the performer ... More than a definite position; the dialogical stance is situated in the space between competing ideologies. It brings self and other together even while it holds them apart. (Conquergood, 1985, p. 9)

Genuine educultural practice envisions performers like Scott and characters like Sylvia as coequals, occupying the same performative space, bridging the distance and cultivating accessibility between their cultural identities without ignoring their very real differences. Conquergood's analysis emphasizes that we must respect the Difference of the Other, have the courage to question, and make vulnerable our deeply held assumptions.

> When we have true respect for the Difference of other cultures, then we grant them the potential for challenging our own culture. Genuine dialogic engagement is at least a two-way thoroughfare. (Conquergood, 1985, p. 9)

The distancing intellectual or aesthetic gaze also means that other people can be subjected to "ethical and moral removal as well" (Conquergood, 1985, p. 2). We have seen the forms of this removal even in the most benign of social spaces. We recognize it in the performative stances of disengagement, elitism, and lack of social commitment on the part of those with greater social privilege. Conquergood packages this set of attitudes as "four ethical pitfalls" to achieving dialogical performance. For cultural performers, they serve as cautionary points on his conceptual moral mapping of the ground between the self and the Other— Identity and Difference. Here is what they look like theatrically and in everyday life (Conquergood, 1985, p. 4).

Conquergood calls the first stance "The custodian's rip-off"—characterized as selfishness or performative plunder (Conquergood, 1985, pp. 5–6). This is a predatory attitude that the other's culture is available for "colonization" and exploitation. Practices deemed sacred by minority cultures are acquired without permission and or plundered for gain that provides no constructive benefit to the targeted, but may often have devastating consequences for them. This is the culturalist who goes in search of some "good material" or who wants to colonize a particular community because it is trendy and will advance his/her personal agenda. "I want your culture, but I don't want you!" Conquergood sees this form of power play and disrespect as comparable to theft, rape, and desecration. The Other is objectified and, though desired, a lack of respect is shown for his/her basic humanity and cultural productions (Conquergood, 1985, pp. 4–5).

Conquergood calls the second pitfall "The enthusiast's infatuation" which certainly has the benign ring of innocence. However, it is no less insidious than the Curator's Rip-off because it erases the distinctive identity of the Other in a "glaze of superficial generalities" such as, "Aren't we all just alike!" The answer is "No!" This performance stance actually masks a distaste for the other. It is a hiding place for one who is terrorized by Difference. So the other is trivialized, sanitized, and homogenized for consumption by privileged players so that the other can never call the privileged one's form of life into question (Conquergood, 1985, pp. 5–6).

Conquergood's third stance, "The curator's exhibitionism" is for those who enjoy perverse entertainment. It is the slave block, the spectacle of the scaffold, the freak show deftly contrived by the privileged to sensationalize the other. The curator is the talk show host who is committed to the Difference of the Other who frames the performance with his/her gratuitous moralizing that never goes beyond the studio or classroom door. It is an immoral stance because it dehumanizes the Other, encourages "museum behavior" instead of "genuine human contact (and risk)." The aesthetic, sentimental, or political distance created by the curator "denies the other membership in the same moral community" as him/her self and the "mute and staring" audience (Conquergood, 1985, p. 7).

"The skeptic's cop-out" is the fourth stance characterized by those who want to disengage from intercultural dialogue all together. They do not want to deal with the "ethical tensions and moral ambiguities" that pave the way to dialogical performance. They allow their cynicism and cowardice to paralyze them and avoid playing roles that do not arise out of what they are accustomed to in their own culture. Their justification is "I am neither Black nor female. I will not perform 'The Lesson' by Tony Cade Bambara!" This unfortunately typified much of what Conquergood claims he encountered in his classrooms:

> Refusal to take a moral stand is itself a powerful statement of one moral position…
> "The Skeptic's Cop-Out" is the most morally reprehensible corner of the map because

it forecloses dialogue. The enthusiast, one can always hope, may move beyond infatu-ation to love. Relationships that begin superficially can sometimes deepen and grow. Many of my students begin in the enthusiast's corner of the map. It is the work of teaching to try to pull them toward the center. The skeptic, however, shuts down the very idea of entering into conversation with the other before the attempt, however problematic, begins. (Conquergood, 1985, p. 8)

Such performative stances are to be confronted. The student must be made aware that he is locking him/her self in a box of their own making and that his/her illusion of safety is just that—an illusion, "an echo-chamber…with only the sound of his own scoffing laughter ringing in his ears" (Conquergood, 1985, p. 9).

A sense of the other is crucial to our humanity and knowing the right thing to do. Overriding what Conquergood calls selfishness, superficial silliness, curi-osity-seeking, and nihilism, the stance offered by "[d]ialogical performance is a way of finding the moral center as much as it is an indicator that one is ethically grounded.… Dialogical performance is the means as much as the end of honest intercultural understanding" (Conquergood, 1985, p. 10).

CONCLUSION

Of critical interest to Conquergood, Alexander, Pineau, and others refer-enced in this chapter, is the dialogical performance or "cooperative enterprise" (Conquergood, 1985, p. 10) between ethnographers and educulturalist. It is a relationship that must be acknowledged, cultivated, and extended for

> The performance ethnographic movement is dependent on the existence of traditional interpreters and teachers of literature, who continue to teach the navigation of the above mentioned pitfalls, deepen new generations of students' sensitivity to the Other and make it possible for more voices to join the human dialogue. (Conquergood, 1985, p. 11)

How power is traditionally constructed and orchestrated in the classroom and how subjectivity is denied to some groups and accorded to others (bell hooks, 1994, p. 139) compels many to call for a "return … to a state of embodiment in order to deconstruct" those traditional practices that foster disengagement, elit-ism, and a lack of social commitment. For those educulturalists concerned with classroom and institutional reform, performance studies' intercultural nature and interdisciplinarity (Schechner, 2002) can help change "formal as well as infor-mal structures" (Stucky & Wimmer, 2002, p. 1) that cultivate intercultural dis-tance. Broadly conceived, performance scholars such as Pineau, Alexander, and Conquergood are contributing to the ongoing redefinition of such "cultural, social and educational practices" (Stucky & Wimmer, 2002, pp. 1–2).

The promise of what I am calling educultural performance is a

rich weaving of performance studies with cultural studies—the intersection of the language of the pedagogical and the performative ... [offering] interdisciplinary, transgressive and oppositional pedagogical practices that connect to a wider public project and social justice, deepening imperatives to radical democracy. (Stucky & Wimmer, 2002, p. 5)

Performance embodies, reflects, and engages us in the world. It is culture in the making and culture is a performance of insight and understanding—a vital and essential conception in the practice of the modern educulturalist.

REFERENCES

Alexander, B. K. (1999). Performing culture in the classroom: An instructional (auto) ethnography. *Text and Performance Quarterly, 19,* 307–331.

———. (2002). Performing culture and cultural performances in Japan: A critical (auto) ethnographic travelogue. *Theatre Annual, 55,* 1–28.

Bambara, T. C. (1972). The lesson. In *Gorilla My Love* (pp. 87–96). New York: Random House.

Boyer. E. (1994). Keynote address. Western states communication conference. San Jose, California, February.

Conquergood, D. (1985). Performance as a moral act: Ethical dimensions of the ethnography of performance. *Literature in Performance, 5,* 1–13.

———. (1989). Poetics, play, process and power: The performative turn in anthropology. *Text and Performance Quarterly, 9,* 82–88.

Harjo, J. (1983). *She Had Some Horses.* New York: Thunder Mouth Press.

hooks, b. (1994). *Teaching to transgress: Education as the practice of freedom.* New York: Routledge.

Pineau, E. L. (2002). Critical performative pedagogy: Fleshing out the politics of liberatory education. In N. Stucky & C. Wimmer (Eds.), *Teaching performance studies* (pp. 41–54). Carbondale: Southern Illinois University Press.

Pratt, M. L. (2003). Arts of the contact zone. In R. Bass & J. Young (Eds.), *Beyond borders: a cultural reader* (pp. 249–262). New York: Houghton Mifflin.

Schechner, R. (2002). Fundamentals of performance studies. Foreword. In N. Stucky & C. Wimmer (Eds.), *Teaching performance studies* (pp. ix–xii). Carbondale: Southern Illinois University Press.

Stucky, N. & Wimmer, C. (Eds.). (2002). The power of transformation in performance studies: Introduction. In *Teaching performance studies* (pp. 1–29). Carbondale: Southern Illinois University Press.

Inviting AN Exploration OF Visual Art INTO A Class ON American Cultures

JUDY HELFAND

As an adjunct instructor in the Humanities department at my local community college, I received a faculty evaluation in which I was told to add more "art" to my American Cultures course. The reviewer wrote that I was doing a "very effective job in the sociological and political areas (race, class, and gender)" but pointed out that the title "Five guidelines" described a course that focused on the "visual arts, music, drama, film, literature, and philosophical/ religious thought within a cultural context of the United States." At first, I felt scared and defensive. Was I being asked to back off from my experiential teaching style that engaged the students through self-reflection and dialogue in issues of race, class, and gender? The part of the official class description that stood out to me was "An interdisciplinary exploration of American identity and the invention of what it means to be an American." Anyway, I already did focus on art and music throughout the course; it simply was not evident from the written syllabus. However, all those things aside, I finally admitted that I was reacting as I often do to constructive criticism: the criticism outweighed all the positive comments and I felt I was being told to completely change what I was doing. This led to a feeling of helplessness, because I was already doing the best I could. Instead of wallowing in fear and defensiveness, I needed to think about ways to bring more visual art into the course. My Masters is in American Studies and Cultural Studies, but it's true that my strength—and prevailing interest—has been on cultural identity issues, especially around race and white privilege, with little experience or understanding of how to teach about visual art.

Further internal struggles with the critique of my American Cultures class seemed to mirror some wider cultural debates. Although I was not being asked

to focus on "dead white men" who had been chosen by "experts" to represent the highest artistic achievements humans were capable of, I felt myself being pulled into a familiar combative stance where I wanted to reject those representatives as without meaning in my life or the lives of my students. In a sense, when I tried to empty my mind from fear and defensiveness, the familiar cultural debates of post-modernists and conservatives were handy to rush in and fill the space. Although I teach my students about both/and thinking, a method that honors complexity and multiplicity, rejecting the invidious binaries so often found in Western philosophies, it is not easy to avoid the familiar action of choosing sides. I had to leave aside any questions of which artists to include, and refocus on my teaching objectives—other answers would flow from there.

BEGINNING WITH TEACHING OBJECTIVES

My teaching objectives and my social justice activism are intertwined. As college students leave home and take on work and social positions within the wider community (or as reentry students, come from such experiences), they also take on decision-making responsibilities that ripple out into the community and beyond. To make decisions that will benefit the larger community as well as satisfying an immediate goal, they need at least a rudimentary understanding of how they exist in relationship to others in the community, to community institutions, and to community structures of power. Beyond that, they need skills for asking questions that relate the immediate issue to their personal worldview and to the greater interests of social justice. Without some explicit attention to the question of how a decision is connected in complex ways to the entire social system, students may unthinkingly do what their peers most commonly do or what they have done habitually before and not realize the effect of the decision on those around them and, inevitably, on themselves.

College provides an opportunity for students to not only begin to acquire the technical and specific skills they will apply in their work, but to begin to think critically about their own identity, the identities of others, and how these identities exist within a web of power relationships—to begin to recognize and understand their *social location*. School also represents the potential for building relationships— or at least communicating—across the boundaries often created by race, ethnicity, gender, sexual orientation, and other aspects of our identity. Without emotional engagement with each other, it is difficult to feel ourselves joined within the complex social web of connections. I believe that as educators, we must provide the structure, the encouragement, and the guidance to ensure that these opportunities are not lost and that students begin that crucial journey into awareness and

connectedness. In taking on these responsibilities myself, I have used the concept of undoing whiteness to guide me, where whiteness is defined as

> a constellation of knowledge, ideologies, norms, values, identities, and particular social practices that maintain a race and class hierarchy in which white people dispro-portionately control power and resources. Within the group of white people, a small minority of elite control most of the group's power and resources.[1]

In the classroom, I aim to make whiteness visible, to model behaviors that challenge whiteness, and to introduce activities and readings that help the students question ideologies, norms, and values that maintain whiteness. This attention to whiteness helps the students to see themselves within the political, economic, and cultural hierarchies within the United States. Further, they can begin to under-stand the meaning of their own social locations within these hierarchies in terms of self-identity, relationships with others, and responsibilities within the larger community. Within the classroom, students work together to construct knowl-edge that can help them in building a more equitable system.

I believe that attention to whiteness is especially important, given the demo-graphics of the school where I teach. Most of my students identify as white and are from middle-class suburban homes. In three years of teaching, I have had less than ten African-American students. In a class of approximately 30 there are usually several students who identify as Chicano, Latino, or Mexican, several who identify as mixed-race, one or two Asian students (usually immigrants), and sometimes students who identify as Native American. In addition, my students are largely young, under 21.

My experience as a classroom teacher and in presenting workshops in other settings has taught me that experiential activities are highly effective for engag-ing students in self-reflection and critical evaluations of unquestioned beliefs. Experiential activities provide a container for students to utilize their own lived experiences in exploring the topics offered for dialogue and to create opportuni-ties for getting to know each other and learning about other life experiences and worldviews. Therefore, I knew I wanted to create some experiential activities to introduce art into my course. Moreover, any activities needed to emphasize mul-tiple perspectives and complexity, encouraging students to ask more questions and muddying their previously held views.

RESEARCHING ART FOR AN AMERICAN CULTURES COURSE

Beyond identifying my general methods and goals for teaching, what specifically were the important questions I needed to ask about visual art? I decided to do

some research. How did others talk about art? What questions about identity and culture had others explored through art? Were online reproductions easily available to students so that we could project and share images easily in class? To narrow my research I started with African-American art, as for the first weeks of class the focus is on African-American identity and culture. I began checking art books out of the library; for example, *Black Artists on Art* (Lewis & Waddy, 1969) and *A Century of African American Art* (Amaki, 2004). I also looked for books focused on criticism and theory, for example, *Art Is on My Mind: Visual Politics* (hooks, 1995). *Black Issues Book Review* (November–December 2005) came out with an annotated bibliography of books on African-American art that proved very useful. The community college where I teach has an excellent media library and I also committed myself to reviewing videos. Many of these bored me so badly I just skipped through quickly. Others went on the list for possible classroom resources. Although I was taking some notes on my readings, copying a few especially interesting pages, and compiling lists of books and artists to look into, during this process I wasn't thinking very much about how any of this input might be translated into my class. Rather, I was dunking myself in the sea of art and art theory; letting myself become familiar with the names, ideas, themes, and vocabulary; and letting myself drift with the currents that interested me the most.

While I was engaged in this process, a new semester started. Not being ready yet to incorporate any of my research into the syllabus, I did want to add something more on visual art and decided to have the students help me with my own learning by doing a little research themselves and then bringing in images to share with the class. Early in the semester, I gave them a list of African-American artists. They were to use the school's art databases or any other online resources to find an artist whose artwork resonated with them. They would then either print out a picture of a particular piece to hand in or use our in-class computer to project an image for the whole class. Later in this chapter, I describe this activity and student responses more fully. Especially relevant now is one particular outcome of trying out this assignment—the gift of a remarkable book on art from one of my students. After the in-class sharings and discussions, a student told me that she had taken an art course with a text on multicultural art. She thought I would like it and might want to use it for the class. The book she gave me was *Mixed Blessings: New Art in a Multicultural America* by Lucy R. Lippard (1990)], and I felt an instant connection. In the Introduction, the author writes,

> I want to make it clear from the outset that this book is not a survey of art from the Native, African, Asian, and Latino American communities. It is not a book "about" artists of color in the United States. . . . The art reproduced here demonstrates the ways in which cultures see themselves and others; it represents the acts of claiming turf and crossing boundaries *now*, in 1990, two years before the five-hundredth

anniversary of Columbus's accidental invasion of the Americas. More specifically, it deals with the ways cross-cultural activity is reflected in the visual arts, what traces are left by movements into and out of the so-called centers and margins. . . .This book is above all a record of my own incomplete learning process, and I hope it will encourage its reader to pursue a similar process. (p. 4)

Mixed Blessings assured me that I was not alone in my desire to find an approach to teaching about art that lived, that was about shifts and connections, and that was truly a multicultural conversation. As I read the text, I could feel the drag of my conditioning about "art" falling away: the hierarchy of masters, the memorization of European schools and periods, the intellectualism of art criticism (and more recently, cultural theory), the relegation to "crafts" not "art" for many women-made and tribal people's pieces. I had not realized I was carrying so much cultural baggage about art or that what I wanted was a way of talking about art that engaged me through heart and spirit as well as intellect. Lippard made the whiteness visible in my own education and socialization around visual art.

CREATING CLASSROOM ACTIVITIES

By now I had exposed myself to a number of readings, watched many videos, and had new information on how students responded to visual art–based assignments. I was ready for the next step. In my course I layer several strands: the class reads, listens to, and looks at the cultural productions of a particular ethnic group over a several week span, while themes for each week suggest how we will use theory and lived experience to consider the meanings of, and what we might learn from, what we are reading, seeing, and hearing. For example, Defining Culture, Voice and Language, Socioeconomic Class are some of the themes layered with African-American culture.

Storytelling is an early theme of the course, encompassing the exploration of how our own experiences reflect our positions within structures of power. I suggest that we need the personal stories of others to understand our own social location and our relationship to the world around us. As an example, I may share my own story of growing up white in a mixed Jewish and Christian, upper-middle-class family with very little exposure to, much less interactions with, people of color, and how my experiences after I left home gradually brought me into a wider community in terms of socioeconomic class, ethnicity, and race, and then I began to see the privilege of my own upbringing. In addition to illustrating social location, I also argue that personal narrative provides a spiritual and emotional content that is necessary to transformative learning, a learning that allows one to shift in worldview as other realities join with one's own. Furthermore, in listening to each

other we build community. Finally, I point out that not all social groups are represented in the classroom (as they are usually not represented in our personal social circles) and that to hear those voices we need to seek them out actively. Using storytelling as a theme, I encourage students to share their lived experiences in class discussions and to pay attention to their responses to other students' stories, asking questions of themselves about where those reactions come from. Using storytelling as a central theme encourages explorations of stereotypes, of ways in which the dominant culture marginalizes other cultures, of oral and written traditions, and more. I feel that the theory I present on storytelling provides a foundation for reading critically and opening oneself to the written and spoken work—creative verbal expressions—studied in American Cultures. I wanted to develop a similar jumping off place for visual art.

Of course, my theory on storytelling has evolved from years of work teaching about white privilege and racism and thinking about the importance of voice in transformational learning. I had only a small store of experiences teaching about visual art. Still, I had to start somewhere and being committed to experiential activities combined with self-reflection and group discussion takes some of the burden off the teacher to serve as an "expert" in every field: I may not know much about visual art and artists, but I do know how to teach. I started by asking myself, why should we care about or study visual art? What purpose does art serve, for individuals and for a community? Can we define art? In other words, are there boundaries that separate art from nonart? The "purpose of art" theme seemed most promising as it would lead into investigations of not only art and the individual viewer or artist, but would also raise questions of cultural differences for the role of art. In a first incarnation of the design for an introductory activity, I wrote, "What does art offer the individual viewer? The community? The artist?" but thinking about "purpose" and what art "offered" was not quite right. Visual art was not a tool employed to reach a certain outcome. Rather, it existed in relationship with viewers, artists, and the wider community.

TAKING THE ART ACTIVITIES INTO THE CLASSROOM

When I took the activity into the classroom, students divided into groups of five or six and discussed the question "What are the relationships between visual art and the individual viewer?" After five or ten minutes of discussion, I asked them to decide as a group on a few relationships to share with the whole class. A few minutes later, the class came together as a large group and the smaller groups reported back. This process was repeated for the two other questions: "What are the relationships between visual art and the artist?" "What are the

relationships between visual art and the community?" After I wrote the first question on the board, there was a kind of stunned confusion. Relationship? Art? What did I want? However, after some encouraging repetitions and suggestions that they just start talking and see where it went, the groups took off. Soon the room was buzzing and I could see intent listening to each other. As each group reported back, the others were attentive, and the whole group discussion lively and creative. With the second and third questions, the engagement continued as the students really grappled with the differences in relationships between art and the viewer, the artist, and the community.

During the activity, the students raised many questions: What is art? Does one need to be knowledgeable about art to appreciate it? Are children's drawings art? What about art that is used for advertising? Some argued that "art is in the eyes of the beholder." Others felt that not just anything could be considered art. For example, as one student said, "If I throw shit on a bathroom wall and call it a masterpiece, does that make it art?" Others brought up some public art in San Francisco, such as a building where chairs were fastened to the outside all over the wall. Graffiti came up often and was identified as illustrating generational differences—those from the younger generation seemed more able to appreciate graffiti. One young man talked about a mural in his neighborhood that covered the wall of a house and was sad that the owner had posted a sign stating that it was art—not graffiti. Many examples of graffiti in the surrounding areas were discussed. There seemed to be a shifting line dividing graffiti from public mural art. The students saw that public art could exist not only in relationship to the community, as with graffiti or murals, but also through organized art projects such as Sonoma's Salute to the Arts, in which artists in the community created artworks on the blank model of a cow. One young woman later reflected on public murals and community when she wrote that

> the class discussion of art truly left an impression on me because I explored what made me part of a population known as, "Casa Grande Students." We talked about public murals and art, and I discussed the artwork around my high school's campus. I realized in doing this that I would share this art with other Casa students forever. This makes us united in a unique way. It made me realize how important that part of my life was.[2]

The artists in the class were talking about their own experiences in creating art: art can come from a deep place within; it can be a talent, in the way some people are good at math; it can be a way to express how one is feeling. Students who felt a strong connection to art, as viewer and as artist, participated eagerly and presented strong opinions. Interestingly, among them were many students who had been quiet in previous classroom discussions.

Although the discussion was still active, I interrupted it to show a 30-minute film, *Persistent Women Artists* by Betty LaDuke (1996), in which she interviews Lois Mailou Jones, Mine Okubo, and Pablita Velarde in their own studios. The film is filled with images of their work, powerful paintings, drawings, lithographs, and murals that reflect their experiences as Native, Asian, and African-American women. In their 70s, 80s, and 90s, these remarkable artists discuss the political and social obstacles they encountered while continuing to create their vivid images expressing both the pain and the beauty of persisting in their endeavors. I chose to present the film immediately after the class discussions so that the questions I had asked and the further questions and issues that arose from them would be fresh, providing a critical framework for viewing the film. Now they were hearing from three elders talking from their wisdom and experience on the relationships between their art and themselves as artists, and their art and their communities. In addition, these artists talked about the ways in which their race and ethnicity informed and had affected their work. Finally, the stunning impact of the work itself allowed the students to experience art after talking about it. We did not discuss the film, but ended class, nearly everyone leaving quietly, filled with images.

I had hoped the activity would take away any fear of talking about art by starting with questions that do not have right or wrong answers. Moreover, the activity was effective in breaking down any monolithic definition of "art" the students may have learned or imagined and in providing glimpses into the diverse manifestations of creativity they had encountered, which may or may not be labeled "art." But still missing was more theory, more exploration of art as rooted in particular cultures or identities. These ideas were explored in the video, but I wanted to go deeper. I had prepared an overhead with points taken from bell hooks on what the African-American community can expect from its artists, which included: portray the "best" of our people; reclaim/celebrate a relationship with a rich past; serve as a catalyst for transformation; provide images of "us" and "them"; protest injustices and oppression; create art as a commodity. There was no time for this on the day for which it was scheduled, but next semester, I will be sure to include it—perhaps after the activity I describe next.

The next week I assigned the art research activity I had tested the previous semester. I asked my students to choose an African-American artist and briefly answer three questions: (1) What does the artist's work tell you about African-American culture and the importance (or not) of race and ethnicity? (2) Find a statement by the artist about their work. What does the artist say about the importance of race and ethnicity in their work? (3) Make a copy of one work of art that you especially relate or react to. Why did you choose it? Finally, I asked them to copy an image onto a CD, create a transparency, or save the URL of a site

where the image was stored and be prepared to project the image for the class and share their answers to the questions.

I was amazed at the responses to the assignment and especially enjoyed my surprise at the artwork: I could never have predicted which artist a student would choose or what moved them to select a certain piece. The in-class sharing worked well and everyone was actively engaged in looking, listening, and discussing. As a group, we received an introduction to a wide variety of African-American artists along with contrasting perspectives on what meaning the art held for us as viewers.

The strength of this activity was in breaking down stereotypes. In a white supremacist system, nonwhite peoples are, of course, relegated to an inferior position and so are their cultural productions. Art critiques often use "primitive" in connection with African-American artwork. Although this term did appear in some of the written responses from the students, probably taken from online critiques they found, in class they talked about how the artist was taking forms and symbols from Africa, or using bright colors to convey life and strength. Interestingly, while students described the paintings of artists such as Emma Amos and Betye Saar as clearly representing African-American culture, in part owing to the presence of African motifs, they also identified works with somber colors and no signs of Africa, such as Palmer Hayden's *Street Blues* or Henry Ossawa Tanner's *The Banjo Lesson*, as clearly created by black artists because the works showed the full humanity of black people. During the presentations, I felt the presence of the many, varied images of black people projected on the screen, taking apart the stereotypes of who and what African Americans are that permeate all aspects of dominant culture in the US. We focused our gaze and attention on a beautiful portrait of *Bill T. Jones* (Emma Amos), on the tender connection between the banjo teacher and his pupil (Tanner), on the lively, spirit-filled community depicted by Ernie Barnes. In addition, because each image had been chosen by the students presenting, based on a connection they felt to the work, their words reinforced the humanity of the subject. The student who chose Barnes wrote,

> His characters and style has a sense of movement and expression that reflects the human spirit. The other painter that comes to mind that has also depicted the human spirit is Norman Rockwell. I think Ernie Barnes is just as great as Norman Rockwell but specializes in painting African Americans more than white people.

The images brought by the students also addressed historic and contemporary social and political issues, some simply by the setting and situation depicted, and others in a more overt manner. For example, a student showing Saar's *Liberation of Aunt Jemima* said it made a bold statement against racism and for black pride. A young woman of color projected Amos's *Tightrope* and *Work Suit* and wrote

that Amos's artwork "shows how strong black women can be and even if you're a woman of color you are still equal." A young man chose William Johnson's *Jacobia Hotel* because the artist was arrested for loitering while painting it, something that shocked and angered the student. The class got a little more information on segregation and racism in the south from the student who chose to present on the quilts from Gee's Bend. After talking about the importance of family, of women passing down techniques through generations, he recounted how the town was cut off from the outside world of commerce and employment by a sheriff who said it's "not because they are black, but because they don't know they are black." I believe that hearing about history while gazing on specific works of art brings that history to life and makes if possible to empathize with people from a very different time and set of circumstances. However, it is not always possible for students to carry that compassion and outrage into contemporary situations. The young white woman who chose Hayden's *Street Blues* wrote that she could tell from the painting, Hayden is proud of his culture, and that the people in his paintings are proud as well.

> When I see his paintings I think of African-American culture from the south…rather than the life of black people I see around where I live, like Oakland…. Through his work I see a distinct culture that is happy about whom they are and embrace every part of the culture. It shows me that African-American culture is still alive and well today in some areas, like the south.

I commented on her paper that Harlem is in New York and that Oakland is one of the centers of contemporary African-American arts, but her statement gave me ideas for further explorations of contemporary local artists. Clearly there remain large gaps in learning coupled with misperceptions and, probably, white self segregation, all combining to make the vibrant living African-American culture of Oakland invisible to this student.

Two students chose abstract painters, Terrance Corbin and Sam Gilliam. Corbin's *Uccello's Ubiquitous Journey—Bebop and Jelly Jam* was especially enjoyed, bringing laughter to the room. I had not seen these artists' works and was aware of my own racist conditioning that left me surprised that black artists had created the paintings. Not intellectually surprised—of course, I "know" that African-American artists create abstract art and I have seen it before—but more of a cultural conditioning that had prepared me for representational paintings with images of black people, so there was a little jolt when the paintings were first projected.

In a follow-up critique of the activity, students talked about how much they appreciated the opportunity to look at art, something many felt they did not "know" anything about. I described my own feelings on being asked to teach

about art and how I'd been brought up to think that art was something to be understood intellectually, to be categorized according to period and style, and to be gazed at in a museum. Without discounting the value in studying art in these ways, I reminded them of our earlier activity when we talked about our relationships with art. In that sense, we all "know" about art, at times feeling it in our body and bypassing the intellect altogether. One student wrote about Amos's portrait of *Bill T. Jones,* stating that it was a moving piece of art but "I can't explain why I feel that way; it is just a type of emotion my body senses from the attitude and tone."

In this sense, I believe the art research and sharing was undoing whiteness in that it was joining spirit and emotion with intellect and building connections between people, rather than putting African-American art out there as something separate from the student viewer, and in particular, unintelligible to the nonblack viewer. The student who chose Tarrence Corbin's abstracts could not find much of a statement by the artist and he wrote,

> Tarrence doesn't say a lot about the meaning of his works, which I think gives room for people to find their own meaning. This gives hope to those who see his work. It can affect each person in a different way. I think the artist is encouraging people to find themselves in his work, to express their imagination in what they see.

Wondering what meanings the artist might ascribe to his paintings, I looked myself for a statement and found a transcription of an interview. Reading it increased my own knowledge of abstract art and of the artist's process, widening the space my upbringing had allocated for African-American artists in my own imagination. Interestingly, Corbin mentioned playfulness as a quality he strived for in his paintings: the student who chose Torbin was drawn to the painting because of its playful qualities. The simple activity of research and sharing I used might stimulate students to want to know more (as it has stimulated me to want to learn more!). One student described staying up until midnight because she was so interested in exploring all the different artists on the list.

HAVING BEGUN THE JOURNEY

I do believe that learning about art encompasses far more than this activity touched on and academic disciplines that focus on African-American art can expand understanding of African-American cultures in particular, American cultures in general, and historic themes and tendencies in the art and what they tell us about the times. Investigations of where African-American art is on display, the statistics on numbers of black artists in collections and exhibitions, the access or lack of access African-American artists have to galleries, where and whether

African-American art is reviewed, and so on tie directly to exploring how cultural institutions maintain whiteness. In my research, I have noted artists talking about their struggles to have their work shown and the creative ways they have dealt with racist cultural guardians.

American Cultures is about the many cultural groups that make up the United States. I am currently exploring activities to use with Chicano/a art. I also invited an art history instructor to guest lecture in my World Humanities class to learn more about Islamic art and to see how she talked about the images, how she taught about art. I plan to ask some others to come to the American Cultures class. The activities I introduced in my American Cultures class are actively evolving as I become more comfortable with them and continue my own explorations of the concepts and issues surrounding viewing, creating, displaying, and talking about visual art.

From defensiveness and fear, my initial reactions to being asked to bring more art to my class, I have traveled to curiosity and openness. When I wrote *Entering Whiteness with Conscious Intent in Post-Secondary Classrooms* (Helfand, 2002), I noted that there are many entry points into examining whiteness. The study of art was not one I mentioned (or thought of), even though I had read Dyer's (1997) in-depth examination of what the visible images of white people reveal about white supremacy. Certainly, these first experiments with my students indicate that it can be an entry point. I find it interesting that I shied away from teaching about visual art because I felt I did not know enough about it, where "know" referred to intellectual knowledge only. Repeatedly, I find that I most effectively subvert whiteness when I remember to engage intellect, emotions, and spirit, asking what each can teach me. Within academia, this always feels risky, as if I am stepping outside the bounds of acceptable behavior in doing so. Having friends and colleagues who can support me, knowing which authors to turn to for going deeper into an understanding of the need to include emotion and spirit, and maintaining my own spiritual practice help me in this ongoing struggle to reclaim my full humanity, valuing the parts that have been split off and devalued within the dominant philosophies, religions, and practices of Western civilization.

Once I step into this awareness, I am eager to try out new classroom activities and invite my students to enter subversive space. As described in this chapter, accepting that invitation in their American Cultures class, my students made cultural stereotypes visible and brought in authentic images of African Americans, part of the process of breaking down racial barriers that maintain white supremacy. They critiqued dominant cultural standards for visual art. Taken together, the classroom activities I added on visual art allowed many students to experience transformative learning—learning that leads to changes in worldview and openness to multiple perspectives. This process is necessary to an ability to

question, and eventually challenge, norms, behaviors, ideologies, and identities that maintain whiteness.

In fact, my own process of changing my syllabus and developing activities for learning about art has taken me through further explorations of whiteness myself—as has the writing of this chapter, which I utilized to bring to conscious awareness much of the process I've described. Following the words as they appeared on the computer screen, I opened myself to unexpected connections and new insights created through that alchemical process of writing. My self-reflections on my own relationships to art, my research, the development of classroom activities, and the writing itself all supported me in undoing whiteness, both internalized and institutionalized. Today I find myself visiting more art exhibits, picking up books about art and artists, and generally inviting the beauty, spirit, playfulness, deep messages, and cultural symbols, meanings, and mysteries of art into my life.

NOTES

1. This definition was cocreated with Virginia Lea, emerging from work we did together when I was working on my Masters.
2. This and other students' quotes are from students in my Fall 2006 Humanities 6, American Cultures class, who gave their permission for me to use their words in this chapter.

REFERENCES

Amaki, A. K., (Ed.) (2004). *A Century of African American Art.* Piscataway, NJ: Rutgers University Press.

Dyer, R. (1997). *White.* New York: Routledge.

Helfand, J. (2002). *Entering Whiteness with Conscious Intent in Post-Secondary Classrooms.* Self-published thesis for Antioch University McGregor School.

hooks, b. (1995). *Art Is on My Mind: Visual Politics.* New York: New Press.

LaDuke, Betty. (1996). Persistent Women Artisits [Film]. (Available from Reading and O'Treilly, 3617 S. Omar Ave. Tampa, FL 33629).

Lewis, S. S., & Waddy, R. (1969). *Black Artists on Art.* Los Angeles, CA: Contemporary Crafts.

Lippard, Lucy R. (1990). *Mixed Blessings: New Art in a Multicultural America.* New York: Pantheon.

Imaging Whiteness Hegemony IN THE Classroom: Undoing Oppressive Practice AND Inspiring Social Justice Activism

VIRGINIA LEA AND

ERMA JEAN SIMS

Why is it so hard to undo the hegemony of whiteness? By the hegemony of whiteness we mean the economic, social, cultural, and symbolic practices by which white, upper middle-class people, who are mostly men, continue to hold, *disproportionately* to their actual numbers, the power and privilege in the dominant institutions in the United States, Europe, and the world (Lewis, 2003). Not only are these practices most obviously represented by racism, but whiteness also includes all of those practices and policies that interlock to maintain the existing socioeconomic, political, racial-ethnic, class, and gender hierarchy (Featherston & Ishibashi, 2004).

In comparing how racism is *currently* practiced in the United States as compared with before the civil rights era, Edward Bonilla-Silva (2006) writes,

> Compared to Jim Crow racism, the ideology of color blindness seems like "racism lite." Instead of relying on name calling (niggers, Spics, Chinks), color-blind racism otherizes softly ("these people are human, too"); instead of proclaiming God placed minorities in the world in a servile position, it suggests that they are behind because

they do not work hard enough ... Yet this new ideology has become a formidable political tool for the maintenance of the social order. Much as Jim Crow racism served as the glue for defending a brutal and overt system of racial oppression in the pre–Civil Rights era, color-blind racism serves today as the ideological armor for a covert and institutionalized system in the post–Civil Rights era ... Thus whites enunciate positions that safeguard their racial interests without sounding "racist." Shielded by color-blindness, whiteness can express resentment towards minorities, criticize their morality, values and work ethic, and even claim to be the victims of "reverse racism." (pp. 3, 4)

In this chapter we explore one of the several ways in which we help the student teachers, enrolled in our Multicultural Pedagogy course in a northern California State University, to identify their own orientations toward race and racism, including color blindness, and to recognize how whiteness as hegemony plays out in public school classrooms in California.

As can be seen by Bonilla-Silva's observation above, those of us who embody and reproduce whiteness often see ourselves as benign, socially just individuals— people who bear no resemblance whatsoever to overt Ku Klux Klansmen who blatantly, if under the veil of a hood, expressed and express their antipathy to people of color, Jewish, and gay and lesbian people. Every semester while teaching the Multicultural Pedagogy course, we introduce the topic of whiteness, which runs like a mainstream through the heart of our classrooms, schools, and U.S. society. Figure 11.1 illustrates this mainstream/dominant culture and some of the narratives of whiteness that we meet as we navigate its waters. In addition to color blindness, they include meritocracy, standardization, high-stakes testing, tracking, individualism, cultural deficit theory, and dualistic thinking (black/white; them/us).

The majority of our preservice, largely white teacher candidates are horrified at the thought of being perceived as racist, or of teaching in racist ways. They are also uncomfortable with the idea of explicitly addressing issues of race, and many find a color-blind position normal. We try to mitigate these feelings by harnessing our different positionalities around race (Maher & Tetrault, 2001). As a white woman from an upper middle-class background, whose partial Arab ancestry is *not* worn stereotypically on her face, Virginia encourages the white student teachers to identify with her and take a journey similar to the one she took to identifying and working to transform the waters of whiteness into which she was born (Maxwell, 2004). As an African American woman, also from an upper middle-class background, whose Cherokee ancestry is also not worn stereotypically on her face, Erma Jean encourages her student teachers to hear the lived experiences of people of color and others who have been oppressed by whiteness. We both try to remove blaming from the process that we want our student teachers to engage. We know from our long combined teaching experience that when our students

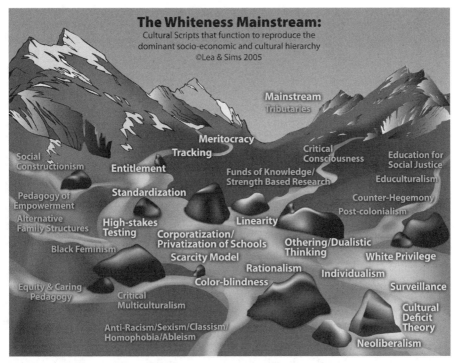

Figure 11.1. The Whiteness Mainstream: Cultural Scripts that Function to Reproduce the Dominant Socioeconomic and Cultural Hierarchy. © Lea & Sims (2005).

feel this emotion they tend to refuse to even begin the journey toward greater critical consciousness of the hegemony of whiteness, in themselves, in their schools, and in the wider society in which they live.

In addition to identifying *color blindness* and some of the other narratives or "cultural scripts" of hegemonic whiteness that function to reproduce the dominant socioeconomic and cultural hierarchy in the United States, we ask our student teachers to name a few of the counterhegemonic narratives that may be of service in interrupting whiteness. Figure 11.1 also illustrates some of the counterhegemonic scripts that begin in the tributaries of the mainstream and flow downward to challenge/contest whiteness as it plays out in schools, the media, the workplace, the political arena, and the other institutions of mainstream U.S. society (McLaren, 2007, pp. 289–314). These include critical multiculturalism, social constructivism, pedagogy of empowerment, hope, and love (Freire, 1993/1970, 1994, 1998), and black feminism (see Bullen, this volume).

Given that the vast majority of inhabitants of U.S. society, including people participating in the growing indigenous movement, cannot avoid participating in its dominant institutions, it is also hard for them to resist the torrential power

of the cultural scripts that they encounter within the mainstream. In *Why Is Corporate America Bashing Our Public Schools*, Kathy Emery and Susan O'Hanian (2004) provide us with a vivid analysis of the ways in which hegemonic corporate practices are reproducing the existing social and cultural hierarchy. Their research throws light on the extensive forethought, preplanning, and organization that has gone into, for example, the national Business Roundtable efforts to fit the work of schools to their economic agenda:

> In 1989 and again in 1995, the national Business Roundtable put its special brand on education reform, hammering home an agenda that defined reform thusly: state content and performance standards; a state-mandated test; rewards and sanctions based on test scores; school site councils composed of administrators, teachers, and parents; professional development focused on using test scores to drive instructional decisions; and phonics instruction in pre-kindergarten ... But as we discover that the essence of reform is not politics, not even philosophy—but money and power ... In order to understand school reform, one need remember only two rods: Standardistas lie. (p. 114)

Hegemony refers to more than dominance (Gramsci, 1971). As Herman and Chomsky (1988) so well illustrate, hegemony is about the highly effective "propaganda system" that works through the media to manufacture consent for socioeconomic, political, cultural, *and* schooling practices that are unwarranted and inequitable, that meet the interests of those in positions of power, and that lead to outcomes that do not serve the interests of all citizens.

> [Compared with the situation] where the levers of power are in the hands of a state bureaucracy), it is much more difficult to see a propaganda system at work (in the United States) where the media are private and formal censorship is absent. This is especially true where the media actively compete, periodically attack and expose corporate and governmental malfeasance, and aggressively portray themselves as spokesmen for free speech and the general community interest. What is not evident (and remains undiscussed in the media) is the limited nature of such critiques, as well as the huge inequality in command of resources, and its effect both on access to a private media system and on its behavior and performance. (Herman & Chomsky, 1988)

Therefore, with the cooperation of the mainstream media, the hegemonic mainstream veils the full nature of the arbitrary, socially constructed, and unequal economic, political, and educational structures and culture. Hegemony also renders invisible the process by which consent from the people for the existing system is gained. Indeed, hegemony works through our school system so that our student teachers come to see the traditional, Eurocentric classroom as benign and normal, and student teachers (or faculty), who question or disrupt the structure or content of this classroom, as problematic or deficient. Of course, some educators, parents,

community members, *and* students have knowledge that hegemonic processes govern the mainstream—the schools, the health system, the legal system, the political system, and the economic system—in which they are obliged to participate. However, because one of the characteristics of hegemony is concealing its own process (Lea, 2007), few have clear knowledge of how hegemony works, and/ or they are fearful of becoming fully conscious because this would result in cognitive dissonance (Festinger, 1957; Griffin, 1997). We experience cognitive dissonance when we possess conflicting sets of knowledge. In this case, knowledge of ourselves as socially just, and knowledge that the system in which we live and work is unjust. We must rationalize that the system is not unjust, or hide that knowledge away in our unconscious minds (see Berlak, this volume) if we are going to go on acting as if we are socially just individuals (at the same time doing nothing to change an unjust system).

Currently, those in control of political hegemony paint people who would challenge whiteness hegemony as the unpatriotic "other," and, at the extreme, as the "terrorist" (*Democracy Now*, 2004). In other words, counterhegemonic narratives have been carefully managed, and their progress down the tributaries into the mainstream of society (Figure 11.1) has been hidden behind an invisible "dam." The mainstream waters of schools still depict the United States, currently and historically, as a society founded on ideologies of egalitarianism and democracy. Most student teachers do not learn about the complex and contradictory nature of the actual history of their nation before they get to university, and not always when they do. Once "patriotized" from an early age in school (engaged in practices such as the Pledge of Allegiance that help them to identify with the state, become fearful of dissent, and rewarded for patriotism), student teachers have little opportunity in public schools to revisit their assumptions and those of their parents that the society in which they live is essentially benign. In other words, for many of our student teachers in our classrooms, it is initially impossible to see the hegemony of whiteness, let alone imagine and develop counterhegemonic practices that have a chance of undoing the normalized and monolithic whiteness that operates in and through our schools. However, it is the unveiling of these hegemonic practices of whiteness that we try to achieve in our courses.

Given their disenfranchised position in society, it is often low-income, underserved, and often disrespected students, disproportionately but not exclusively of color, who have the clearest view of how whiteness hegemony operates in our schools. When Malik, a tenth-grade student in a northern California high school, refused to engage in his Language Arts class he was seen as a poor student, even though he claimed that his resistance was associated with unwillingness to engage in a learning process in which he found no meaning (Kohl, 2007). However, Malik's experience in his History class was quite different. As he told Babatunde

and Virginia Lea when we worked with him on an Educultural Foundation project, his African American history teacher was one educator from whom he could learn. This teacher encouraged all of his student teachers to approach subjects such as the civil war from the perspective of the community with which they best identified. As Malik told us, "once you learn about yourself, then you're ready to learn about other people. If you don't know about yourself then you don't know nothing." Malik brought with him a clear sense of some of the hegemonic practices associated with racism and classism that are meted out to low-income people in the United States. He learned further to recognize how the history of dominated peoples has been silenced. He learned the multiple ways in which history could be interpreted, and how some stories are given salience and others are hidden. He learned how the hegemony of whiteness operates and how it can be undermined through interrogating systems of power from the position of a disempowered, working-class, black male student who is not expected to see through hegemony (Loewen, 1999; Takaki, 1993; Zinn, 1997). In other words, Malik learned how to see and challenge the practice of power.

For most people, however, including those who have been oppressed, the processes of power in the United States are indeed hard to see. Michel Foucault provides a very important framework for understanding the development of these processes of power over time:

> Since the sixteenth century, a new political form of power has been continuously developing ... [T]he state's power (and that's one of the reasons for its strength) is both an individualizing and a totalizing form of power. (Foucault in Rabinow, 1984, p. 14)

Within this paradigm, schools can be clearly seen as the institutions designated to prepare student teachers to perform the functions of the state, and today's capitalist state is one in which those individuals must be made into citizens who uphold the state's corporate function. Schools design citizens (Featherston & Ishibashi, 2004; Kalentzis & Cope, 2004); they design different citizens for different work roles (Anyon, 2005). Most of us who fill the roles of teachers in public schools today are, often unknowingly, frontline agents in the reproduction of the corporate-military capitalist state.

Foucault identified "disciplinary technologies" that he considered to be the precondition for capitalism (Rabinow, 1984). Although the technologies have changed over the few centuries,

> without the availability of techniques for subjecting individuals to discipline, including the spatial arrangements necessary and appropriate to the task, the new demands of capitalism would have been stymied. In a parallel manner, without the fixation,

control, and rational distribution of populations built on a statistical knowledge of them, capitalism would have been impossible. (Rabinow, 1984, p. 18)

We apply "disciplinary technologies" on our students early in their lives, usually less than consciously, to prepare them to fit in to the existing socioeconomic system. These technologies are embedded in the minutiae of everyday practices in public schools. They include depriving students of privacy; using grades and test results as carrots and sticks to make students intellectually and emotionally dependent on the teacher, and stars on whiteboards to publicly shame certain students and bring them into line by showing the whole group who among them is and is not obedient and worthy of belonging; using devices such as the bell to control movement; categorizing knowledge to confuse and disconnect potentially empowering ideas; and getting students accustomed as a group as well as individuals to obeying a "manager" (teacher) (Gatto, 2002).

The disciplinary technologies also include the standardized and standardizing tests and Americo-centric curricula and pedagogies, which are used to prepare students for these tests and sort students into different school and future life paths. "Americo" here signifies whiteness hegemony, preparing students for low-income positions within the political economy (see the afterword to this book). Curricula and pedagogies tend to be especially Americo-centric in low-income communities, and selected voices of people of color and women are conspicuously absent, except during certain moments of history like slavery and the suffragette movement (Anyon, 1981). However, those who devise the textbooks, who see traditional textbook forms and content as normal and natural, usually present these voices as disconnected from wider socioeconomic and political processes, and rarely presented in counterhegemonic ways (Herman & Chomsky, 1988). They are operating within a disciplinary matrix.

Through these disciplining technologies, including pedagogies and curricula, our student teachers develop identities, relationships, categories of relevant knowledge, and "normal" objects of that knowledge that are consonant with the objectives of the capitalist, consumer-oriented, mainstream, Americo-centric nation-state. Unless we become capable of interrogating what it means to uphold these disciplining technologies—the modalities by which we are made ideal teachers and student teachers (Gatto, 2002)—we shall not realize the goal of an equitable democratic and egalitarian society to which so many of us ideally aspire.

To help our student teachers contribute to this goal by understanding the nature of and acting to transform the hegemonic practices that divide, control, and blind us to the inequities that exist in the United States and beyond, we need to develop creative experiences through which they can begin to socially *deconstruct* what is considered "normal" in public schools. We need to provide them

with opportunities to identify the hegemonic practices that divide us and that constitute us as ideal subjects that reproduce the status quo. We need to help them to question the dominant categories of knowledge that those in positions of corporate and political power consider acceptable and appropriate. The dam that prevents counterhegemonic knowledge from reaching the mainstream could theoretically burst if more of us joined the already growing number of individual and group activists to plan, organize, and work in solidarity to publicly challenge the whiteness hegemony that is being practiced in our names—from the standardized testing and tracking practices in schools to the imperialist policies abroad.

WHITENESS HEGEMONY AND THE MEDIA: THE IMUS EXAMPLE

The effects of the power of whiteness hegemony in the modern capitalist state were recently displayed in the public outcry after CBS radio show host Don Imus called the Rutgers University Women's Basketball Team "nappy-headed hos." Given the context of the horrendous military atrocities being carried out in the Middle East, elsewhere in the world, and indeed in the United States, this incident might seem less significant. However, it is part of an insidious, and increasing number of public incidences of racism since the civil rights era of the 1960s and 1970s when personal, institutional, and cultural racism began to be legally addressed. The racist nature of these incidences is rarely given mainstream coverage, representing the willingness of corporations to tolerate, even promote, racist sensationalism if this behavior results in a larger audience or greater sales.

The following is one response to the Imus incident, posted to the *San Francisco Chronicle* on May 4, 2007:

> Settlement! CBS doesn't want to have to produce the internal memos and letters of complaint showing that they knew he did this stuff and then just OK'd it to keep the ad money coming.

What was most important for the corporate media in the Imus case, then, was the bottom line, not the ethical nature of Imus's program and its impact on vulnerable individuals and groups within the wider society. In fact, such media practice goes on all the time. The Imus case was one of the few that *was* brought to the public's attention. Eventually, CBS sacked Imus, who is now suing the corporation and may win:

> [Imus] has a specific "written warning" clause in his contract. Meaning he has to be warned in writing of "controversial or edgy" behavior that is unacceptable before being fired. CBS will argue that he was grossly beyond the bounds of acceptable FCC taste, but Imus will win. CBS will settle for $13M. (*San Francisco Chronicle*, May 2007)

CBS's guiding philosophy throughout this incident has been pragmatic. The incident was met with several other responses that suggested that behind closed doors, CBS representatives had no problem with racist discourse. This cynicism represents for us what has long been a typical, hegemonic view of human social relations: one in which it is acceptable to exploit others in the service of profit, even if the greatest part of that profit goes to those in power. It is representative of the "possessive investment in whiteness" (Lipstiz, 1998) that guided and legitimized the socioeconomic system of slavery and the genocide of indigenous people and has shaped the development of capitalism in the United States over the past four hundred years.

> Lipstiz argues that from colonial times to the present there has existed systematic efforts "to create a possessive investment in whiteness for European Americans" [p. 371]. Identifying what he calls a new form of racism embedded in "the putatively race-neutral liberal social democratic reforms of the past five decades" [p. 371], Lipstiz asserts that the possessive investment in whiteness can be seen in legacies of socialization bequeathed to U.S citizens by federal, state, and local policies towards African Americans, Native Americans. Mexican Americans, Asian Americans "and other groups designated by whites as 'racially other.'" (Clark & O'Donnell, 1999, p. 30)

Lipsitz echoes Bonilla-Silva's argument concerning the form whiteness hegemony has increasingly taken since the civil rights era—less visible, less clearly identified with color, yet still embedded in notions of race. In what follows, we report on how our preservice teachers have responded to an assignment designed to help them identify and interrupt whiteness hegemony in the classroom through the process of "imaging whiteness."

IMAGING WHITENESS

What does "imaging whiteness" mean? Given the "normal" nature and invisibility of whiteness as a hegemonic process in the school context, we theorized that to identify the process effectively we needed to employ an educlutural activity that required our student teachers to reify the process of whiteness. We, therefore, ask them to identify the hegemonic process of whiteness in the form of an image. (We ask student teachers to produce images that are either in the public domain or personal photographs.) In addition, given that many but not all of our student teachers are visual learners, and others favor a linguistic learning modality (Gardner, 2005), we ask our student teachers to develop a caption that encapsulates the essence of the hegemonic process as represented by the image.

Each of our student teachers is required to submit an image and caption as one of their assignments. We then collect the images and place them into a Powerpoint. The Powerpoint is played back to the student teachers, presenting the image first, and asking how this represents whiteness, in terms of the classroom and the wider socioeconomic and cultural systems in which the school is located. The caption is then introduced on the same slide as the image, and further dialogue ensues about whether the caption effectively captures the hegemonic process. In spite of many other activities, videos, readings, dialogue, and presentations in all the semesters designed to show the interlocking nature of whiteness hegemony, it remains hard for student teachers to identify the process. Therefore, some efforts at imaging the process are much more evocative than others. What helps student teachers in their struggles to see beneath and beyond the normal is a sense of support from the professor and their peers. As Leni Strobel (2004) has written, "this deep level of sharing ... requires a space of safety, respect, and empathy" (p. 40).

Figure 11.2 is an example of how one of our student teachers has imaged whiteness. (Shimmering Wolf Studios recreated this image and the others to replace copyrighted images.) Figure 11.2 was presented by a white female student teacher in her twenties, who was enrolled in Virginia's class in the summer of

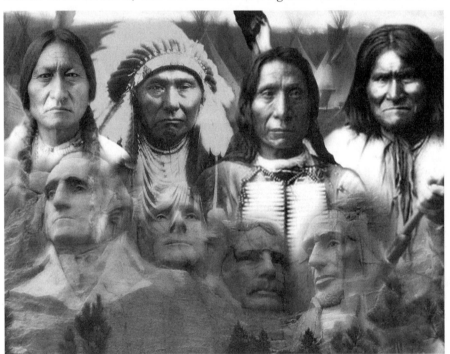

Figure 11.2. Who Were Your Founding Fathers?

2006. This was a student who presented herself as keen to practice social justice in her classroom. The image she chose cleverly juxtaposes the so-called Founding Fathers of the United States with some of the Fathers of the First Nations on the North American continent. It opened up a dialogue about the colonial origins of the United States. It evoked for the student teachers in the class familiar, Eurocentric/Americo-centric dualistic thinking that allowed them to question the hegemonic process of whiteness through which First Nations have come to be "on the downside of power" (Ahlquist, 2007). Several of the student teachers said that they had never before seen or questioned the legitimacy of the images of the Founding Fathers that were posted on the walls of their teaching practice classrooms. Many of the student teachers said that the image evoked strong sentiments that included sorrow, the pain associated with injustice, and guilt. These students said that the exercise made them feel ashamed about the history of the United States, or defensive about their lack of awareness of the hegemonic process by which white privilege has been imposed on the mainstream consciousness. As Leni Strobel (2004) wrote in her chapter on "Teaching about Whiteness When You Are Not White," "[e]motions are very good teachers" (p. 39).

We showed this image as part of a presentation on Imaging Whiteness at the 2006 National Association for Multicultural Education (NAME) conference. Asked to contribute their own caption for the images, one of the participants in the conference responded, "White memories are always carved in stone." For us this was a profound comment. It helped us to understand why it was so hard to arrive at a more truthful portrayal of history, and a more nuanced understanding of the nature of power and privilege in the United States. Whiteness hegemony is indeed a process by which the symbols and historical narratives that reflect white, disproportionately upper class and male power and privilege have acquired a certain permanence (Bell, 1992). They are used to reinforce the idealism that undergirds much of the hegemony of whiteness in the United States. Idealism as a philosophy pretends that certain knowledge exists outside of the human cultural process. According to Socrates, speaking through Plato, the philosopher's job to uncover this knowledge, the highest form of which is "pure" (Gutek, 2003). From an early age, the "pure forms" of U.S. historical knowledge are etched into our brains. They are also appealed to by those in power to remind us who "should" control and be in power in the United States and the world. Interrupting these messages is no mean feat.

Many of our students arrive in my class having already experienced culture shock on a continuum from guilt to paranoia, as a result of discovering in college that the history of the United States was not as they were told when they were in school. They talk about their emotional reactions to learning about alternative

historical narratives—that the United States was built on the genocidal and racist actions of some of its leaders and their followers, driven by economic and power-related goals (Loewen, 1999; Takaki, 1993; Zinn, 1990). These new truths may, however, be repressed if the same students encounter mentor teachers who see no need for or find few avenues for deviation from the mandated texts promoting a hegemonic historical perspective that is given predominance in K-12 classrooms. Student teachers need and want to build strong, supportive, and information-ally nutritious relationships with their mentors, and mentors in teaching creden-tial programs vary in the extent to which they are looking for ways to resist the content mandates imposed by No Child Left Behind (NCLB) and state testing programs.

It is also true, though, that a majority of our student teachers in our north-ern California State University teacher credential classroom claim to "see" the relationship between the hegemony of whiteness and Eurocentric/Americo-centric texts. Figure 11.3 and its caption were offered by yet another white, middle-class student teacher in her twenties. She referenced Sonia Nieto's (1994) paradigm of multicultural education that we have incorporated into our critical educultural model in the afterword to this book. In this student's view, K-12 students need to be served a counterdiet of "affirmation" of their cultural backgrounds, "solidarity" with each other across race, class, gender, and other

Figure 11.3. Truths I Never Learned In School.

divisive categories of experience, and "critique" in that they need to learn to question dominant scripts and demand rich, multicultural perspectives on the human experience.

On the other hand, the promotion of a hegemonic narrative about the history of the United States is apparently entirely logical at the highest levels of the U.S. political establishment. Chomsky (1993) tells us that in 1960, Hans Jurgen Morgenthau, a so-called realist, would have had his readers distinguish between America's transcendent purpose to bring about liberty, equality, and peace in the world and America's historical record, which has deviated sharply from this picture. To Morgenthau, it is the purpose that matters. It would, in his view, be a logical error to focus on the negative in U.S. history since one should make a distinction between "reality" and "the abuse of reality" (Chomsky, 1993, p. 120). Morgenthau's "reality" denotes history as interpreted through the dominant American perceptual set, defined here as whiteness. "It is only necessary to consult the evidence of history as our minds reflect it" (Morgenthau, 1960, p. 8). This "evidence" is what Americans, positioned alongside Morgenthau, would prefer to see, prefer to believe as having happened. It is a mythical "reality" that is logically, not to say imperatively, acceptable to Morgenthau.

On the other hand, the multiple actualities of history—genocide, the horrors of slavery, and indentured serviture—constitute for Morgenthau "the abuse of reality." They may represent what really happened, but are unacceptable as American truths, which are rewritten in the so-called national interest and couched in hegemonic rhetoric. Many of today's executive pronouncements are couched in the same logic. (The Imus example is a case in point. The CBS Corporation felt they could ignore it.) It is a macro application of "W.I. Thomas' famous dictum that 'if men define situations as real, they are real in their consequences'" (Wineburg, 1994, p. 165). Although this is frequently played out on the track or the football field or in the classroom in terms of teachers' expectations of students or students' expectations of themselves (Good, 1987) as an ideological maxim for national or international policy, it has not been shown to result in a more egalitarian socioeconomic structure (Anyon, 2005).

To return to Morgenthau's reality, this process of colonizing the truth is widespread, as testimony with regard to the United States purpose in Iraq would indicate (USLAW, 2007). Whiteness hegemony is a discursive process that is informed by an extraordinarily strong ideological sense of entitlement. It includes the practice of avoiding "truths" that promise to disrupt this entitlement, and employing "novel combinations of old and new" discourse categories to legitimize this avoidance. Whiteness entitles people to impose certain cultural shades of "reality" on reality—shades that reflect best on the norms, values, and accomplishments of men of European origin, but as Herman and Chomsky told

us, not to the total exclusion of other cultural perspectives. As Raymond Williams (1994) argued,

> It can be persuasively argued that all or nearly all initiatives and contributions, even when they take on manifestly alternative or oppositional forms, are in practice tied to the hegemonic: that the dominant culture, so to say, at once produces and limits its own forms of counter-culture. (p. 599)

Figure 11.4 was contributed by a well-meaning, white, twenties-something student teacher, largely unaware of the hegemony of whiteness. When this student teacher proudly presented this figure to the Multicultural Pedagogy class as one slide in a Powerpoint, the entire class, including ourselves as professors, was impressed with the acuteness by which it helped us to recognize the invisibility of the process of whiteness hegemony. None of us saw initially the deficit perspective that it promoted. Focusing as we were on the hegemony of whiteness, we failed to see how our assumptions about the negative nature of blindness were engaged in a dualistic thinking process to throw the invisibility of whiteness into relief. We failed to question our stereotypes about blindness as a totally negative condition. In fact, it was not until a participant in the NAME conference mentioned earlier questioned the use of blindness to recognize whiteness that we became fully aware of the negative juxtaposition we had accepted. While we both strive

Figure 11.4. Warning! Whiteness Causes Blindness.

to disrupt labels such as "disabled," commonly seen as deficient in some way, and we strive to empower those labeled "disabled" to move away from the margins by using alternative terms such as "differently abled," we often miss seeing how we are practicing what we preach against.

Subsequently, we added the word "color," to the caption, which now read: **Warning! Whiteness Causes Color Blindness**. Although the new caption drew our attention to the link between whiteness hegemony and the modern racism identified by Bonilla-Silva in his book *Racism Without Racists*, when associated with the image it did nothing to remove a deficit implication about blindness. It therefore remained highly problematic.

As a footnote, the student teacher who contributed this narrative undertook her full-time student teaching in the fall of 2006, one semester after she had completed the imaging activity. With Virginia as her supervisor, the student teacher experienced severe difficulties in her final teaching placement moving away from traditional Americo-centric teaching practices, toward more critical multicultural, educultural teaching strategies, especially with respect to race. Although the student teacher was open to changing both the form and content of her curriculum so that it was engaging to all of her students, she could not "see" beyond her own Americo-centrism. Virginia wonders whether she could have better prepared this student if hegemony, in all of its forms and content, had been more visible to her as the professor. It is clear to us that individual teachers can make an enormous difference in the preparation of student teachers.

CONCLUSION

We started this chapter with a question: Why is it so hard to undo the hegemony of whiteness? The question was somewhat rhetorical as we already knew that the hegemony of whiteness was not stable or fixed. It is a process that draws on extensive state and corporate resources, including school and the media, to maintain and create practices, policies, and processes that reproduce the existing, "Americo-centric," socioeconomic, political, and cultural hierarchy.

However, in writing this chapter, we have gained a lot of insights into why it is so hard to undo whiteness. The hegemony of whiteness is more than color blindness or "racism lite." It is safeguarded through established "disciplinary technologies" and depicted as normal and natural within the social and cultural mainstream. It is standardized, invisible, and many avoid challenging it because they are fearful and/or do not want to appear unpatriotic. Finally, whiteness hegemony invalidates counterhegemonic scripts and concomitantly promotes ideologies that tell us that we are entitled (and obliged in the case of young children) to perceive

only positive representations of U.S. history and the present as legitimate. We learn that if we identify with narratives that see truth in "the abuse of reality," we could personally experience negative consequences. We learn that if negative representations of history or the present cause us to *feel* uncomfortable or *experience* discomfort we are entitled to see this version of history as an "abuse of reality" and to avoid it in favor of a sanitized set of narratives that support the status quo.

In this chapter, we have shared one of the many activities in our Multicultural Pedagogy course to help our student teachers get to the heart of the hegemony of whiteness and how it plays out in their classrooms. This chapter has considered how one of these activities has contributed to this process. We have examined a few responses to this activity that are representative of the most effective of our student teachers' contributions (Figures 11.2, 11.3). We have also included one problematic example (Figure 11.3) that cleverly identifies a central theme in whiteness hegemony but draws on deficit thinking about blind people to do so.

We have collected our student teachers' responses to the activity over the last four semesters with a view to (1) evaluating the extent to which they are able to recognize and consider ways of interrupting the hegemony of whiteness *as it plays out in our classrooms* and (2) assessing the contribution of the exercise to our goal of helping our student teachers develop increased critical consciousness concerning the process of whiteness hegemony. We also collected our student teachers' final reflections about the activity. In these reflections, they were asked to reflect on the extent to which they believe the activity had contributed to their achieving and understanding the hegemony of whiteness and how it plays out in the classrooms.

Our conclusions from analysis of the above data is that, over this four-semester period, a growing number of student teachers have gained significant insights into what whiteness hegemony is practiced. Given that we have seen a pattern in which the number of student teachers expressing awareness has grown and claimed that this activity is the one that has been most helpful for them to recognize how whiteness hegemony is practiced, we have concluded that we are becoming increasingly competent in explaining and dialoguing about whiteness. Hegemony is hard for all of us to identify.

As is the case for all of our classes, recognition of a problem is not a good place to leave a course. The next stage—action—is essential if our student teachers are going to be empowered to sustain critical multicultural and *educultural* practices once they become teachers in increasingly standardized and corporatized schools. Therefore, our students leave our course with plans for how they are going to implement critical multicultural education in their classrooms, including ideas for undoing the hegemony of whiteness. In addition, we are engaged in research with other colleagues in the California State University system to follow

our student teachers into their teaching placements. We hope to learn from them what would help them to implement counterhegemonic practices in their classrooms and school sites. We want to find out how we can better serve future teacher candidates in our Multicultural Pedagogy course, and how we can support them in the field.

REFERENCES

Ahlquist, R. (2007). Neocolonial representations of the other in Ruby Payne's a framework for understanding poverty. Part of a larger presentation by R. Ahlquist, P. Gorski, V. Lea, T. Montano, & R. Quintanar, *Uncovering classism, linguicism and racism in Ruby Payne's framework for understanding poverty: Challenging deficit views in 2007.* American Education Research Association, Phoenix, AZ.

Anyon, J. (1981). Social class and school knowledge. *Curriculum Inquiry,* 11 (1), 3–42.

—— (2005). *Radical possibilities: Public policy, urban education, and a new social movement.* New York: Routledge.

Bell, D. (1992). *Faces at the bottom of the well: The permanence of race.* New York: Basic Books.

Bonilla-Silva, E. (2006). *Racism without racists: Color-blind racism and the persistence of racial inequality in the United States.* Lanham, MA: Rowman & Littlefield.

Chomsky, N. (1993). *Year 501: The conquest continues.* Boston, MA: South End Press.

Clark, C. & O'Donnell, J. (1999). *Becoming and unbecoming white: Owning and disowning a racial identity.* Westport, CT: Bergin & Garvey.

Democracy Now. (2004, September). Hijacking catastrophe: 9/11: Fear and the selling of American empire. Retrieved August 18 2007, from Democracy Now website: http://www.democracynow.org/article.pl?sid=04/09/10/1350224&mode=thread&tid=25.

Emery, K. & O'Hanian, S. (2004). *Why is corporate America bashing our public schools?* Portsmouth, NH: Heinemann.

Featherston, E. & Ishibashi, J. (2004). Oreos and bananas: Conversations on whiteness. In V. Lea & J. Helfand (Eds.), *Identifying race and transforming whiteness in the classroom.* New York: Peter Lang.

Festinger, L. A. (1957). *A theory of cognitive dissonance.* Evanston, IL: Ron Peterson.

Freire, P. (1993/1970). *Pedagogy of the oppressed.* New York: Continuum.

—— (1994). *Pedagogy of hope: Reliving pedagogy of the oppressed.* New York: Continuum.

—— (1998). *Teachers as cultural workers: Letters to those who dare teach.* Boulder, CO: Westview Press.

Gardner, H. (2005). *The development and education of the mind: The collected works of Howard Gardner.* London: Taylor & Francis.

Gatto, J. T. (2002). *Dumbing us down: The hidden curriculum of compulsory schooling.* Gabriola Island, BC, Canada: New Society.

Good, T. (1987). Teacher expectations. In D. Berliner and B. Rosenshine (Eds.), *Talks to teachers* (pp. 159–200). New York: Random House.

Gramsci, A. (1971). *Selections from the prison notebooks.* New York: International.

Griffin, E. (1997). *A first look at communication theory.* New York: McGraw-Hill. Retrieved August 18, 2007 from http://www.afirstlook.com/archive/cogdiss.cfm?

Gutek, G. L. (2003). *Philosophical and ideological voices in education.* Boston, MA: Allyn & Bacon.

Herman, E. S. & Chomsky, N. (1988). *Third world traveller. Manufacturing consent: A propaganda model, excerpted from the book Manufacturing Consent*. New York: Pantheon Books. Retrieved August 18, 2007, from http://www.thirdworldtraveler.com/Herman%20/Manufac_Consent_ Prop_Model.html.

Kalentzis, M. & Cope, B. (2004). Designs for learning. *E–Learning*, 1 (1), 38–93.

Kohl, H. (2007). I won't learn from you! Confronting student resistance. In W. Au, B. Bigelow, & S. Karp (Eds.), *Rethinking our classrooms: Teaching for equity and justice, Volume 1*. Milwaukee, WI: Rethinking Schools.

Lea, V. (forthcoming) Why aren't we more enraged?: Whiteness hegemony in deficit frameworks for understanding poverty. In R. Ahquist, P. Gorski, & T. Montano, (Eds.), *The Resurgence of Cultural Deficit Theories in Education: Disrupting Ideologies of 'Less than'*.

Lewis, A. (2003). *Race in the schoolyard: Negotiating the color-line in classrooms and communities*. New Brunswick, NJ: Rutgers University Press.

Lipstiz, G. (1998). *The possessive investment in whiteness*. Philadelphia, PA: Temple University Press.

Loewen, J. (1999). *Lies across America: What our historic sites get wrong*. New York: New Press.

Maher, F. A. & Tetrault, M. K. (2001). *The feminist classroom: Dynamics of gender, race, and privilege*. Lanham, MA: Rowman & Littlefield.

Maxwell, K. (2004). Deconstructing whiteness: Discovering the water. In V. Lea & J. Helfand (Eds.), *Identifying race and transforming whiteness in the classroom* (pp. 153–168). New York: Peter Lang.

McLaren, P. (2007). The future of the past: Reflections on the present state of empire and pedagogy. In P. McLaren & J. Kincheloe (Eds.), *Critical pedagogy: Where are we now?* New York: Peter Lang.

Morgenthau, H. J. (1960). *The purpose of American politics*. New York: Alfred A. Knopf.

Nieto, S. (1994, Spring). Affirmation, solidarity, and critique: Moving beyond tolerance in multicultural education. *Multicultural Education*, 1 (4), 9–12, 35–38.

Rabinow, P. (Ed.). (1984). *The Foucault reader*. New York: Pantheon Books.

San Francisco Chronicle. (2007, May). Retrieved August 18 2007, from Democracy Now San Francisco Chronicle website: http://www.sfgate.com/cgi-bin/blogs/sfgate/detail?blogid=7&entry_ id=16220.

Strobel, E. (2004). Teaching about whiteness when you're not white: A Filipina educator's experience. In V. Lea & J. Helfand (Eds.), *Identifying race and transforming whiteness in the classroom* (pp. 29–36). New York: Peter Lang.

Takaki, R. (1993). *A different mirror: A history of multicultural America*. New York: Little, Brown.

USLAW (U.S. Labor Against the War) (2007). Retrieved August 18 2007, from USLAW website: Available online: http://www.uslaboragainstwar.org/.

Williams, R. (1994). Selections from Marxism and literature. In N. B. Dirks, G. Eley, & S. B. Ortner (Eds.), *Culture/power/history: A reader in contemporary social theory*. Princeton, NJ: Princeton University Press.

Wineburg, S. S. (1994). The self-fulfillment of the self-fulfilling prophecy. In J. Kretovics & E. Nussel (Eds.), *Transforming urban education*. Boston, MA: Allyn & Bacon.

Zinn, H. (1997). *A people's history of the United States*. New York: New Press.

Figuring THE Cultural Shape *We're* IN

CATHY BAO BEAN

"What's your favorite color?"

"Who's your best friend?"

"Which is the coolest game?"

Children can exist in and with multiple realities—from a Santa Claus who can slide down chimneys into apartments with no fireplaces to the evil demons that can be warded off by the sound of firecrackers. However, when we ask questions that require one right answer, it is little wonder that we squeeze our answers into a single, pyramidal world. In this world "common sense" and "being reasonable" mean that there is room for only one answer at the top. Regardless of relevance, choosing *the* one is not only possible but also expected, even desirable.

"Be yourself."

"To thine own self be true."

"Develop self-esteem."

By talking about personal development in the singular and, at the same time, warning people against being "self-inconsistent," "two-faced," "fork-tongued," and so on, we promote the presumption that being "whole" and "one" is the ultimate goal of human development. We hyphenate our multiple identities to sustain the illusion of wholeness. In this context, positive classroom *discussions* of diversity— the antithesis of wholeness—can feel like problematic, probably negative, states of cultural schizophrenia for which the cure is the kind of "Americanization" that values homogenization and conformity. This is especially true if we have not

experienced or absorbed multicultural lessons from school or experience (Bao Bean, 2005).

Measuring the cultural in these "singular" terms is to value being monochromatic and standardized. In North America, this is "whiteness." Official methods of regulating behavior, such as those used in boot camps and business meetings, have value but they need to be kept in context. When their homogenizing function is generalized, they instigate whiteness.

Many immigrants to the United States *think* in English but still *feel* in the language of home. This cultural reality is devalued in the dominant culture of the United States that objectifies knowledge. In this culture, people tend to disregard the idea that "feelings are facts too" (C. A. Torre, pers. comm., August 29, 1996). I am a female who arrived in America from China at the age of 4 in 1946 and who grew up in New Jersey at a time when the country had fewer Chinese than now live in this state alone:

> Because I speak Chinese but think in English, my bilingual experience doesn't afford me as much leeway in which to navigate as those who can speak and think in both languages. Sometimes I can make up for the lack by being mindful of the terrain beneath the surface of people's words but, other times, just saying it is the problem. I remember going to bed the night I realized that, one day, I'd have blond hair and blue eyes. If I was good. Assuming the position of all those angelic (fair-haired and fair-skinned) little girls I'd seen on Christmas cards, I kneeled, hands folded, head bowed, and prayed.
>
> Now I lay me down to sleep.
>
> I pray the Lord my soul to keep.
>
> Then, afraid my mother might come in and find me in such a compromising position, I got into bed and figured it couldn't make that much difference if I finished up prone as long as I signaled my intention with folded hands.
>
> If I should die before I wake,
>
> I pray the Lord my soul to take.
>
> As soon as I spoke the words I got really nervous. There I was, on my back, arms across my chest, like Bela Lugosi in his Dracula coffin. God may know it all and stick to His plan no matter what, but [Chinese] deities can get ideas they hadn't thought of but a human suggested. Of the 150 or so gods, none are omniscient, omnipotent or omnipresent and many are not all that bright. And though I never knew anyone who actually "believed" in them, I knew none who didn't behave as if they did exist. So I, right away, took back the first part of the prayer, then added enough of an addendum to clarify any remaining confusion about wishing for my imminent demise, but not so much that they might dwell on the subject, and finished up on my stomach.
>
> And bless Mommy, Daddy, Bette and SanSan.
>
> And Miss Diamondis (she's my teacher).

Not sure if an incantation worked if only half of it was said out loud, I did know that, in any system, "being good" meant I was the sort of person who didn't just think of herself exclusively or too directly.

[Later], when I was in fifth grade, my mother said, "You're living in America, you should know about American religion. Why don't you go to church with your friend across the street?" I went to the services as well as attended classes, choir practice, Luther League meetings and socials. Going to church and coming home became routine. I would get in the car after Sunday School in Tenafly, humming,

I will make you Fishers of Men,

Fishers of Men, Fishers of Men.

I will make you Fishers of Men,

If you follow Me.

And head for home, a Disciple of Jesus, ready to reel 'em in. Arriving in Teaneck, I'd emerge from the car, a Follower of Confucius, no relation to Adam and Eve. The transition that occurred en route was natural, part of needing to "swing" into a different mode—like an athlete who cross-trains or a prison guard who's also a lenient mother. (Bao Bean, 2001, pp. 157, 101)

While I was a child, being of "two minds" was not usually traumatic so that putting my selves "back together" was not always because I had been "torn apart." I accepted my multiplicity as normal. However, as I got older and spent more time, energy, and thought in the world of school and church, and then community and nation, the contrast with the world of home sharpened and deepened. The former was in English and about activity, discussion, power, testing, deduction, belief, laws—all in a white, Anglo-Saxon, Protestant mode (even in a town that was 38% Jewish!). Meanwhile, home was about eating, sleeping, changing, bathing, chores, and television, and these activities often happened in silence or in Chinese. We avoided the unpleasant so as not to provoke the gods' interest and left unsaid that which my parents presumed we knew by absorption, by being "Chinese."

Similarly, everyone outside my home culture had their presumptions that were so obviously true or right that *not* discussing them was "normal"—like "a mother's love." Their unexamined status made them inviolate and impenetrable. This was the "whiteness" that was the foundation and backdrop for my public life. Nondominant cultural norms were indeed "Other." Today we often describe and explain them with special "months" —black history month, women month, Asian Pacific American month, and the like. These get *special* attention because they are Other than the norm.

In college, we talked about being a "Banana" or "Oreo"; we talked about race, class, and gender. I was 22 when I first *heard* myself speak a kind of pidgin. Superficially, this was ludicrous. I spoke with an American accent when speaking

English and I had scored in the top one percentile on the Graduate Record Exam (GRE) for verbal competence! Yet, between bouts of laughter, my fiancé insisted that I sounded like a recent immigrant when he listened to me talk on the phone to my mother. After the next call home, I realized he was right. Wanting to connect my two worlds by telling my mother about graduate school, I also did not want to flaunt my know-how relative to her linguistic and intellectual accomplishments. Unconsciously, I had adopted this way of talking, despite my limited Chinese, by arranging the English words according to Chinese grammatical rules. It was not broken English; it was mended Chinese.

Reflecting on this episode in my life, I knew Edward T. Hall (1959) was right to say in *The Silent Language*, "Culture hides much more than it reveals, and strangely enough, what it hides, it hides most effectively from its own participants" (p. 39). As a preteen, I began to try to make things in one of my worlds "unhidden" while keeping it from colliding with my other world. This began when the minister insisted that I had "The (One) Way, The Truth, and The Light," and I must take this knowledge to my Chinese home. Yet, home was a place where the gods were not so unreasonable, so inefficient, as to demand that everybody be or do the same as everybody else. On the other hand, the pastor put such zeal into his request. How could I bear to disappoint him or the person I was when I heard him? I prided myself in being one who followed instructions well, who pledged allegiance with fervor. Was I benighted by some dark force into believing that switching between worlds was good when it wasn't? However, if I was not a dupe of darkness, was I then a hypocrite? I had never experienced having something like that believed of me. Not by friends or by people who still liked me. The thought put me off balance—it was so final, eternal, and, worst of all, *personal*.

At 64, I am still learning how to pay attention to how the different worlds in which I live function, and then bringing into a public space the words that help me and others reveal and "re-cognize" our participation in those worlds. The first step is not deciding which worldview is "better." Refraining from *pre*scribing before *de*scribing is a pivotal social, political, and academic skill. However, most teachers in this country, regardless of personal ethnicity, characterize the world and the people in it primarily in terms of a single identity set by Western(ized) thinkers and institutions. For example,

- Plato's Aristophanes would have us be wholly ourselves through sexual unification;
- Later adaptations of the sexual project by St. Augustine, Martin Luther, and other Christian thinkers regarded the "ideal" as the rejections of the physical or "cave" self;

- Aristotle and his philosophical descendants—St. Aquinas and Maimonides—described life as a process of actualizing our *innate* possibilities as an acorn should become an oak tree and not a maple;
- Descartes and his critics conceived identity as a "ghost" or a "ghost in the machine."

Although other "Western" philosophical variations of "body and soul" imagery have portrayed our "self" to be something less bifurcating—for example, existential and dialectical ways of "being in the world"—most Western intentions are framed in terms of the cultural and experiential *singular*. As a result, as mentioned earlier, it is not easy to take multiculturalism seriously, or to know *and* believe the following:

- That the *uni*verse is (and should be?) *di*verse such that there are indeed "worlds of difference" in how we accomplish seemingly common goals;
- That people who live "on the hyphen" as, for example, Asian-Americans, Irish-Americans, African-Americans, will probably have several cultural "selves" such that single-mindedness is not (and should not be?) their norm.

Consequently, students are overtly and subliminally taught that cultural "differences" are not fundamental, and that underneath it all

- we are "the same," "human," and so on in that we all want to be, for example, "free" even though, from some cultural perspectives, this entails shameful "individuality";
- we are able to live in harmony in that we all can be, for example, tolerant even though, from some cultural perspectives, this entails guilty "sympathy";
- we are able to be respectful in that we all can say, for example, "please" and "thank you," even though, from some cultural perspectives, this entails insulting "politeness."

The often unspoken corollary to each is that, if you do not concur and/or are unable to confirm and conform to these basics, you (and the culture that produced you) are "deviant" with deficiencies in aptitude and morality. These tacit messages of single-minded similarity comprise the "whiteness" that can overwhelm the "Other" with its self-evidence. The messages are delivered and reinforced by institutions—from classrooms designed to value the "quiet and well-behaved," to offices that can only incorporate policies and plans that are quantifiable and expressed in English only.

We knowingly and unknowingly communicate in the classroom that there exists a "natural," "normal," "customary" way of being that makes taking multiculturalism seriously very difficult. This is not to say that we should not want or promote a fundamental way of being or broad set of values, such as described in the Bills of Rights, or the U.N. Charter. However, this desire or goal is itself a matter of enculturation. For example, the U.S. Postal Service, and those who have been Americanized and who embody whiteness, regard mail to be "private" from the time an individual is capable of reading. It, therefore, makes perfect sense for anxious parents to wait for their high school seniors to rush home to open letters from college admission offices or that, once in college, grade reports will be addressed to students. In contrast, many cultures would regard such mail as a "family," not an "individual," matter, so opening a letter is dictated by function, not form. The Western/alternative cultural rub happens when students meet this invasion of privacy with incredulity, even horror, demanding a "rational" explanation of how it could be tolerated by anyone, *regardless of culture.*

Further, I think the U.S. educational system compels us to "arrive at a conclusion," "come to terms," and "summarize." This cuts short the time needed for what we teach and learn to sink in and transform us. In this way, those who have been Americanized tend to value "information," "knowledge," and "new tricks," although the Asian stresses the "wisdom" that usually only comes with older age (measured in decades, not minutes!). "Culture" did not happen overnight. Understanding cultures will not either.

Again, in my case, I could articulate my feminist views long before the "Chinese American" ones. Thinking in English and forgetting in Chinese, I consciously identified with the Declaration of Independence, the Bill of Rights, and the Emancipation Proclamation. What associations I had with the Exclusion or McCarran-Walter Acts were not as passionate as the indignation I felt about how long it took for *Brown v. Board of Education of 1954* to happen. The experience of being "Other" had to be translated from the emotional/psychological, often silent, language of the home culture into one that could not only clarify but also validate this experience. The response needed to be more constructive than the expression of pride born of resentful defiance and/or hostile separation. In other words, I have reached a more complete understanding of the hyphenated selves because I am now consciously, intellectually, and emotionally *pleased* with the discrepancy between my various cultural worlds, and delighted with the energy generated by their differentiation. It may not always be fun but it is rarely boring.

Consequently, for me, the ethical, political, economic searching and finding are inseparable from the cultural. I have replaced the imagery of "one" and

"whole" with

and the question: *What cultural shape(s) are you in?*
First about the drawing (Bao Bean, 2001, p. 215):

> Is it a rabbit? A duck? A duck-billed platypus? A plucked daisy? Nude descending the staircase? If you concentrate, one or the other comes into view. Or something no one else has seen.

> But no matter how many images you perceive, no matter how quickly you can switch from the "duck" to the "rabbit" and back again, the drawing can only be one thing at a time.

> Carol Gilligan [Gilligan, 1985] once likened this phenomenon to what (most) women and (some) men may experience when, for example, they render a verdict. They may first decide in terms of "the law," according to [seemingly] objective and impersonal standards, and then, almost, but not quite, instantaneously view the same set of circumstances "in a different voice," in terms of the more subjective, personal, and/or individual considerations.

> The same kind of "cultural" double-take occurs when you go to the doctor's office: first seeing yourself as an "object," an anatomical specimen that is "examined," not touched; then seeing yourself as a subject, a person with history and worries, for whom the touching can be medical or sexual.

> Background-foreground cartoons are often found in children's books. They can be more than a moment's entertainment. They can be a lesson in how to review our lives and our many cultures—as double visions, twice removed, by time and understanding. They can train us to admire the variety before deciding which, if any, is "better." They can remind us of what John Gillis has written [Gillis, 1996], "We all have two families, one that we live with and another we live by."

Once we replace the "whole" with the "duck-rabbit-platypus-and the like" model, it is easier to resist the unifying goal in favor of diversifying which, after all, is what most schools *espouse* as mission and curricular guidepost. The duck-rabbit approach is a device to reveal how and why there are many more viewpoints than there are people and that this condition is not something that needs "fixing" but is itself "normal," even desirable. By using a device that does not itself have any specific cultural content, we can experience the action of switching with little, if any, preference.

More problematic is the *question*, "What cultural shape(s) are you in?" It is dangerous because it has to do with the idea that cultural diversity is real. But, once we "characterize" a cultural group we should never forget that all such generalizations are inductive, limited by the breadth and depth of our past experience and subject to the input of future experience, as well our individuality. To forget this is to stereotype. With this caution in mind, we have to generalize or we would have to interject so many "ifs, ands, and buts" that our lesson plans and syllabi would be unwieldy.

Actually, generalizing about a group of people is probably what our (grand)mothers did when we were still tied to their apron strings. For them it was no big deal to say, "Chinese do this, not that" or "Irish like that, not this." They handed down their cultural heritage with the noodles we slurped or twirled, the dances we skipped or stomped, the sounds we hushed or shouted. Most thought their way was "natural," maybe even "best." Few gave a hoot about being "politically correct." However, once you step outside of your house or neighborhood, you need to understand what the version of slurping, twisting, skipping, stomping, hushing, and shouting that was handed down to you means. Just because it was your (grand)mother who handed down her version of cultural definitions it does not mean you have a clue what you got from her.

More often than not, we stereotype ourselves by identifying with someone else's lived (but often unexamined) close-at-hand norms. Whether we are emigrating from a grandparent's heritage or a neighborhood ethos, we often journey without knowing how to preserve its virtues and be democratic at the same time. By not recognizing how stereotypical our starting points are, and then being too "politically correct" to mention this, we overlook the emotional glue of our cultural heritage. This is exacerbated when we play down intercultural differences and conflicts in the context of political and economic demands. At the same time, the terms we use to describe the cohesion the Other exhibits with respect to his traditional culture—tribalism, territoriality, ethnocentricity, Old Boy network—have derogatory connotations. Yet, the everyday effects of this cohesion should not be minimized. Our myriad ghettos are communities, and leaving one can be as sorrowful as it can be a relief (Bao Bean, 2001, p. 188).

Therefore, if educational experience paves the students' way toward developing "character" and "characterization," it should take into account where they start so they know from whence they came and how their families placed them in that cultural mode. Happily, at the university level, some of this happens in first-year experience seminars and/or in the "office of multicultural affairs." But this is often by happenstance and by self-selection. In the K-12 arena, it may be more difficult to institutionalize the value of understanding our many starting points. One is the lack of teacher expertise. But, if we can elicit long conversations in the classroom

via the duck-rabbit and the following shaping devices, we can tap into the hidden trove of our students' home experience and learn more in the process. For, if the only viewpoint we build into the curriculum is the "American," as currently portrayed in too many texts, we will never undo the whiteness, let alone prepare our students for their national and international futures. By heightening, not mitigating, the connectedness of culture, identity, and meaning, we actually take our multicultural origins seriously. Doing so is personally and globally paramount even if this leads to less "wholeness" or "unity" and a heck more "relativity."

The following examples point to another way of talking about personal and cultural identity. It is based on useful generalizations that can be fine-tuned by individuals so as to get and convey information without being personal or offensive. Hence the question: What cultural shape(s) are you in? Not just physically but culturally, maybe psychologically, possibly philosophically. If what you see, think, hear, see, or feel is informed by how your cultural universe is shaped, then literally "figuring" out that shape can be both a shortcut and a seminar in understanding the choices we make.

I describe my Americanized self as being in a pyramid. This state of being, believing, and bearing is involuntary insofar as it is the "whiteness" that I absorbed outside the home culture before any critical examination; it is voluntary to the extent that I now knowingly participate as a citizen, consumer, parent, teacher, and so on. This "shape I'm in" is the result of the bylaws that form most of the major institutions of the society in which I live, metaphysically and practically, from governments to corporations, from churches to schools. More often than not, there is room for fewer or only one at the top (god, president, CEO, pope, principal, et al.). In this hierarchy, individualized power over self, others, information, intelligence, and objects is concentrated and we rank and rate relative merit by measuring the scope and nature of domination.

- Progress is linear and upward so we "climb the ladder of success," "break through the glass ceiling," "join the heavenly hosts," "soar above and beyond," and so on.
- The most desirable is primarily a matter of exclusion and choosing only one is the first method of expressing our opinions and, thereby, describing our individuality.
- The "half full" rather than the "half empty" glass is indicative of optimism.

- "Perfection" and "ideal" are meaningful terms as are "forever after" and "immutable."

If we now populated this world with the kind of individuals created by the Bill of Rights, and by employee manuals, psychology, and/or Holy Scriptures, we would have highly individualized beings who could exist independently of others regardless of being connected by happenstance. The following values, norms, and practices would occur:

- A person can "get what she or he deserves" regardless of how the punishment may affect family members. Similarly, winning the lottery happens to the actual ticket-holder—sharing it is a matter of conscience or lawsuit.
- Relationships between and among individuals are formed because we consent by saying "I do" or "I love you," signing on the bottom line, pledging allegiance, attending Thanksgiving dinners, being homesick, and so on. In the extreme, everything is "personal." However, why we consent to do so is another matter insofar as America is permeated with psychiatry. With a conscious (collective, shadow) sub-or unconscious, ego, superego, id, et al., a person can be the last one to know who he or she is. Indeed, a doctor can be paid to deal with an identity that has been lost or split, and an attempt at suicide can be a "reaching out" to a total stranger who can be of help by reaching back for no other reason than it's part of a job. In addition, if that is not sufficient, we shall soon know enough about human DNA to predict personality propensities, which are "given." In this sense, the stress is on Nature more than Nurture.
- Democratic and "civilized" interaction is regulated by logic, Robert's Rules of Order, and Miss Manners ("survivor" programs notwithstanding!).
- Typically, a college applicant who edited the school paper, captained a varsity team, received straight-As, scored perfectly on every available standardized test, volunteered at the hospital, and cared for a severely ill family member is the shoo-in, "all-around" candidate. The teacher with a student who asks a new question elicits pride on both sides.
- It is "more tragic" if an elderly driver survives an accident instead of the child because the former already had a "full life" while the latter still had his whole (Aristotelian) life ahead of him.
- There was a time that nearly every English-speaking schoolchild was taught Kipling's sentiment, "If you can keep your head when all about you are losing theirs ... you'll be a Man, my son!"

The upper levels of the North American (socioeconomic and political) pyramid are overwhelmingly occupied by white people, who consider the above values, norms, and practices "basic." To be accepted into the upper echelons of

this pyramid you must, philosophically and practically, embrace the dominant cultural values, norms, and practices. There is no contradiction between the facts that so many of us begin our journeys from diverse starting points. The dominant culture devalues alternative cultures and represses diversity since the latter makes "no sense" to or for human beings living and striving in a pyramidal world.

On the other hand, I describe my Confucian self (and most other "traditional" selves, including the gender-based role for the prefeminist woman!) as being the central space of a spider web. In this web, there is no "I" except that which is formed by the strands or "relationships" to family, neighborhood, company, government, and so on. In this world, I am less concerned with what "I" want as how I will affect others. In the extreme, nothing is "personal." We nurture sensitivity and mutuality over individuality. What is of utmost importance is that each person does his or her relational duty (as son, teacher, parent, mayor, etc.) to contribute to the strength and well-being of all, not just himself or herself. Indeed, to say "please" and "thank you" or tip for service well done is traditionally considered an insult, intimation that the person might have done otherwise, that is, chosen not to do what is "right" or his or her duty. Yet, to overtly do someone else's duty as well as your own is to overstep and/or make another less significant.

In traditional China, the "student" competed to get the best test score to receive an imperial appointment and, thereby, elevate his entire clan. However, not all the (male) children are expected to take the scholar's path, nor is the student expected to supersede his teacher by asking a question that has yet no answer. In this way, the responsibility for the clan's other needs—financial and practical—are distributed to other siblings and the subordinate educational position means never causing the professor to lose face until, at the very least, the other students have left. Transplanted to America as a "student" means to strive for high scores as well as being first to raise a hand or blaze a trail ... editing the school paper, captaining a varsity team, and volunteering at the hospital, and so on. Hence the Model Minority! This combination model of excellence creates enormous pressure because it is

- imbued with the individualism implicit in the pyramid world with its self-starter, even aggressive style of the dominant culture, including *whiteness, and*

- overlaid with identification and responsibility to the clan—living, dead, and yet-to-be!

This latter Confucian-minded web of being has also meant the following:

- Relationships are rarely by choice so one is not easily isolated or "alone." As a result, there are fewer *attempts* at suicide. However, because no stranger can restore one's identity, when at a total loss, any attempt at suicide is more likely to succeed.
- Success and failure are rarely an individual matter. Thus, when glory and ignominy are shared, one cannot stand on top of the world as the lone victor but neither is one totally bereft when hitting bottom.
- There is no civic or moral obligation to be "charitable" to non-relatives. On the other hand, to allow a second cousin who has the same surname to beg or live disgracefully is a clan failing. My older sister knew something very important was happening in Tiananmen Square in 1989 when she saw street vendors, instead of taking home the food not sold, give the leftovers to the students protesting the government's corruption and totalitarian policies.
- There is no "perfect" or "ideal" and no absolute list of "thou shalt" or "shalt not." There is always room for improvement in an always-changing world. Whatever may be necessary to maintain a balance between chaos and order can be justified.
- Human history travels through cyclical time frames.
- The empty glass or hub is valued for its capacity to receive.
- If you could only save one, the traditional Asian would choose the grandmother over the child because you can always make another baby but can never replace the wisdom that comes with old age and long experience.
- Control over our conduct is within our power and, with luck, more reliable than control of inanimate objects or natural forces. Being different or "standing out" is rarely good, even for the leader.
- Had Kipling been Asian, his poem might have been, "If you can keep your head when all about you are losing theirs … then there is probably something very wrong with you, your family, your village, your ruler, and your ancestors."

Aware of the different shapes I can be in, I had better understand what is happening when I morph from the web Chinese to the pyramidal American and back again and again. So, rather than choosing between the two worlds and ways of being, I get more proficient in switching. In fact, I gain confidence in doing so, in being capable of venturing into other cultural shapes, whether located across

oceans or railroad tracks. Concomitantly, I can control access to the playgrounds and avoid the minefields associated with each of the worlds. In doing so, situations that once put me in "moral binds" are relaxed:

- The "drinking" that conjures up puritanical (i.e., pyramidal to the extent the "thou shalt not" partake in the fruit of the grape is biblical) disapproval, Mothers Against Drunk Driving (MADD), (il)legal limits, designated driver rule, loss of control, and so on is now not "opposed" to excess indulgence—as long as everybody else is equally inebriated or sober.

- Similarly, taboos about allowing, let alone teaching, a child to gamble is now not "opposed" to enjoying our family tradition to play poker and roulette (and on Christmas Eve to boot).

- I am less stringent about absolute rules and truths, and having no compunctions about lying if someone's "face" was being saved, I resolved the possibility that my son would say "Yes," if I ever needed to ask, "Have I ever lied to you?" by calling St. Nick the "Make-believe Santa" and the Woman with the Dental Fixation the "Imaginary Tooth Fairy." (Happily, left to their own devices, most children have no problem with multiple realities, "races," etc.)

- I have compassion for people for whom I have no sympathy yet hardly blinked when my father expressed his thought that it is not necessarily evil to kill millions if that would deal effectively with overpopulation and maintain the balance between order and chaos (in that this is more "reliable" than hoping for interplanetary travel—and, besides, there's reincarnation). A hyphenated person can simultaneously be "hated" for failing the web but "respected" for being one's own person.

Raising our "Asian-Caucasian" son, William, to be at least bicultural in a part of New Jersey where he met chickens way before he had human playmates, I realized how much he had absorbed of both the Chinese and the American when, at 3, he went to preschool. The first day he was "Confucian." I dropped him off at the classroom, drove home, and returned a few hours later. In between he did what a Montessori child should do and, thereby, fulfilling his role/duty as a "student." The second day, William behaved as a pyramidal "American," an atomic individual who has rights and identity independent of others and whose relationships he chooses and affirms with words and actions.

I escorted William down the hall to his classroom. Giving him a hug and kiss, I told him to have a good time and that I would see him later. Turning, I started

to make my way through the phalanx of parents and children huddling and sobbing near the door. Feeling rather smug that we didn't have their problem, I was only a few steps out the door when I heard William cry out, "MaMa." Going back through the crowd, I saw him standing by himself, arms at his side, tears rolling down his face.

"What's the matter, William?" I asked in Chinese

"Nothing," he replied in the language of school and his father, English.

"Then why are you crying?"

"I'm supposed to."

"What do you mean, you're 'supposed' to?"

"Children cry when parents leave them at school."

"Well," I thought to myself, "The kid's observant." With no Chinese vocabulary for "kid" or "observant." … Although he was too young to have had the experiences that would deepen his grasp of the Chopsticks-Fork Principle that took me half a lifetime to gather, his dutiful crying did exhibit an important aspect of the idea, that is, not to join his tears with the others' might be construed as criticism of them. As he continued to cry, I asked, "Why do you think they cry?"

"Because they're going to miss their mothers."

Happy he also understood enough about their First Day at School ritual to be concerned that I might need the reassurance of his tearful good-bye, I nevertheless didn't want common sense to get overrun by oversensitivity. "How can you miss me, William? I was just here."

"But I might. Later."

While his "later" gave me pause, I said, "Not likely, you'll be too busy. Anyway, you should stop crying because you'll get a stuffy nose."

"Okay, MaMa."

But it was said with less than wholehearted belief. Asking him to wait a minute, I rummaged in my purse … Going through the pile [of pictures], I found one …

"Here, William. Put this in your pocket. If you think you miss me or BaBa, then look at the picture. Okay?"

By giving him the picture, I conveyed a complex of yeses: "Yes, you are right not to shame others unnecessarily," and a "Yes, you are kind to think about me," and a "Yes, we both have needs." But I also gave him the message," "Be strong," and "For goodness sake, let's not overdo it."

Holding it, he studied it first, then put it in his breast pocket, instinctively treating it like an Asian handles a business card. Giving me a nod of firm conviction, his second "Okay" closed the subject. Waving good-bye, I left. No more hugs or kisses. I didn't want him to think his serious decision needed reinforcement or that he was being consoled for a loss, imminent or eventual. The parents who had been watching

looked at us in horror—I must be heartless. Unloving. Without emotions. Another inscrutable Chinese raising an inscrutable child ...

The picture was my idea, but the impetus came from long ago, another urge as old as parenthood, one I did not resist. Like his forebears, I would go back and forth, back and forth, weaving into this child the stories, intertwining his lifeline with threads I have brought out of the past and returned with the present. But the texture of his future—our immortality—would be in words and deeds that can always mean more than they seem at one time, so I had to develop a way of joining them, without enjoining him. For while every culture abounds with wisdom about the best pattern and instruction for the surest stitch, and every generation passes on to the next the tales and games, songs and images, plays and books that define the hierarchy among colors, the value of tried and true methods, this wouldn't be enough for what I had in mind: a fabric of Chinese silk and American cotton. (Bao Bean, 2001, pp. 44–46)

By talking about what was happening and not presuming the reason for his tears or hugs and kisses, we both learned to think about how we and others can and do shape our worlds. As part of that responsibility, his teacher and I agreed that my frequent presence in the classroom was one way for the children to become accustomed to the existence of Chinese in the world, to help make the foreign more familiar. She understood what many of her fellow liberal educators forgot in their commitment to preserving a child's natural creativity: that no human mind can possibly imagine the richness of the world as it is. Throughout William's childhood, we repeated stories that illustrated this point such as when he first looked up from his crib at a neighbor and, uncharacteristically, screamed bloody murder. She was his first blond. I would be the kids' first Chinatown.

For similar reasons, I made it a point to stop, with William, at the classroom down the hall, whenever its door was open. We would watch the children inside. Sometimes we lingered to comment on a new drawing someone had put up on the wall, or evaluate the shape of the cutouts taped on the windowpanes. Often our being there would entice the attention of someone inside. If he or she then approached to touch us or just to stare, William learned not to shrink back or avert his eyes or grab my hand. Counter to both my cultures, he learned not to pay attention to his schoolmates' parents complaining about "them." He got to recognize a few of the regulars, to realize that their way of being might require him to move less quickly or speak more slowly, but this was not essentially different from what he did elsewhere. At my parents' house, he modified his pace to their lifestyle; in an antique shop, he must walk with his hands clasped behind his back; and at school, he got to know that being with retarded people was just another aspect of being-himself-with-others. He got to know that "appearing normal" is often no criterion for good value (Bao Bean, 2001, pp. 60–61).

Periodically we consciously *reconfigure* the shape and contents of our world to accommodate what we learn.

By truncating the pyramid, there is room for more than one at the top but there is still hierarchy. By drawing multiple webs, I can also indicate the several

selves I am depending on whether I am operating within the familial, political, recreational, scholarly, neighborly, professional, generational, commercial, social, religious, ethnic, charitable sphere that can each be further characterized in terms of how each is formed and its governing "etiquette." By this configuration, I see my "individuality" as much in terms of the nature and number of webs in which I find myself, as well as in how the person that I am when I am in one of the webs connects to the others—by power, rules, money, authority, knowledge, talent, charm, conversation, silence, law, contract, happenstance, and so on. By periodically drawing variations through time, I can "see" how webs diminish or gain in number, connectedness, importance, longevity, mortality, homogeneity, and diversity.

In doing this, I can better understand how people occupying one web may regard those occupying others. For example, I am able to recall how many of my high school teachers/administrators were puzzled, even hostile, to the fact that I interconnected seemingly "incompatible" webs by getting good grades, drinking illegally, attending church two or more times a week, playing sports seriously (long before Title IX!), winning a seat on the Student Council, getting summoned to court, receiving the Junior Citizen of the Month award. I can now appreciate the strength of their assumption that I should be only one "self" with only one kind of acceptable behavior. To be otherwise was "hypocritical," "wishy-washy," "unbecoming." The same kind of difficulty occurred when my mother decided that my being comprehensively attentive to my mother-in-law was an act of "disloyalty" to my "real" family, even though I had been raised to be the sort of person who would be a good daughter-in-law by both Chinese and dominant American standards. Similarly, when I recently taught a workshop at a Youth Correctional Facility, participants understood immediately that, having decided to get their equivalency degrees during their incarceration, they faced retribution from unsympathetic gang members. These kinds of responses may be testament to how ingrained is our desire to be monochromatic.

If this is so, how much more must we work to undo whiteness as homogenization by elucidating, ameliorating, and alleviating its impact. As both the means and the ends of undoing whiteness, we must figure out our cultural shapes. To do so, I suggest you first seek and find your "duck-rabbit" phenomenon by gathering the facts or circumstances that produced the various or diverse cultural situations that have characterized your life. For example, I cite a few of my own (Bao Bean, 2001, pp. 2–5).

- In 1946, my parents, older sister, Bette, and I arrived in the United States (as nonresident aliens with no visible or cultural ties to the most powerful country in the world) from China (the site of a civilization that dates back to about 5000 BCE).
- One day later, Bette and I were enrolled in Public School #8. I spoke no English. Bette could say "Lucky Strike" and "Shut up." The principal let her skip two grades and made me do kindergarten twice. We both spoke Chinese.
- In 1949, I started to think in English and forget in Chinese.
- In 1960, I went to college where I majored in History, Government, and screaming. The screaming did not get me the lead role in *The Diary of Anne Frank* because the director did not think a Chinese could play a Jew from Amsterdam but it did get me on the Tufts cheerleading squad, and, from there, onto a full page of *Sports Illustrated* ... clothed.
- In 1962, I heard Malcolm X tell my roommate she was no longer a Negro, she was a black woman.
- In 1963, my sister married one of "the most eligible bachelors in the country," Winston Lord. As a result, he was dropped from the Social Register. That same year, debutante Hope Cooke married the Crown Prince of Sikkim. She, too, was dropped from the Social Register. In those days, marrying an Asian (or nonwhite) automatically disqualified anyone from being socially elite. Later, Bette wrote four worldwide best sellers about the Chinese, and Winston became the American ambassador to China.
- In 1964, I went to graduate school in California. I met Bennett Bean, a Caucasian male who did not wear socks and wanted to make art. He thought I was Japanese. Two days after he found out I was not, he was declared psychologically unfit to serve in Vietnam.
- In 1965, I went to Berkeley, CA. There I met Bennett's friends. Most of them lived in Hippie Communes or nudist colonies. I became a Democrat.
- In 1967, the Whitney Museum bought Bennett's sculpture even though it was upside down, and I was accused of being a prostitute in a big New

York hotel because the concierge did not know that women with long Chinese hair might prefer using their brains for a living.

- The next year, I started teaching at a state college for less money than I made as a waitress. Meanwhile Bennett started teaching at a college that expected him to wear a suit in the Ceramics Studio. One year later, we were both fired. The students protested and we were rehired.

- In 1970, we met Billie Burke. Once the good witch Glinda in *The Wizard of Oz*, she had since become a real estate agent. She pointed us toward the eastern equivalent of Kansas—northwestern New Jersey—where we bought an old farmhouse. The neighbors thought I was the maid.

- One year later, I got tenure so nobody could fire me again. When the chairperson of the Philosophy department asked me to make curtains for the office, I resigned.

- In 1973, I became a U.S. citizen—that's when the mayor asked me to be a Lenape Indian in the town's Bicentennial Parade.

- In 1986, I turned 44 and did not stop smoking because the hypnotist could not find my subconscious so I opened up an aerobics studio. Around this time, my college roommate became an African American.

- In 1993, Bennett was invited to the White House. He wore pink socks and sandals.

After listing the facts of your life, draw the figure that represents the cultural world(s) or presumptions in which your private and public lives took place. Then describe the character, connections, and importance of the webs that came into being during this time, letting their relative standing suggest a (new or different?) shape. Looking at what you have described, think about what prescriptions might bring about improvements in quality, comfort level, proficiency, and/or whatever else you consider worthy life goals from all your cultural perspectives.

This kind of prescribing will likely entail making some hard choices. Do this only after

- listening carefully to each other and your several selves;
- suspending judgment until you understand what is going on and are more comfortable with the diverse.

In this way, we can interrupt whiteness by understanding that we have multiple shapes. We are all multiple selves, just like immigrants. In "opening" rather than "closing," I urge you to keep in mind six thoughts:

- that the "facts" of your life may be hard to identify but the brain does not have to be hard and inflexible;

- that cultures are rarely "pure";
- that if you do not have a sense of humor—pretend!
- that options can be weighed in terms of "shutting the fewest doors" remembering that good laughter can keep some doors from being locked;
- that the cumulative effect of intellectual openness, critical flexibility, and doodling will help you to stay calm when undergoing multiple and multicultural identity crises;
- that there are very few universal truths. The rest is up to you and those in your webs;
- think of your efforts as "preemptive resilience." Sociologist Lee Clarke (2005) writes of this attitude as a bottom-up tactic that may very well be the only strategy available to us in the face of enormity. If we can teach more "regular people" to honor multiculturalism by undoing monochromatic presumptions, we will be fostering the kind of preemptive resilience we can hope and live with.

REFERENCES

Bao Bean, C. (2001). *The chopsticks-fork principle, a memoir and manual* (2nd edition). New Jersey: We Press.

Bao Bean, C. (November, 2005). Do parts = more than the whole? *Journal of College & Character,* VI (8), pp. 1–6.

Clarke, L. (2005). *Worst cases: Terror and catastrophe in the popular imagination.* Chicago: University of Chicago Press.

Gilligan, C. (1985, March). *On In A Different Voice.* Paper presented at the State University of New York at Stony Book.

Gillis, J. (1996). *A world of their own making: Myth, ritual, and the quest for family values.* New York: Basic Books.

Hall, E. T. (1959). *The silent language.* Greenwich, CT: Fawcett.

Black Woman "Educultural" Feminist

PAULINE BULLEN

I am an act of kneading, of uniting and joining that not only has produced both a creature of darkness and a creature of light, but also a creature that questions the definitions of light and dark and gives them new meanings.

—(ANZALDUA, 1990, P. 380)

This chapter is a critical look at approaching social justice "educultural" teaching from a Black[1] radical feminist and activist standpoint. I discuss what it means for me to be an educator and cultural worker—an "*educulturalist*"—"one who is conditioned but conscious of the conditioning" thus "fit to fight for freedom as a process and not an endpoint" (Friere, 1998, p.70). I examine what may be defined as "modern" Black radical feminism by looking at the work of Canadian and American theorists and artists, who challenge exploitative relationships. Their work will be integrated into this chapter as I discuss the equity work that I have been engaged in with public schools in Toronto, Canada—work that involved examining certain "cultural inheritances," such as ideas of inferiority and superiority—that negatively repeat themselves from generation to generation (Friere, 1998, p. 71). Leadership and artistry is required for effectiveness in doing such work.

Becoming a skilled teacher, facilitator, social justice advocate, and advocate for the most disenfranchised in the school community involves becoming a skilled communicator. In my research, writing, and everyday practice, poetry, art, music, drama, and an antiracist approach have been essential tools in addressing issues of oppression. I demonstrate this from a radical "strong-willed" (Collins, 2000) Black

feminist standpoint. My experiences and the experiences of those with whom I join forces are at the center of what is presented here and reflect my commitment to action research and activism.

BECOMING AN *"EDUCULTURALIST"*: WHAT DOES IT MEAN?

As a Black woman, single parent and teacher/activist living and working in a white racist patriarchal society, I realized several years ago that I had to develop new and creative forms of resistance to survive mentally and physically. This involved developing a value system that connected me to others in the planet. It meant living my life believing that the lives of others truly mattered and knowing that this involved honesty, integrity, humanity, and humility. I had to look at how the choices I made marked my life and the spaces I would or would not be allowed to enter—the choice of wife, of mother, of divorced woman and single parent, and of activist-educator. I had to recognize similarities of experiences across race, gender, and class lines. I had to examine the world inhabited by women and recognize and navigate societal structures built on numerous inequalities. I had to examine the world inhabited by **Black** individuals in the Canadian society in which I live and recognize a structure of inequality based on racism, sexism, heterosexism, able-ism, and various other "isms" and "schisms."

As a Black woman, I needed to look carefully at where I positioned myself politically to preserve my sanity—to survive. As an educator and "cultural worker" I recognized that I am "neither only what [I] have inherited nor only what [I] have acquired" (Freire, 1998, p. 69). My growing activism involved examining theories proposed by those who are most privileged in the society—theories that allow Eurocentric beliefs and privilege to prevail and undermine the quality of life for those who do not share a similar worldview. I became actively involved in making, for example, Blackness *and* whiteness visible while deconstructing ideas of Black as "evil" and white as "good." As "educulturalists"—educators and cultural workers committed to an activism that involves dismantling oppressive systems—it is necessary to examine how economic contradictions cause conflict in our societies, as oppressive capitalist systems and ideologies of inferiority and dominance invade every aspect of our lives.

Educulturalists who recognize that the mainstream curriculum remains unchanged in terms of its basic Eurocentric structure, goals, and salient characteristics will attempt to infuse, sometimes in a gradual and cumulative manner, various alternative cultural perspectives and frames of reference into the whole school curriculum. This is done with the hope of expanding students' understandings of the nature, development, and complexity of the society in which they live

so that they learn to honor others by trying to understand them. Educulturalists acknowledge the necessity for studying who we are and who we are in relation to those with whom we eat and sleep!

> I am not a revolutionary ... I believe in revolution because everywhere the crosses are burning ... there are snipers in the schools ... (I know you don't believe this, you think this is nothing but faddish exaggeration. But they are not shooting at you) ... the bullets are discrete and designed to kill slowly ... these bullets bury deeper than logic. (Cervantes, 1990, p. 5)

As an instructional leader in the Equity department of Canada's largest school board, I was often called into schools by teachers unable to cope with the diverse population of students they were hired to serve. Diverse individuals, from their various social locations, brought their biases and prejudices with them into the classroom, packed neatly into lunch bags by those who parented them. They had been cautioned not to associate with those considered inferior, as a result of race, class, creed, sexual orientation, ability and so on, to avoid the "Other."

In schools across the city of Toronto, elementary, middle, secondary, and adult learners would attack each other with ethnic and racial slurs. I had been invited into schools to speak with Asian parents for example, who told their children that Black children were criminal and that they should not associate with them. Increasing numbers of Black parents complained about being perceived as threatening by predominantly white female staff and as a result having "No Trespassing" letters served against them that blocked them from entering the schools and advocating for their children. I received complaints about homophobic comments such as "you're so gay" being bandied about in classrooms and hallways. Physical and verbal attacks on students and staff have been incessant despite ongoing equity workshops and increased resources in the schools.

It has been a challenge to rid schools of derogatory stereotypical images and logos of First Nations people from school uniforms, gym floors, and athletic uniforms. It also, ironically, appears challenging for those who supposedly adhere to Christian religious principles to accept the fact that equity in education teaches that one religion should not dominate within public institutions. As various teachers, other staff members, parents, and youth express their fury at the erosion of "traditional" values, rituals, and symbols of dominance, schools cannot possibly be viewed as neutral environments, but must be seen as *complicit* in the production of raced, classed, and gendered identities.

It is important to be aware, as educulturalists, of ideological differences among people and the diversity of ideas and cultures within our society. It is necessary to be prepared to deal with inevitable culture clashes or conflicts. We need to be aware of the cultures and communities we belong to and how they influence

our understanding and perceptions of what is going on around us. To demonstrate how this may be done I share the music of singer and songwriter Faith Nolan, and the works of visual artist Sandra Brewster—two individuals who are not afraid to use their craft to challenge white supremacy, patriarchy, heterosexism, and other notions of superiority and inferiority. I highlight the work of these two women in Toronto, Canada, because they appear to me to truly view antiracist feminist struggle as a relentless battle and effectively and repeatedly disrupt systems of inequity and iniquity through the use of their "art." They recognize as educulturalists/artists/activists that social behavior stems from multiple causes. I highlight their work because I am not interested in the work of those who adopt a passive stance. My interest lies in those who adopt a "counter-stance" that refutes ideas of one "dominant" culture, one knowledge system, and one ethnocentric way of being and living in the world. Brewster and Nolan are two Canadian Black women who, in an activist, educulturalist tradition, question what is defined as "normal" in "dominant" and discursive practices and reject feelings of guilt as they work for change.

It appears to me that when Black individuals become involved in the struggle to achieve structural equality, we may embrace, in a deliberately discriminating manner, feminist ideologies that assist us in the struggle. As we encounter culturalists, structuralists, poststructuralists, radical feminists, socialist feminists, and the whole host of "feminisms" that abound, we are often clear that we need to reconstruct and understand the lives of those who live within cultures of domination.

FAITH NOLAN

Faith Nolan, Canada's leading Black folksinger understands the need to continue to learn even as we teach. Her work demonstrates an ongoing search for harmony and for dynamic dissonance as she sings, "[I]f you don't know my people then you really don't know about me." Faith sings, "They can put a woman on the moon, can make a blind person see, they can do this and do that but they can't make peace." As activists, artists, educators, or educulturalists we may ask, "Who benefits from a people's refusal to work at getting to know one another? Who benefits from the refusal to make peace by dismantling inequitable systems that benefit a select group of people? How are our creativity and our overall lives influenced by the multiple oppressions that we face?" We must question and seek answers to determine the relationship between the "signifier" and the "signified" and to determine how we can reorganize and reconstruct a reality imposed on us as victims of an ongoing war.

In much of their research writings, music, dance, visual arts, and more, Black folk, like Faith, boldly exert their professional and personal authority to examine the oppression that affects their lives. They thus challenge white supremacist notions. Faith Nolan commits her life to working with women in prisons around the world. She sings of "sisters in the shadows"—sisters behind bars and sisters whose lives are hidden and have been lost. She wants to see social changes occur that will stop the degradation of women and will stop unjustly punishing women for defending themselves. Her concerns focus on the increased incarceration of not only women—particularly racialized women—but also young Black men for whom the increase of federal prisons in Canada from one to six, signals a serious danger. Canada's Tory government under Prime Minister Stephen Harper has pledged to crack down on crime and private security companies eagerly wait to see the increase in the federal prison population. Such an increase promises to open a new era of private-for-profit prisons across the country. Security cameras being placed in "strategic" places in areas of the city with large numbers of Black and other racialized groups will also ensure the growth of prison industrial complexes.

Faith sings about the need for funding education rather than incarceration; she sings of "the brand new cities, by highways and dumps; cities that are growing by leaps and bounds"; she sings too of "a brand new nation called the jail plantation that's growing and that has got to stop." The prison industrial complex in Canada grows as it is injected with the bodies of young Black men and those from other racialized groups, branded as terrorists. These young people are too often tried and convicted as criminals by those who own things that have not even been invented yet or as in the teaching profession, those who get jobs for which they do not yet have the qualifications. Faith's work "fractures the very ideologies that justify power inequities ... pry open social mythologies that others are committed to sealing" (Fine, 1994, p. 24). She sings "I'm not going to let anybody stop me from doing what's right"; she sings of the "richest in the world and the poorest in the heart"—those who "make a war, make a villain and plunder for all they need; start a revolution, make a country and call it peace!" For those who have died fighting for justice, Faith makes the "solemn vow" to all beloved comrades that "the fight will go on."

Faith sings of those individuals who value money more than people and who think the world is theirs alone to possess. Nolan is a Black queer feminist singer, songwriter, and community activist—a self-taught musician who says that it appears she was not supposed to exist. She is cautioned, often by those who will hire her to perform in schools and other community forums, not to be too "out" there with her values and beliefs for fear of offending families. Faith asserts that this attitude is one that overlooks the fact that she too is part of a family and that hers may take offense at the heterosexism that negatively affects their daughter's life.

On her 1995 CD entitled "Hard to Imagine," Faith Nolan sings of a corrupted media and the fact that millions die and nobody cries. In her song, "Gracey's Blues" she asks the artist, "sister to sister" to "paint the good, the bad, the righteous," to paint "all the dreams we see … all the things that we know." She wants the artist to "paint a peaceful time," to show her what she sees to "ease" her troubled mind. Faith wants her music to be a testimony to the fact that she is "alive." "Sister to sister," she acknowledges that we must work to free our souls, free ourselves of oppression, and struggle against attempts to make us invisible—attempts by those who will pretend not to see how racism, classism, sexism, heterosexism, and the various other "isms" mark our lives and privilege the so-called dominant.

Through song, Faith sends out a cry to those who may not see her as a "sister." She sings, "Sister hold my hand, guide my feet, walk with me, while I walk this race, 'cause I don't want to walk this race alone." Faith enters classrooms across the country, reaching out to students, elementary and secondary, and teachers: children from war-torn countries placed furtively on flights to borders where they are told to claim refugee status; teachers in various "additional qualification" programs; women, men, children. Faith is able to touch their hearts, "soothe their troubled minds"—even if only for a minute—and they are moved to contemplate living in "a peaceful time." Faith's work, however, is motivated by more than a desire to make us feel pity or feel good. Her work advocates for teacher and student involvement in social justice and labor movements. Faith has been relentless for years in her quest to place the knowledge of the history of civil rights movements and the need for ongoing human rights work at the forefront of the everyday school curriculum. She fights for the freedom to love and brings people together in their various workplaces, with "different drums" willing to do the "same beat now." Mobilizing and organizing, solidarity is her song as she encourages teachers, students, sisters, and brothers in the struggle to join her on picket lines to fight for union and human rights.

Faith recognizes the difficulty in being "an army of one" and recognizes the need to collaborate and work in solidarity with others. She hopes for deep and lasting friendships and feels that we need to see meaning in our lives—oppressive lives. In her song, "Everythang gleaming ain't gold," Faith confronts the oppressor and sings, "I know you won't change, just want you to know, I know your name." The oppressor and the oppressed are locked in that knowing gaze and though historically beaten, incarcerated, and killed, for meeting the gaze of the oppressor, this Black woman will meet that gaze head on with her own bold gaze and lyrics.

Born in Halifax, Nova Scotia, Faith is determined to teach about that region's rich Black history that is still left out of the schools' curriculum. She points out

that there are still race riots at Coal Harbour High School in Nova Scotia, and that many people are ignorant of the fact that in 1968 the city council in Halifax destroyed Africville, a Black community in the area. In song, Faith encourages us to ask what happened to Africville—"all the people just torn from the land; left alone without family or friends." Claiming to need the land Africville was on for industrial development the city flattened homes, erased streets, expropriated land without consultation or payment, and then created a park after displacing hundreds of Black families and forcing many into subsidized housing developments (Winks, 1977). Hers is a historical/political approach that interrogates the institutional power and privilege of the "richest in the world and the poorest in the heart."

SANDRA BREWSTER

Canadian visual artist, Sandra Brewster asks us to interrogate the attitudes and the perspectives of others. She tells us that her artwork "depicts emotions and demeanors," a sense of history and representations of issues concerning contemporary society and the human condition. It reflects her interest in those Canadians whose identities are formed in Canada while they maintain roots elsewhere.

"Stance 1", Charcoal on Watercolour paper 22" X 30"
(Image by Sandra Brewster © 2006)

She is passionate about portraiture and how people's features invoke a variety of dispositions and mannerisms. Sandra challenges us to read in those faces and facial expressions a variety of histories and experiences. Her goal is to present

each person as a unique individual by creating realistic representations of people rather than the distorted and false popular images we often see in media. This radical work articulates a "vision of resistance, of decolonization, that provides strategies for the construction of a liberatory, black ... body politic" (hooks, 1999, p. 67): one that is aggressively vocal on the subject of Black identities and Black life; one that includes an oppositional gaze and is not shaped by dominant ways of knowing or a colonized stance.

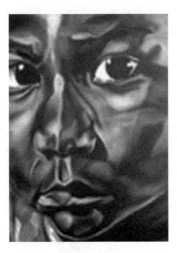

Acrylic charcoal conte´ on watercolour 22" X 30"
(Image by Sandra Brewster © 2006)

Through her artwork Sandra shows the "cool pose" that may be adopted to confront discrimination. The "cool pose" says Sandra, depicts "the tendency to wear invisible masks." It is a "silent rebellion" and "a form of resistance" against oppression. Again, historically, such a pose has resulted in minoritized individuals being perceived as behaving "out of place," imposing, defiant, hostile, threatening, and in short refusing to submit to being less than and accepting of an inferior status. Such a "cool" stance is particularly detrimental to systems of hierarchy and oppression that depend on subservient, fearful, behavior to maintain supremacy. Increased repression and attempts to destroy the individual psyche is a commonplace response to the "cool pose" and it is possible to bear witness to these responses in classrooms and boardrooms globally.

Sandra's work demonstrates how a dark expression or an intense gaze can be juxtaposed with a West African-like mask to show where "cool" is rooted. It is rooted in the painful history of African peoples stolen and sold into slavery and forced at the threat of death to look though giving the impression of not

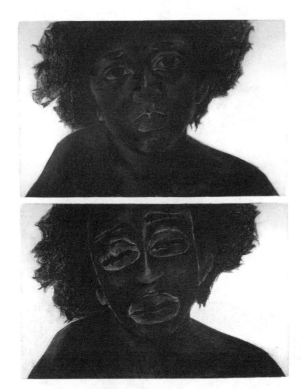

"Cool Pose 9" Charcoal on watercolour paper 40" X 25".
(Image by Sandra Brewster © 2006)

seeing—to remain "cool" or detached under the most horrible of circumstances. Among Sandra's artwork are poignant examples of the masks that we wear to resist abusive assaults and evidence of the effects, of this ongoing need for resistance, on the psyche.

Sandra confronts the stereotypes that exist which prevent some folk from seeing the diversity within the Black community in "Smith," her most recent series of paintings inspired from the section of the telephone pages with the most common name. On slabs of wood Sandra paints rows of Afro heads, their faces replaced with the "Smith" section of the telephone pages—"a generic symbol of Black folk," distorted images in pop culture, accepted as a "norm," envied, and simultaneously hated.

Through her work, Sandra attempts to fit together the pieces of her own life with that of her friends and family members who are the subject of many of her paintings. Her work is a statement of her desire to rethink her own life and compose it in new and dynamic ways, and through workshops with young and old, in various forums, she offers others a similar opportunity.

Smiths Installation, Acrylic, Phonebook Newsprint on various sizes of wood (Image by Sandra Brewster © 2005)

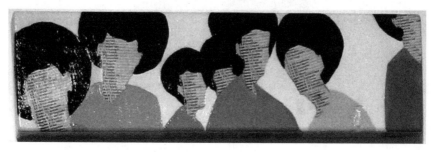

Smiths Installation, Acrylic, Phonebook Newsprint on various sizes of wood (Image by Sandra Brewster © 2005)

FAITH NOLAN AND SANDRA BREWSTER:
ARTISTS IN THE CLASSROOM

In Language Arts, Social Studies, Visual and Dramatic Art classes, and in fact in all classrooms in our oppressive cultures and overall societies, it is important to be able to carve out spaces to unlearn much that is negative that taints our lives. It is possible for the vision to become reconstituted through reflection, especially with the addition of the music and art, for example, of those who engage in teaching cultural awareness, sensitivity, and equity—educulturalists such as Faith Nolan and Sandra Brewster.

bell hooks (1999), in her essay "Naked without shame: A counter-hege-monic body politic," tells us that to "live in our bodies but always away from them was to live always alone in states of fierce and lonely abandonment" (p. 66).

We can become "naked without shame" and look with the desire to see the depth of meaning beyond the nakedness and beyond the shame. To do otherwise, hooks says, is "refusing history." She recommends that we criticize white supremacist patriarchal constructions that usually highlight stereotypes, and in this way "articulate a vision of resistance, of decolonization" (hooks, 1999, p. 67).

As Black folk involved in social justice work it is possible to construct a liberatory, Black body politic as "educulturalists," willing to agitate and interrogate systems of oppression. As human beings who recognize our interconnectedness and interdependence, we can look for ways through art, music, and culture to help others to learn to think critically, become exposed to multiple literacies, multiple intelligences, and the varied locations from which the world is perceived. The work presented here is not the work of "well-intended" individuals who feel it necessary to go along with the status quo to "move forward" or achieve "success." The commitment expressed here takes precedence over material desires. It is a commitment that comes from embracing feminist ideals, challenging white supremacist notions and structured inequality. It is a commitment that derives from the being of the "situated knower." Dorothy Smith (1999) wrote,

> The situated knower is always also a participant in the social she is discovering her inquiry is developed as a form of that participation. Her experiencing is always active as a way of knowing, whether or not she makes it an explicit resource. (p. 6)

DEVELOPING A BLACK RADICAL FEMINIST STANDPOINT

I approach my work from a radical Black feminist standpoint. I *mean* to continue to confront authority and do work that disrupts the status quo. This is "radical" when the expectation, as a result of a history of abuse, is silence, passivity, and complicity. I embrace a "Black" identity that proudly traces my heritage back to the African continent. I take the feminist stance of a Black working-class woman who has had to repeatedly struggle against having to justify her very existence in classist, racist, and patriarchal societies. The Black feminist stance I advocate

1. effectively and repeatedly disrupts systems of inequity and iniquity because of the understanding of antiracist feminist struggle as a relentless battle;
2. is not a passive stance, but a "counter-stance" that refutes ideas of one "dominant" culture, one knowledge system, and one ethnocentric way of being and living in the world;
3. is proudly defiant, revolutionary, and inclusive and does not see "inclusivity" as the ability to demonstrate goodwill toward everybody and anybody since

such notions translate to a lack of "guts" when it comes to addressing issues of privilege and white supremacy and does not leave space for influencing the thinking of those who would adhere to the status quo;

4. recognizes that interrogating race, class, and gender dynamics is crucial for achieving equity in societies;

5. accepts that the commitment to social justice work and embracing feminist ideals often takes precedence over the need to assimilate and precedence over material desires; and

6. finally, challenges the institutional structures that are designed to erase whole peoples, through its education system, with the awareness that this is larger than the self and that such a challenge will result in forming alliances with others as part of a collective struggle.

Feminism is a struggle to end sexist oppression and it is, therefore, necessarily a struggle to eradicate the ideology of domination that permeates "Western" and various other cultures on all levels. hooks (1984, 2000) states however, that the type of definition of feminism that many "liberal" women appear to find appealing "evokes a very romantic notion of personal freedom that is more acceptable, than a definition that emphasizes radical political action" (p. 25).

The concept of feminism that I embrace is revolutionary because it advocates continuous self-reflection on one's perspectives and place in society, and sees radical political training, teaching, and action as necessary for achieving equity and social justice on a global level. Revolutionary change involves resistance by all who are able to identify themselves as subjects and are willing to define their own reality and shape new revolutionary identities devoid of the various stereotypical notions of, for example, what "Black is and Black ain't" or what "white is and white ain't." It involves the willingness by oppressed people to name their history and tell their own stories (hooks, 1988, p. 43), at the risk of being accused of "essentialist" thinking, having a "chip on the shoulders," or of directing blame and causing guilt. It also involves "the painstaking reconstruction of past and present to fill the crucial gaps and erase the slanders of the globally dominant European worldview" (Mills, 1997, p. 119).

BLACK WOMEN, HISTORICALLY FEMINIST

Black women "bear the brunt of sexist, racist, and classist oppression" and from their "special" marginalized vantage point can and may directly challenge, criticize, and create counterhegemony to challenge the prevailing classist, sexist, racist social structure, and its concomitant ideology (hooks, 1984, 2000, p. 16). They have

historically faced their oppressors and demanded a response to issues involving inequity and injustice. One well-documented example of this was the question posed by Sojourner Truth in her famous "Ain't I a woman" speech in Akron, Ohio, in 1851. Truth asked, "If my cup won't hold but a pint, and yours holds a quart, wouldn't you be mean not to let me have my little half measure full?" Truth might have been propelled by fear when she risked her life to speak out and challenge a racist status quo that depended on the physical and psychological enslavement of her people. hooks shares the sentiment, however, that even the most politically naive person can comprehend that a white supremacist state, asked to respond to the needs of oppressed Black people and/or the needs of particularly white middle and upper-class women for example, will find it in its interest to respond to whites (hooks, 1992, p. 17). Yet, black women historically have fought and resisted objectification; they have resisted, and *continue to resist*, being used as token representatives for their entire racial/ethnic group. Black women have not shown themselves to be blind or indifferent to being racialized, to being devalued, and to being stereotyped.

Black working-class women have not employed passivity as a survival mechanism and their sometimes aggressive actions are often compared with those of white middle-class women and labeled antagonistically as "unfriendly," "angry," "counter-productive," and "unfeminine" (Zinn et al. 1990, p. 37). Despite being ignored in our workplaces, threatened, demonized, and accused of being "reverse" racists, we acknowledge with the "beloved comrades" with whom we are able to join forces that "the fight must go on." As an educulturalist, who is also a Black woman and feminist, my experiences have become a shared resource. I write to survive. I write about what I think and feel "in the actualities of my everyday/every night living" and I acknowledge that there is always "rethinking of established positions and representations to be done" (Smith, 1999, pp. 16–17). Black individuals may examine and use feminist theories to understand the continuous need to always interpret and reinterpret the realities that we face. Our lives are often unstable. Meaning is unstable. Peace is often only temporary; unity is often temporary as we are controlled by the economic need, it appears, for war. Yet we struggle, because of a fundamental belief in our own humanity and the humanity of others, to transform oppressive world disorder. The struggle continues because we understand and continue to bear witness to the fact that "whether we speak or not, the machine will crush us to bits" (Hull, 1983, p. lvii).

NOTE

1. I use the term Black with an initial capital letter as it was used in the 1986 work by Bhaggiyadatta and Brand entitled, *Rivers have sources, trees have roots: Speaking of racism*. Black is given an initial

capital to stress a common heritage, a cultural and personal identity, proudly claimed by Black people who assert their African origins.

REFERENCES

Anzaldua, G. (1990). La conciencia de la mestiza: Towards a new consciousness. In *Making face, making soul—haciendo caras: Creative and critical perspectives by women of colour* (pp. 377–389). San Francisco, CA: Aunt Lute Foundation Books.

Cervantes, Lorna D. (1990). Poem for the young white man who asked me how I, an intelligent, well-read person, could believe in the war between races. In *Making face, making soul—haciendo caras: Creative and critical perspectives by women of colour* (pp. 4–5). San Francisco, CA: Aunt Lute Foundation Books.

Collins, P. H. (2000). *Black feminist thought: Knowledge, consciousness, and the politics of empowerment* (2nd edition). New York: Routledge.

Fine, M. (1994). Dis-Stance and other stances: Negotiations of power inside feminist research. In A. Gitlin (Ed.), *Power and method: Political activism and educational research* (pp. 13–35). New York: Routledge.

Freire, P. (1998). *Teachers as cultural workers: Letters to those who dare teach.* Colorado: Westview Press.

hooks, b. (1984 and 2000). *Feminist theory: From margin to center.* Cambridge, MA: South End Press.

hooks, b. (1988). *Talking back: Thinking feminist. Thinking Black.* Cambridge, MA: Southend Press.

hooks, b. (1992). *Black looks: Race and representation.* Toronto, Canada: Between the Lines.

hooks, b. (1999) Naked without shame: A counter-hegemonic body politic. In E. Shohat (Ed.), *Talking visions: Multicultural feminism in a transnational age* (pp. 65–74). New York: MIT Press.

Hull, Gloria T. (1983). Poem for Audre. In *Home girls: A black feminist anthology* (pp. lvii–lviii). New York: Kitchen Table—Women of Colour Press.

Mills, C. W. (1997). *The racial contract.* Ithaca, NY: Cornell University Press.

Nolan, Faith. (singer/songwriter). (1995). Everythang gleaming ain't gold, The richest in the world, and Gracey's blues. On *Hard to Imagine* (CD). Toronto, Canada: Multicultural Women in Concert.

Smith, D. E. (1999). *Writing the social: critique, theory, and investigations.* Toronto, Canada: University of Toronto Press.

Truth, Sojourner (1854). *Ain't I a woman?* Retrieved October 11, 2007, from http://www.feminist.com/resources/artspeech/genwom/sojour.htm.

Winks, R. W. (1997). *The Blacks in Canada: A history* (2nd edition). Montreal: McGill University Press.

Zinn, M., Cannon, L. W., Higgenbotham, E., & Dill, B. (1990). The costs of exclusionary practices in Women's Studies. In *Making face, making soul—haciendo caras: Creative and critical perspectives by women of colour* (pp. 377–389). San Francisco, CA: Aunt Lute Foundation Books.

One IS THE Sun: Mesoamerican Pedagogy AS AN Adjunct TO Undoing Whiteness IN THE Classroom

CARLOS ACEVES

No culture can survive if it attempts to be exclusive.

—MAHATMA GANDHI

When a social group feels it needs to impose on the resources of another group, its members do not simply tell themselves it is "time to act like thieves." Rather they seek ways of justifying their actions. At that point, they might begin differentiating themselves as "civilized" while others are labeled "uncivilized." For example, the official script is that the United States is in Iraq not to possess the country's oil wealth but to "bring democracy" to an "undemocratic or backward" society. All cultures that become imperialistic begin creating an ideology that presents their culture as normal and civilized thus justifying their imperialism. Thus, they give themselves an "exclusive" right over those on whom they impose their power.

When I decided to draw upon my Mesoamerican heritage as a source to recreate a process of undoing whiteness in the classroom, I faced a dilemma. Was I recreating the colonial process described above by focusing exclusively on my own ancestral culture? I resolved this contradiction through focusing on process rather than content. I realized that the initial attempt of all groups is to create a means of survival for their culture and ensure the survival of coming generations by passing on this knowledge. The need for the "exclusivity" of that culture arises only when

the original structure created by the group is transformed in an attempt to take and control the natural resources of other groups.

When I started attending Canutillo Elementary School in 1960, I encountered overt racism and a sociopolitical message that wreaked havoc with my self-esteem: to be Mexican was bad. Only through the Chicano Movement almost ten years later did I realize I was being conditioned to occupy a lesser position within the political and economic system of the United States, a society that had long ago become imperialist and colonialist.

Throughout my schooling the invasion by the United States of Mexican territory had been justified by portraying Mexico as an undemocratic country. Texas had been severed from Mexico because its new residents wanted "freedom." Arguments in favor of the taking of the rest of Mexico simply followed the same reasoning. As my seventh grade history teacher told us, "The Mexican-American war was just as important to Mexicans as it was to Americans. Mexicans would finally have a free country to live in."

However, did a postcolonial argument entail the reverse of the colonialist proposal that being Mexican was bad? In other words, did it mean that being Mexican or Mexican American is automatically good? In the Chicano Movement, we had to tackle this question when we found that many cultural beliefs steeped in Mexican culture were reactionary. My parents and their contemporaries believed that women were inferior to men. Protestants were considered the enemies of Catholics and Jews murdered Christ. They certainly did not believe in sex before marriage, much less in a woman's right to an abortion. At face value, reaching into my Mesoamerican roots meant embracing seemingly equally bad contradictions: human sacrifice, institutional slavery, political and social hierarchy, religious dogma, and superstition.

However, my anti-imperialist consciousness developed through the Chicano Movement helped me not to abandon the idea of using cultural awareness as a pedagogical tool in a similar way that we had used Mexican American-culture as a weapon against white supremacy. Within the roots of any culture, there are the human aspirations for freedom, dignity, and artistic expression. As cultures become imperialist or subjected to imperialism, these aspirations become distorted and suppressed but find their way across history in the form of social struggle that often shakes the foundations of the contemporary society they now operate in.

When Jack Forbes, at that time the director of Native American Studies at the University of California at Davis, visited the University of Texas (UT) at El Paso in 1974 in which I was a student activist, I brought my concerns about the problems associated with Chicanos identifying too closely with our Aztec roots. He counseled me to have a critical eye toward the sources from which we obtained such information about our history, reminding us that the history of indigenous Mexico was written by the same people who colonized Mexico and who were thus

seeking to justify the colonization of the Americas. However, other than books, where should I look? At that time, I was introduced to a source of knowledge that I was not aware of but nonetheless already had academic value: oral tradition.

That was 1974. In 1980, with the Chicano Movement waning, I finally stirred my interests in earnest toward my Mesoamerican roots. I was fortunate to find sources of the Mesoamerican oral tradition.[1] By 1991, I was ready to take some of what today might be called educulturalist designs into a classroom. I had a vision that fused ancient cultural constructs of civilization with critical pedagogy. My research had taken me not only to sources of oral tradition in Mexico concerning indigenous culture and history, but also to persons I would never have thought to be part of my work. I became intrigued with Rudolf Steiner, a German mystic who seemed to have designed similar pedagogy around the turn of the twentieth century. I also read *Symbol Formation: An Organismic-Developmental Approach to Language and the Expression of Thought* by Heinz Werner (1963). This work compares the similarities between the modes of expression of indigenous peoples, children, and schizophrenics. Werner seemed intrigued with how these groups' view of reality was essentially mythological in that they engage the world through modes that are full of fantasy. However, it is not a fantasy that creates and engages a fictitious reality. Rather it is something that in contemporary pedagogy called "holism" that "any local organ of activity is dependent upon context, field, or whole of which it is a constitutive part: its properties and functional significance are, in large measure, determined by this larger whole or context" (p. 3).

One maestro after another had stated this, although in not such academic terms. They were concerned that unless human beings learned to relate the part to whole and practice this integrity in whatever lifestyle they create, humanity was embarked on a self-destructive path as a species. The fundamental principle in the pedagogy of my Mesoamerican ancestors was to teach the children, and thus coming generations, how to express this integrity. They created a symbology that educates through participatory activity how the Universe, especially the Earth, is mirrored in the human mind and body.

Carrasco (1990) labels this process as world making (the group creates space for their community), world centering (placing members around a common center), and world renewing (establish a process for the use of community time) through which "the ceremonial centers of Teotihuacan, Chichen Itza, Tollan, and Quetzalcoatl Tenochtitlan were organized as replicas of this cosmic geometry, so that elites, warriors, captives, traders, farmers, poets, and commoners could experience this cosmo-vision and participate in its nurturance" (p. 52).

In 1990, I attended a small meeting of former Chicano activists in Phoenix, Arizona, where the term Xinachtli Project was first introduced. Xinachtli is a Nahuatl (Aztec) term that refers to a germinating seed. The idea was to introduce

Mesoamerican-based pedagogy into the public schools. There I argued for the importance of a participatory approach that emphasized process not just content. I returned to El Paso with a pilot project that involved three classroom settings: a kindergarten, third grade, and freshman high school. In each were Chicano activists willing to explore this educational "experiment" based on Mesoamerican mythology. I went once a week to present an hour lesson to the kindergarten and third-grade classrooms. Heriberto Godina, the high school teacher, did his treatment independently and used the results for his Master's thesis at UT, El Paso (Godina, 1992).

What we presented were not new approaches but constructs time tested over hundreds if not thousands of years but contextualized to a contemporary classroom. For us these practices had given rise to earth nurturing societies. They seemed the natural allies of those seeking to reorient education toward a balanced integration of the self, the social, the environmental, and the spiritual. What better way to countering and undoing an ideology that through its Eurocentricity promotes disintegration and alienation of self for the purpose of justifying colonialism—the domination of one group over another—rather than a process that engages students in creating critical consciousness.

These early treatments of Mesoamerican pedagogy became an initial outline that I used when I changed careers in 1992 and entered the classroom as a bilingual kindergarten teacher in the Ysleta Independent School District in El Paso County in Texas. Three years later, I would join the Canutillo Elementary as a faculty where the Xinachtli Project would be further developed.

THE XINACHTLI PROJECT

Although not all of the approaches can be explored here, I focus on three basic constructs currently at work in a variety of classrooms at Canutillo Elementary: *Tlahtocan, One Is the Sun*, and *In Tloke Naouke*. I still use the practice of visiting a classroom once a week and introduce a 45-minute interactive exercise that involves the interpretation, creation, and use of symbols. A large part of this exercise is in the form of ritually based play.

Young children play. It is their natural, primary activity. It is in their play that the importance of rituals and symbols surfaces. Waldorf Education founder, Rudolf Steiner (1924), describes the child's first seven years of playing as a sustained effort to adjust her spirit to an earthly realm, the grounding of the child's body-spirit to her environment.

Russian developmental psychologist Vygotsky (1976) regards play as a basic activity for socialization to explore cultural meanings, express unfulfilled

wishes, and transform motives into acceptable modes of behavior. Karby (1989) concludes that symbolic thinking and language development are key to this process. Tahallary (1991) found that fantasy play has a highly significant effect on the language development of young children.

The use of symbols is integral to a child's play, expression of feelings, and ways of joining with other children to compare and create imaginary worlds that allow him or her to explore his or her experienced reality from a distance (Dyson, 1990). When Werner (1963) found commonality with children's development of language to the symbolic interaction of indigenous peoples, he was discovering how both groups use symbols as a means of not only interpreting but also interacting with the world.

Sobel's (1991) five-year observational studies of his daughter Tara revealed a plethora of metaphorical perceptions that, like Native American mythology, "bridges the gap between images and concepts in language, between unlike organisms and creates a kind of inter-species empathy. Cultivation of this empathy in early childhood is one of the foundations … for ecological living" (p. 7).

TLAHTOCAN

Creating a structure to tap into this metaphorical play became relatively simple once you understood the Mesoamerican process of council called *Tlahtocan*. The term means "place of the spoken word" and any circle of people where Carrasco's (1990) elements of ceremonial gathering are placed serve as a *Tlahtocan*. Basing the activities of the project on this structure seemed a natural choice, the first and primary exercise of any Xinachtli effort. This community takes the form of all participants, students and teachers, sitting on the floor in a circle. This creates a more egalitarian atmosphere with a visual semblance of equality, and participants are geometrically linked in whatever activity follows. This becomes our community and is itself a symbol, the Circle. It is a form of a *world making*.

The next is the step of *world centering*, the creation of a symbolic center to our circular community. This can be done through the simple use of a candle or a mirror. As the children become more literate in Mesoamerican symbols, I use a replica of the Aztec Calendar. Once this center is established, it is not only interchangeable but can also be removed to accommodate an activity.

World renewing is initiated through totemic membership. Each participant is given a stick, sometimes a pebble, which becomes his or her symbolic membership card in our community. This totem is used as a way of entering into an activity, but the symbolic entry into the community through our totems generates a veneration of the mythic community, a sense of rightful participation, and general

respect. As the circular seating is complete, the members place their stick in front of them facing the center.

Another symbol that is chosen for the activities of world renewing: a common totem that gives the holder "la palabra" or the voice. Referred to as a "talking feather or stick" in Native American circles, this totem serves as a way of structuring dialogue within the Circle. Whoever holds the totem holds the right to speak and the others respect this until the member gives way either by acknowledging another's right to speak or handing over the totem. This activity also creates a sense of empowerment and is good for nurturing self-esteem and further group respect.

Creation of community in this form accomplishes two goals of the Xinachtli Project. It establishes an indigenous form of social interaction, thus giving the children a sense of an ancient construct that is now contextualized with a contemporary setting. The students do not see it as something foreign or outdated to the world of the classroom. The other goal is to provide a forum for critical dialogue. The "talking circle" becomes a safe and conducive place for the children to express themselves and listen to what others have to say. It allows the teacher to model and guide the process of dialogue. As students and teacher engage in subsequent activities, each activity and the interactions that come with it are in turn shaped into an indigenous process by virtue of happening within the structure of the metaphorical community.

Two activities are important to the *Tlahtocan*. These activities are not limited to a particular grade level; I have used them with kindergartners as well as middle school students. One is the discussion around the question, "Who I am?" This allows a child to explore identity from a personal basis and later relate it to a social context. Without exception, all children first give their answer as their names. However, I shift the focus by asking, "If your name was changed today, would you still be you?" They are inevitably intrigued by this question but quite naturally and energetically answer in the affirmative. Their subsequent responses evoke quite critical responses, some of which are definitely metaphorical.

Here is a list of responses from 2005 to 2006 first-grade class to "Who am I?" They range from the obvious to the more complex:

> I am me. I am a boy. I am a girl. I am someone who can walk. I am someone who can move. I am someone whose hair grows. I am someone who is valuable. I am someone who needs air, who needs water, who needs food, who needs a home. I am someone who has feelings. I am someone who speaks in the languages I am taught. I am someone who comes from my father and mother. I am someone who can touch, smell, hear, taste. I am someone who can think. I am someone who comes from the Earth.

The purpose of this exercise is not only to give students a sense of identity outside their given name, but also for them to create subject matter for discussion

and further reflection. Take for example the response, "I am someone who speaks in the languages I am taught." First, the student who spoke these words did not name a language, nor did he answer in the singular. When asked what languages he was referring to the answer was "español y inglés." Why did he not name them? "Because I can learn other languages. You're also teaching us Nahuatl, but I don't know it yet." Then we began identifying the sources of their learning. For most students Spanish had come from their parents, and they viewed school as the place where they would learn English. A few came from homes where both Spanish and English were spoken and they saw school as a place where they would learn to read and write in both. The children were empowered in their understanding that learning other languages was possible beyond their homes.

An equally important side of this dialogue is discussing the identities that students identify with their names. Here the talk turns to social forces outside themselves—parents, religions, languages, institutions—that require members of society to adopt identities that are not strictly personal but social. The need for social studies then becomes contextualized for the students not as an abstract subject matter, but as a way of understanding those social forces that act on their lives daily.

Within this discussion, I am able to share with my students how I came to learn English under conditions different than theirs. They are astonished to find out that I was physically punished for speaking Spanish while they are being taught primarily in this language. "How did things change?" is their inevitable question. What an opportunity that presents to include the role of social struggle in the formation of social identity and changing the institutions that affect our lives. I make this discussion a part of the Social Studies curriculum that requires us to cover Martin Luther King and the civil rights movement. The students' personal identification with language empowerment makes the discussions richer. They clearly see not only the wrong in punishing someone for speaking a language, but also see the practice as "stupid" or a mistake because "it is better to know more than one language."

The appeal of the English-only movement to immigrant parents is that they see it as empowerment, a way for their children to succeed in a society in which the English language is the *lingua franca*. In a classroom where the children are learning two languages and being introduced to a third, they begin to understand the strength that lies in being multilingual. This kind of dialogue engages the children in nothing less than critical pedagogy where they begin to see education as a process of creating their reality rather than simply acquiring the skills to survive an already structured one.

Another activity is the Feelings Box, a simple shoe box decorated with bright colors and a slit through which pieces of paper can be deposited. As part of their Social Studies, the children learn to name feelings beyond the usual sad,

angry, scared, and happy. In my classroom, we identify at least 30 feelings: bored, apprehensive, nervous, deceived, betrayed, enthusiastic, and so on. The children regularly pursue the following writing format: Write a feeling you experience, describe the situation that created it, and tell how you will deal with it. These "identity and emotions activities" develop in children an active, practical, and empowering knowledge of self as well as integrate language arts, reading, and social studies curricula. I have found that exercises in introspection are rare in public education. In fact, in Texas schools, counselors are no longer allowed to provide "therapy" for students; they can only refer them to other public or private psychotherapeutic avenues. However, as children in my classroom engage in identifying and expressing their feelings, they inevitably connect them with situations in their homes or neighborhoods. The *Tlahtocan* at times leads to engagements in psychotherapy that are well justified as extensions of the Social Studies curriculum.

ONE IS THE SUN

A playful, metaphorical exercise that we engage in begins with the saying "One Is the Sun." It is a slight variation of Mesoamerican numerology that I first came across in the works of Domingo Martinez Paredes (1971), Mexico's foremost scholar of Mayan origin. Later it was elaborated through discussion with one of his students, Hunbatz Men (1984).

The children are taught a series of 14 phrases involving 0 through the number 13. These phrases are said in conjunction with arm and hand movements that correlate to each phrase. Often we improvise, and the children can create their own motions as playful expression. The exercise begins with "One is the Sun" and continues,

> Two is the Earth ... Three are the animals ... Four are the people ... Five is the world ... Six is the sky ... Seven is the moon ... Eight are the birds ... Nine are the seasons ... Ten is death ... Eleven are the waters ... Twelve is community ... Thirteen are the stars ... Zero is infinity.

This ongoing exercise of combining numbers with natural phenomenon is part of Joaquin Galarza's (1991) assertion that Mesoamerican languages practiced using two or more unrelated images to create a montage as a form of communication. It is also a mnemonic device to remember information about the natural world and thus creates a montage effect in thinking, an automatic creation of metaphorical language that begins to teach children how information can be fun as well as factual. After the children practice repeating these phrases in combination

with body motions, we dialogue about why the number and the phenomenon would be combined. No answer is discounted but rather is incorporated into the Mesoamerican meaning of this numerology. In the 15 years of using this exercise, I have never found children lacking in opinions about each number/phenomenon combination. Once a healthy dialogue occurs, the teacher introduces the historical information about each numerical sentence.[2]

Regular classroom work is integrated into this numerology by creating activities that explore that phenomenon. They can be as simple as observing how the Sun rises one side (in the east) but sets on the other (in the west). It can be the construction of a sundial, measuring how sunlight changes temperature. It can be a more elaborate activity that I do yearly when we make adobes or mud bricks. This activity is related to the numbers one (the Sun dries them), two (they are made of Earth), and five (bricks are one way we construct the world).

I also incorporate stories that reinforce each phrase. *Arrow to the Sun*, a pueblo myth (1974), is an excellent adjunct story for One is the Sun. A young maiden becomes pregnant with a ray from the Sun and the child suffers alienation as a result, but through an epic journey becomes a leader of his people. When Clay Sings (1972) deals with Earth (two) using pottery and the story is about death, clay becomes a way of honoring the ancestors (ten).

Mesoamerican oral tradition abounds with mythic stories that can be contextualized to a contemporary setting. Take for example the story of Quetzalcoatl discovering corn. When the people of Central Mexico were hungry, they summoned Quetzalcoatl for help. He searched for a food that would feed the people. He discovered an ant that was taking some corn to the anthill. The ant told him what corn was. Realizing it was the food he was looking for, he turned himself into an ant, went into the ant hill, and brought back seven grains from the multi-colored corn. He also brought back the knowledge of the *tekiotl*—the social structure of how the ants worked their community and harvested the corn. Tekiotl is a combination of two words: teki (instrument) and yotl (way). Its montage meaning is the way of the instrument. It simply means work.

I tie this story to a unit on corn. The children learn that ants are the only other species besides humans to harvest corn. They learn that Quetzalcoatl is a symbol for the human quality of intelligence and that he represents how people observed and learned from the ants. They learn that corn originated in Mexico and is now a food staple all over the world. I also have songs and stories in Nahuatl that relate to corn. This story ties in well with "Two is the Earth, Three are the Animals, and Four are the People" in the Mesoamerican numerology.

In the "talking circle," stories are usually presented orally rather than read from a textbook. Stories read from books are done in a different classroom setting. This reinforces the *Tlahtocan*'s definition as a "place of the spoken word."

In their language arts, the children create their own stories using one or more of the sentences as prompts. These stories can be introduced into the *Tlahtocan* for further discussion. Here is an example of a story made-up and told by a student in kindergarten:

> La niña, Flor, woke up in her house. She ran away from home. She went to play in the sea. She was attacked by a crocodile and a shark but a big ball came and rescued her. She drowned and died. But she wasn't really dead. She was rescued by her brother and parents. She was rescued with a rope. When she got home, she went to bed to sleep.

"What happened when she woke up?" I asked. The author, who was a girl, thought for a moment. Then another child added, "It was only a dream!" The girl smiled and nodded in agreement.

The story by itself is simple but quite creative for kindergarten. Metaphorically she used the image of a "big ball" to express forces in life that are often powerful but unseen. The animals are symbolic of those forces as well, circumstances or people with greater power that injure us. The rescue by her brothers and parents tell of her reliance on family. This story can also be seen as an attempt to bridge the gap between the realities of dreams and the waking state. Although young children may not be able on their own to fully discuss the ramifications of such a story, they can be guided by the teacher toward in-depth discussions. The use of metaphor and symbols as a way of interpreting, coping with, and renewing (impacting) our reality is one of the goals of the Xinachtli Project. It is almost like teaching children another language, but it is definitely giving them another model for critically viewing themselves in the world they live in.

Mesoamerican numerology is using numbers as mnemonic devices that also interpret phenomenon but always leave the door open for interpretation and knowledge gathering. When this numerology was presented to a fifth-grade classroom, they began changing the combinations. For example, they assigned two to the sun explaining that the sun gives us two things: light and heat. When interpreting geometric shapes, some say "four is a square" because it has four sides or "three is a triangle" for the same obvious reasons. However, one form that is often argued about my presentations, especially to grades third and higher, is whether a circle is zero or one. They argue the circle is one because it has only one edge, but they also argue that it is zero because a circle has no beginning or end. The ongoing lessons of One is the Sun are not mystical dogma, but continuing interpretative conversations leading to the increased use of metaphor and critical thinking to interpret information across the curriculum.

IN TLOKE NAUOKE

One way that imperialism weakens a people being colonized is by taking away their ability to continue to use the cultural symbols they have relied on for their social interaction and defining their relationship to their environment. Whiteness in the classroom is pedagogy that continues to debilitate and negate cultural connections to history from which oppressed peoples can draw liberating strength. In Mexico, the Spaniards outlawed the sacred symbols of the people because they perceived them as symbols of the devil. When these were relegated to academic texts, written by the same oppressors who had outlawed them in the first place, they were ill-defined and distorted. However, the texts provided a basis on which Mexicans could renew their use once the rule of the Spanish Crown had been vanquished.

Through the Xinachtli Project, I have used the knowledge of the tradition (see note 2) to reintroduce these symbols back in the classroom. However, I do not use them as cultural icons that merely inform students that they are part of their indigenous heritage. Rather, I use them as vehicles for teaching elements of the contemporary core curriculum. Thus, these symbols are literally restored to life and made practical once more to the descendants of those who also once used them as practical tools of pedagogy. They are "liberated" from their colonial academic prisons, perhaps eventually to serve as weapons for the liberation of the people they once served.

One of these symbols is the *In Tloke Nauoke*. It encompasses a cosmological vision that states that the whole reflects the part and vice versa. Such a concept is familiar to those acquainted with dialectical materialism and holism. María del Carmen Nieva (1969) explains that *In Tloke Nauoke* is that which holds and brings together. All parts of the Universe, including human beings, as well as the Universe itself, are *In Tloke Nauoke*. This symbol expresses how the dual creative energy comes together to create everything in the cosmos (pp. 87–88).

On a geometric level, this symbol is a circle that hold within it a square. The edge of the circle is tied to the square at the square's vertices. However, it can also be expressed as a square holding within it a circle. The edge of the circle touches each side of the square. When the circle is within the square, it is simple to demonstrate that the relationship of the square to the circle is 3.14 of its sides. Thus, the Mesoamericans had also discovered the constant Pi at least a thousand years before Archimedes (Esparza, 1975).

Hunbatz Men (1984) later explained how *In Tloke Nauoke* was the basis for Mesoamerican calendar designs, and how its geometry was necessary to incorporate key celestial cycles. I demonstrate how the geometric progression incorporates 7 circles and 6 squares (a total of 13 shapes). This allows the Aztec Calendar to create 20 divisions of each of the 18 segments, then 4 divisions of one 20 unit

segment, and 4 divisions of one segment. The result is 365.25 days for the year, which is the way Mesoamerican calendars have measured Earth's orbit for millennia. When an eighth circle is added to the progression, the form automatically becomes a proportional representation of the Earth, where the angle relations between the equator and the tropics can be traced and measured to the exact degrees they exist on the planet.

Elementary students are too young to appreciate the fact that one of the effects of whiteness in the classroom is to discount such symbols as primitive or outdated. However, whenever I do presentations of the *In Tloke Nauoke*, the adults present are usually astonished at the sophistication of such indigenous mathematics and science. They may not verbalize it but when they say, "I didn't know this," what they are really expressing is that until that moment they only saw the science and mathematics of the dominant society as sophisticated, and those who dominate that society as originators of such discoveries.

> The international nature of modern mathematics is a relatively recent phenomenon and represents a continuation of mathematical developments which occurred in Europe during the centuries from 1600 to 1900 ... Historians of mathematics have concentrated on the great main stream leading to modern mathematics and have paid only scant attention, if any at all, to mathematics in cultures not directly contributing to it. (Closs, 1986, preface)

In the classroom, the symbol *In Tloke Nauoke* is introduced in relation to "zero is infinity" and it is part of our *Tlahtocan* work. We begin with the simple question "What makes a circle possible?" After the students attempt to draw a circle and conclude that it is not "real" because is not "the same all the way around," next, through some enthusiastic interactive dialogue the children eventually arrive at the basic solution to creating a circle: find a center. I illustrate with string and pencil how a center makes a circle possible. Nevertheless, I quickly ask, "Before the center what did I have?" The inevitable answer is "nothing," and I follow up with, "Does nothing ever end?" This sets up a good context for talking about zero as infinity, what never ends. But I also ask if the circle has an endpoint? I do this as I walk one of them around the circle drawn in the middle of our *Tlahtocan*. Thus, they visually see how the number zero and the circle are related to infinity.

This exercise is followed up by demonstrating, as Leonardo da Vinci did centuries ago, that the human body is an *In Tloke Nauoke*, the unity of a circle and square. First, one child lies flat on the floor while two others work with a string and a chalk. I guide them to draw a circle using the navel as the center and draw their attention to how the circle line flows through the fingertips and soles of the feet. At this point, I do not continue da Vinci's illustration showing how the human body is also a square when laid out as a cross. Rather I have the children

use a compass to draw a perfect circle, cut it out, and fold it into quadrants. They then trace lines between the points where the quadrant line meets the edge of the circle, thus forming a square. It is important for them to grasp the relationship between forms. Later, they explore how this symbol is a geometric template for the Aztec Calendar and how it gets transferred from simple lines and angles into an astronomical computation wheel.

In a subsequent activity, I demonstrate how a square gives way to a circle. The children make a large square in the middle of the *Tlahtocan* and ponder how to divide it exactly in half without measuring. Eventually they conclude that it can be done with a diagonal line from corner to corner. Two lines in the same manner also create quadrants. The midpoint of the diagonal lines gives us a center to create a circle.

Calling the unity of these two geometrical forms *In Tloke Nauoke* introduces the children to information about history and the mindset of the ancient people who developed it. It also personalizes geometry for them. They see the formation of geometric shapes and measuring as extensions of themselves. In their identity exercises, they also see how they are *In Tloke Nauoke*. As Mexican Americans, they learn that this simple yet amazingly sophisticated symbol is part of their heritage. The use of this cultural awareness is well presented in the film *Stand and Deliver* when teacher Jaime Escalante tells his Chicano students that they are natural mathematicians. He demonstrates for one of the main characters the Mesoamerican way of finger counting to add and subtract (which I also do) and reminds him it was his ancestors the Maya who invented the number zero.

Use of this symbol is ongoing. We use it to introduce fractions and later to create fraction workbooks. The children also witness how the geometric constant Pi is derived through the relationship of a circle and a square. This year we did it for the whole school as part of International PI Day organized at our campus by the UT at El Paso Education Department. The *In Tloke Nauoke* is also an example of fractal-like geometry, and numerous mathematical assignments are created to explore such a mysterious aspect of chaos theory.

The combination of *In Tloke Nauoke* shapes also gets transferred into the art center, where the children give these forms beauty through painting. Their art activities are divided into two categories: exploration and assigned. Through their assigned artwork, I incorporate the idea of the symbol so that they learn to use shapes to create new shapes. In their exploration, they evolve at different rates to incorporate this skill to paint landscapes, houses, people, and animals. Because their first encounter with the *In Tloke Nauoke* came from using their own body to form this unified symbol, art becomes more consciously personal without subtracting its creatively playful nature.

Finally, since the vast majority of my students are Mexican American they are able to appreciate the complexity and richness of their ancestral culture. In

the last two years, I have had five students who, through discussion with their parents about what they learn in the classroom, have found out that their grandparents were fluent Nahuatl (Aztec) speakers. Information about their tangible indigenous past is something Mexicanos rarely share. When I talked with their mothers about this revelation, they told me that before they did not think this was important and therefore had not shared it with their children!

THE ROLE OF TEACHERS

Henry Giroux (1988) in *Teachers as Intellectuals* believes teachers have a special and unique opportunity to not only instruct but also to involve themselves in a transformative process through an interactive partnership between themselves, the children, parents, community, and society at large. When teachers become active coparticipants in an introspective and validating effort for the experiences children bring into the classroom, they become cocreators of new bodies of knowledge.

When teachers organize themselves around the learning rather than the teaching process by maintaining the children's viewpoint as well as a bird's–eye view of the classroom, they can be open to the authenticity of the children, to their uniqueness and needs at a particular moment. Acting on day-to-day realities such as moods, social concerns, interests, and forms of exploration, teachers can initiate learning without requiring children to fit into expectations that mechanize learning, such as the attempt to separate play from learning.

As teachers, we know that the notion that we stop learning when we start teaching is false. Teaching and learning are interactive. We are in fact participants in a covenant of hope when we realize that we are engaged in transformation rather than a mere transference of information. Teaching is not an act of replication but an act of creation in which we are not afraid to experience the unraveling of a finite experience into a chaos filled with infinite possibilities. Through symbolic, interactive, democratic dialogue, and activities we see learning emerge as a combination of two or more of these possibilities. Then learning becomes an act of faith and intuition as much as critical consciousness. This is Xinachtli.

UT El Paso professor, Lawrence Lesser (2005), reflecting his observations and those of some of his students concerning Xinachtli presentations, expressed the following:

> Aceves teaches using mythic pedagogy that could safely pass for a holistic multicultural approach to a conventional observer's eye. But it goes deeper by allowing his elementary students to experience their culture as something that is dynamic and interdisciplinary history within a universal context. (p. 1)

Recently I was discussing with a fellow teacher the home situation of many of my students. I related the conditions of abuse, alcoholism, addiction, and parental absenteeism. She looked at me rather surprised and asked, "How do you find out so much about your students?" The question confused me for a moment, as I had not pondered on it myself. Somehow, I assumed all teachers learn about their students' home life. "We do," she explained, "but not with so much detail as you."

This brought home a pleasant though sometimes painful reality. The *Tlahtocan* and subsequent explorations across the curriculum creates a bonding community in which the children develop an emotional confidence to discuss painful things and develop a trust in the teacher to be able to share these things with him or her. It also creates in the children a social consciousness that they gradually perceive as being absent in their counterparts. The Xinachtli Project includes interaction between my students and those of teachers who are part of the project. The children often comment, "How come they (other students) don't know what we know?"

Recently in the *Tlahtocan* one student asked me, "Maestro (teacher), do you teach all your students what you teach us?" I said, "Of course." They looked at each other nodding as if in deep thought. "We," he said, "were just wondering."

REFLECTIONS

The lack of longitudinal study on the effects of student exposure to the Xinachtli Project exercises has been one of my deepest frustrations. Four years ago, we arranged such a study through partnership with a professor at an out-of-state university. Due to procedural errors, the study had to be abandoned.

To continue the project, I currently depend on the positive results I see in my classroom, the overall satisfactory comments of faculty who participate, the expressed approval of parents who are pleased that their children are learning details about Mexican culture that they themselves did not know, and the overall campus academic success rate as measured by the state exams demanded by the No Child Left Behind (NCLB) law. However, the need to complete such a study of the Xinachtli Project's effects is needed if we are to expand it and find what modifications are needed for implementation.

Zimmerman et al. (1994) has already found enculturation, the degree to which one is embedded in one's culture, as a resilient factor among youth against "addictively harmful behavior" and "criminal delinquency." Whitbeck et al. (2001) also discovered that among Native American youth is "a positive association between child enculturation and school success" (p. 7).

I cannot think of a more empowering process for undoing whiteness in the classroom than to contextualize ancient constructs, the pedagogical instruments

of an indigenous culture decimated by European imperialism and white racism, into a contemporary pedagogy, and have children learn not only the basics but also be empowered to examine their lives and world through a model of critical thinking, metaphorical expression, and self-identity.

NOTES

1. In central Mexico, I found quite a few keepers of the oral tradition. My longest and deepest convers\ations were with Francisco Jimenez Tlakaelel, a Nahuatl man of knowledge from Coacalco; Andrés Segura, Capitán-General of the Conchero style of Aztec Dancing; Hunbatz Men, a Mayan from Yucatán taught and keeper of the spiritual philosophy centering on Hunab K'u, which translates into *In Tloke Nauoke* in Nahuatl.
2. These are the traditional meanings behind Mesoamerican numerology.
 One is the Sun: the sun is our single most visible source of light.
 Two is the Earth: the Earth is composed of its opposites, day and night, soft and hard, above and below, right and left, male and female forms of life.
 Three are the Animals: all animals depend upon one of three Earth levels to survive: land, water, and sky.
 Four are the People: four is the pattern of the human reproduction; mother and father engender daughter and son.
 Five is the World: with the five fingers of our hand, we create the World from Nature.
 Six is the Sky: there are six visible phenomena in the sky: sun, moon, stars, shooting stars (includes comets), clouds, and rainbows.
 Seven is the Moon: the moon is divided into seven basic faces. The new moon or empty face is not counted because it is invisible.
 Eight are the Birds: each one of our hands symbols the evening and morning presence of Venus but together they show us the Evening and Morning Stars are one celestial body. Our five fingers represent the five patterns of Venus; the one bird formed by two hands has eight wings because each pattern repeats every eight years.
 Nine are the Seasons: a human life has eight special, functional epochs: the womb, infancy until our skull is complete, early childhood when we learn to use our first teeth, childhood when we get our regular teeth, adolescence, maturity, parenthood, grandparenthood, and old age.
 Ten is Death: In the natural, as opposed to the accidental, progression of human life after old age comes death.
 Eleven are the Waters: Death does not end human life as life returns through the water as we all develop in a womb filled with water.
 Twelve is Community: A complete human body has twelve main joints that work in community to allow us motion.
 Thirteen are the Stars: Our thirteenth area of motion is our necks that allows a movement that generates exploration, learning, and development of consciousness. Stars are symbols of our consciousness as they represent sparkling elements in the midst of darkness—our own consciousness lies within us, as in darkness.
 Zero is Infinity: The spiral is how the number zero is written in Mesoamerican mathematics. It represents infinity, what never ends.

REFERENCES

Baylor, B. & Banti, T. (1972). *When Clay sings*. New York: Scribner.

Carrasco, D. (1990). *Religions of Mesoamerica*. San Francisco, CA: Harper & Row.

Closs, Michael P. (1986). *Native American mathematics*. Austin: University of Texas Press.

Dyson, A.H. (1990, January). Symbol makers, symbol weavers: How children link play, pictures, and print. *Young Children, 45* (2), 50–57.

Esparza, David H. (1975). *Computo Azteca*. México DF: Editorial Diana.

Galarza, J. (1991). [Cited in the proposal "*Xinachtli—seed of Nahuatl culture: A pilot project for the re-introduction of Nahuatl culture in the public schools of the Chicano-Mexicano community*"]. Phoenix Union High School.

Giroux, H. (1988). *Teachers as intellectuals: Towards a critical pedagogy of learning*. Granby, MA: Bergin & Garby.

Godina, H. (1992). *Indigenous Mexican culture as an impetus enhancing Chicano/Chicana adolescent education*. Master's Thesis. University of Texas at El Paso.

Hunbatz Men (1984). *Hunab Ku' y los Calendarios Mayas*. Merida, Yucatán, México: Communidad Indigena Maya de Difusión Cultural.

Karby, G. (1989, December). Children's conception of their own play. *Intercultural Journal of Early Childhood*, 21, 49–54.

Lesser, Lawrence M. (2005, October). *Getting students to engage in conceptions as well as content*. Paper presented at the 4th annual SUN Conference on Teaching and Learning, University of Texas at El Paso.

Martinez-Paredes, D. (1971). *El Idioma Maya Hablado y Escrito*. México DF: Editorial Orion.

McDermott, G. (1974). *Arrow to the Sun: A Pueblo Indian Tale*. New York: Viking Press.

Nieva, Maria de Carmen (1969). *Mexikayotl: Esencia del Mexicano*. México DF: Editorial Orion.

Sobel, D. (1991). A mouthful of flowers: Ecological and spiritual metaphors from early childhood education. *Holistic Education Review*, 4 (3), 3–11.

Steiner, R. (1924). *The kingdom of childhood*. (Helen Fox, trans. 1974). London: Rudolf Steiner Press.

Tahallary, L. C. (1991). Fantasy play, language and cognitive ability of four-year-old children in Guyana, South America. *Child Study Journal*, 21 (1), 37–36.

Vygotsky, L. S. (1976). Play and its role in the mental development of the child. In J. Brumer, A. Jolly, & K. Sylva (Eds.), *Play—its role in development and evolution* (pp. 537–554). New York: Basic Books.

Werner Heinz (1963). *An organismic developmental approach to language and expression of thought*. New York: Wiley.

Whitbeck, Les B., Hoyt, Dan R., Stubeen, Jerry D., & LaFromboise, Teresa. (2001). Traditional culture and academic success among American Indian children in the upper Midwest. *Journal of American Indian Education*, 40 (2), 48–60.

Zimmerman, M., Ramirez, J., Wahieko, K., Walter, B., & Dyer, S. (1994). The enculturation hypothesis: Exploring direct and protective effects among Native American youth. In H. McCubbin, E. Thompson, & A. Thompson (Eds.), *Resiliency in ethnic minority families, Vol. 1, Native and immigrant American families* (pp. 199–220). Madison: University of Wisconsin.

Educulturalism in the Service of Social Justice Activism

VIRGINIA LEA AND
ERMA JEAN SIMS

In editing this book, we have become more and more convinced of the value of educulturalism (Educultural Foundation, 2007) as a process through which we can facilitate the undoing of the hegemony of whiteness in ourselves, in others, in schools, and in the world. In large measure, this is because of the many lessons we have learned from the marvelous contributors to this book in terms of the diverse ways in which whiteness works in our conscious and unconscious lives, in and beyond the classroom.

In each of the several semesters during which we were preparing this text, we taught separate sections of the Multicultural Pedagogy curriculum that we both use. On each occasion, we applied some of our new theoretical insights. In this Afterword, we wanted to share some of these theoretical insights, acknowledging the contributions of the contributors to this book to two important areas of our lives: directly, to our own growth as educators and human beings committed to teaching for equity, caring, and social justice; and indirectly to the experiences of our students. Our evaluations tell us that the application of our new insights is influencing our preservice teacher students in profound and exciting ways. Although the depth of their inquiry and action varies, the course assignments are helping them to inquire into and recognize the effects of power on what they take for granted in and out of school. Without the benefit of a field placement while they are taking the course, preservice teacher students

undertake educultural assignments that include experiencing and reflecting on the following:

- *A Culture Shock Experience*: Preservice teacher students put themselves into a safe situation in which they will experience culture shock. The assignment prepares them to learn strategies to deal with the emotional disruptions that will inevitably take place in their teaching lives; to be empathetic toward the culture shock experienced by many of their students; and to take action to transform their classrooms into spaces in which their students are given the critical tools to express their voices, and feel included and empowered;
- *A mini "Funds of knowledge" Project* (Moll et al., 1992): Preservice teacher students go into the homes of K-12 students from backgrounds different from their own (often low income and of color) *as learners* to learn about the rich and valuable cultural knowledge that makes up the families and communities' lives. Preservice teacher students often express concern about "using" or "prying into" the families. We reassure them that in ten years of doing this work, it is our experience that the families welcome the opportunity to share their knowledge and being made to feel of value to the educational process of their own children and others. It is our view that many of our preservice teacher students rationalize their fear of taking themselves outside of the spaces in which they do have relative power. As long as they are well prepared and do not make the families feel used by the experience, 99% of the assignments come to very successful conclusions. This assignment takes place late in the semester, after the culture shock and certain cultural portfolio (see in the following text) experiences, so preservice teacher students are already more aware of their deeply embodied, cultural assumptions, and able to address emotional culture shock in effective ways;
- *Culturally responsive, critical multicultural and educultural, social justice lesson plans*: Drawing on the above and engaging cultural profiles of real K-6 children, preservice teacher students develop culturally responsive, critical multicultural, social justice lesson plans, and integrate them into a mini-unit as a final project. The lessons in the unit meet state standards. However, the content is co-generated by preservice teacher students and reflects their knowledge of the social issues experienced by K-6 children in terms of culture, race, class, gender, sexual orientation, disability, and whiteness. Often inspired by Ira Shor and Caroline Pari's (1999) *Education is Politics: Critical Teaching across Differences K-12, A Tribute to the Life and Work of Paulo Freire*, the overall goal of the lessons and

unit is to help K-12 students develop their own critical consciousness about the ways in which discourses of power operate in their lives. The lesson plans must engage critical, multicultural, pedagogical strategies, and inspire social action.

- A cultural portfolio, including
 - *personal narratives* and responses to these narratives from peers that help the narrator see his/her experience from different perspectives. This process is hardest in the absence of racial-ethnic diversity, but even when the latter exists, the instructor must not make students of color feel they are being used as tools to enlighten their white colleagues. The narratives must address preservice teacher students experiences with culture, race, class, gender, sexual orientation, disability, and whiteness (Lea, 2004);
 - *a mask* that (i) identifies the outer persona that we wear that is/are the product(s) of the social process(es) by which we are made subjects by the dominant discourses in our social and cultural worlds; (ii) identifies the inner self, that often experiences conflict with the outer persona that others perceive, and which we may wear to fit in with groups or individuals whom we see as significant in our lives (Lea & Griggs, 2004);
 - an *"I am"* poem, that helps students to better recognize the (potential) complexity and diversity of their inner selves, and help them to find voice; and
 - a *whiteness artifact,* that represents the ways in which whiteness hegemony plays out in the preservice teacher students' classrooms (see Lea & Sims, Chapter 11 in this book).

The following are a few of the evaluations of the course, received from preservice teacher students in May 2007.

Throughout this semester we have had to write two cultural portfolio stories, make a mask, find a whiteness artifact, and write an "I am" poem. These were all projects to be included in our cultural portfolio. The projects that we did for our cultural portfolio were for us to see how much our perceptions change from the beginning of the semester. It was also to see how we have grown and everything we have put into our work. I think I have grown a lot throughout this class, and my work shows it. (White, undergraduate, Liberal Arts, preservice teacher student, in her early 20s)

I realized that my biases may hinder the learning of certain students, but now that I have started to work on recognizing them, I can make a change. If I find Hispanics to be slow or not as intelligent, I may treat them in a manner without even knowing. With the power of understanding my feelings, I can work to do better. It is never okay to make students think they are not as capable as others, which in a way was

how I was feeling toward the Hispanics subconsciously. (White, undergraduate, Liberal Arts, preservice teacher student, in her early 20s)

As I look over my poem and my stories, I feel like I have a lot of anger built up in me against whiteness and attacks against me. I look back at my story about how I faced racism in high school and the writings on my locker and it brings me right back. It is relieving to express myself through my poem and my stories so that my peers may hear my voice. It is ironic to me because even though I have had issues with whiteness and racism, I feel like I embody many white cultural traits. As I looked over my mask, I realized that I am more white than Chinese. When it comes to my culture, I feel like I have lost touch with my Chinese culture. I feel like I don't know anything about my Chinese culture like the history, the art, the values, etc. I identify more with the dominant white culture, in which I was born and raised upon my entire 23-year-old life. (Asian, undergraduate, Liberal Arts, preservice teacher student, in his early 20s)

Through the readings, videos, activities, and dialogue in class I have seen how whiteness plays out in today's elementary schools. I remember the article I read about the social studies teacher who thought that there was nothing wrong with telling a San Antonio classroom full of Latino-American students that the white settlers were the first people to settle in Texas (Shor & Pari, 1999). When the student questioned by saying, "Then what are we?" the teacher was so blinded by his whiteness that he was unable to see what he was telling the students weren't just lies but were harmful to the students' sense of self-pride. Reading this helped me become aware that although we may not mean harm to students we, as teachers, need to know what we are saying and tell the students the truth, even if that means disagreeing with the Eurocentric curriculum sometimes. (White, undergraduate, Liberal Arts, preservice teacher student, in her early 20s)

I never really observed my outward behavior or inward thinking in terms of cultural scripts. But, just like everyone else, I take part in speaking and acting in terms of such scripts. I categorize our population. I maintain biases. And yet, I would like to think of myself as an open, accepting, and socially just human being. I think that as we mold into our society, we don't even realize the ways in which our behavior is perpetuating social inequalities. In the end, many of us mean well, we are just living with our eyes half open. (White, undergraduate, Liberal Arts, preservice teacher student, in her early 20s)

THE EFFECTS OF POWER IN THE MODERN CORPORATE CAPITALIST NATION STATE

This book is titled, *Undoing Whiteness in the Classroom: Critical Educultural Approaches for Social Justice Activism*. We came into this project with a clear understanding that undoing whiteness in the classroom will mean taking action inside ourselves and outside the classroom, as well as inside public school

cultural spaces. The recent public analysis of the corporate function of schools (Emery & Ohanian, 2004) has rearticulated the economic function schools have always played (Bastian et al., 1993), and some of our contributors reinforced this understanding (see, for example, Ahlquist & Milner, Chapter 6; Lea & Sims, Chapter 11). Indeed, these economic practices should themselves be seen as "cultural formations" (see Babatunde Lea, Chapter 5), constructed to mediate "asymmetrical socio-economic power relations" (Coronil, quoted in Turner, 1983).

Fully undoing whiteness in the classroom will therefore require change in economic policy, in legislation, and in the dominant culture. This long-term goal also requires a clear, flexible plan of action that links the above changes to classroom practice. It must be flexible because whiteness hegemony is itself dynamic: those in positions of power change their hegemonic practices to ensure the reproduction of a socioeconomic order that is in their economic interests.

Moving our focus back into the work we can do in the classroom to undo whiteness hegemony our goal should be to develop ways of helping students who are categorized into different, hierarchically arranged racial-ethnic groups, with a "superior" white group at the summit, to see through this hegemony. To reiterate, for us whiteness is not an essential attribute. People of color cannot reap the benefit of white privilege associated with the skin color and features associated with the socially constructed racial category, "white." They can, however, harness some of the cultural advantages of whiteness by embracing and practicing some of the cultural scripts associated with it. We wanted to remind the reader of this perspective since the following focuses on the disproportionate benefit whites received from whiteness.

One such video is *Skin Deep* (1995), which offers excellent insight into the realities of racism as prejudice plus power that we already know but as individuals find it hard to evidence. In the video we meet a group of university students from the University of California at Berkeley, the University of Massachusetts, and Texas A & M who have come together in a retreat in northern California to talk about racism. Two of the white student participants from Texas A & M, and one from the University of Massachusetts, talk openly about the racist discourse that they encounter in their private lives. The white male student from Texas A & M talks about one of the pastimes he and his friends engage in when they try to think of as many epithets as possible for African Americans and other people of color, the "n" word amongst them. The white female student expresses her sadness and cognitive dissonance with respect to her family's disapproval for the young Latino man that she wanted to date. This desire was met with censure from her family. A line was clearly drawn between white people and people of color, and the young white woman is trying to reconcile her love

for her family with her desire for greater social harmony (Thandeka, 1999). She wants to be part of creating this harmony and finds it hard to hear that her peers of color do not want her involvement in *their* social change process. At the start of the video, she is struggling to come to terms with not being wanted by these peers, with their perceptions of her as "the Other." Whiteness is so ubiquitous, and generates such a sense of entitlement that the experience of not being publicly wanted is novel for most white students. She only partially understands what Victor in Lee Mun Wah's (1993) video, *The Color of Fear*, means when he expresses his reservations about sharing in public the conflicts that exist between men of color in the United States. Victor is afraid that white men will see this conflict as the same as that which exists between whites and people of color. He argues that it is not the same. What white people do to people of color lifts them up; what people of color do to each other also lifts white people up. (Mun Wah, 1993). Whiteness is a process that facilitates advantage whatever the circumstances.

Marc, the young white male student from Boston, who comes from an Italian background, has learned to appreciate African-American culture through his love of gospel music. In fact, he has been singing in a Baptist church choir without the knowledge of his family. In the case of this young man, educulturalism has once again led to a deeper understanding of whiteness and a desire to undo this hegemonic system, but only on an intercultural level. Like the white female student, Marc is still struggling with the tension between his love of and need for acceptance by his family, the members of which express highly deficit views of African Americans, his desire to bridge the color line, and his knowledge that a successful professional life awaits him if he does not disrupt the status quo. By the end of the film, he is still embracing whiteness, as expressed in his comment to one of the African-American students, Brian: "In a way I'm thankful that I don't have to worry about it because I am all set up ... I know that I don't have to worry as hard as you do ... I don't know what you are going to do (in life) but I'm set up."

Brian's response to Marc amounts to a plea to all of the students at the retreat to "begin to work together or they all die." His idea of action is that their lives "have to become a 'have to.' Every day I have to interact, you know what I am saying? ... show me your courage and I'll respect that." Brian exhorts the white students to come to a black function and show their intent to be allies by not running away when the expression of four hundred years of pain associated with racism is directed at them—although he does not wish the pain he has felt as a result of racism and stereotyping of black people to be felt by the white students. Finally, Brian calls for all of the students to "be there in the square together." Each one of them needs to "work on their own people ... every ... day."

Brian's idea originated with Malcolm X (Malcolm X & Haley, 1991) In 1963, Malcolm X spoke to a "little, blonde, co-ed girl" after a speech at her college in New England. She asked him if he believed there were any "*good* white people?" Malcolm X said to her, "People's *deeds* I believe in, Miss—not their words" (p. 286). Later, Malcolm X regretted his negativity to this young woman:

> I told her that there was "nothing" she could do. I regret that I told her that …Where the really sincere white people have got to do their "proving" of themselves is not among the black *victims*, but out on the battle lines of where America's racism really *is*—and that's in their own home communities; America's racism is among their own fellow whites. That's where the sincere whites who really mean to accomplish something have got to work. (p. 376)

In our view, the exhortations from the African-American student in *Skin Deep* and from Malcolm X, whose name at the end of his life was El-Hajj Malik El-Shabazz, are paramount if we are ever to translate moral outrage into a new social paradigm in which power, racism, and whiteness are challenged and more equitable socioeconomic structures created.

In the following, we offer a theoretical model for undoing whiteness that draws on the work of our contributors.

THEORETICAL INSIGHTS FOR UNDOING WHITENESS IN THE CLASSROOM

The authors in this book have helped us to develop the theoretical model for undoing whiteness that we offer in Table A.1 (Aldridge & Goldman, 2007; Freire, 1993/1970; Nieto, 1994).

A: Americo-centric Education

This monocultural teaching model functions to reproduce the status quo by transmitting to or banking in students the existing Americo-centric curriculum. Within this model, whiteness remains the definition of normal cultural practice and recolonizes classroom practice everyday (Aldridge & Goldman, 2007; Freire, 1993/1970). Absent are curricula that are culturally responsive and relevant, and engage students' own "funds of (cultural) knowledge" (Moll et al., 1992) in critical and creative dialogues from multiple social and cultural perspectives. The practice of power remains veiled and students are not encouraged to develop a deep awareness of their own embodied discourses or cultural scripts, to avoid personal

Table A.1. From Perpetuating to Undoing Whiteness

A.	B.	C.	D.	E.
Americo-centric education	Sightseeing Americo-centric education	Cultural, exchange Americo-centric education	Critical, cultural immersion education	Critical, educultural education & social justice activism
Monocultural teaching model that functions to reproduce the status quo by attempting to engage in **transmitting** or **banking** the existing curriculum in students. No inclusion of non Americo-centric cultural elements.	Cultural reproduction model that encourages some **tolerance** of non-hegemonic cultural worlds *and* **transmits** Americo-centrism through the inclusion of some alternative cultural elements.	Cultural reproduction model that encourages **acceptance** of non-hegemonic cultural worlds by including more alternative cultural elements. This model allows teachers to engage in **transactions** with hegemonic curriculum materials.	**Inquiry,** model of education in which the structure of the curriculum changes to allow a critical, rational analysis of different cultural perspectives that involves **respect.**	**Transformation, problem posing** education that **affirms** students' cultural knowledge, encourages **solidarity** over race, class, gender, different abilities, and sexual orientation lines, and **critique** of self and society (1) Finding the "one" through polyrhythms (Chapter 5); (2) Envisioning transcultural spaces (Chapter 1); (3) Identifying the adaptive unconscious (Chapter 2); (4) Engaging the emotions and the spirit (Chapter 3); (5) Humanistic pedagogy through culturally relevant literature (Chapter 4); (6) Identifying deficit discourse through critical media literacy and performance (Chapter 6–9); (7) Rejecting the binaries through multicultural visual art (Chapter 10); (8) Imaging whiteness (Chapter 11); (9) Legitimizing multiple identities through imagery (Chapter 12); (10) Seeing through educultural black feminist standpoint theory (Chapter 13); (11) Undoing whiteness through Mesoamerican ancestral culture (Chapter 14).

discomfort. Educulturalism, reflectivity, and social action to transform inequities are not a part of this model.

Well explained by Sonia Nieto in her well-known essay (1994), monoculturalism or Americo-centricity is represented by the current, corporate, scripted curriculum, and mandated in many public schools. Several of our student teachers, with the support of mentor teachers, struggle to find spaces in their preservice teaching to teach in critical multicultural ways. Others find the hegemony of the scripted model overpowering and succumb to what for them was and remains "normal" Americo-centric education. The arts, where present, are Eurocentric and are not directed toward educultural goals.

B: Sightseeing Americo-centric Education

This model allows students, from the vantage point of an Americo-centrist cultural shore, a superficial sightseeing expedition into other cultural worlds. It encourages some tolerance of non-hegemonic cultural worlds *and* transmits Americo-centrism through the inclusion of some alternative cultural elements.

The approach offsets any real change to the curriculum in form or content by ensuring that students return to the normative Americo-centrist cultural shore, after a brief sortie into an exploration of "heroes and holidays," and food. It is therefore an effective cultural reproduction model in that it *claims* multiculturalism, thus precluding the need for action toward real structural change in the curriculum. The arts, where present, tend to be Eurocentric and are not directed toward educultural goals. The sightseeing Americo-centric education is one of the models that many student and practicing teachers feel most suits their aspirations to make some change in schools.

C: Cultural Exchange, Americo-centric Education

This model inches forward into allowing a modicum of curricula reform. It encourages some acceptance of non-hegemonic cultural worlds in the mainstream curriculum by including more alternative cultural elements. The model also allows teachers to engage in transactions with hegemonic, scripted curricula. Teachers are encouraged to take these curricula and adapt them so that they are more culturally relevant and responsive to their students' needs. The cultural exchange, Americo-centric approach remains a cultural reproduction model because it amounts to a series of reactions to an existing educational system that is not critical or multicultural. It is not proactive, in the sense of imagining and putting into place a social action agenda to transform the existing school structure and curriculum content. The arts, where present, still tend to be Eurocentric and are rarely directed toward

educultural goals. It is, however, the other model, that many student and practicing teachers feel most suit their aspirations to make some change in schools.

D: Critical, Cultural Immersion Education

This model makes a real contribution to the critical multicultural process of engaging students in inquiry and critical thinking. Within this approach, educators begin to restructure the relationships at the heart of the educational process, and embrace an immersion in and critical, rational analysis of different cultural perspectives. The emerging process is characterized by respect. The critical, cultural immersion education engages the arts in Eurocentric and other-centric ways, both directed toward educultural goals. There remains a tendency to leave this process at the level of empathy and moral critique, thus offsetting the need for real social activism for social change.

E: Critical, Educultural Education and Social Justice Activism

In this model, critical multicultural practice is imbued with critical educulturalism for social justice activism. The goal is to offer students a transformational, problem posing approach to developing critical consciousness. Drawing on the work of Paulo Freire (1993/1970), students are empowered to generate their own critical, culturally relevant issues, and develop critical literacy through dialogue aimed at finding solutions to these issues. The approach affirms students' cultural knowledge, and encourages solidarity between students around a critique of power, as represented by race, class, gender, different abilities, and sexual orientation. Ultimately, students take social action to resolve the injustices associated with these mechanisms of power. It encourages critical self-awareness through praxis. It also insists on the development of literacy skills to enable students to contribute to a more equitable society and world, and to choose their socioeconomic roles as part of this process.

The following are short synopses of the ways in which the authors assembled in this book have contributed to undoing whiteness in the classroom through critical, educultural education, and social justice activism.

(1) *Finding the "one" through polyrhythms*

In Chapter 5, "Polyrhythms as a metaphor for culture," Babatunde Lea points
us toward the lack of cultural polyrhythms in the one-size-fits-all, scripted
classrooms in which he has offered his educultural programs. The goals of
the California State mandated assessment systems for K-12 education and

teacher-education programs straightjacket our educational processes and preclude alternative goals for education. They enable the mechanisms that support the grand, universal narrative of whiteness hegemony. According to Babatunde, the absence of polyrhythms signals the absence of a full expression of humanity. In his view, the presence of cultural polyrhythms is one of the conditions for social justice and equity to flourish.

(2) *Envisioning transcultural spaces*

Catherine Kroll in Chapter 1, titled "Imagining ourselves in transcultural spaces: Decentering whiteness in the classroom," reminds us of "the artificial construction of whiteness [that] almost always comes to possess white people themselves unless they develop antiracist identities, unless they disinvest and divest themselves of the investment in white supremacy." In helping her students to develop these antiracist identities, Kroll engages the empowering nature of oppositional art forms as a way of revealing the disconnect between the ideologies in support of social equality held by her students and the lived experiences of oppressed people. Her use of oppositional art forms invited the students in her college-level writing class into transcultural spaces in which they dialogued about, listened to, watched, read, critiqued oppositional art forms, and examined the whiteness that often blinds us to the interconnectedness of racial, class, and gender inequalities. The dialogue was used to mediate, navigate, and change these spaces into more human realities in which students were better able to see the oppressive nature of white supremacy, cultural deficit theories, and the economic power of the white power elite that serve to suppress and marginalize the stories of poor people, women, and people of color.

(3) *Identifying the adaptive unconscious*

Ann Berlak in Chapter 2, "Challenging the hegemony of whiteness by addressing the adaptive unconscious," describes her use of the theory of the adaptive unconscious to make whiteness visible for her preservice teachers. In her research, Berlak found that the resistance strategies that her students utilized were both conscious and unconscious attempts to avoid dealing with their own complicity in the reproduction of white power and privilege in schools and classrooms. Guided by the theory of the adaptive unconscious, Berlak was better able to help her preservice teachers unveil the master narratives of whiteness deeply entrenched in their unconscious minds. Through her insightful use of film and videos, like *School*

Colors (1994), and inviting people of color into her class as guest speakers, Berlak's students gained insights into their unconscious minds through examining their own practice, including the transmission of the narratives of whiteness to their own public school students. As Berlak points out, the adaptive unconscious "operates almost entirely out of view, behind a locked door, but is nevertheless a greater source of teacher's minute-to-minute, second-to-second classroom behavior than is our consciousness. Therefore, we ignore it at our peril." Berlak's students were challenged to critique the deeply entrenched master narratives of whiteness and interrupt the transmission of these narratives to their own public school students.

(4) *Engaging the emotions and the spirit*

In Chapter 3, "The transformative power of poetry to engage the emotions and invoke the spirit," Erma Jean Sims and Virginia Lea explore how poetry can be used to transform the hearts of their preservice teachers in their Multicultural Pedagogy classes by engaging their emotions and spirits. The students read selected poetry from people of color with authentic voices and lived experiences with whiteness hegemony. These poets share the beauty of their cultures as well as the pain of racism, internalized oppression, and a longing to be white. Lea and Sims' students are also asked to write their own "I am" poems in an effort to examine their public personas and private identities that are often unconscious. The students are encouraged to come face to face with their own biases, prejudices, racism, sexism, classism, homophobia, and stereotypical notions and taken-for-granted realities. They use their new understandings of "self" to create culturally sensitive and culturally relevant empowering pedagogy that enlightens, inspires, and moves their own students to greater equity and social justice activism in the schools, classrooms, and wider communities.

(5) *Humanistic pedagogy through culturally relevant literature*

Rosa Furumoto's Chapter 4, "Future teachers and families explore humanization through Chicana/o/Latina/o children's literature," reminded us that education is never neutral. We learned about the power of Chicana/o/Latina/o children's literature as an art form to undo whiteness by narrating images of our collective humanity, and creating opportunities for dialogue and social justice activism. Furumoto's interactions with the preservice teachers in her class suggested that these future teachers would develop into more critical multicultural educators by interrogating their beliefs

about literacy, and engaging in a critical and comprehensive examination of the sociopolitical and cultural context of literature-based literacy instruction. In her course, Furumoto required that the teachers interact directly with Chicana/o/Latina/o families. Because of this interaction, the teachers were better able to refute the dominant discourse of whiteness that reproduces myths about Chicana/o/Latina/o parents' lack of interest in their children's education.

(6) *Identifying deficit discourse through critical media literacy and performance*

Roberta Ahlquist and Marie Milner, authors of Chapter 6, "The lessons we learn from *Crash*: Using Hollywood Film in the Classroom," dissect the Oscar-winning movie, *Crash* (2004), which "is situated within [the] invisible norm of whiteness, where people of color and white people interact, interrupt, and sometimes confront the inequities and racism that are part of the social fabric of life under a competitive me, my, and I economic system." Ahlquist and Milner extract from the movie powerful vignettes that may be used with preservice teachers and high school students to aid them in understanding the invisible and insidious ways in which racism, prejudice, and whiteness hegemony are reproduced. They pose questions that help students to expose the ways in which power shapes the lives of those on the "downside of power." This dialogical process helps students to self-decolonize by disrupting their preconceptions about race, privilege, ethnicity, and class that have consequences in their own practices.

In Chapter 7, Karen McGarry shares the educultural approaches she uses to destabilize the "cultural anaesthesia" of her students. She uses the film, *The Couple in the Cage* (Argueta, Fusco, & Heredia, 1993) to target the students' perceptions about race and whiteness by encouraging their emotional responses to the "sensorial, mimetic displays" in the imagery of the film. In other words, she engages "visuality" to break through the students' "anaesthesia." McGarry also found that her students had a limited understanding of multiculturalism. To them, the mere physical presence of ethnic and racial diversity in the classroom was tangible "proof" of the successes of the inclusive goals of Canadian multiculturalism; they saw tolerance as an acceptable position in race relations. McGarry's use of film helps her students to explore the "erasure" of the voices of indigenous people in Canadian history, and the prevalence of color evasion or color blindness in Canadian society as a way of maintaining whiteness hegemony and inequality. Her students come to understand that a truly

multicultural society is one that *actively* incorporates the cultural traditions and values of various groups rather than simply tolerating them.

Denise Hughes-Tafen reminds us in Chapter 8, "Black women's theater from the global south and the interplay of whiteness and Americanness in an Appalachian classroom," of the ways in which theater can be used as "performative inquiry" to investigate issues of identity and power. Hughes-Tafen used this process with her students in the Upward Bound Summer Program in Appalachian Ohio to create a critical dialogue on "Otherness," "whiteness," and "Americanness." She discovered that Americanness was a barrier to critical dialogue about Otherness and whiteness for her students because, consciously or unconsciously, they had been taught to value whiteness and to objectify others who were not as "American" as they were. By studying and reenacting four plays from women from the Global South, which dealt with issues of gender, race and class, her students gained insight into the ways that Americanness and whiteness are inter-related and are implicated in the "Othering" of marginalized groups. The summer program culminated with the students engaging dialogically in the creation of their own play about understanding different cultures. During this process, the students addressed issues of cultural conflict and whiteness. Finally, they performed the play, in the presence of families and friends, thus demonstrating how the drama process and performative inquiry can lead to social justice activism and undoing whiteness.

In Chapter 9, "Educultural performance: embodiment, self-reflection, and ethical engagement," Eileen Cherry-Chandler introduces the work of three performance ethnographers. These amazing artists articulate a cultural responsive, socially just, critical and creative process that may be used to ensure that the voices and social concerns of the less-privileged are heard. In her view, "(educultural) performance embodies, reflects and engages us in the world." It is "the intersection of the language of the pedagogical and the performative…[offering] interdisplinary, transgressive and oppositional pedagogical practices that connect to a wider public project and social justice, deepening the imperatives of radical democracy." Educultural performance is a cultural process of insight and understanding in the making that can engender intercultural respect and social justice.

(7) *Rejecting the binaries through multicultural visual art*

Judy Helfand, author of Chapter 10, "Inviting an exploration of visual art into a class on American cultures" uses storytelling and visual art as central

themes in her American Culture college course to enable her students to explore their own experiences and reflect on their own social positions/ locations within structures of power. She described how her students came to the realization that they needed the personal stories of others to understand their own stories and their relationships to the world around them. The sharing of their stories and selected visual art images of African Americans encouraged the breaking down of stereotypes and led to an understanding that "in a white supremacist system, nonwhite people are, of course, relegated to an inferior position and so are their cultural pro- ductions." These educultural activities allowed many of Judy Helfand's students to experience transformative learning that led to changes in their worldview and openness to multiple perspectives.

(8) *Imaging whiteness*

In Chapter 11, "Imaging whiteness hegemony in the classroom: Undoing oppressive practice and inspiring social justice activism," Virginia Lea and Erma Jean Sims reported on how their preservice teachers responded to an assignment to identify whiteness hegemony in the classroom. The teach- ers were asked to identify the practical manifestations of whiteness as an everyday process, initially in the form of an image and caption, and then as an analysis. Lea collected the images and captions and put them into a power point, which was then played back to the entire class. Carefully developed questions lead to critical dialogue and ideas for social action to undo the hegemonic practices of whiteness represented on the power point. A year-long research project into the impact of this assignment on preservice teachers indicated that it has helped them to better understand the ways in which they embody the cultural scripts of whiteness.

(9) *Legitimizing multiple identities through imagery*

In Chapter 12, "Figuring the cultural shape *we're* in," Cathy Bao Bean shared cultural metaphors to help us understand the processes whereby we live out different cultural identities and worldviews. Whether we realize it or not, we are complex, interrelated beings and not the simplistic and singular persona to which whiteness hegemony would have us conform. In complex, human ways we are the same; at the same time, we express multiple cultural shapes, and we experience the world in diverse ways. Bao Bean uses a social constructivist lens to articulate the ways in which human beings "periodically consciously *reconfigure* the shape and contents of our world to accommodate what we learn." Her drawings of the cultural

shapes that she has been in and continues to find herself in are a reflection of her attempts to maintain a sense of self that embodies interconnected cultural webs of significance that endure or diminish over time. By asking our students "what cultural shape(s) are you in?" we can prompt them to draw and analyze the intricacies of their own lives, and address the impact of whiteness on their identities.

(10) *Educultural black feminist standpoint theory*

In Chapter 13, "Black woman 'educultural' feminist," Pauline Bullen takes a critical look at social justice–oriented, "educultural" teaching from a black radical feminist and activist standpoint. In her scholarship, Bullen examines the work of Canadian and American theorists and artists who challenge exploitive relationships. In her classroom, Bullen's college students are asked to interrogate the attitudes and the perspectives of the "Other" through an examination of, for example, the portraitures of Canadian Visual Artist, Sandra Brewster. The students learn how to read "in those faces and facial expressions a variety of histories and experiences (of oppression)" that are characteristic of world majority people of color, as well as realistic representations of contemporary society and the human condition. Bullen's "radical work articulates a 'vision of resistance, of decolonization, that provides strategies for the construction of a liberatory, black,…body politic' (hooks, 1999, p. 67), one that is aggressively vocal on the subject of blackness; one that includes an oppositional gaze and is not shaped by dominant ways of knowing or a colonized stance."

(11) *Undoing whiteness through Mesoamerican ancestral culture*

In Chapter 14, "One is the Sun: Mesoamerican pedagogy as an adjunct to undoing whiteness in the classroom," Carlos Aceves first expresses his concern about using his Mesoamerican heritage as a source for undoing whiteness in the classroom. He does not want to reproduce the imperial cultural imposition and oppression represented by the Eurocentric curriculum that is still prevalent in U.S. public classrooms. He resolves this dilemma by focusing on the pedagogical processes that can be drawn from Mesoamerican culture to undo whiteness and generate universal educational and social equity. The process includes three basic constructs: Tlahtocan, One is the Sun, and In Tloke Naouke. By utilizing Mesoamerican oral tradition, which abounds with mystic stories, young children are involved in a culturally relevant, "symbolic, interactive, democratic dialogue and activities" through which education becomes empowering to students

from communities disempowered by whiteness hegemony, and "learning becomes an act of faith and intuition as much as critical consciousness." He calls this "Xinachtli."

CONCLUSION

We, Virginia Lea and Erma Jean Sims, shared the same mentor, Dr. Anita de Frantz, who gave us both insights into how the hegemony of whiteness works, without even mentioning the word whiteness. It takes a tremendous amount of power, Anita said, to define other people's reality, make them accept this definition as real, and act accordingly. In our view, those in positions of power manipulate the hegemony of whiteness to realize their ambitions.

The educultural teachers in this book have taken on the task of challenging this hegemony. They embrace the goal of helping their students to see through the practice of whiteness. They are taking action to enlighten themselves. They prepare and empower us for an activist educultural journey to see through and act to interrupt the "normalizing" and "dividing" processes (Rabinow, 1984) that have made socioeconomic hierarchy and largely segregated racial-ethnic social categories seem natural to people born and socialized in the United States. They inspire us to challenge this hierarchy by developing counterhegemonic understandings and insightful curricula with which we are able to re-read texts seen as normal—academic, popular, and personal—in critical, liberating ways. With these tools, we will be better able to go forth and work in solidarity with others to work to transform oppressive law, economic and educational structures and policy, and social and cultural practice. We are inspired to continue to use creative narratives in our own classrooms and beyond, to undo whiteness and develop critical educultural approaches for social justice activism.

REFERENCES

Aldridge, J. & Goldman, R. (2007). *Current issues and trends in education.* Boston, MA: Pearson.

Argueta, L., Fusco, C. & Heredia, P. (1993). *The couple in the cage: A Guatinaui odyssey.* United States: Third World Newsreel.

Bastian, A. Bastian, Fruchter, Gittell, Greer, & Haskins. (1993). Three Myths of School Performance. In H. Svi & Purpel, David (Eds.), *Critical social issues in American education: Toward the 21st century.* New York: Longman Publishing Group.

Crash. (2004). Dir. Paul Haggis. Santa Monica, CA: Lions Gate Entertainment.

Educultural Foundation. (2007). Available online: http://www.educulturalfoundation.org.

Emery, K. & Ohanian, S. (2004). *Why is corporate America bashing our public schools.* Portsmouth, NH: Heinemann.

Freire, P. (1993/1970). *Pedagogy of the oppressed.* New York: Continuum.

Hooks, B. (1999) Naked without shame: A counter-hegemonic body politic. In E. Shohat (Ed.), *Talking visions: Multicultural feminism in a transnational age* (pp. 65–74). New York: MIT Press.

Lea, V. (2004). The reflective cultural portfolio: Identifying public cultural scripts in the private voices of white student teachers. *Journal of Teacher Education*.

Lea, V., & Griggs, T. (2004). Behind the mask and beneath the story: Enabling students-teachers to reflect critically on the socially constructed nature of their "normal" practice. *Teacher Education Quarterly*.

Malcolm X & Haley, A. (1991). *The autobiography of Malcolm X*. New York: Ballantine Books.

Moll, L. C., Amanti, C., Neff, D., & Gonzales, N. (1992, Spring). Funds of knowledge for teachers: Using a qualitative approach to connect homes and classrooms. *Theory into Practice*, 31 (2), 132–141.

Mun Wah, L. (1993). *The color of fear*. Berkeley, CA: Stir Fry Seminars & Consulting.

Nieto, S. (1994). Affirmation, solidarity and critique: Moving beyond tolerance in multicultural education, *Multicultural Education*, 1 (4), 9–12, 35–38.

Rabinow, P. (Ed.) (1984). *The Foucault Reader*. New York: Pantheon Books.

School Colors. (1994, October). Boston, MA: Frontline Series, American Public Television. Available online: http://www.pbs.org/wgbh/pages/frontline.

Shor, I. & Pari, C. (1999). *Education is politics: Critical teaching across differences, K-12, A tribute to the life and work of Paulo Freire*. Portsmouth, NH: Boynton/Cook.

Skin Deep. (1995). Dir. Frances Reid. Berkeley, CA: Iris Films. Available online: http://www.irisfilms.org/SD/con1.html.

Thandeka (1999). *Learning to be white: Money, race, and God in America*. New York: Continuum.

Turner, T. (1993). Anthropology and multiculturalism: What is anthropology that multiculturalists should be mindful of it? *Cultural Anthropology*, 8 (4), 411–429.

Contributors

Carlos Aceves, 52 teaches first grade bilingual at Canutillo Elementary School in west Texas. He holds a B.A. in journalism and an M.Ed. from the University of Texas at El Paso. He has been an activist in education since age 16 through such organizations as the Movimiento Estudiantil Chicano de Aztlan (MEChA), the Global Allaince for Transforming Education (GATE), and the Xinachtli Project.

Roberta Ahlquist is a professor at San Jose State University where she teaches race relations courses from a post-colonial and anti-racist perspective. She has recently taught race relations courses in Finland (as a Fulbright scholar) and given equity workshops in Australia (as a visiting lecturer). Most recently she is writing and speaking out against the hyper-accountability movement and cultural deficit theorists like Ruby Payne.

Cathy Bao Bean, author of *The Chopsticks-Fork Principle, A Memoir and Manual* and co-author of a bilingual reader for ESL and CFL learners, is a daughter, mother, wife, friend, sister, aerobics instructor, business manager, and board member of the Claremont Graduate University School of the Arts and Humanities, the NJ Council for the Humanities and Society for Values in Higher Education. In a previous incarnation, she was a philosophy teacher, cook, student, carpool driver as well as founding member of the Ridge and Valley Conservancy. In the process, she has been learning how to make the "foreign" more familiar and the ordinary and extraordinary into each other. None of it has been painless. All of it has been fun - except the cooking.

Ann Berlak has been exploring questions of social justice with pre-service teachers for almost three decades. Currently she teaches the foundations courses for the elementary education program at San Francisco State University. She is co-author with Sekani Moyenda of *Taking it Personally: Racism in classrooms from kindergarten to college.*

Pauline Bullen is an assistant professor at Brooklyn College, CUNY. She is also an affiliate faculty member for the Women's program at the college. Within the "SEEK" department, Pauline works with students traditionally underrepresented in university communities and continues the scholar activism and advocacy of her former 20 years as teacher, counselor and Equity Consultant for the Toronto District School Board in Canada. Her 2006 Ph. D. thesis, completed at the University of Toronto's Ontario Institute for Studies in Education, examines race and racism and their effects on Black students, primarily at the undergraduate level. She is currently editing "Facing Intolerance," a collection of her writings on racism in Toronto's educational system, and completing "Beyond Powerlessness," a book that focuses on the development of a Radical Black Feminist stance.

Eileen Cherry-Chandler completed graduate work in curriculum and instruction: interdisciplinary arts education from Loyola University Chicago and received her doctorate in performance studies from Northwestern University. She has held faculty positions at Northwestern, Columbia College Chicago and DePaul University and has been an arts activist, performer and writer on the Chicago cultural scene for many years. She is a veteran of numerous community arts initiatives involving arts-in-education and teacher training. She is currently serving as assistant professor of Theater and Film at Bowling Green State University. In addition to her research interest in Performance Studies, identity politics and issues of social disparity, her teaching focus is literary performance and cultural studies.

Rosa Furumoto, Ed.D. is an assistant professor at California State University Northridge, in the Chicana/o Studies Department. Rosa is a long time community activist working with parents and communities of color for educational justice.

Judy Helfand is an educator and activist whose scholarship is focused on understanding the relationship between dominant culture in the U.S. and white identities. She is also interested in the role of spirit and emotion in learning. At age 55 she took her activism into the classroom by obtaining an

M.A. in American Studies and Cultural Studies and now teaches American Cultures and World Humanities at Santa Rosa Junior College. She co-edited *Identifying Race and Transforming Whiteness in the Classroom* with Virginia Lea (Peter Lang, 2004), writes letters to the editor on racism and white privilege that get published, and recently became a grandmother.

Denise Hughes-Tafen earned her Ph.D. in Social Foundations of Education at Ohio University. She is from the Caribbean island of Antigua and is currently teaching at West Virginia University. Her research interests include Post Colonial Studies, Disability Studies, emancipatory forms of education and the use of theater in the classroom. Her most recent research focused on women and Calypso in the Caribbean and the use of theater from women living in the Global South in an Appalachian classroom.

Catherine Kroll is assistant professor of English at Sonoma State University. She is the author of "Rwanda's Speaking Subjects: The Inescapable Affiliations of Boubacar Boris Diop's *Murambi*," *Third World Quarterly* 28:3 (2007) and "Fair Trade: The Contemporary African Novel's Traffic with the West," a chapter in *Challenges in the Study and Teaching of African Literatures*, forthcoming from Heinemann.

Babatunde Lea is an internationally celebrated drummer, performer and recording artist. His recordings—including Sweet Unseen: Summoner of the Ghost, March of the Jazz Guerrillas, Soul Pools, and Level of Intent—have been critically acclaimed. Babatunde Lea also has more than 30 years of classroom experience, at the primary, middle school, high school, and college levels. He is artistic director of the Educultural Foundation, a California educational nonprofit organization. In this capacity, Babatunde develops educultural curricula, with a focus on music. For more information about Babatunde's work, please visit www.babatundelea.com; www.myspace.com/babatundelea; and www.ixtlanartists.com

Virginia Lea is currently an associate professor of education at Sonoma State University, and executive director of the California nonprofit organziation, the Educultural Foundation. She received her Ph.D. in social and cultural studies in education from the University of California, Berkeley. She sees her research and teaching as a means of developing greater understanding of how whiteness hegemony contributes to global inequities. She tries to live a commitment to greater socio-economic, political and educational equity.

Karen McGarry completed her PhD in Social Anthropology at York University in Toronto, Ontario, in 2003. She currently teaches Anthropology at both Trent and York universities. Karen's research interests include the anthropology of Olympic-level sport, mass media, spectacle, and the performance arts in Euro-Canadian and American contexts. Her dissertation research focused upon an ethnographic analysis of Olympic-level Canadian figure skaters, with a special emphasis upon the intersections of race, ethnicity, gender, sexuality, and nationalism in mediated skating performances. She has also conducted research among competitive swimmers, and she is beginning a long term project on nationalism and Canadian identity at the *Stratford Festival of Canada*, a seasonal Shakespearean festival in Southern Ontario.

Marie Milner is a secondary school English and ELL teacher at Andrew P. Hill High School in San Jose, California. She is also an associate director of the San Jose Area Writing Project, which is associated with San Jose State University and is a part of the larger National Writing Project centered at UC Berkeley.

Erma Jean Sims is a lecturer in education at Sonoma State University. She received her Juris Doctor (J.D.) in Law from the University of California Hastings College of the Law. She uses her classroom as a social justice laboratory, raising the consciousness of pre-service teachers about the complexities of racism and whiteness and empowering them to engage in social justice activism.